D1582689

BALLENESQUE

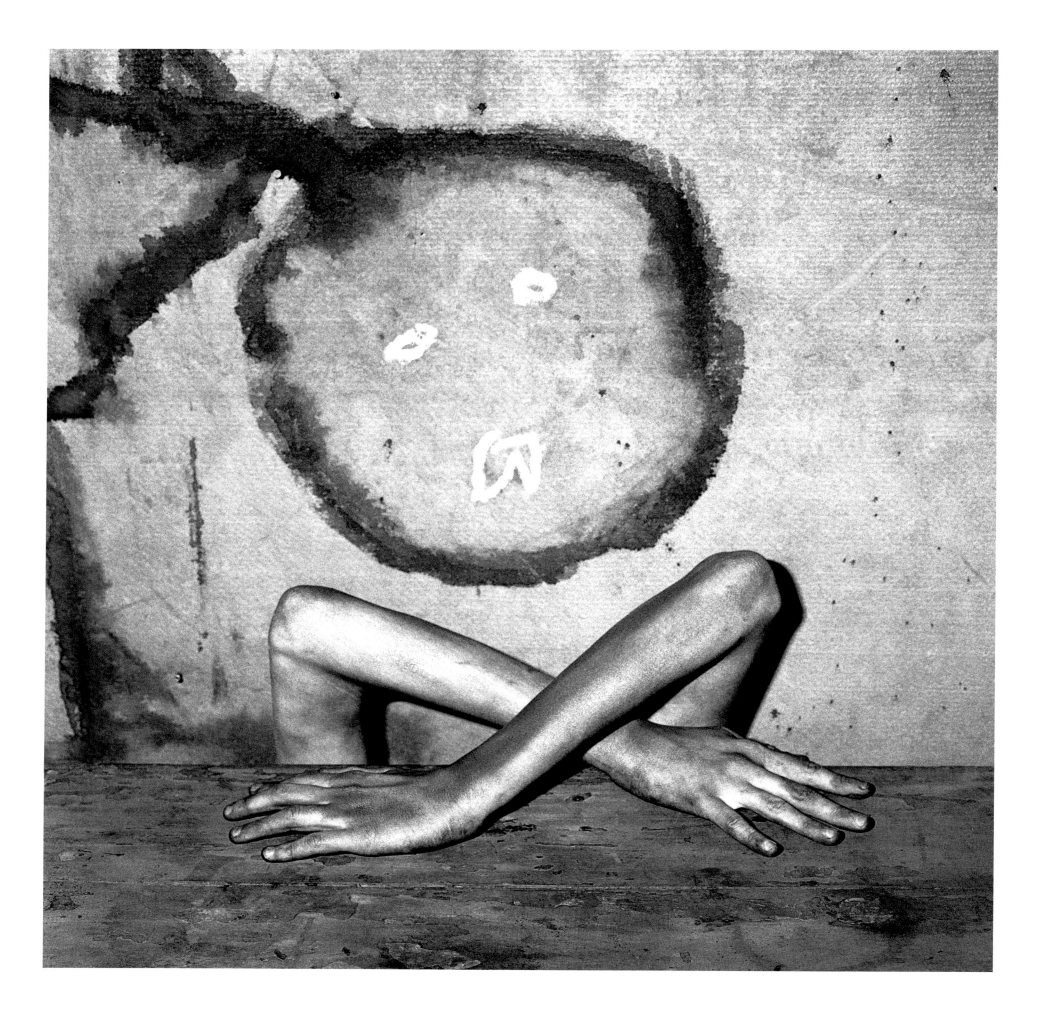

BALLENESQUE

roger ballen: a retrospective

roger ballen

introduction by robert j.c. young

 Thames & Hudson

To Lynda and Amanda Ballen, Marguerite Rossouw, Jenny Da Silva, and Adrienne, Kate and Sian Ballen, whose presence is in some way embedded in my photographs, and whose dedication, insight and vision have enabled me to discover new possibilities.

Frontispiece: *Mimicry*, 2005

Ballenesque: Roger Ballen – A Retrospective
© 2017 Roger Ballen

Introduction © 2017 Robert J.C. Young
All other text © 2017 Roger Ballen
Photographs © 2017 Roger Ballen; for exceptions,
see page 334

All Rights Reserved. No part of this publication may be reproduced or transmitted in any form or by any means, electronic or mechanical, including photocopy, recording or any other information storage and retrieval system, without prior permission in writing from the publisher.

First published in 2017 in the United States of America
by Thames & Hudson Inc., 500 Fifth Avenue, New York,
New York 10110

www.thamesandhudsonusa.com

Library of Congress Control Number 2017931784

ISBN 978-0-500-51969-1

Printed and bound in China by Artron

contents

introduction **roger ballen: the -esque factor**

robert j.c. young

-esque: 'in the style of, resembling'. For the suffix -esque to be added to a noun or a name, it must evoke something distinctive enough to be imitable. The mark of a great artist, of a great photographer, emerges when his or her particular aesthetic mode becomes instantly recognizable. There is a certain point in the evolution and trajectory of Roger Ballen's photographs when they become identifiably his, so much so that even if you discovered that they were not actually taken by him, the images would remain Ballenesque. They would still in some sense be his even if not his, or, possibly, only partly his, as in his recent collaboration with Danish photographer Asger Carlsen.[1] Can we detect the moment at which this happened? No. By definition, the -esque factor is that magical additional element that is undefinable. But let this not stop us from trying to define it anyway, to identify the assemblage of particular elements that make up the distinctive individuality of Ballen's work and mark it as his own. We will isolate four; you, the viewer of his photographs, may add a fifth to complete the secret.

It is equally impossible to find the historical moment of the emergence of the -esque, for however distinctive, Ballen's style does not remain static. It is constantly evolving, metamorphosing into something else, finally spilling out beyond the frame of the photograph into the installations that have grown to be part of its subject. As Ballen's work begins to look like himself, he becomes something else, which then in turn resembles himself. We associate great photographers with a certain style: Cartier-Bresson's decisive moment, Rodchenko's upended perspectives, Diane Arbus's portraits that challenge the conventional aesthetics of human beauty that drive the typical choice of photographic subject, or Lee Friedlander's hustling cityscapes. Once a photographer achieves that recognizable idiom, he or she tends thereafter to work within it and through it, perhaps extending the range of subjects – recall Cartier-Bresson's journeys around the world – but rarely evolving into new styles or idioms. We associate the characteristic of continual change more with painters: their distinctive moves between early, late and other named periods, from realism to impressionism, the formal portraiture of early Picasso before the explosion into cubism, or the darkening of late Rothko, whose colours, as John Berger put it, had been awaiting the creation of the visible world. In that sense, Ballen resembles more a painter than a photographer, since his work demonstrates a constant evolution, not just of subject matter but also of aesthetic modes, techniques and preoccupations; what is remarkable is that his images still remain recognizably, distinctively Ballenesque throughout. To identify the Ballenesque, let us think in terms of the qualities of his unique aesthetic outside the frames of his individual books. For the aesthetic emerges outside the book, outside the box, from the outside ...

Ballen's aesthetic takes us back to the age-old issue of the relation of photography to painting. The dialectical relation of photography to painting has been dynamic since photography was first invented: many artists have engaged with both mediums, and the two forms of representation have constantly imitated, reacted against and fed off each other. Few photographers, however, have transformed their photographic work into a form of painting; even Saul Leiter's colourist paintings remain a distinctive, separate idiom from his overall output of photographic images of the hues, textures and typographies of New York. What is unusual about Ballen is that his photographs gradually become paintings, or rather they become indistinguishably photograph or painting before

our eyes and remain in the statelessness of the in-between, or re-emerge beyond that as sculpted installation art or theatrical video, presenting us throughout with stage-sets of chaotic, bizarrely populated interiors in which each person, each animal, each object, or part-person, animal or object, obtrudes into the image from an unknown place on the other side of the outside.

Ballen himself has pointed to his own photographic heroes – Cartier-Bresson, Weegee, Arbus, the Brassaï of *Graffiti* – and hints of all these photographers can be detected in his images.[2] These influences, however, do not help us to isolate the distinctive -esque factors through which Ballen has created the Ballenesque. While we can consider Ballen according to his different books, periods and idioms, they are not neatly segmented: it is not as if one style changes seamlessly to another and its traces are lost. What we see instead is a shift of idiom, of foregrounded elements by which we can characterize the originality of Ballen's own -esque. Although we can detect in the early photographs hints of what would become the Ballenesque – particularly with respect to images of predominantly texture and form (see, for example, page 31) – or the slight hints of the strange and the weird, as we look at them we are reminded of the work of Aaron Siskind (page 22), or more often of Cartier-Bresson (pages 36, 37, 46, 72). These are compelling photographs, but as we look at them we do not yet experience the -esque. The -esque will not appear in smooth chronological unfolding: it is generated from elements that appear, retreat and then return, to repeat and interact with one another in more developed or extreme forms.

It has been suggested that we will be isolating four unique elements as the partial secret of the Ballenesque. The first of these can be characterized as prehensile portraits of the unprivileged. Why 'prehensile'? Because these portraits do not simply present us with their subjects made up from marginalized people who live at the peripheries of society; rather, the images have an in-your-face quality, too close for comfort, that means that the portrait grasps at you, seizes you, and holds you fast. It is not so much we who are looking at them, but rather they who are looking at us, compelling us to respond and submit to their gaze. The second component of the -esque can be defined as recurring sets of aleatory assemblages. 'Aleatory' is a word whose origins come from the name of a dice game: it suggests that the scenes we are watching incorporate random elements coinciding here by chance encounter: it is as if they have been put together by a throw of the dice. There is no context for their appearance or explanation of any relation between them, leaving them hanging in an absurdist limbo of alienation. The third feature of the -esque comes with Ballen's windowless walls, often bedecked with winding wires, drawings, smudges and graffiti, that make up such a distinctive feature of his images, while the fourth can be characterized as dark junctures of disjunction, that is, disturbing visualizations in which we can no longer identify ourselves as remaining in the realm of the real. In their various shifting combinations and relations, together these make up the constituent ingredients of the -esque factor.

-esque 1: prehensile portraits

Everything that Ballen does with his photographs is anchored to the square-format form of the original celluloid film in his camera. The effect of the square format is to

present a neutral frame for the image that allows the viewer no distance from it. While the rectangular pictures of boys in *Boyhood* (1979) portray them embedded within the wider surroundings in which they play, with the Rolleiflex portraits of *Platteland* (1996) Ballen often moves so close that the depth of field itself disappears altogether. The faces of his subjects – usually shot from a position directly in front of the subject, who poses solemnly as if for an old family photograph – almost grab you as they push out of the frame. The proximity is so intense that you have to recoil, which paradoxically then creates an aesthetic distance or aura that separates you from them.[3] Ballen describes his early subjects as white people living in the rural hinterlands whom the apartheid regime had left behind, despite all the privileges that the system had reserved for whites. The faces and the bodies of these individuals already signal Ballen's interest in those who live their lives on the edges of society. Their expressions and physiques emphasize physical distortions that simultaneously suggest forms of psychic disturbance, a combination that quickly became a hallmark of Ballen's photography. Like *Brian with Pet Pig* (1998; page 126), these are marginalized characters who seem to be inhabiting or coming from a strange and alien world. Whether on the farm or in indeterminate interior space, however close they get the image enforces a psychic distance that blocks any kind of empathy for the viewer. This dynamic lack of identification encapsulates the secret of Ballen's early portraits, and this is a quality that endures throughout his work. They seem to offer no possibility of compassion, or of sympathy, or of the self-discovery of human interaction as we view them without being able to prevent ourselves from being sutured by them into their world. Contrast the rugged portraits of Richard Avedon in his *In the American West, 1979–1984*, which at first sight they may appear to resemble. Avedon's blank background takes his subjects into the studio, where they enter a common space with the viewer. Ballen's cast of characters never leave their often bizarre domestic or theatrical surroundings, always remaining remote from us. This world, although recognizably a human world of sorts, propels the viewer into its alien auratic space, even while it remains unfamiliar, inaccessible, deranged, even to the imagination.

-esque 2: aleatory assemblages

While Ballen's early portraits are of subjects with whom he had interacted, and who had sometimes invited him into their homes, he subsequently moved himself into worlds of the marginalized, befriending them so that they became less his subjects than the actors for his photographs. As we pass through the portraits, one photograph suddenly compels and arrests the eye: *Elias Coming Out from under John's Bed* (1999; page 83). While there is a vanishing-point perspective here across the bed, the eye is drawn instead to the mirroring faces that emerge from above and below. The startling disconnection between the face of the white man staring slightly to the side of the camera, and the upside-down young African man staring directly into it, without explanation or context, forces the viewer down on to the plane of their mirrored reflection, joined not just by the viewer who links the two gazes with his or her own, but also by the rough texture of the grey wool rug stretched between them.[4] In putting these two figures together in such an inexplicable way, Ballen utilizes a technique of montage, juxtaposing incompatible elements in an unexpected way to produce new meanings that have yet to be formulated,

that remain hanging between us and the image. Henceforth, this uncanny disjuncture becomes the core of his work. Body parts of humans appear momentarily, but these are not people whom we are invited to consider as individuals. Human characters, parodied and mimicked by primitive masks, are now placed in an incomprehensible, unfathomable dynamic relationship with other animals and objects that populate the image. It is no longer human beings alone who appear to be living on the edge, but the whole environment – human and animal – that has become dislocated and out of joint. Humanity merely comprises one element of natural and unnatural worlds that have now come together in a surreal theatrical space of the absurd. Here we can locate the second component of the Ballenesque: the juxtaposition of humans with animals and other material elements on the same plane of being, whose random contiguity offers neither human meaning nor value. Humans and animals alike are portrayed as precipitated into an empty, degraded limbo of material waste, of refuse, debris and decay, where they live together as equals but without any earthly relation between them.

-esque 3: windowless walls

Along with the face, the wall remains a constant. After Ballen moved inside to interior spaces, the disturbing portraits shot outdoors were abandoned for something even more peripheral than their subjects. Some of Ballen's characters had already been photographed in their houses against whitewashed walls smeared with dirt, graffiti, with crude wires strung across from side to side, with staring portraits of ancestors or pornographic images of women fixed to their upper levels. This motif appears first in *Bedroom of a Railway Worker, De Aar* (1984; page 93), where we are presented with an old Victorian wash-table with a bed bedside it, each of these objects half cut off by the edge of the frame. The upper two-thirds of the image shows the plain wall behind, with a battered desk lamp strung up on the wall and connected to rough triangulations of electric wires spread out so that they split the wall into abstract shapes. Ballen becomes preoccupied with these two-dimensional planes, whose poignant inscriptions on the walls inside the South African houses, as in *Boy with Guns, Western Transvaal* (1993; page 102), become the increasingly random and bizarre configurations that are staged for the photographs of *Shadow Chamber* (2005). The title of this volume aptly characterizes these chamber creations, in which smudged spectral mask-figures on the wall enact a *nature morte* where life seems more than stilled: it has been evacuated. The shades of the smudge, the smear, the stain have become the subject of the photography, as for example in *Children's Bedroom Wall* (2000; page 133). These rooms never seem to have a window, and even when windows do appear, in *The Theatre of Apparitions* (2016), they shift into forms of darkness and eyes that glower back at you from a voided vacancy. There is no outside, no world that we can reference here. We are enclosed within a claustrophobic realm of surface, of inscriptions, marks and lines, where even the objects have become rolls of barbed wire. It is these scripts and drawings that transmute into the repeated graffiti faces and stick figures, the crude masks and puppets, that dominate many of the surreal images presented in *Boarding House* (2009), *Asylum of the Birds* (2014) and the ongoing series *Ah Rats*. The drawings become three-dimensional, the wall a display case of haphazard dismembered curiosities, the masks a *tableau vivant*.

-esque 4: dark junctures of disjunction

The last element of the Ballenesque can be identified with his constant tendency to push towards the limits of photography, where its function of the representation of the real is removed almost altogether and shifted to the performance of abstraction, of assemblages of primitively drawn figures, of disassembled debris and bones, dolls and roughed fabrics and stuff. These imaginary theatricals are already anticipated in *Pathos* (2005; page 204), from *Boarding House*, where the blind monkey puppet doll sits resignedly in front of a wall of decaying ragged cloth that echoes and imitates the abject surface of his fur. We have moved to an unimaginable space of representations that no longer evoke the real, even though we know, through the medium of the photograph, that they are situated in the real: if at first sight we do not recognize the real, a bird or a rat will remind us that we are still there to some degree, even if we have no idea where we are. So, in *Asylum of the Birds*, we shift into remote realms of what could be a private, crudely drawn installation or a grotesque altar created for unknown gods, replete with its own panoply of worshippers and sacrificial victims, emptied out of all significance except for the live dove caught flying across the image. Here, these doves do not evoke their customary metaphoric meaning of either peace or transcendence; instead, they seem trapped, isolated, struggling to free themselves from the claustrophobic inhuman world to which the viewer has been submitted. We are propelled further inside. There is no exit from the bleakness of Ballen's cluttered, mutated, uncreating world: for Ballen, this is life itself.

In recent videos and images, Ballen has increasingly figured himself as the haunted alien of whom all the strange individuals that he has befriended and photographed over the years have now become merely an anticipation. Paradoxically, once your style becomes unique, recognizable, imitable, then your own photographs begin to look like … yourself. In that sense, Ballen's photographs and their subjects have been resembling him all the while, and this is what has been driving, generating and producing the confluence and conflux of outlandish, disaggregated elements that can be characterized as the Ballenesque. What makes Ballen's photographs so distinctive are those qualities of the Ballenesque that continually prompt his viewers to ask questions to which different audiences in different places will form their own responses. You too will be asked to decide. Are we following a journey with these photographs into the terrors of the human unconscious, in which the viewer is forced to come into contact with a part of their own being, with the dark inner realities of the human condition that are common to us all? Or are we looking through the microscope of the camera into the uniquely creative unconscious of the artist himself? Does the Ballenesque conjure up something inside each one of us, or does it display something unique to his genius that captures and fascinates the viewer? Could it be doing both?

1 Roger Ballen and Asger Carlsen, *No Joke*, V1 Gallery, Copenhagen, 23 September – 22 October 2016.

2 For more on Ballen's relation to earlier photographers, see my 'Marking the Unconscious: The Art of Roger Ballen', in *Lines, Marks and Drawings: Through the Lens of Roger Ballen*, ed. Craig Allen Subler and Christine Mullen Kreamer (Washington, DC: Smithsonian National Museum of African Art; New York: DelMonico Books/Prestel, 2013), pp. 11–23.

3 Walter Benjamin defines this aura as 'a strange weave of space and time: the unique appearance or semblance of distance, no matter how close the object may be'. Walter Benjamin, 'A Short History of Photography', in *One-Way Street and Other Writings* (London: New Left Books, 1979), p. 250.

4 Compare the technique of *Monks, Burma* (1976; page 37), where the vanishing perspective down the hallway is cut across by the line of the non-reciprocal looks between the two monks.

chapter 1 **finding the core**

early work

boyhood

A shadow runs through my work.
The shadow spreads, grows deeper as
I move on, grow older. The shadow is no
longer indistinguishable from the person they
call Roger. I track my shadow (life) through
these images.

Roger Ballen will ultimately be defined by
these photographs. What would have become
of Roger and his shadow had he not possessed
a camera?

Where did it all start? Where have the images I have taken come from? What would Roger be without a camera to define this mysterious being?

I bought my first camera, a Mamiya, when I was thirteen. By that stage, in the early 1960s, my mother had been working for Magnum for some years. Through her conversation, and particularly her collecting, I was exposed to the work of many photographers – some of them now considered historically important. In this milieu, there was a complete belief in the value of photography, particularly in its ability to capture and convey meaning in a socio-documentary context.

The Magnum photographers were my idols, my heroes. My mother hung their photographs all over the walls of our suburban house in Rye, New York. I ended up assimilating their images, and by the time I went out to photograph seriously, which was around the age of eighteen, I had a clear idea of the level I was aiming at.

At an early age I was captivated by the work of Paul Strand. He operated as a photojournalist, but considered himself an artist. He was a street photographer, yet he worked with his subjects in a very intimate way. Even today his work seems timeless. (And yet, in its idealism, it now strikes me as belonging to a previous era.) His deep respect for the inherent formal qualities of a photograph, and his use of the square format, were to be significant for me. He was my first role model.

I got to know André Kertész through my mother's friendship with him. Kertész had left Europe for the United States during the Second World War. He had been influenced by the surrealists: their qualities of puzzlement and contradiction were intrinsic to his eye. My mother was the first person to sell his work in the States, at a photographic gallery that she had opened. Americans had considered his work unsaleable; he in turn was appalled at the unsophisticated state of photography in America. I often visited his apartment with my mother, and during these visits, like the great master, I photographed from his balcony overlooking Washington Square Park. On one occasion I photographed a metal rooster that he had sometimes featured in his own works (page 16). It was a kind of tribute to him. I owe to Kertész the understanding of enigma, the quixotic, and formal complexity that underlies much of my work. He taught me that photography could be an art form.

Among other photographers who have influenced me are Henri Cartier-Bresson (the decisive moment), Elliott Erwitt (the humorous and the absurd) and Ralph Eugene Meatyard (the psychological).

The most vivid and pivotal moment in my life occurred in 1968 when my parents gave me a Nikon FTn camera for my high-school graduation.

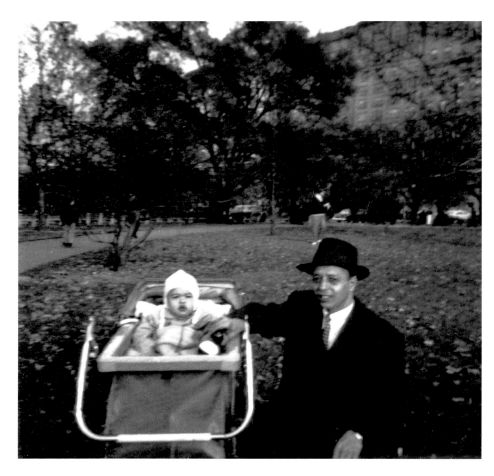
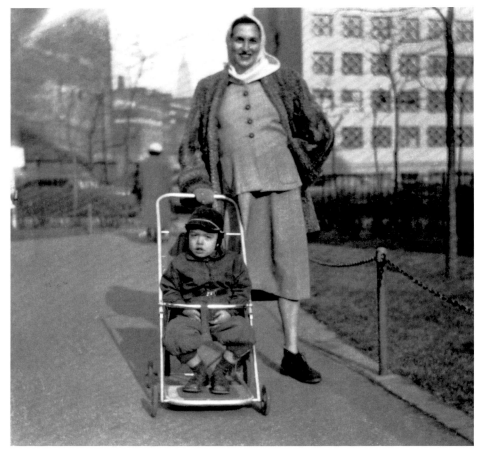
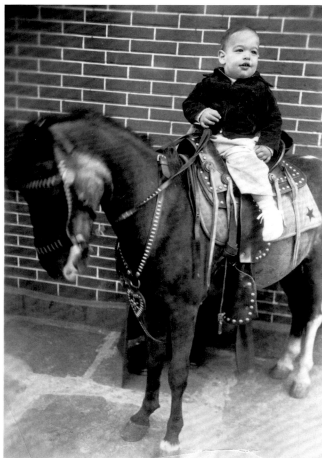
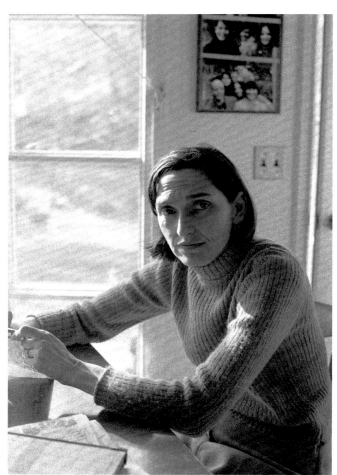

Roger in a baby carriage with his father,
Irving Ballen, 1951
Roger with his (pregnant) mother,
Adrienne Ballen, 1952
Roger on a horse, 1951
Adrienne Ballen, 1969

I remember that the camera, sent from Hong Kong by a friend, had became lost in customs. After some weeks it was found, and the very same day I received it I went to the outskirts of Sing Sing prison near New York City to take photographs. Even now, I can still remember what that camera smelt like on that first day.

At that time, I was particularly interested in photographing old men, especially those whose demeanor reflected an aspect of what I believed to be an essential element of the human condition. I was particularly drawn to the paintings of Rembrandt for the same reason. I took an image of two men fishing on the pond in one of the main parks in St Louis, Missouri, titled *Old Men Fishing* (1968; page 16). I have often considered it to be the first of my photographs that has an aspect of me in it.

On the same day as taking *Old Men Fishing*, I visited a Van Gogh exhibition at Saint Louis Art Museum. The show was an incredible revelation, as it made me aware that art could be a mechanism for coming into contact with deeper, inner realities.

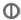

I spent the late 1960s and early 1970s, the formative years of my late adolescence, a the University of California at Berkeley. This was the time of the Vietnam War, 'flower power', the Civil Rights Movement – what has become known as the counterculture. It was a time of questioning, rebellion against the status quo, and unease regarding corporate life and politics. There was a nagging concern about the effects of technology on the human condition, and a deep searching for alternative values.

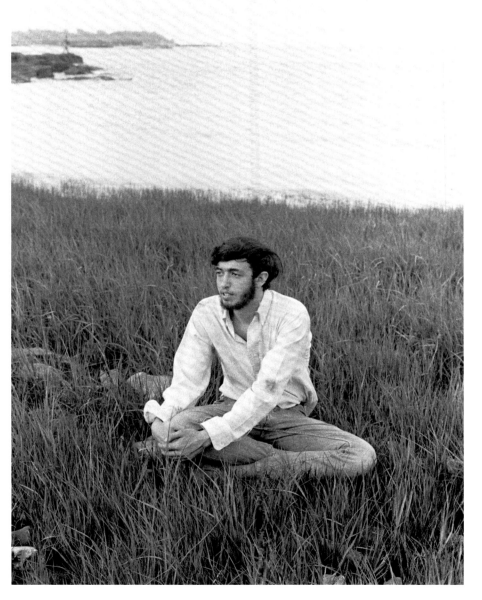

Roger aged eighteen, 1968

In the early 1970s, during my student days at Berkeley, I was involved with the anti-psychiatry movement led by R. D. Laing. According to Laing, the definition of normality and insanity were skewed towards political and social norms. Terms such as 'sanity' and 'mental illness' needed to be redefined to take into account the uniqueness of the individual and his interaction with other human beings. It was common for us to ask why the leaders of the American political and military establishment could be considered normal, given the fact that they were responsible for what we believed was genocide in Vietnam.

My serious involvement with photography began in 1969. I thought of myself as a street photographer emulating the great Magnum photographers. I would shoot from my car, pretending I was playing with my camera. These were exciting times; there were riots on the street and men going to the moon (see page 18). I photographed children in the ghettoes and hippies at Woodstock (opposite). During my summer vacation in 1971 I travelled the length and breadth of Mexico. That trip left a powerful impression on my psyche: it was my first experience of an underdeveloped country, and laid the groundwork for my travels a few years later. I also continued to photograph old men characterized by intense loneliness, separation and an inability to control their fate.

In June 1972, as a present for graduating from Berkeley, my parents gave me a Bauer Super 8 movie camera. I became obsessed with film, and

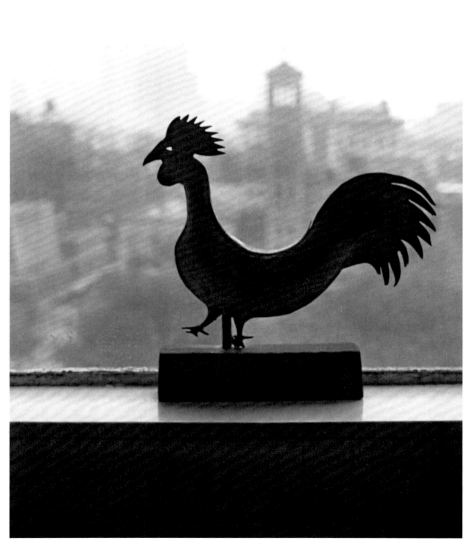

Kertész Apartment, 1972

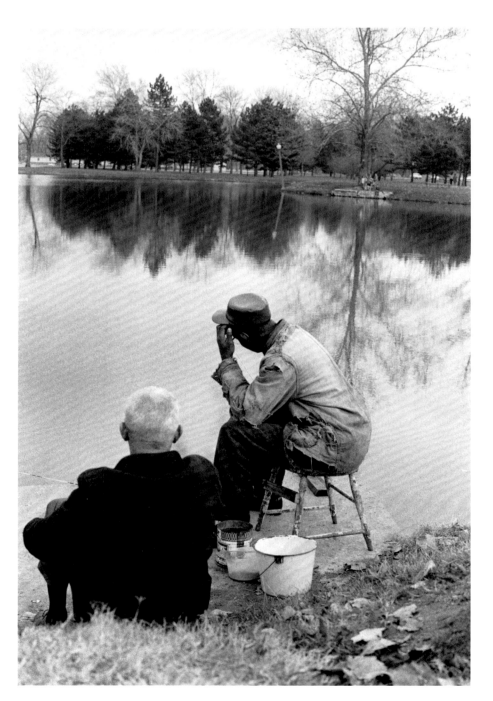

Old Men Fishing, 1968

Woodstock, 1969

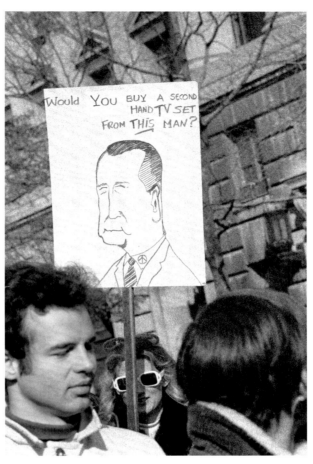

Vietnam Protest, Washington, DC, 1969

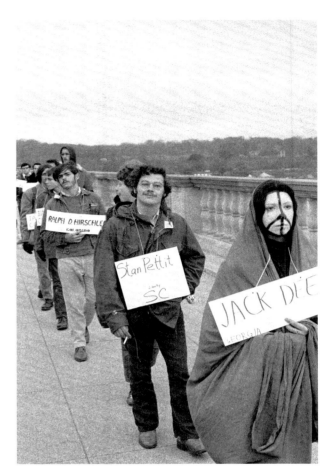

Death March, Washington, DC, 1969

delved into the medium with a passion. Nearly every night, you could find me at the Berkeley Art Museum cinema watching one avant-garde film after the next, from Godard to Eisenstein to Bresson.

During the summer of 1972 I took a theatre course at Berkeley. It was taught by a Professor Oliver, an inspiring academic who introduced me to the theatre of the absurd and such playwrights as Beckett, Pinter and Ionesco. For nearly a month I read a play every day. This one-month course gave me my understanding of the theatre, and would have an impact on my work for the next few decades. Also during the summer of 1972 I took a course in film-making in San Francisco. After completing the course, I decided to direct my first film, *Ill Wind* (1972; page 19), influenced by my studies of the theatre. The central actor in the film was Larry LePaule, a fellow classmate. Larry was a natural, slotting into the character that dominated my script. He had a habit of breaking into a Hitler oration, and had a love affair with a German girl.

In August 1972, with the script for *Ill Wind* completed, I began a month-long shoot with Larry. The film documents a Beckett-like character as he walks from place to place, going from nowhere to nowhere, leading a life of habit and rootlessness. The end of the film repeats the narrative of the beginning, with Larry doomed, like all of us, to a cycle of absurd attempts to find meaning in life. After editing the film at the end of 1972, I did not watch it again until 2014, when by chance I remembered that I had stored it in a safety-deposit box at a Johannesburg bank. The inspiration for the character of Stan in my film *Outland* (2015) can be traced back to *Ill Wind*. Certainly, it has become clear to me that my interest in outsiders, the marginalized, absurdity, extends back to my early youth, and not the point at which I began photographing in the small towns of South Africa in 1982.

At the end of 1972, living in New York once again, I was full of disillusionment and had a deep mistrust of Western values. Like my mother, Adrienne, I could never give in to the conformity of the American suburbs. She spent her last years unknowingly dying of colon cancer while trying to immerse herself in the art world. The death of my mother the following year left a void in my life; my knowledge of contemporary psychology failed to address either my grief or the questions raised by my existential depression. I had no idea how to support myself, and was surrounded by the consumerism of New York. In short, I found myself with a strong dislike of contemporary society.

After my mother's death in January 1973, I had a short, incomplete foray into painting. From February to May 1973 I studied at the Art

Students League of New York. I became fascinated by the fact that a painter works piece by piece, line by line, each shape carrying meaning until the whole image has been built. The street photographer usually has to start with an impression of the whole – and has to grasp it in the instant of the shutter's opening. Only once the photograph has been printed is he fully aware of the details, and can begin the process of unpacking the image. Lacking traditional drawing skills, I decided to use primitive, almost archetypal symbols and graphics in my paintings. I remember a very erudite teacher commenting that my drawings 'belonged in the Stone Age'.

For a period of five months, from Feburary to June 1973, I painted day and night, trying to come to terms with my inner identity (see pages 20–21). Thirty years later, my desire to express myself through the line would erupt, this short period in New York having created the foundation for my later work. I had not finished what I had started.

Driven by my obsession with painting, I began to visit as many galleries and museums as I could. I had an unquenchable thirst to comprehend the nature and meaning of art. Given that I was living in

New York City, the opportunities to educate myself about the art world were almost unlimited, and for a few months at the beginning of 1973 I would regularly photograph different aspects of this world.

In March of that year, during one of my classes at the Art Students League, I met a person by the name of Albert. Albert had injured himself on a construction site and was forced to retire. I remember him walking up to an art brut, crucifix-like painting I was working on. He was obsessed with Van Gogh, and said that he could see connections between the Dutch painter's work and mine. He rambled on and on about how Van Gogh and I had a similar mindset, being able to delve into the psychological core of humanity. Like so many people that I came across, then and now, he suddenly disappeared from my life. I cannot remember how and why. Yet he was the first person to make me aware that my paintings and photography could be a conduit to my psyche.

It was also in the first half of 1973 that I became aware of colour field painting. I was especially drawn to the work of Rothko and Barnett Newman, who spread colour across the entire surface of the canvas, with everything equally in focus. I tried to emulate some of their concepts.

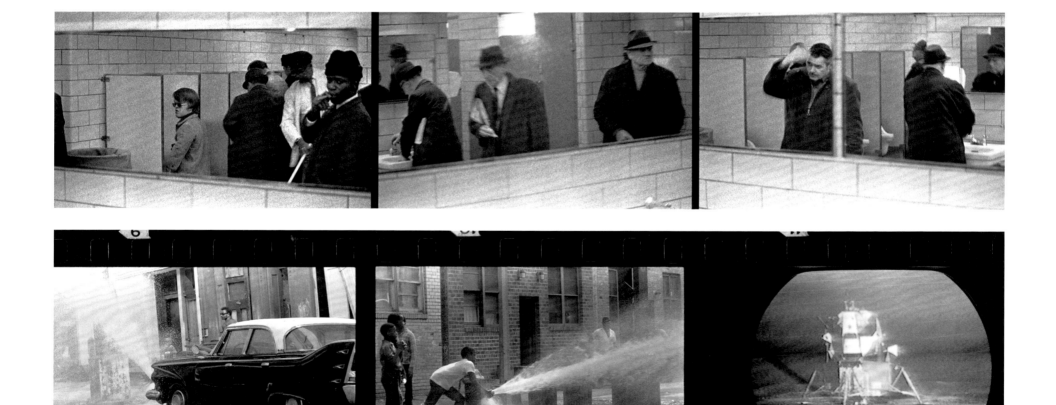

Public Toilet, St Louis, 1969
Photographs taken on the day of the first moon landing, New York, 1969

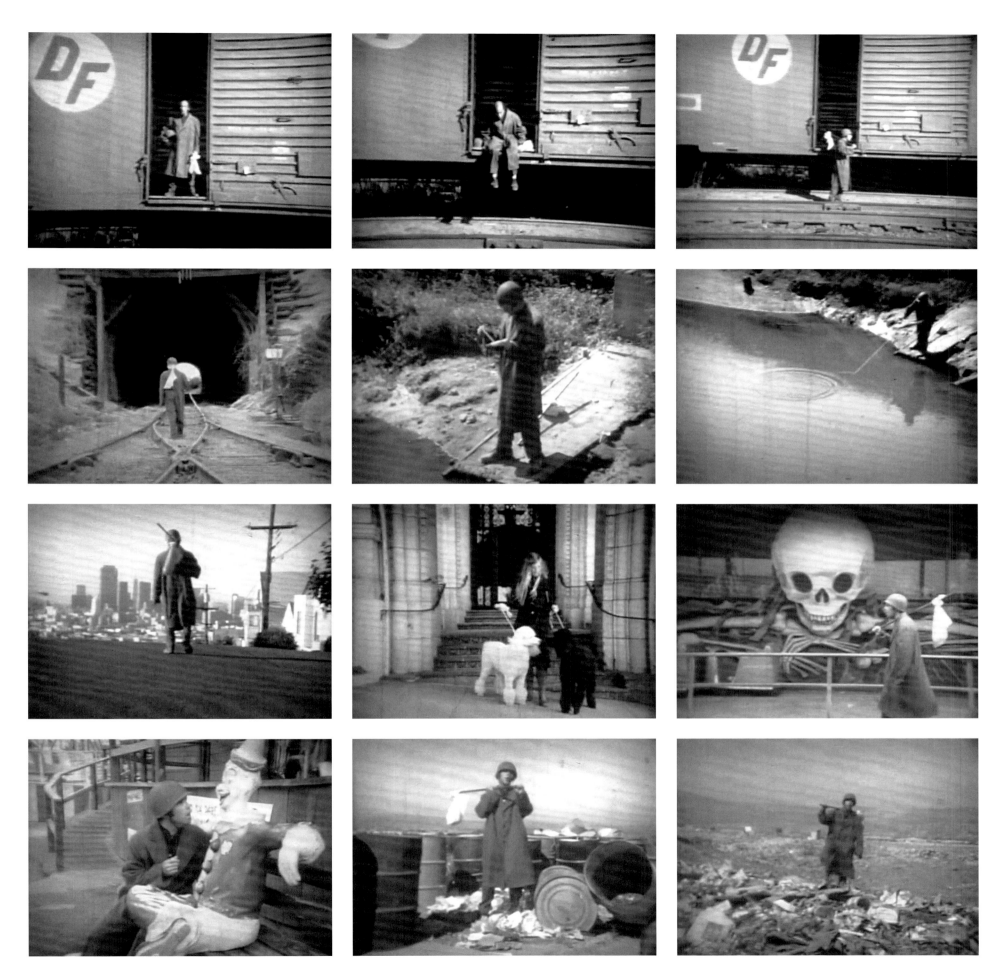

Selection of stills from *Ill Wind*, 1972

Untitled, 1973
Crucifixion, April 1973
Head on Highway, May 1973
Lovers' Last Date, 25 May 1973
Opposite: *The Last Supper*, 11 June 1973

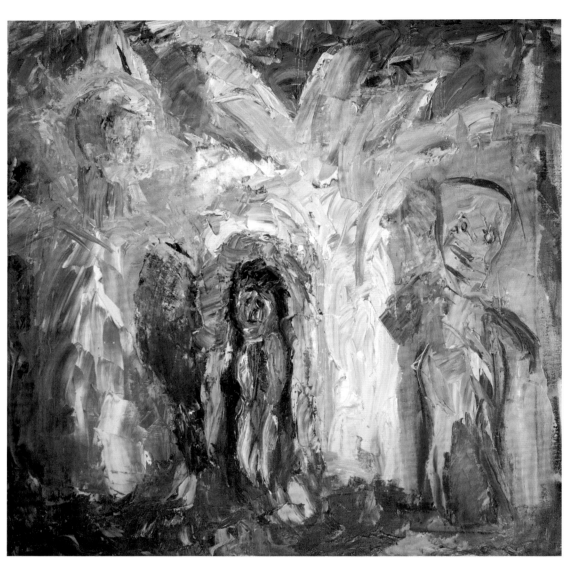

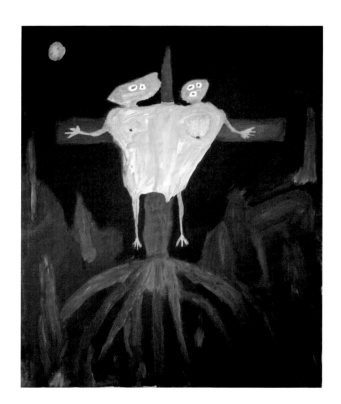

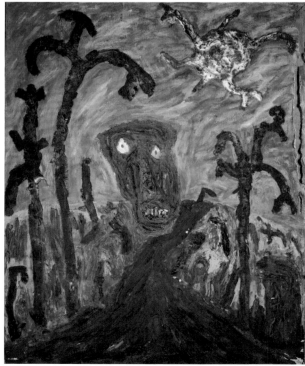

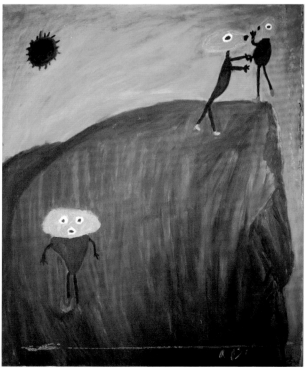

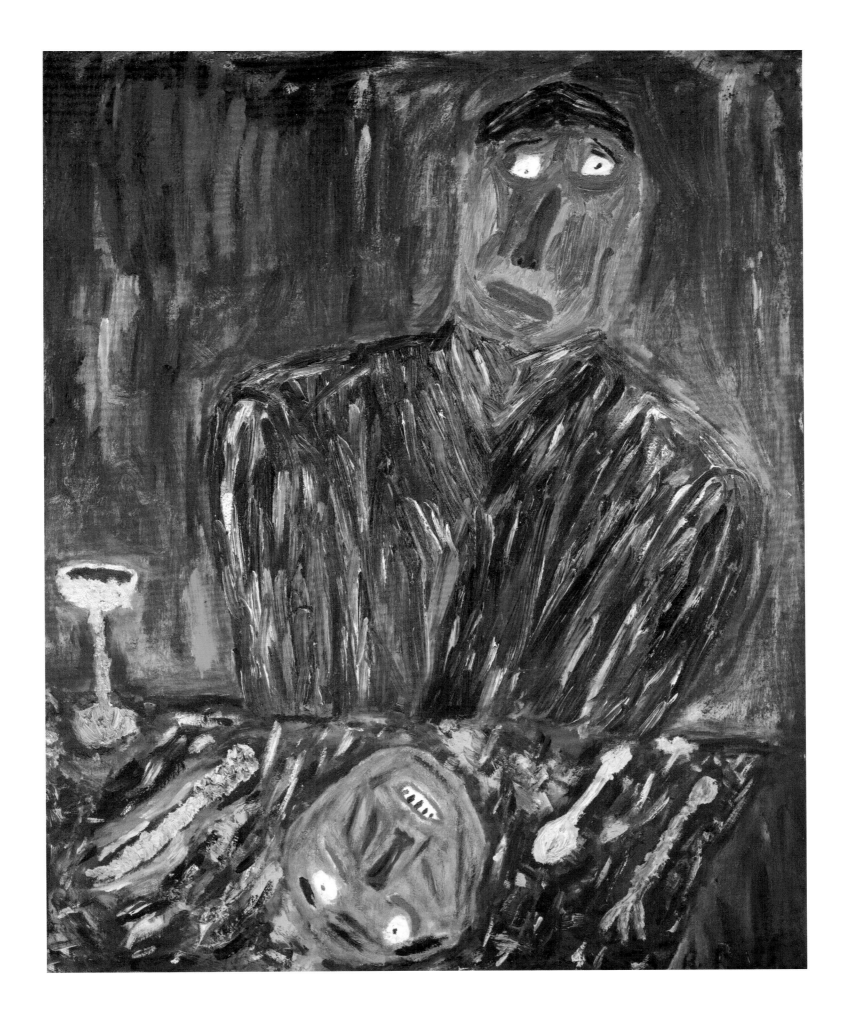

Top: *Peeling Paper, New York*, 1973; bottom: *Aagelic Figures*, 1973

I would point the camera down, creating my own 'field' on a street or earthen path, integrating dogs, bicycles and human body parts into the scene. By using a wide-angle 28 mm lens, I could let people walk in and out of the frame – and keep the picture in focus throughout. This, I believe, is the way the eye sees. We aren't aware of blurred areas; rather, each detail appears in focus as we give it attention. Clarity in the forms and a determination not to waste any part of the image by blurring it have characterized my work down to the present. One can find examples of what I commonly refer to as my 'field photographs' in the images taken between 1973 and 1974 (see pages 30–33).

During the early 1970s I would also seek out walls with particular patterns or shapes on them, where I would lurk like a hunter waiting for

an animal to set off a trap. As the subject entered this space, I would start taking pictures as if I were firing a machine gun (see opposite).

From the time I was eighteen in 1968 until September 1973, I had a deep existential yearning that neither my Jewish suburban upbringing nor my education could resolve. Like many others from the counterculture, I felt a need to move away from the materialism of Western society. Parallel to many of the subjects I photographed, I felt deeply unconnected and spiritually alone. My sister Kate's poetic imagination fired my desire to follow Conrad's quest to discover 'the heart of darkness', as well as to seek out the nirvana of the East. In the autumn of 1973, almost without warning, I left the United States on a five-year journey that would take me by land from Cairo to Cape Town, from Istanbul to New Guinea.

Initially on this journey, I took not only field-like photographs but also images of men in enigmatic and dramatic circumstances. I found my subjects in shrines, temples and marketplaces. I considered myself above all else a street photographer, emulating such iconic individuals as Cartier-Bresson while at the same time trying to reveal a quixotic moment in the manner of André Kertész. I would put all my Kodak Tri-X or Plus-X film – sometimes more than a hundred exposed rolls – in a green canvas knapsack, which I would tie to my leg during meals or on overnight train rides, or to my hotel bedposts. On arriving in such cities as Singapore, New Delhi, Hong Kong, Nairobi or Johannesburg, I would process the film and then send the negatives and contact sheets to my father in New York.

It was during this trip that I first arrived in South Africa, after travelling by land between Cairo and Cape Town. I spent some time there, recovering, before travelling across Asia. It was a time of apartheid, yet despite South Africa's political problems I immediately felt an affinity towards the country. During my stay in Johannesburg I would visit the public swimming pool, and it was here that I captured my most memorable images. I often return to this place, and imagine myself taking these photographs (see pages 34–5).

As I travelled the world I began to observe and photograph boys. They seemed to share a universal language; instinct and raw emotion were primary, wherever I went. The project *Boyhood* came into being one evening in 1976, as I was walking in the streets of Colombo, Ceylon (now Sri Lanka). I recorded the moment in my diary:

Ceylon, a humid evening. Lightening lights up a grey twilight, monsoon rains follow. A black mist drapes the city: the streets and marketplace are unusually deserted. Except for a single light at the end of the street, all is dark. Just as I reach the front of my hotel, two boys appear out

Roly Poly, USA, 1972

of the shadows. Both are shoeless and shirtless; one carries an empty bottle, the other a ball. As if pulled by a mysterious force, we stand face to face, staring closely and intensely. Moments later, a mother's shout punctures the quiet. The boys disappear towards the voice.

Shortly after this encounter I took the photograph *Letting Go, Ceylon* (1976; page 54), one of the more iconic images from this period.

As my travels continued, I became obsessed with what it meant to be a boy. By exploring with my camera the lives of the boys I encountered, I began to discover the lost boy inside me. In time, this led to the publication of my first book, *Boyhood* (1979).

My goal was to capture the essence of this unique period in life, when boys experience the world outside the boundaries of the home for the first time, with a mind that is still naive and open. In particular, I was attracted to the behaviour that I referred to as 'two boys', which plays an important role in this period of human development. Becoming independent of their parents, boys seek a bond with a member of the same sex in a passionate, innocent manner. Exploring, they go from one activity to the next, looking underneath logs, fishing in streams, falling over each other. Of all the images in *Boyhood*, it is perhaps *Pals, USA* (1977; page 62) that best captures this relationship. As I wrote in 1979, it brings back strong memories of my own boyhood:

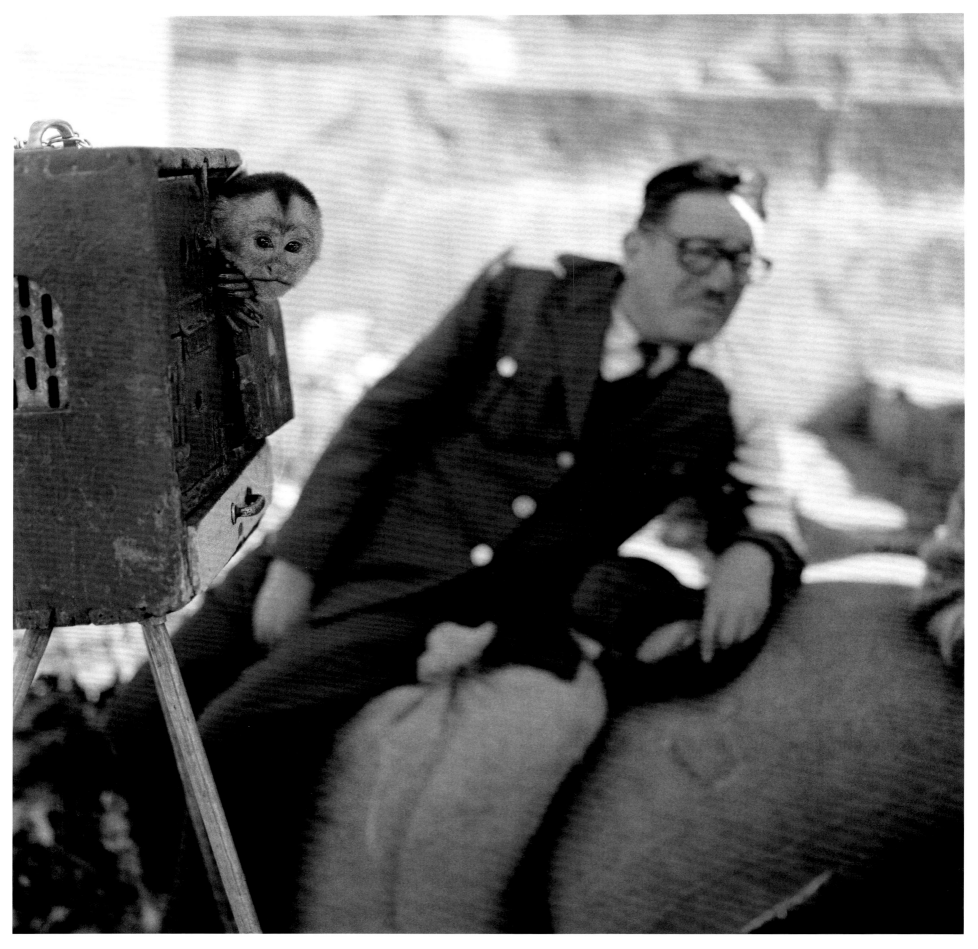

Monkey Man, 1981

When I see two boys together, I often think of Don Lowey, my first real boyhood friend. One day we decided to form 'the Club'. We partitioned off part of the inside of my family's garage with a white sheet. Within its walls important decisions could be made. We brought in our loudest rifles and our best throwing stones and whittled sharp sticks with our Cub Scout knives.

The next day Don came over again. This was the important day – we had decided to use real blood, but when it came time to prick ourselves with needles, we chickened out. Instead, we mixed crayon, wine, ink, rifle caps, brick, berries and cough medicine. After shaking the mixture together and saying 'abracadabra', we went downstairs to the garage. Just as we got to the driveway, my father, who was raking the leaves around the garage, lifted his head to ask what we had been doing.

Don looked at me, I looked at him, and we both broke into wide grins. I said to my father, 'We're pals.'

I travelled to faraway places on the planet, locations that tourists never went to, where children who had never seen a white bearded man thought I was a spirit of some kind and broke down in tears. My experiences in these locations left me with a deep understanding of the human condition, which has remained with me ever since. It gave me a sense of independence and confidence in my ability to transcend difficult situations, preparing me for life in South Africa.

As I journeyed by boat through Borneo and Sarawak, I read Conrad's book *Lord Jim*. I had a feeling of being an explorer in an unknown world; of being at the point at which Western civilization disappears and is replaced by a strange, dark territory. In 2016 I returned to this part of the world. High-rises now dominated the landscape. I remember reading in a local paper how the demand for condominiums was insatiable. I felt privileged to have experienced a period in human history when there were still some remnants of traditional cultures.

I have never forgotten experiences such as the one I had in Sarawak, East Malaysia, in 1976. My diary reads:

As I walked from my campsite to the village one morning to get supplies, I passed a group of boys who were fighting playfully. One boy blew up his rib cage upon seeing me and asked me to photograph him ... Quickly we became friends – fishing and hunting together, walking to neighboring villages on muddy jungle paths, eating in his family's one-room hut ... I will always remember saying good-bye to the 'blown-up boy', as I called him.

Around the time I took *Blown-up Boy, East Malaysia* (1976; page 57), I started photographing graffiti or textured walls, trying to find shapes and patterns that could be used as appropriate backdrops for my subjects. I posed the boys against such walls, creating an elementary stage set where my subject could reveal himself, the stage before the actor walks in. These images were the precursors of those that would begin to appear in 1982 during the creation of *Dorps* (see page 86). My diary from Pagan Burma reads:

In this town of ten thousand golden temples, I crept up on a group of boys, attempting to photograph them before they became aware of me. I found a boy among them who fascinated me, perhaps because he reminded me of myself at his age. After getting to know him, I asked him to pose for me against a wall. In this closed situation, the boy squeezed between the camera on one side, the wall on the other, I realized the essence of the boy was more likely to be forced out.

I spent the summer of 1977 at the apartment of photographer Bruce Davidson with my wife to be, Lynda Moross. During this time, I printed hundreds of the images I had taken during my travels. Following a trip to a summer camp in Westchester County, New York, I took the photograph *Froggy Boy, USA* (1977; page 52), which ended up on the cover of *Boyhood*. I clearly remember Lynda, who had received a Bachelor's degree in fine art from the University of the Witwaterstrand in South Africa, expressing glee over this image. She pointed out how the forms of the leaves mirrored the boy's feet and the frog's legs. It was during this time that I began to understand the importance of formal relationships in a photographic image.

Boyhood was published by Chelsea House in 1979. My dream of publishing a book of my photographs had been fulfilled. I now had the confidence and know-how to pursue other projects. I have often stated that books have always been my primary goal as a photographer, since they have a lasting power that extends beyond the temporary life of exhibitions.

Although I had a passion for taking photographs, I had a strong disdain for commercial photography. Sensing that mixing art and money might not serve either cause well, I enrolled at the Colorado School of Mines, where, in 1981, I received a Doctor of Philosophy degree. For my graduation present to myself, I bought a 6 x 6 cm Rolleiflex, largely because, after purchasing a copy of Walker Evans's *First and Last* (1979), I felt that my previous images did capture enough detail. This was the camera that I would use exclusively until 2015. As well as the gift of a camera, I treated myself to a trip to South America. My first important square-format photograph taken with the Rolleiflex was of a monkey coming out of a box in Ecuador (see opposite). In the Rollei, I had found a camera that would provide the detail and the format that would be crucial to the development of the Ballenesque.

early work, 1969–80

I never get tired of looking at the photograph *Dead Cat, New York*. It was the beginning of my encounter with animals. I found my line, my shadow, the path to my core – a central theme for the remainder of my career.

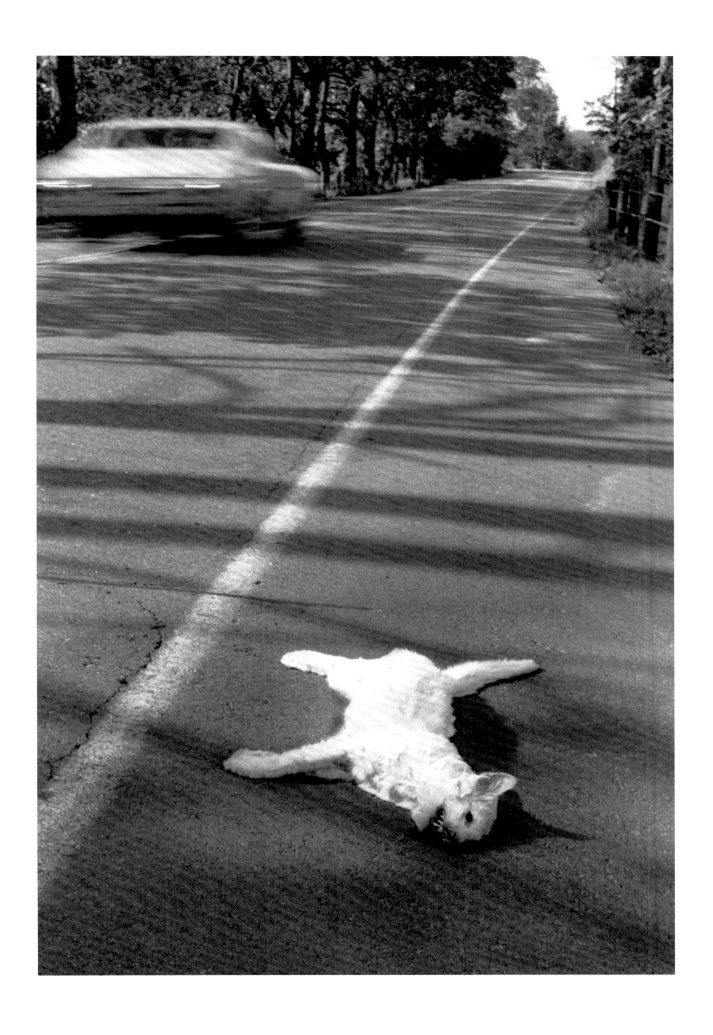

Dead Cat, New York, 1970

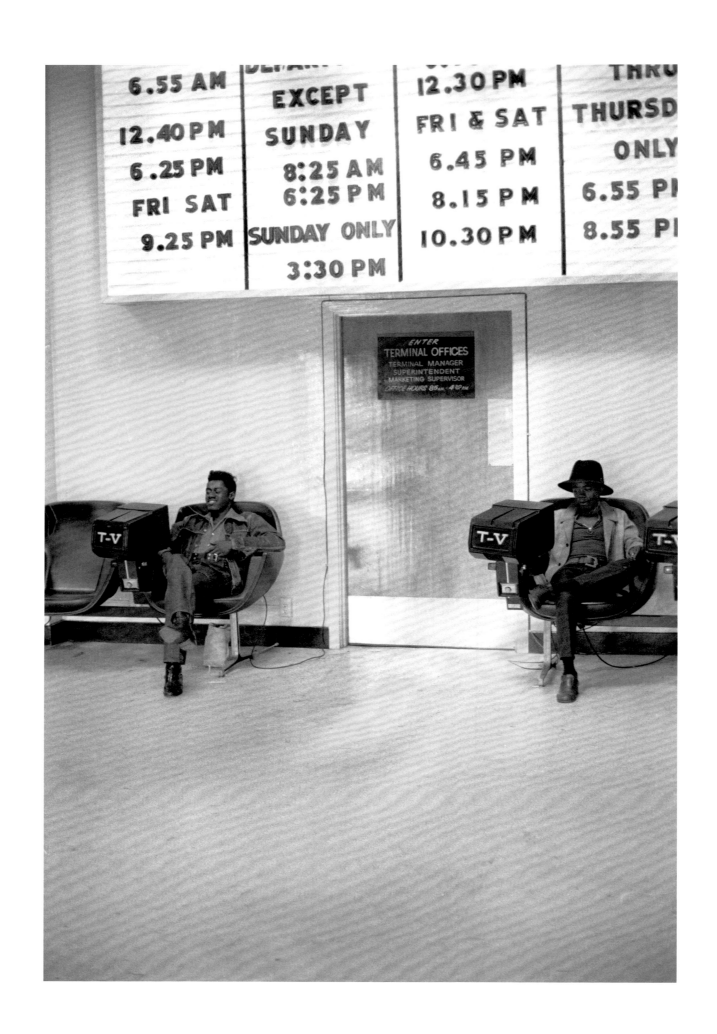

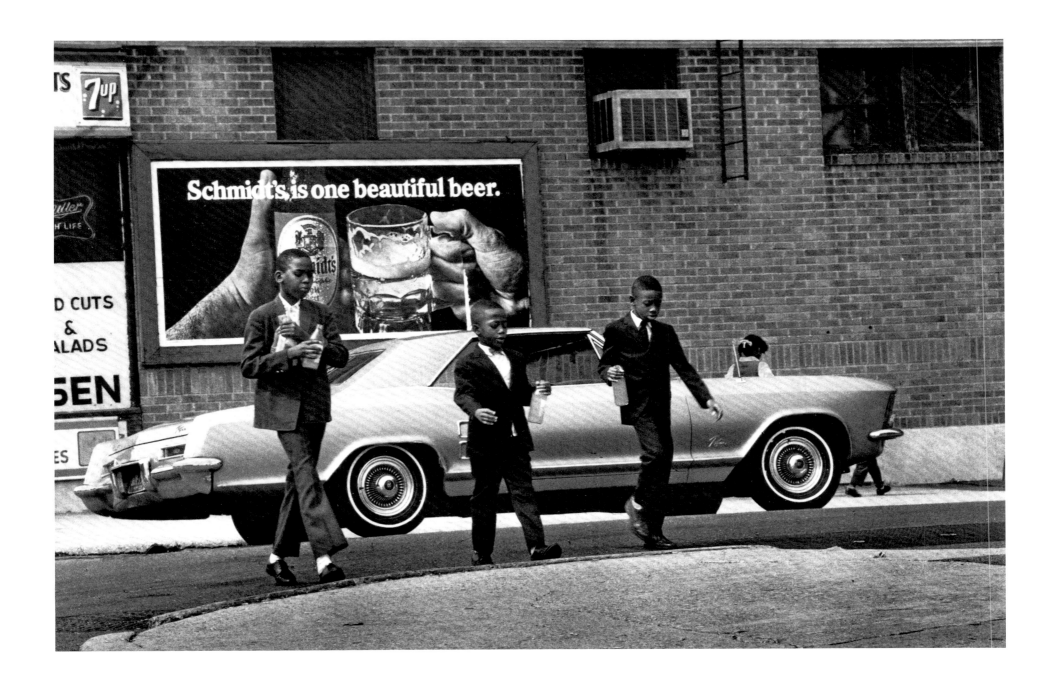

Opposite: *Bus Station, St Louis*, 1969
Homebound, New York, 1969

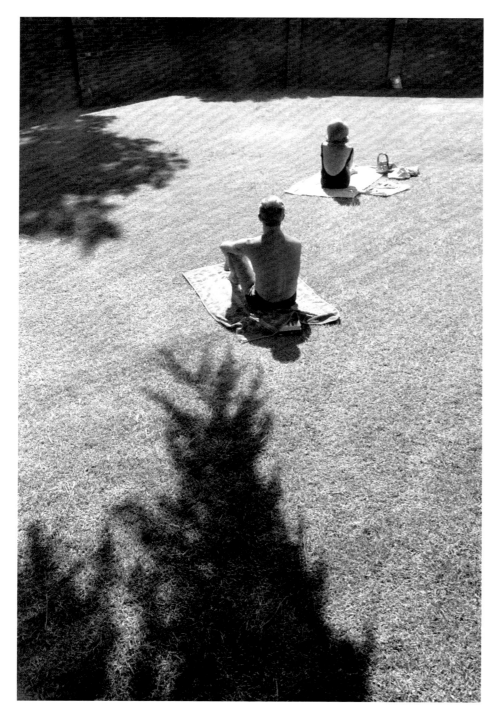

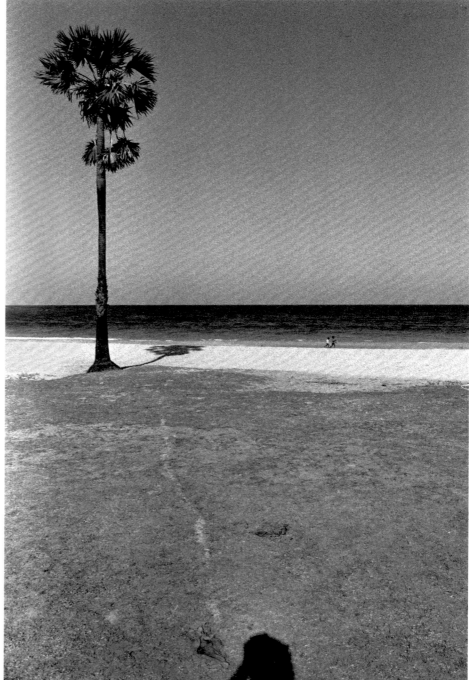

Sunbathers, South Africa, 1975

Lone Tree, Tanzania, 1974

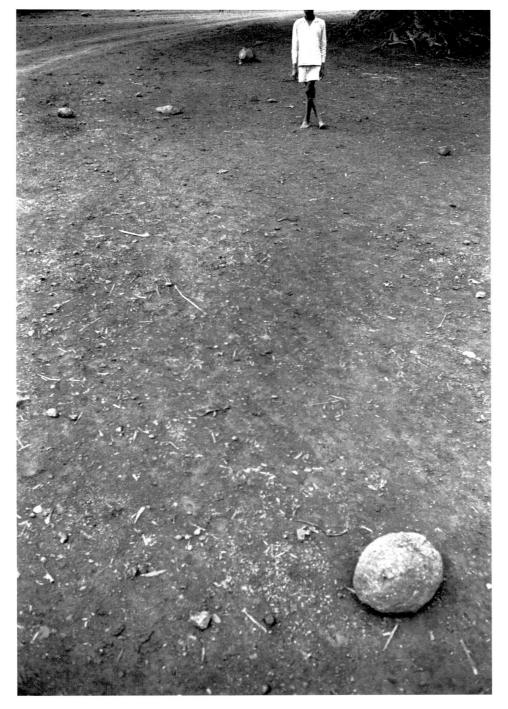

Decapitated, Ethiopia, 1974

Reversal, India, 1973

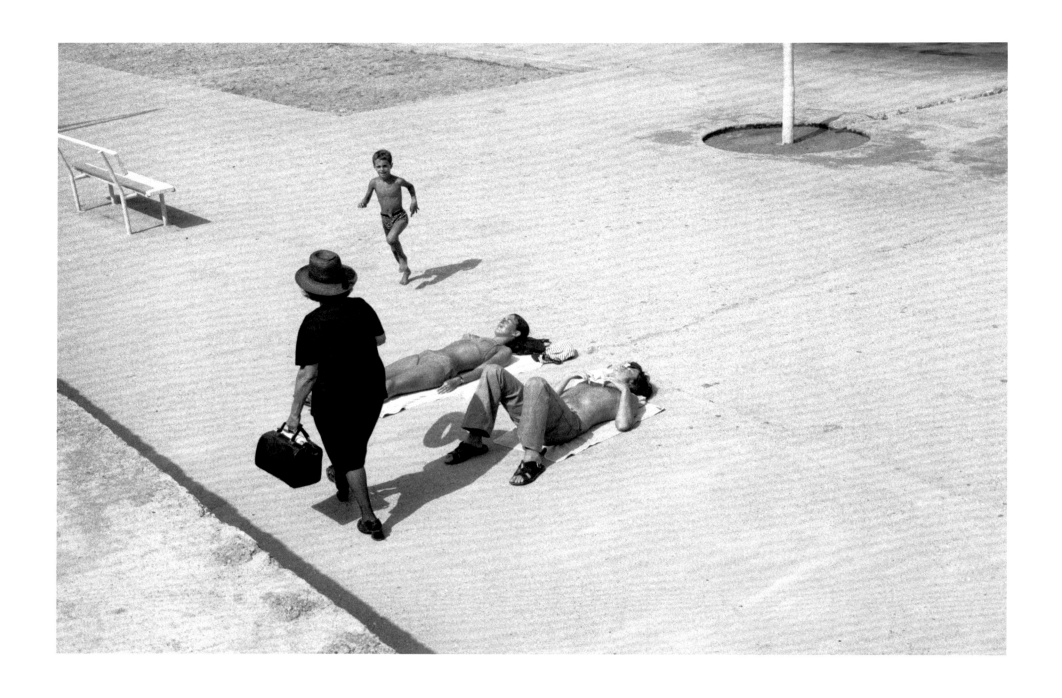

Woman in Black Dress, Greece, 1973

Copycats, Ethiopia, 1974

Emergence, Rhodesia, 1974

Voyeur, South Africa, 1975

My Leg, South Africa, 1975

Window-shopping, San Francisco, 1972

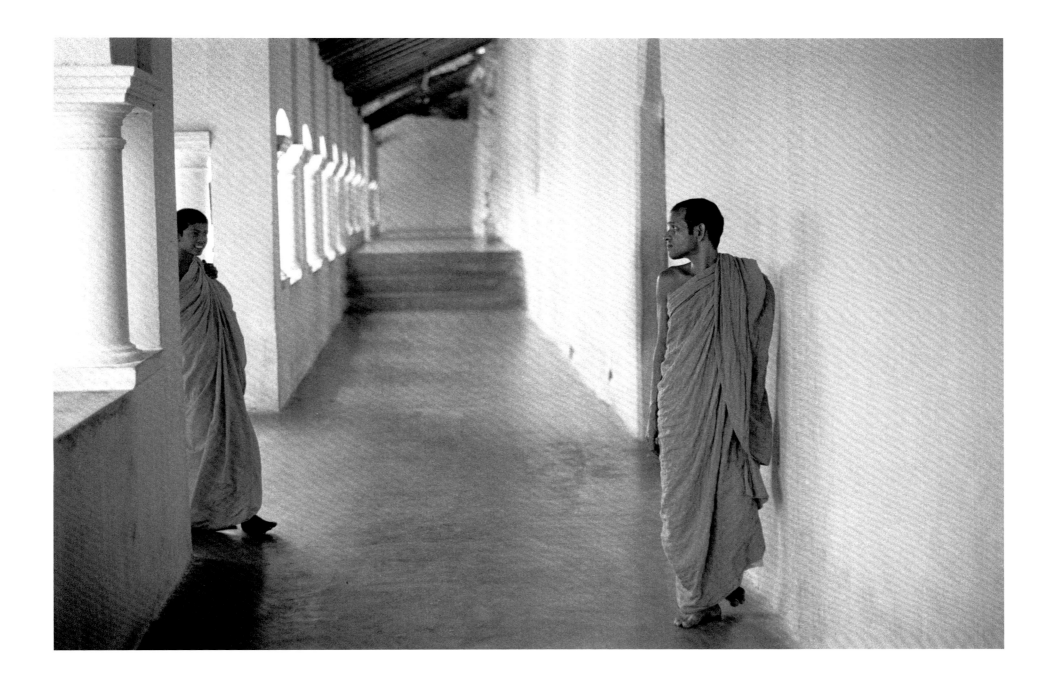

Monks, Burma, 1976

Doorway, Morocco, 1980

Casbah, Morocco, 1980

Dragon Temple, Taiwan, 1977

Bearded Man, Taiwan, 1977

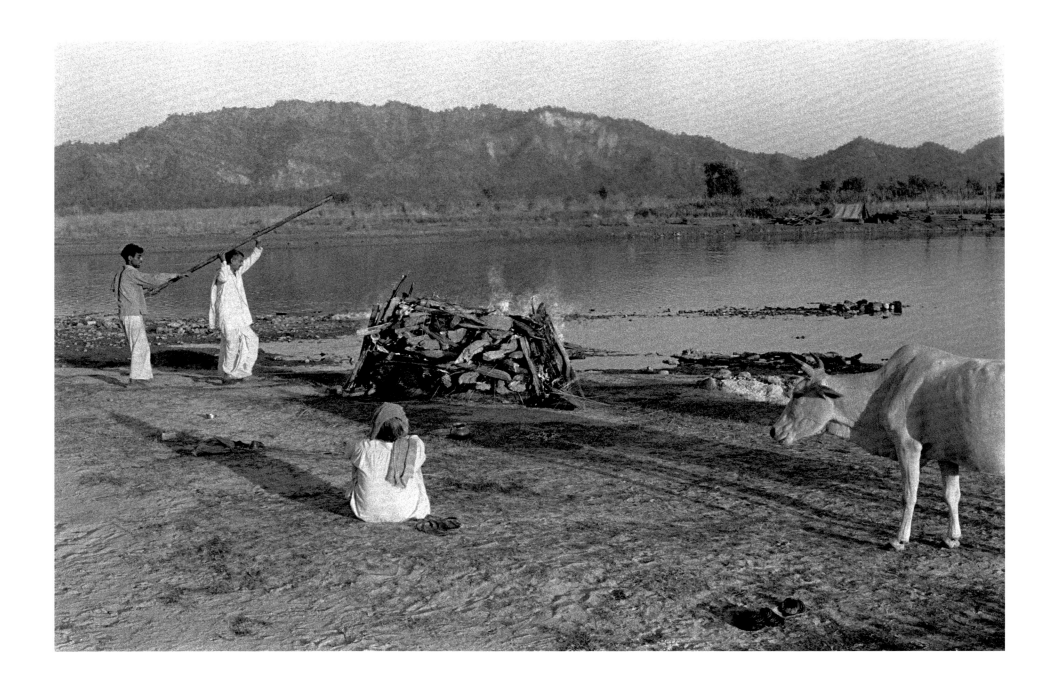

Cremation, India, 1973

Unnoticed, India, 1973

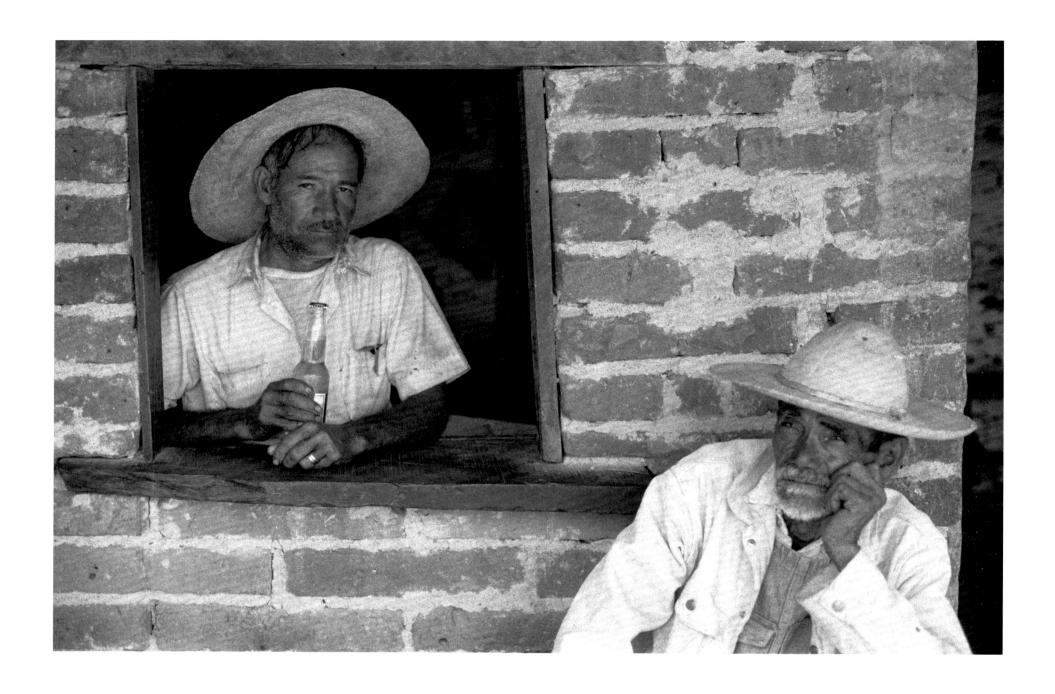

Lunch Break, Mexico, 1971

Advert, Belize, 1979

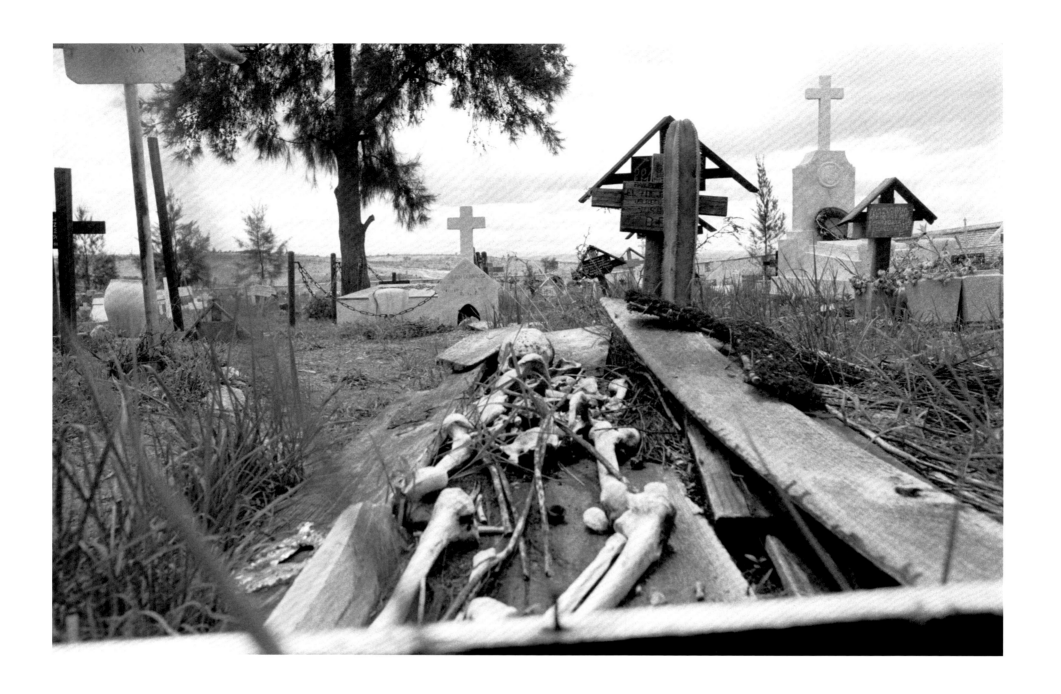

Skeleton, Mexico, 1971

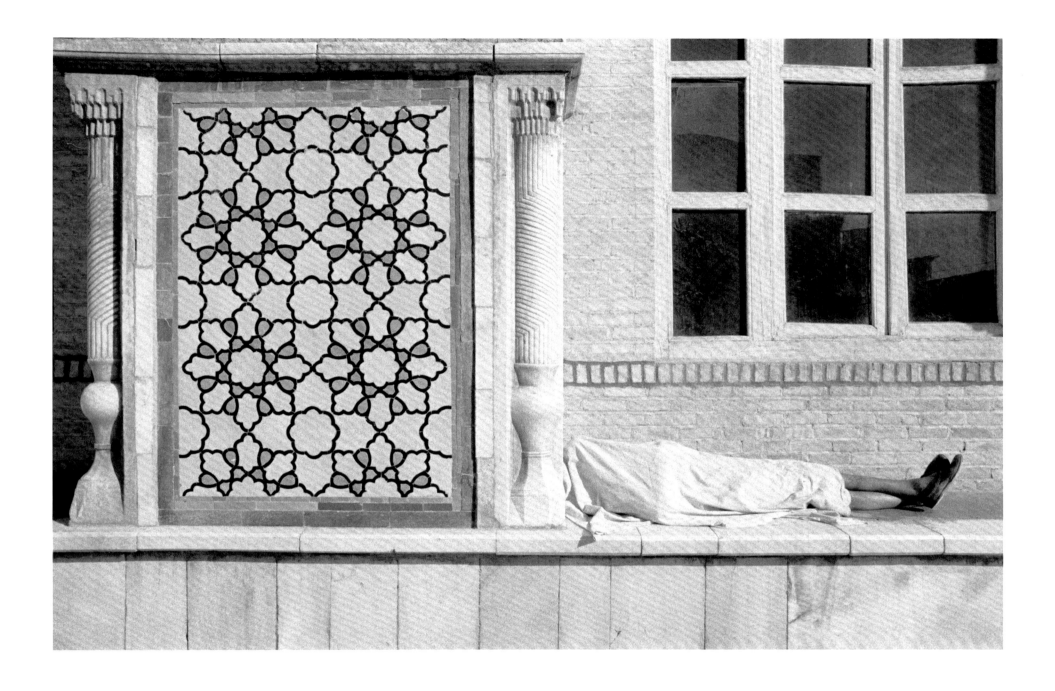

Dead Man Sleeping, Afghanistan, 1973

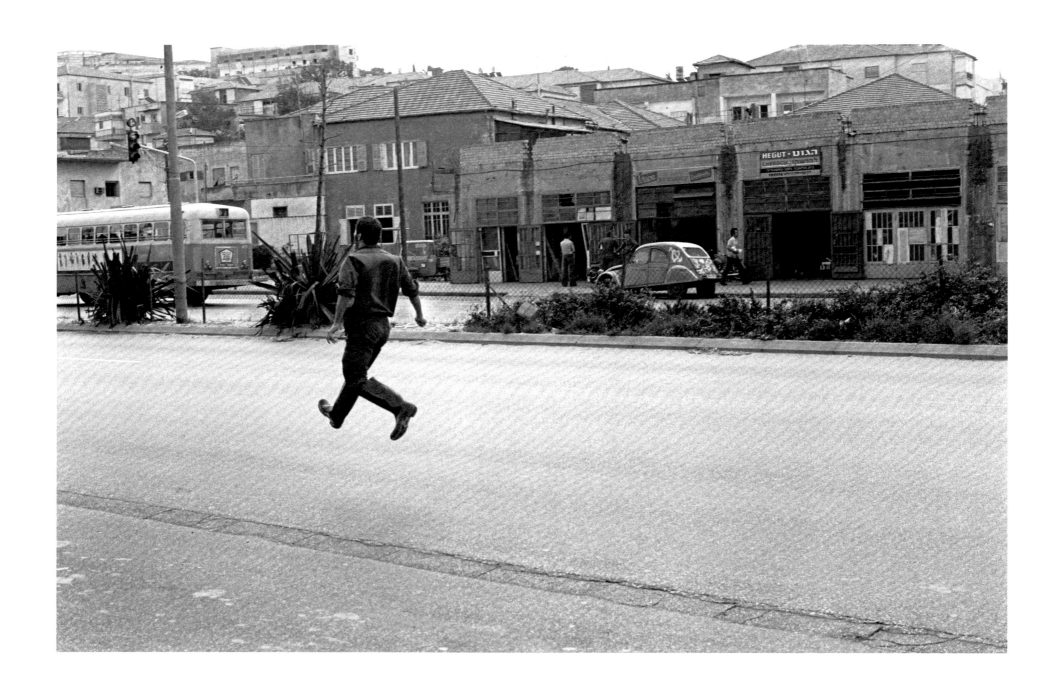

Leap, Israel, 1974

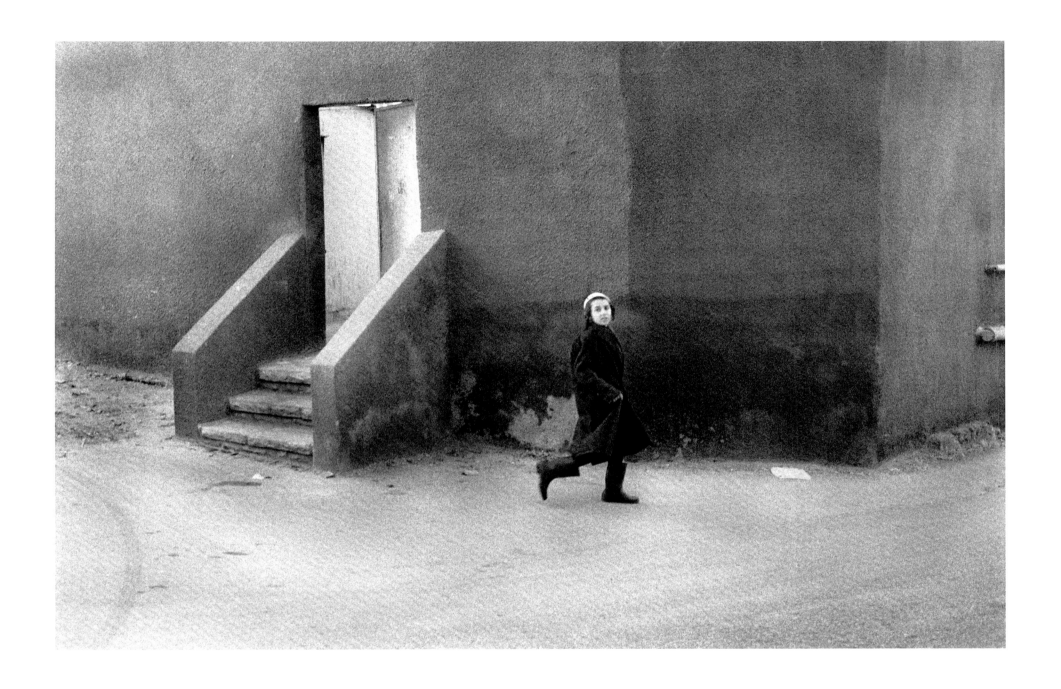

Passer-by, Israel, 1974

Arm in Arm, Kenya, 1974

Orthodox Jews, Israel, 1974

Reaching, Israel, 1973

Hedge, Israel, 1974

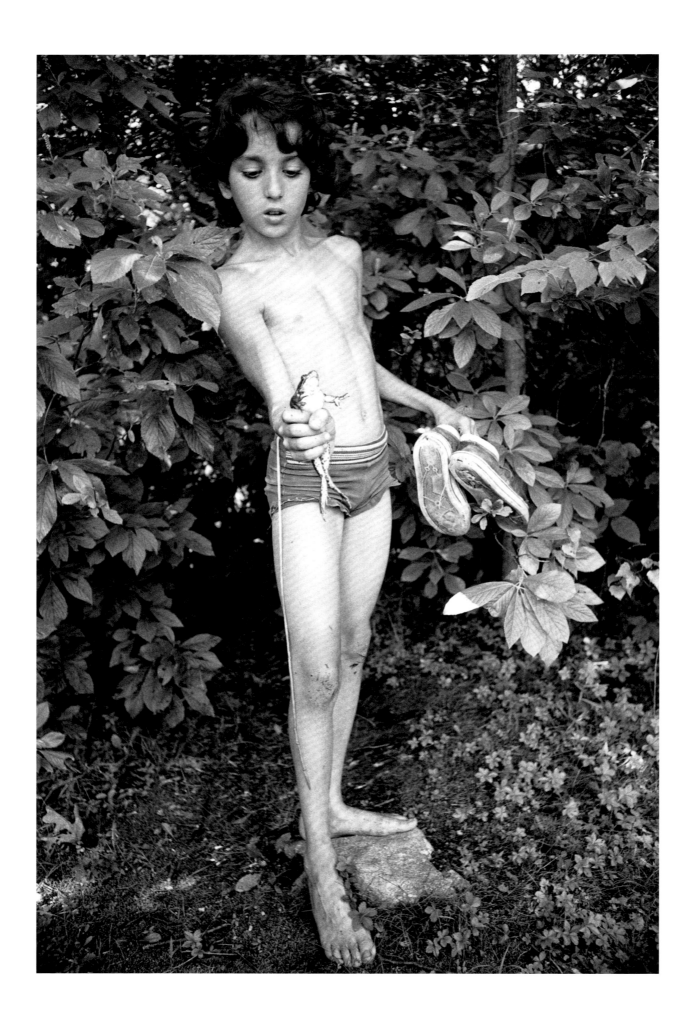

boyhood, 1979

Through my memories of boyhood, I felt
reborn. Interacting with the boys I was
photographing, I began to recreate this
essential part of myself, something I had
long-since forgotten, something that had
seemed only a dream for so long. My journey
through the world now became a journey
to rediscover boyhood.

Froggy Boy, USA, 1977

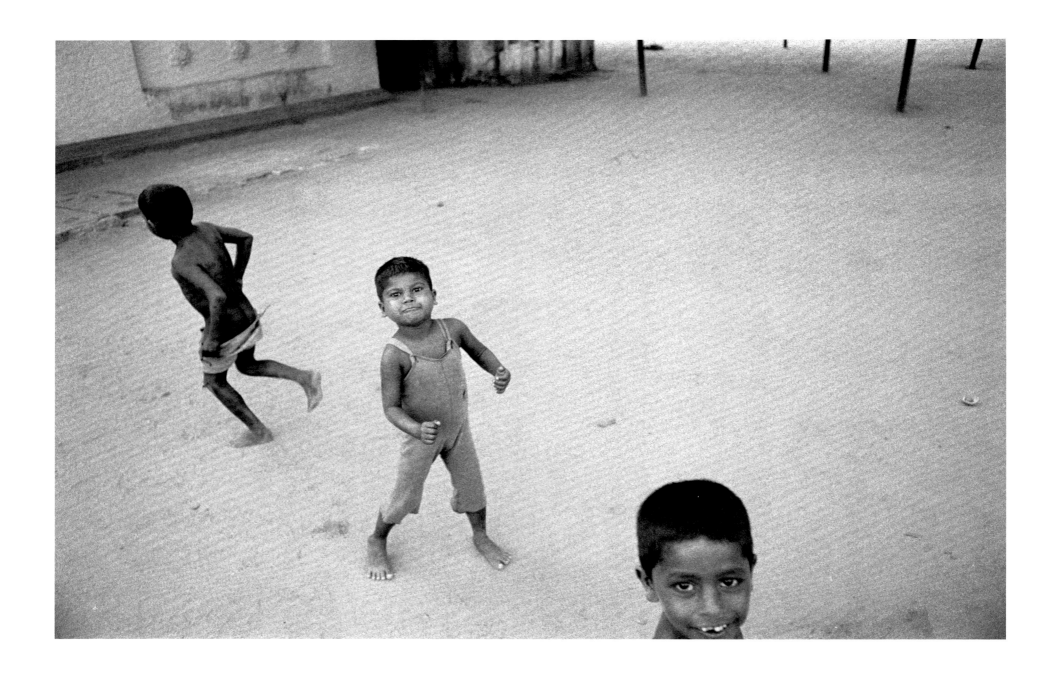

Letting Go, Ceylon, 1976

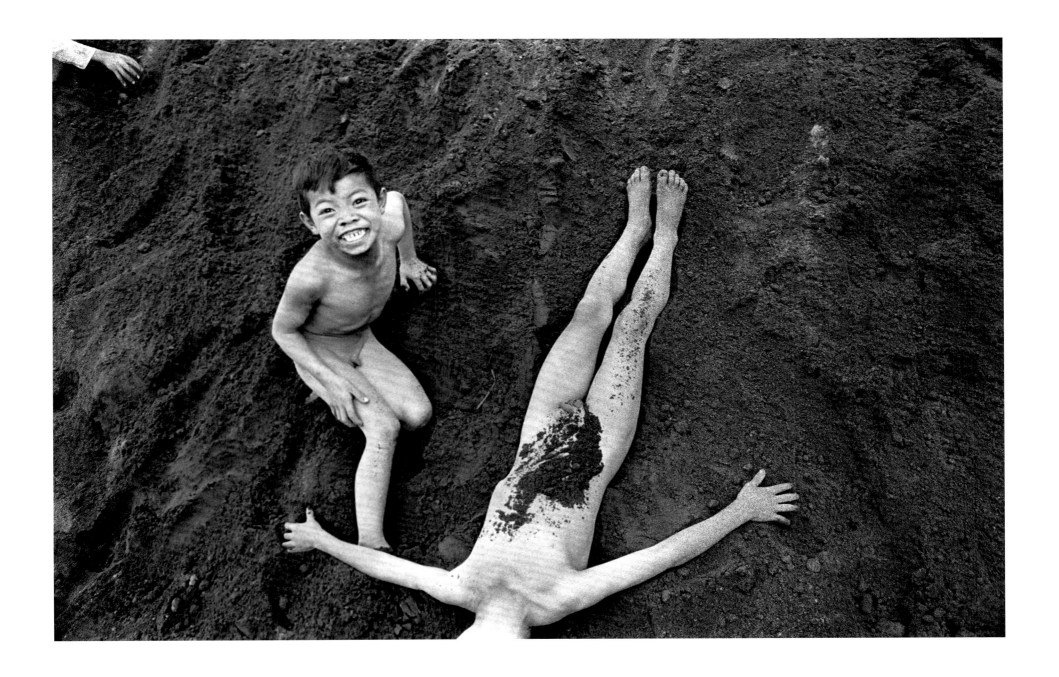

Cover-up, Indonesia, 1976

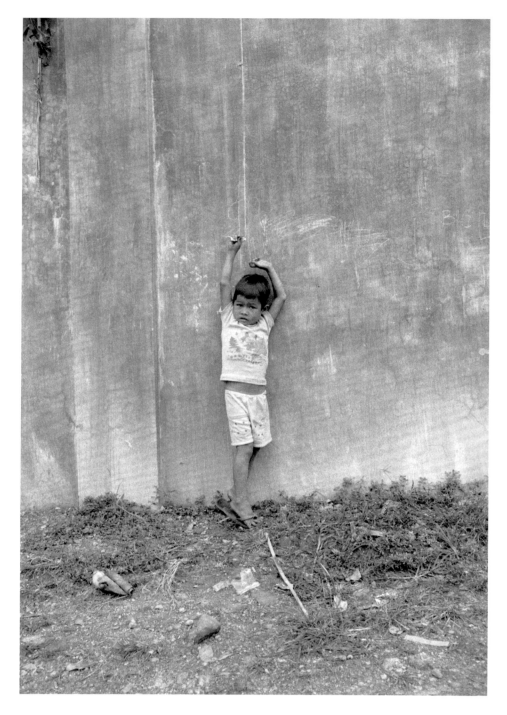

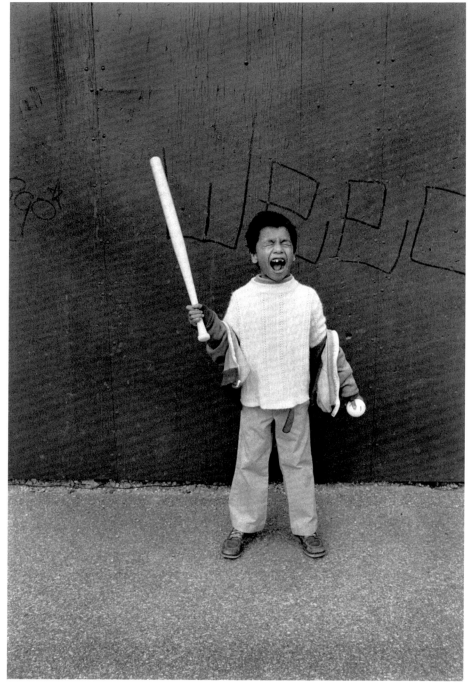

Back to Wall, Philippines, 1976

Yelp, USA, 1977
Opposite: *Blown-up Boy, East Malaysia*, 1976

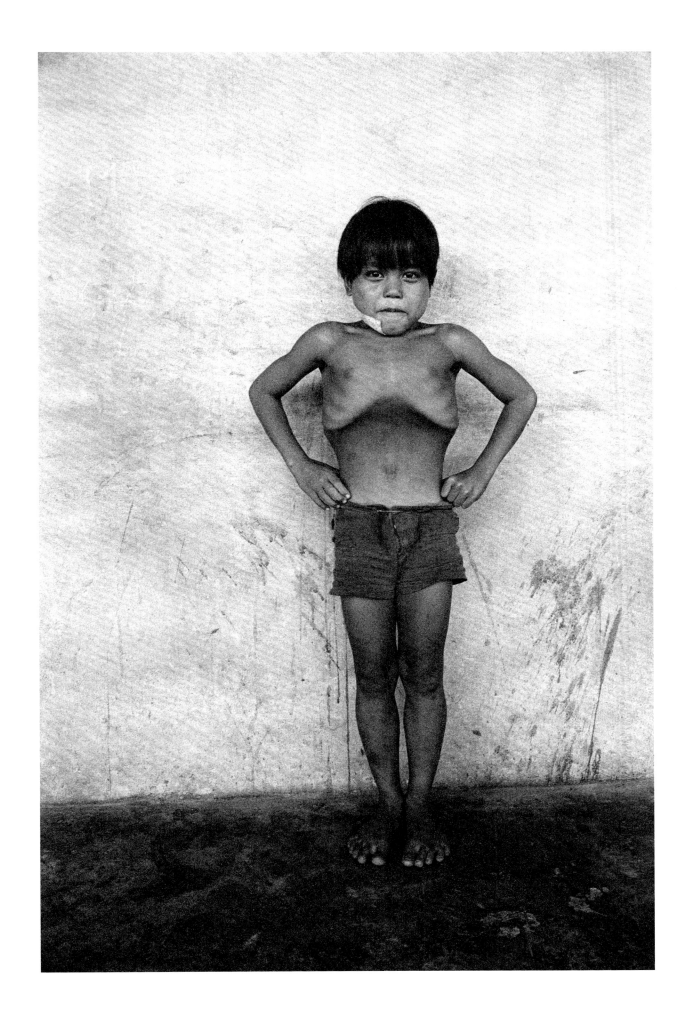

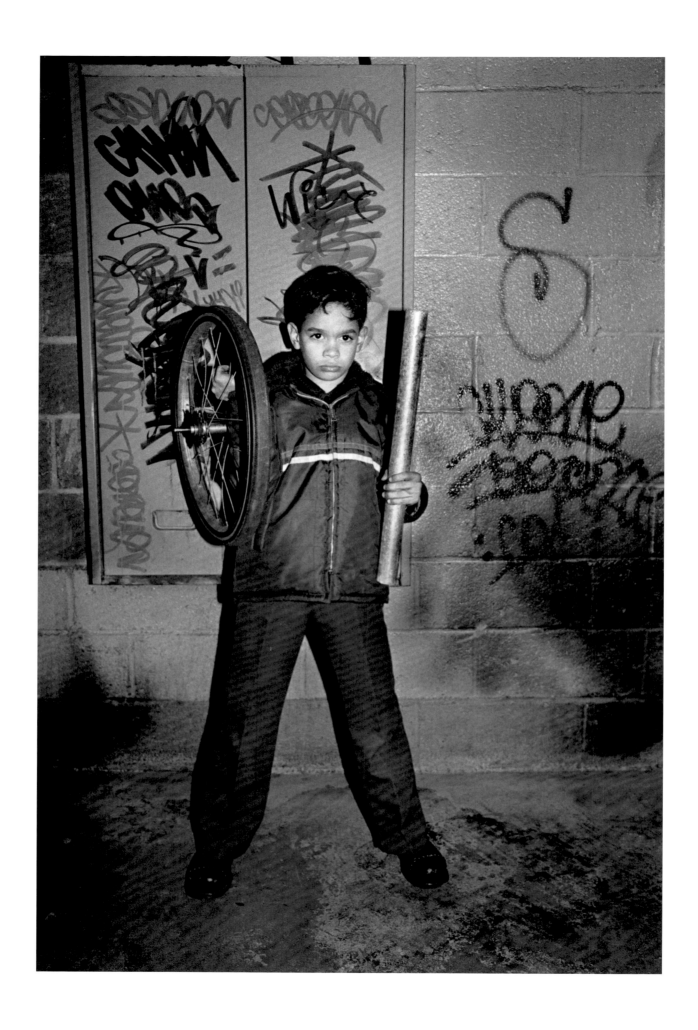

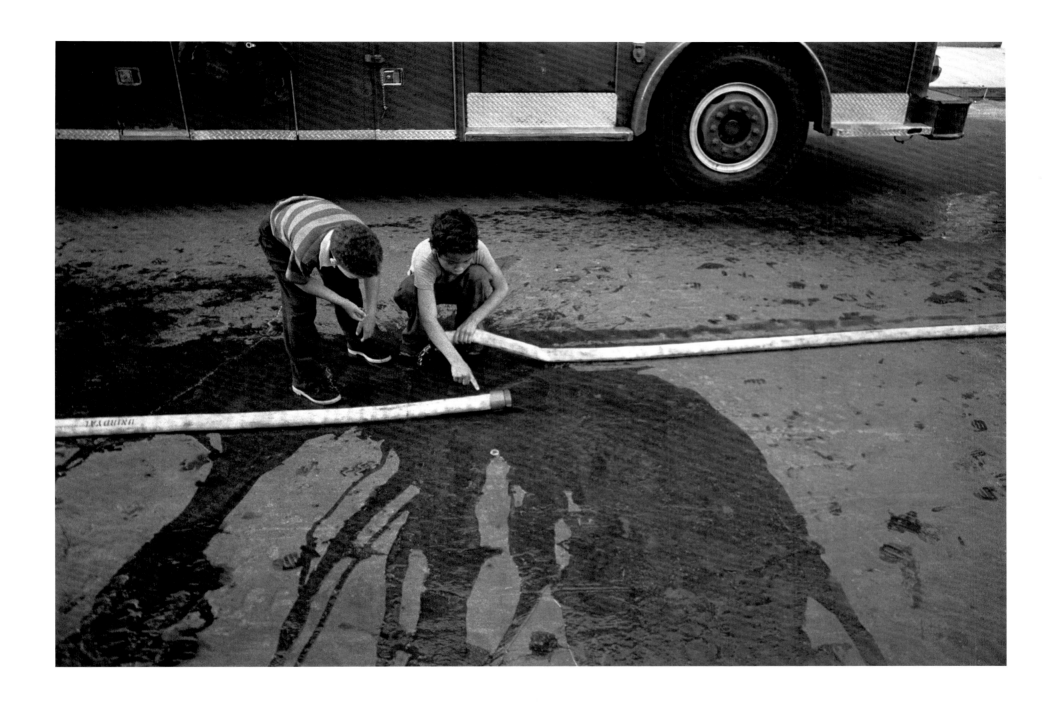

Opposite: *Gladiator, USA*, 1977
Fire Hydrant, USA, 1977

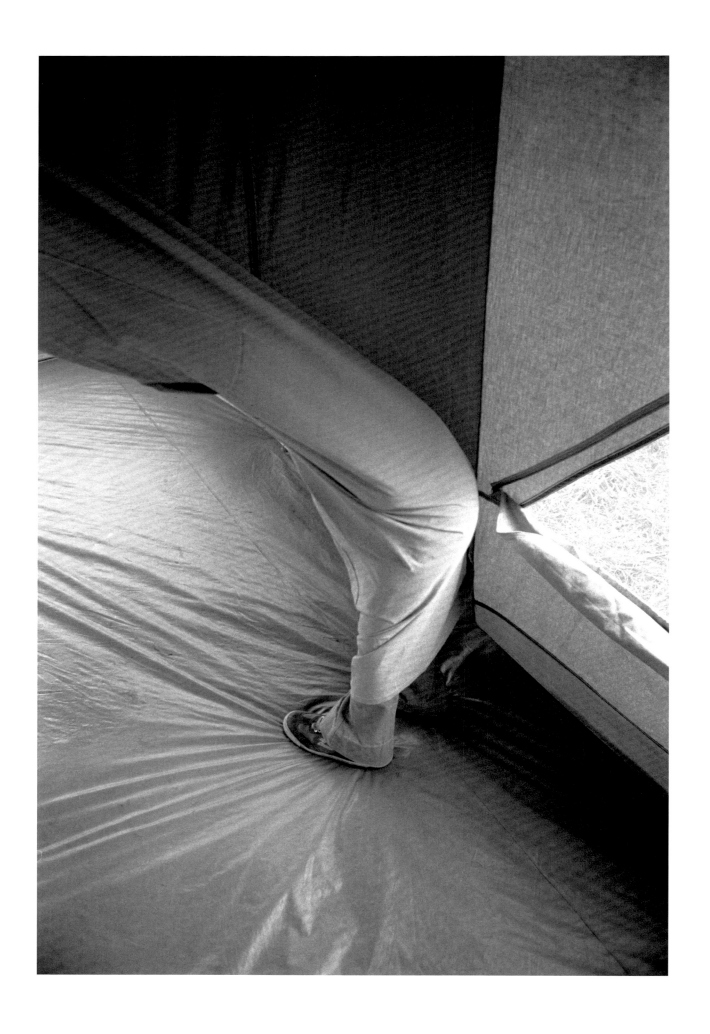

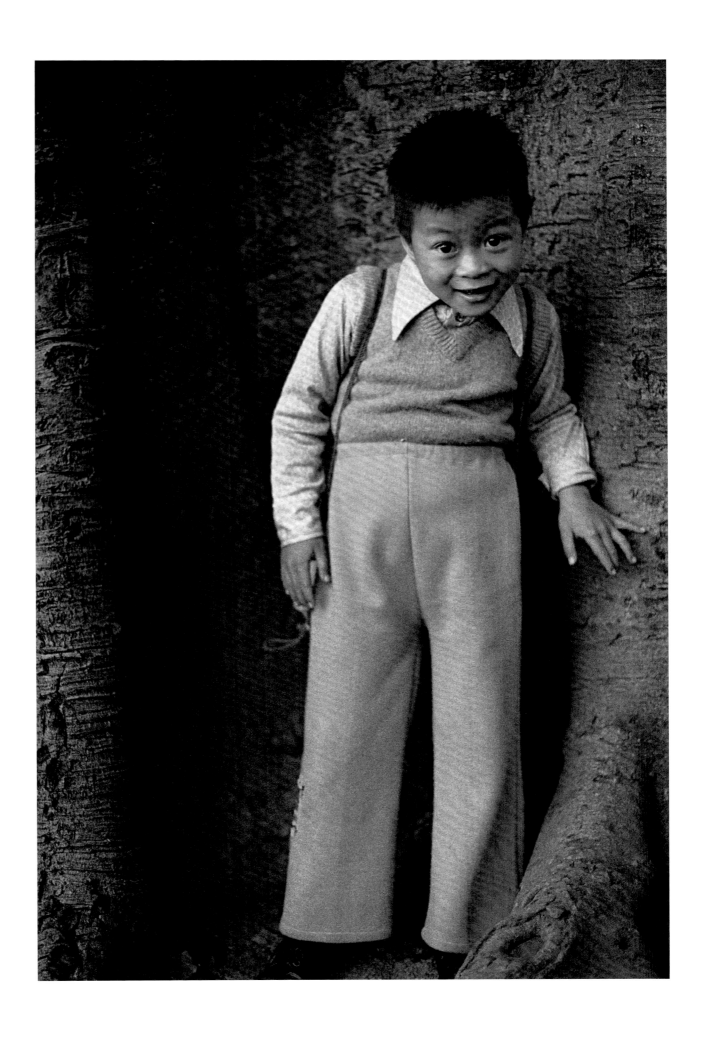

Opposite: *Entangled, USA*, 1978
Little One, Macao, 1976

Pals, USA, 1977
Opposite: *Umbrellas, Japan*, 1976

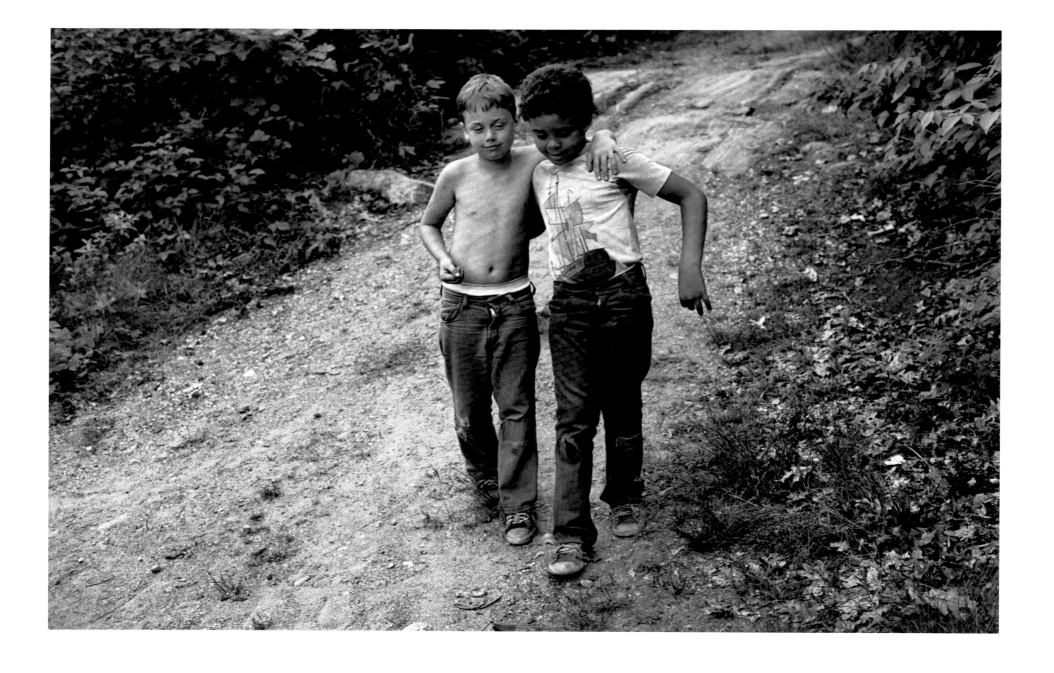

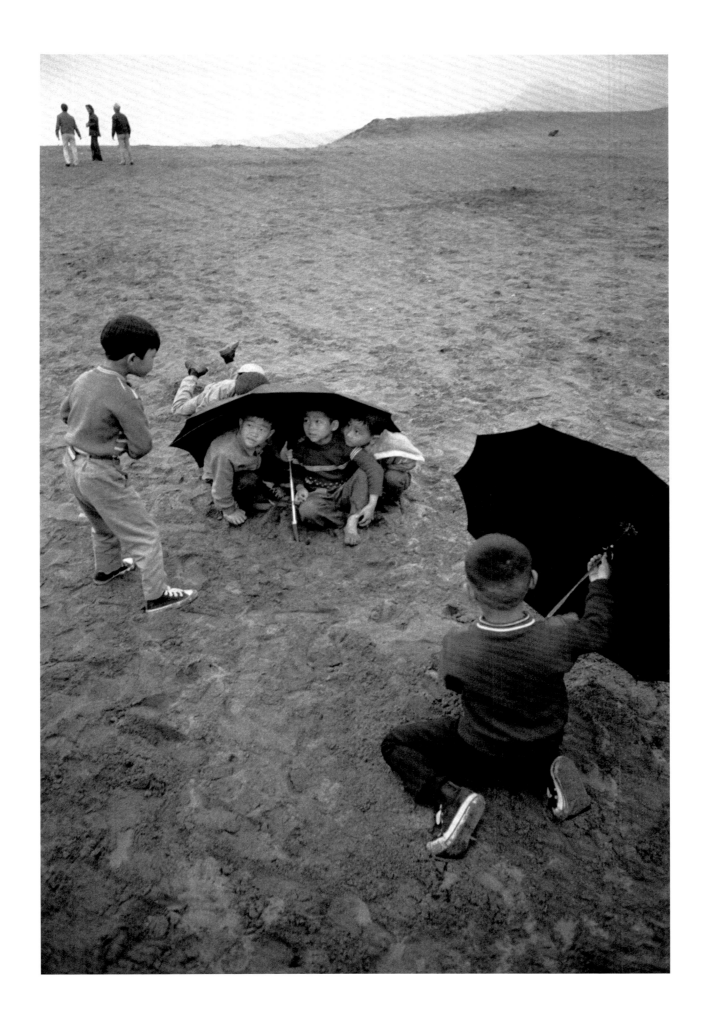

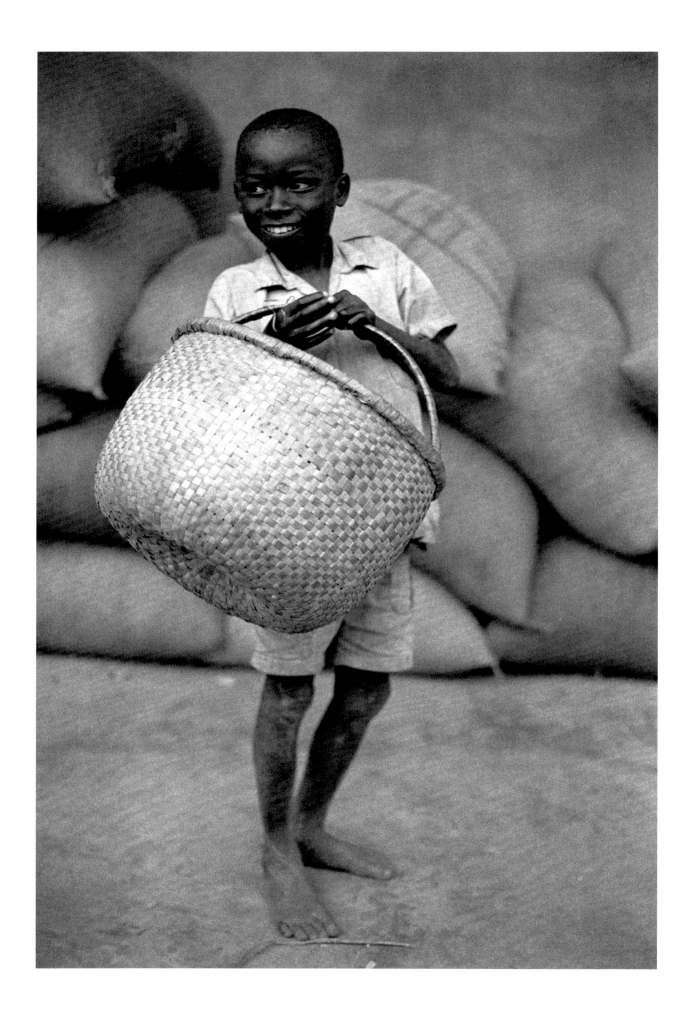

Basket Boy, Rwanda, 1982
Opposite: *Grin, Tanzania*, 1974

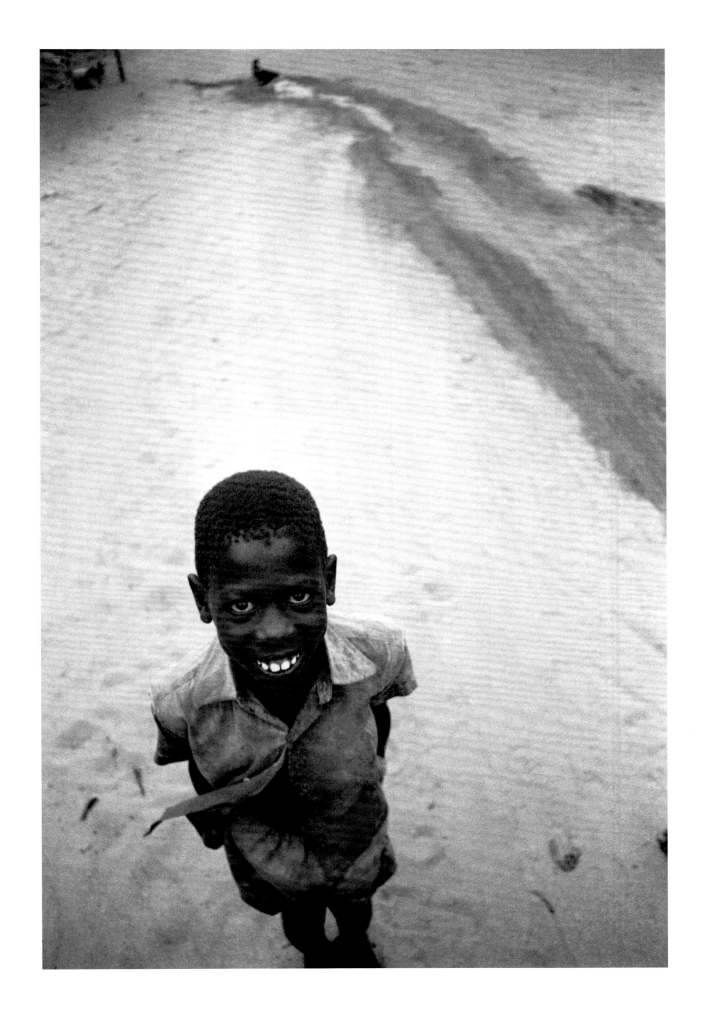

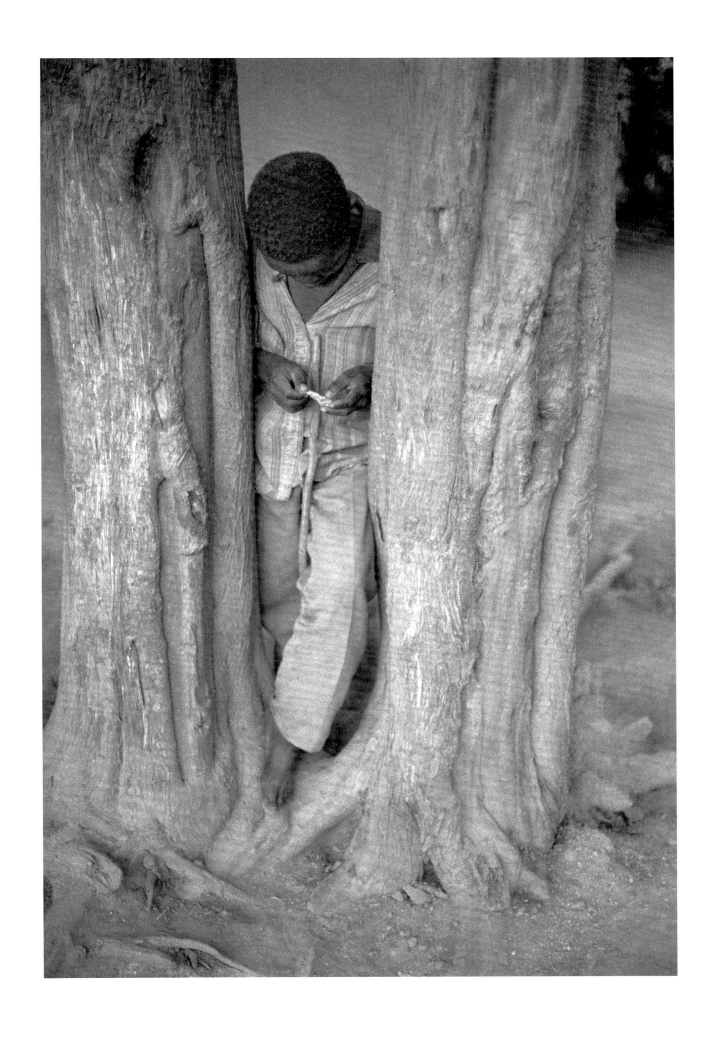

Opposite: *Boy with Slingshot, India*, 1976
Boy between Tree, Botswana, 1974

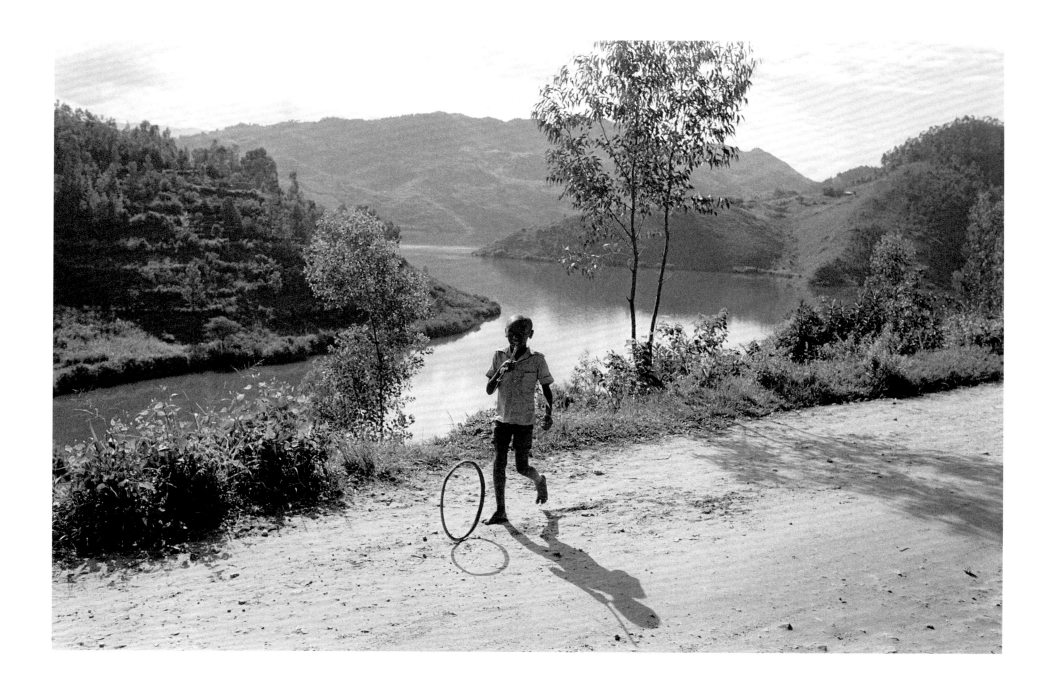

Hoop, Lesotho, 1981

School Courtyard, India,
1976

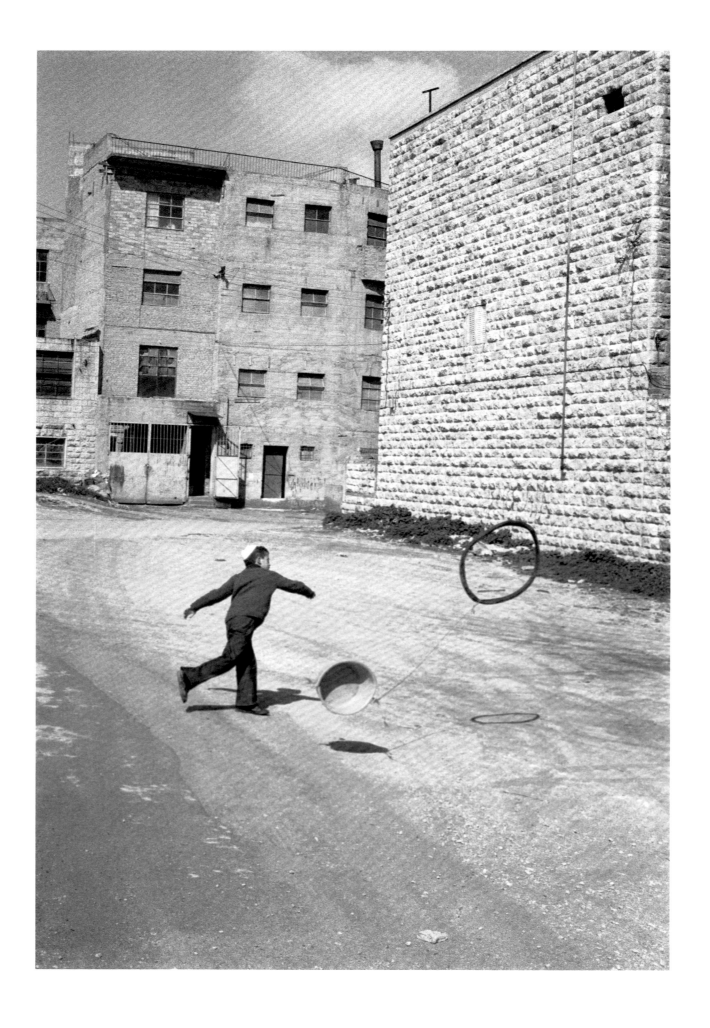

Opposite: *Throw, Israel*, 1974
Sprinting, Guatemala, 1979

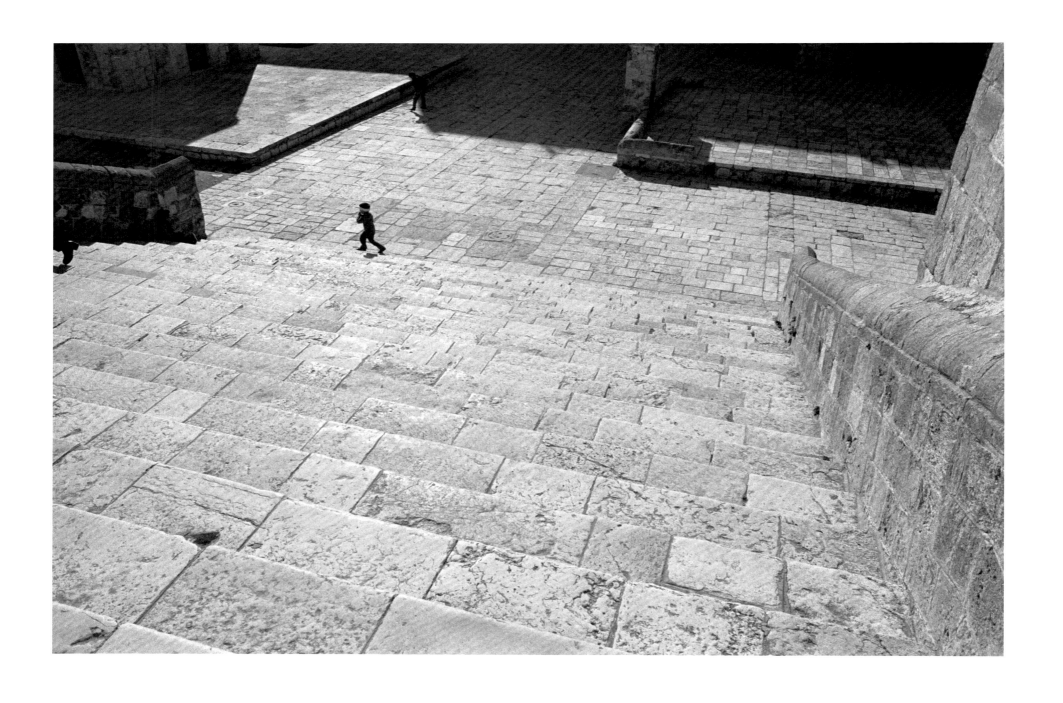

In 1978 I went to visit André Kertész in his apartment, as I was hoping he would write something for my forthcoming book *Boyhood*. After viewing a draft of the book, he stated in broken English that, of all the images, he liked the photograph *Fleeting Boy, Macao* the most, as it reminded him of his days in Paris – of people walking by that were only remembered because they were in one of his photographs. He went on to write the following comment, which was featured on the back cover of *Boyhood*: 'A special insight, revealed delicately in a poetic way, bringing back my childhood memories.'

Fleeting Boy, Macao, 1976

chapter 2 **digging deeper**

dorps
platteland
outland

Rock formations are shaped over time by tremendous heat and pressure, and through vast dislocations. There are rich metaphors embedded in them; they reveal primeval processes.

Under the surface, beneath vast depths of rock, is the white-hot fluid core. The strata is full of layers interbedded, revealing fragments of a world mostly predating human beings and, in places, the first life on earth.

I have often stated that my experience as a geologist led me to the conclusion that my work as an artist needed to reflect the depth of reverence I felt when I meditated on the state of rocks billions of years old.

In 1982 I found myself back in South Africa working in mineral exploration, travelling across vast expanses of the countryside. But while my profession provided me with a living, there were questions about my existence that it did not begin to answer. I still needed to use the camera to excavate layers of my inner life. In common with my work, peering below the earth's surface for a hidden treasure, I began to do the same with the people and places I photographed, trying to pierce their outer layer to reveal their elemental selves.

During these travels in the South African countryside, perhaps because I was an outsider or because I felt a compatibility in isolated places, I was drawn to the unique aesthetic of the dorps, or small towns. On one occasion, I was photographing in a town called Krugersdorp. Returning home that afternoon I experienced something of an epiphany, the word 'dorp' electrifying my being. The word was odd and enigmatic; it bothered me. This experience impelled me to begin my first project in South Africa.

Up to the time I started photographing in the dorps, my camera of choice had been the more portable, less visible 35 mm. In the dorps, however, it gave way to the 6 x 6 cm Rolleiflex I had purchased in 1981. The square format of the Rollei fitted the greater stillness, the more classical and calculated composition, of my new images. Its size meant a slower, more deliberate approach, a more consciously acknowledged relationship with my subject. As I looked through the camera touching my stomach, I felt I was expressing my deeper self. The square was a perfect form, in which every side was of equal importance, equally balanced.

My discovery of Walker Evans's book *First and Last* just before leaving for South Africa would prove critical to the evolution of the dorps project. Not only did I identify with Evans's obsession with detail and form, but also I found examples of his commonplace aesthetic in the dorps themselves.

The people who inhabit the towns in *Dorps: Small Towns of South Africa* (1986) are almost completely absent from the streets and buildings. Owing to this fact, and the harsh light that characterizes much of South Africa, it was very difficult to decide what to photograph. I remember very clearly in a dorp called Hopetown, Cape Province, where the famous Hope Diamond was found, knocking on a door, as I had decided that day that I could no longer wait for people to find me, or for the softer light of the evening. I asked the man who answered if I could enter his house. At that epochal moment, I went inside – literally and metaphorically. It was then that I found the motifs I would work with for the remainder of my career, began using a flash for the first time, and discovered the 'character types' that dominate my imagery from that point on.

In addition, the images became more frontal. The wall was paramount; it was not background, but articulated surface, identified with the picture plane. On the smudged surfaces could be found wires, photographs hung in an uneven, incoherent way, children's drawings, grease and dirt stains. Like a painter, the 'living wall' became my canvas. In fact, if many of the walls I photographed could be transported intact to a museum, they might be labelled works of art.

At the same time as entering the interior spaces of people's houses, I photographed the so-called outside world for the last time in my career. In the sunbaked landscape, images of doorways, verandas, cafés and pillars were captured up to the end of the dorps project in 1986. Many of these buildings incorporate features of Victorian Cape architecture, but the essence of the style is best summed up in the Afrikaans expression ''n Boer maak altyd 'n plan' (the countryman always has a plan). In other words, buildings were adapted to meet the needs of the owners, and are an expression of function and personality.

For some time, I wondered what it was about the dilapidated, broken, un-monumental architecture that so attracted me. It was an aesthetic that I identified with, and which left a permanent mark on my work. Like the broken granite boulders that I often came across in my professional life, this element that I began photographing was a metaphor for the fact that no matter how hard we try, we will be defeated by time.

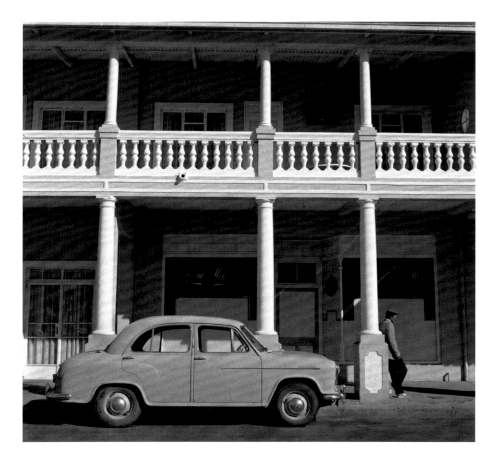

Side View of Hotel, Middleburg, 1983

There are certain photographs from this period, such as *Bedroom, Bethulie* (1984), that, like a river in flood, depositing debris beyond its banks in a faraway location, brought me to a place that was strange and inexplicable. A locale that I could not explain in words. Then the river would retreat and fall back into its original channel. Nevertheless, I had come into contact with another reality, a place where I had not been before. Being in this place, through taking such photographs as *Bedroom, Bethulie*, provided the basis for my understanding of art.

During this period, the work started to shift from being nostalgic to disturbing. The photograph *Old Man, Ottoshoop* (1983; page 95) is one of the last of my photographs that symbolize a milder, more optimistic approach. Towards the end of the dorps project, I found another aesthetic, which was captured in the photograph *Pensioner, Volksrust* (1984; page 94). And although some of the dorps photographs no longer fully satisfy me (the smiling sitters, for example, presenting the faces they would wish to have preserved), I had made contact with my character types – with outsiders, with the marginalized. I would then transform them more explicitly in *Platteland* and beyond.

Perhaps my connection with outsiders stems from my countercultural upbringing and interest in the theories of R. D. Laing. The concepts of 'normality' and 'insanity' were crucial to his teaching, and when I ended up in the small towns of South African in the 1980s, I felt compelled to find out what 'insanity' meant for myself. One could say that insanity is the result of an unbridled subconscious; that insanity is the id. By making contact with the outsiders of these towns and expressing my inner psyche through the camera, I was in fact expressing my own id. Being in touch with your own so-called insanity could be thought of as a creative experience. For me, insanity, while being seen as a threat to Western society – to any society – became a source of knowledge.

From 1986 to 1994, I worked on what would turn out to be my most controversial book, namely *Platteland: Images from Rural South Africa* (1994). 'Platteland', an Afrikaans word that translates as 'flatlands', refers to the South African countryside. The term implies more than a description of its geographical character, its expansive, monotonous, often brutal landscape. Rather, it connotes a particular state of mind.

This was a period of breakdown, violence and uncertainty in South Africa, with the black population struggling to overthrow the apartheid regime. During this time, I photographed a group of people referred to as the 'poor whites'. These individuals felt confused and alienated from the circumstances that existed in the country at the time. In *Platteland* I wrote:

On abandoned farms, on the outskirts of towns, next to worked-out mines, I met protagonists in this drama. Some lived a nomadic existence, drifting from place to place, finding work haphazardly; others leased plots on which to grow maize or potatoes. Some were diamond diggers hoping for a 'stroke of luck', some were traders who filled their trucks with subsistence goods bought from Asian shops to sell in tribal areas, others were railway workers whose escapades had taken them deep into Africa.

There prevailed a perceived glory of a past heritage, its folklore and myth handed down by word of mouth from parents and grandparents, a reference back to ancestors who, as pioneers over a century ago, had crossed the African frontier, hunted game and tamed 'savages'. Those were remembered as the days of the mass migrations of springbok, zebra and wildebeest. Education came through the veld and the Bible. Land in 'the good old days' was free, and there was, according to their mythology, a mutual respect amongst all races. A man could kick the earth and become wealthy; wherever one went there were diamonds and gold.

This legendary land has ceased to be. Paradoxically, the people I encountered were living hand-to-mouth existences. Many South African rural areas are faced with a crisis of economic disorientation and decline. Jobs for unskilled people have become increasingly scarce, and those who seek work have to show a marked ingenuity or be prepared to accept poor working conditions and low wages. Menial jobs such as fixing cars and machinery, selling vegetables on the roadside, peddling second-hand goods or collecting recyclable paper and cans have become increasingly widespread. A fatalistic impotence has taken over.

The tenuous economic circumstances that prevail are evident in the conditions of the homes that I encountered. Houses are rented cheaply or are traditional, old family homes. Decay and dilapidation are everywhere. Building maintenance is postponed and warped floors, cracked ceilings, peeling paint, exposed electrical wires and broken plumbing are common. Old car batteries are used to power light bulbs and TV sets. Plastic sheets cover broken window panes, and when pumps break, hand pumps draw up underground water from wells. Heat for cooking is often obtained from obsolete coal-burning stoves. Ignorance, dejection, apathy and a lack of ambition result in unsanitary conditions. There is an all-pervading smell of filth. Many homes smell distinctly of unwashed clothes, and bed linen. Pests are uncontrolled except, on occasion, by brown sticky paper dangling from above and copper-wire mouse traps lurking in dark corners. Basic

provisions – white bread, salt, tea, sugar, Coke, matches and candles – are staples in kitchens that smell of stale cooking oil and paraffin. Mealie meal, cooked in large quantities, stands around for long periods in a pot on the stove, to be eaten with fatty meat cooked on an outdoor fire.

It was against this background that, in my profession as a geologist, roaming the South African countryside, I encountered my subjects and photographed them. I was drawn to those houses where chaos and disorder prevailed. I found myself among people living on the margins in a world bordering on the edge of the mind. I spoke to Mrs L. Oosthuizen (see page 116) some days after the loss of her son, Henk:

I hear voices from close by and far away. The rats in my roof drive me mad at night. Last night I felt so sick that I went to see a witchdoctor. He gave me muti, a green powder to mix with milk. It made me so sick that I thought I was going to die. I feel like I am going to go mad, mad in my body and in my heart. My son, Henk, and I argued not long ago. He left angrily and wasn't seen for weeks. He was found by Bushmen at the bottom of an old mineshaft, dead.

My neck does not stop jerking, whatever the time of day it is; it's uncontrollable. I'm sure the coloured man is back by the willow tree hitting frogs. I must go and see a witchdoctor today to break the spell.

Mrs Van der Westhuizen, a gaunt, middle-aged woman who had spent long periods of time alone owing to her husband's job as a locomotive driver on the railways, told me:

I don't like it here. People talk about each other all the time. They spread lies and rumours. The townspeople accuse me of sleeping with black men and hoboes, of being a witch. Their neighbours' children are often throwing dead black cats on my front lawn. People here just have nothing better to think about.

I met Selma, who spent her days shifting gravel looking for diamonds and claimed she was the daughter of the queen of England. A local shopkeeper spoke about her:

Selma? She's mad. Her house looks like a bomb hit it. There are spider webs and dust everywhere you look. She collects old junk from the diamond diggers and stores it all over her house and in her garage. The fence around her house is made from the bumpers of cars. Bones from her meals are buried all over her lawn. She has twelve cats in her house that never go outside. Even the social workers avoid her. Once she starts talking nothing can stop her. She is like a machine gun shooting off. When she gets irritated she climbs on top of her

*corrugated iron roof and bangs on it. Sometimes she lifts up her skirt
to all who walk by.*

Mr Le Roux, a pensioner who once worked for the Department of
Mines and now has trouble walking as a result of being hit by a bulldozer
(see page 104), was outspoken about his activities:

*The 'kaffir girls' in the platteland are cheap. All they want is beer
and meat and a bed to sleep in. White women just give you problems.
A black woman costs you five smackeroos a week, a white one, over
three hundred.*

*The people here hate my guts. My neighbours saved up and bought
my last house I was renting. I then bought another place around the
corner and brought my girlfriends with me. The same monkeys are
trying to get rid of me again, but now that the Group Areas Act is gone
they can stew.*

The reaction of the white South African public to the images in
Platteland was immediate, critical and defensive. I received a number of
death threats and was ostracized. The art columnist for South Africa's
largest-circulation daily referred to *Platteland* as the 'worst book of the
year'. Susan Sontag, however, called it 'an altogether extraordinary book,
the most impressive sequence of portraits I've seen in years. Roger
Ballen has used the power of photography to instruct, to shock, and to
discomfit with an exemplary integrity of purpose.'

I think there are two issues here. When the *Platteland* series was
completed, it was an extremely unstable time in South Africa. The white
population was feeling very sensitive to criticism, very vulnerable, very
guilty, and I showed them an aspect of white culture they would have
prefered to have buried. The apartheid government had tried to inflate
the image of the white person as a model human being – efficient,
organized, alert, etc. – and here I was, an American, revealing a group of
poor whites that many people either were unaware of or had tried to keep
hidden. Politically, therefore, the timing of the book was such that
it had an obvious impact.

Yet although people tend to look at the images more artistically
now, they still make an impact. They may know nothing about South
Africa or apartheid, they may know nothing, absolutely zero, about this
period of its history, and yet the pictures still have a marked effect on
them. So while the reason my images were criticized had to do with
timing, it's also because the pictures themselves are intensely powerful
and provocative: they illicit from people's psyches certain things about
themselves that they would rather not have to confront. In a way, the
release of *Platteland* created a mirror, and I think people were scared
about what came out when they looked at the images. So they did what

most human beings do – we see this over and over in history – and
blamed the other one. I was to blame. I was the scapegoat for what they
had buried both culturally and psychologically.

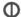

There are two images in *Platteland* that more than any of the others
define this work: *Dresie and Casie, Twins, Western Transvaal* (1993; page
109) and *Sergeant F. de Bruin, Department of Prisons Employee, Orange
Free State* (1992; page 101). For some reason, which is always impossible
to quantify or explain, these photographs had an immediate impact on
those who saw them, no matter where they were shown. While I am also
drawn to these particular photographs, it is disconcerting to realize that
that my identity as a photographer has to some extent been defined by
these two portraits that I shot in the early 1990s.

In 1993 I was driving through a small town in the Western Transvaal
with my three-year-old children Paul and Amanda when I saw Dresie
working on the garden in the backyard of his house. He had a powerful
presence, so I stopped the car and asked him whether I could take his
photograph. He pointed to his mother, who confirmed that I could
photograph her son. I asked Dresie to stand against the veranda wall and
pointed my camera at him. As I adjusted the focus I noticed a shadow
approaching me. I turned my head and Casie appeared. It was a moment
that I will never forget.

The year before, as I was driving around an Orange Free State town
looking for subjects, I noticed a washing line with a wire loop hanging
from it. As I turned the corner, Sergeant De Bruin was sitting on his stoop.
I stopped the car and started a conversation with him. He mentioned
that he worked as a policeman in a prison for political detainees, and that
every night he came home with blood on his hands. As he was speaking,
I noticed his lips had the same form as the wire that was hanging from
the washing line in his backyard. When I asked if I could photograph
him, he requested that I wait while he went into his house to put on his
uniform ... People often ask me where and how I find my subjects. In
response, I often point to this image and state that, without the wire, the
photograph would not have been successful. In other words, the wire
and everything else in the photograph is my subject; and, like any living
organism, if you remove something essential the entire being dies.

It is reassuring to think that, when many of these same images are
shown today in various exhibitions throughout the world, they still evoke
the same psychological reaction as they did when they first appeared.
The *Platteland* images are very strong, very intense images, and are still to
this day able to embed themselves in the psyches of the people who view
them. (That could be one way to define iconic images: they continue to
make an impact on the human mind over time.)

At the time they were published, however, I was unprepared for the attacks on my integrity. As photography had been a passion of mine up to the time of *Platteland*'s release, I had no experience of having to explain my intentions. But the more I was criticized, the more confident I felt about my work. I had major shows in Arles, London and elsewhere, while the television arts programme *The South Bank Show* produced a memorable documentary on my experience in the platteland.

In early 1995, having driven more than 500,000 kilometres around the South African countryside, I decided to concentrate my efforts around Johannesburg. This decision came about for two main reasons. First, the attention given to *Platteland* had given me the confidence to spend more time and energy on my photography. Secondly, rather than spend long periods of time in the countryside, it made much more sense to practise my photography in Johannesburg, where I lived. I began to photograph on a much more regular basis, and my output of successful photographs increased dramatically. Photography was no longer just a hobby.

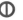

During the winter of 1995, I met with my friend and printer Dennis Da Silva. I had been working with Dennis since arriving in South Africa in

1982. He had played an instrumental role in my photography, providing moral support, printing my photographs and developing my film. Without Dennis, I often wonder what would have happened to the path of my photography. Nearly every year around Christmas time, he and I would spend several days together working on my prints from the previous twelve months. He has always been the epitome of generosity, kindness and professionalism.

I clearly remember mentioning to Dennis that I wanted to spend more time taking photographs, and that I needed an assistant. He hesitated for a few seconds, and then said: 'Doc [as he called me], I know the perfect person: my wife, Jenny.' I would work with Jenny for

the next eleven years, going from house to house, place to place, criss-crossing Johannesburg. I firmly believe that I would not have achieved as much as I have without Jenny's help. The people I photographed and got to know over the years loved Jenny; they saw her not only as a friend, but also as a mother figure. She was one of the few people that they could trust in their unforgiving, violent circumstances.

On numerous occasions, Jenny and I would explore those neighbourhoods of Johannesburg where we thought our subject matter might reside. Once I had spotted someone of interest, or a house whose outer trappings revealed something about its interior, we would stop and talk to the individual or try to make contact with the person inside. Very

quickly, I came to the conclusion that without a suitable background to work with, I could not proceed. In many cases the walls of the interiors were covered with shiny paint, which, owing to flaring, made it almost impossible to take photographs with a flash. I was drawn to houses where objects were scattered all over the place, houses where chaos and disorder ruled. I found inspiration in worn walls of peeling paint, in dirt marks and in dead insects. Equally important were places where toys, plates, papers, dirty laundry and memorabilia were piled all over the floor. Often, the smell of these houses was dominated by a mixture of cat urine and dirty laundry. Moving from room to room, I would try to find objects, furniture and animals that I could start a photograph with. I felt inhibited in places that were too neat and tidy.

Over time, Jenny and I found a number of spaces that we would return to on a regular basis, locations that satisfied three important requirements: subjects we could work with; the presence of suitable lighting, textures and aesthetics; and an environment in which we felt safe and comfortable. These places became my studios.

One such place was called Shepherd's Flock Mission, started by a man called Johnnie. It was here that I took such photographs as *A Boy Named Gary* (1998; page 138), *Balancing* (1997; page 139) and *Toe* (2001). Johnnie had decided to open the mission on an abandoned farm near a squatter's camp on the eastern side of Johannesburg. In order to sustain the operation, he had to find people who were willing to come and live in his makeshift shelters and work for food only on his pet projects, including garlic and ostrich farming, as well as the distribution of rug and car soaps. Johnnie had contacts in the prisons, mental asylums and soup kitchens of Johannesburg, who would inform him of possible recruits. Some of these people stayed only a night, others the nearly seven years that I visited the place. Eventually, after night raids from the inhabitants of a nearby shanty town, in which the raiders either broke or stole whatever was available, Johnnie had to abandon Shepherd's Flock with all those living on it.

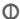

During the first two years of working on *Outland*, 1995 to 1996, my images, both formally and aesthetically, were similar to those I had taken for *Platteland*: individuals photographed mainly from the front, statically, in and around the environments in which they lived. In 1997, however, my approach started slowly but surely to evolve. My photographs ceased being portraits in the traditional sense of the word, becoming instead images in which my subjects, both animal and human, were actors, part of a silent theatre staged in a minimalistic world. It was my goal to eliminate as many visual references to South Africa as possible, and to create a reality that would reveal the universal circumstances of life.

With this change to my work came a concomitant change in the way I perceived myself. I clearly remember, on entering South Africa, filling out a blue entry form asking my profession. For some time I answered 'businessman', as this was the most neutral definition I could think of after travelling in Africa for so many years. Then I ventured to write the word 'photographer', followed, in 1997, by 'artist/photographer'. I will never forget Peter Weiermair, author of the first *Outland* book, commenting that my images were works of art, not photography.

During the *Outland* project, I moved into unchartered territory in and around Johannesburg. The word 'outland' means 'remote' or 'foreign', but for me it meant a place where the human condition is revealed in its truest sense ... a place of the mind, a place I could enter that would allow me to reveal the deepest parts of the psyche. My subjects seemed ultimately powerless, trapped and inert, unable to change their destiny in a material way. The Metz flash located on the left-hand side of my Rolleiflex intensified the sense of doom, dread and disturbance. Above all, this state of existential despair was reflected in the brooding eyes of my subjects. The various people I photographed were unable to escape their destiny, their fears, their fate.

I remember John (pages 83 and 144–5), who, as a young man, had fought in the war in Angola against the Cubans. One day, a shell had landed close to John, leaving him with a severe case of shell shock. His family had committed him to a smallholding near Johannesburg owned by a coloured missionary. John would spend his days lying on his bed, reading magazines and newspapers. To one side of him was an old man from Mozambique, and to the other, one from Lesotho. One day, the man from Mozambique passed away in his sleep; a few weeks later, the man from Lesotho also died in his bed. After returning to South Africa from a trip to Europe, I visited the mission and asked a young man if he knew where John was. 'Sorry, uncle,' he replied, 'John died. He did not eat or drink for thirteen days. He died in his bed.' 'Why did you do nothing?' I asked. Looking down, the young man answered, 'Sorry, uncle.'

During this time I began to feel a need to get closer to my subjects, an emotion similar to the one I had felt while making *Dorps*, when I had substituted a 6 x 6 cm camera for my Nikon in order to be able to capture textures. In 1999 I visited B&H Photo in New York and enquired at the used-equipment department whether they had a macro lens that fitted my Rolleiflex. The shop assistant informed me that I was very lucky as somebody had sold a 90 mm Rollei macro lens the day before. I bought it immediately. The first day back in South Africa I took the photograph *Puppy between Feet* (1999; page 122), one of my early still lifes.

The *Outland* period might be labelled the 'Wire Period'. While the first wire photographs appeared in *Dorps*, most particularly *Bedroom of a Railway Worker* (1984; page 93), the *Outland* project saw a proliferation

of wire-related imagery. I drew with wire, sometimes linking the various formal elements in the image with straight lines, curves, or realistic figures. The wires provided me with a formal tool for integrating the various elements in the photograph. In painting, the line of a wire might simply be considered a line. But in photography, one is faced with the issue that a wire is more than that; it is part of the physical space. I am often asked what the wires in my photographs mean. My response is: look around, turn your head; wires are everywhere. They surround you, infiltrate your life. Their meaning is obvious …

I met the Cat Catcher in 1996. He lived with his parents in a house in which cats and rats shared the same space. I would often see him walking along a road on the western side of Johannesburg, with a burlap bag and an intricate wire mask he had crafted himself. On one occasion I asked him what he was doing, and he responded by saying, 'I am catching cats to sell to the sangoma [traditional healer]. Can you take me to him, under the highway in Johannesburg?' As I had some time on my hands that afternoon, I agreed to his request and drove him to a metal shack near the highway.

There, we were greeted by a man dressed in leopard skins – the sangoma. He grabbed the Cat Catcher's sack, which was full of screaming cats, and weighed it. He then handed the Cat Catcher a bundle of notes for the 9 kilograms of live cats he had caught. While all this was going on, I wandered into the backyard of the sangoma's shack, where, to my surprise, I discovered cat skins, feet and ears hanging from various clothes lines. On the way back that day, the elated Cat Catcher asked me to photograph him with his mask and a cat he had just caught in an abandoned building (see page 134).

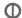

As time goes by, the photographs in *Outland* are increasingly viewed as a comment on the absurdity of life, a state in which there is no reason, no ultimate purpose, to what one does. According to Didi Bozzini, author of the introduction to *Roger Ballen's Theatre of the Absurd* (2014), 'Confusion and loneliness are its embodiment in our lives. It is hard to find your own place when there is no order to things. It is hard to explain it to others when there is no reason why.' A similar sentiment is expressed by Jean-Paul Sartre in his novel *La Nausée* (1938): 'Every existing thing is born without reason, prolongs itself out of weakness and dies by chance.'

The fundamental question that I tried to address through my photography during this period was whether human existence is pervaded by chaos or order. Perhaps this is why I was so attracted to places of disorder. By the time I had finished *Outland*, I had come to the conclusion that the human condition is faced with a situation in which chaos overrides order – something I continue to feel today.

Looking back at the period 1996 to 2002, it was Samuel Beckett's approach to the absurdity of the human condition, not Diane Arbus's or any other photographer's, that had the greatest impact on my aesthetic. The linking of the comic with the tragic; madness as a norm rather than an exception; the proximity to chaos, all acted out within starkly minimalistic environments.

I often remember saying to Jenny, after discovering a subject to whom I was drawn, 'This is a Beckett character.' Tommy was the Beckett-like person I photographed most frequently during *Outland*. He was very thin, with gaunt eyes, a skeletal body and a curved spine. He drifted from place to place, sleeping in boarding houses, in meagre rooms and on stranger's floors. I kept in touch with him for some time, photographing him in various locations. One day he informed me that he was moving to a town on the far eastern side of Johannesburg. I tried contacting him endlessly after that, eventually tracking him down in a town called Boksburg, where he was guarding a mobile-telephone shop. After that, however, I never heard from him again. A typical conversation with Tommy would go something like this:

> Me: How are you?
> Tommy: Do not know.
> Me: What's new?
> Tommy: Nothing.
> Me: When is your birthday?
> Tommy: I do not know.
> Me: Any plans?
> Tommy: None.

In 2000 I took the picture that would become *Tommy Sampson and a Mask*, in which a young boy is holding a white mask over a supine Tommy (see page 84). The photograph became iconic, and was frequently published and talked about. In 2014 the *Süddeutsche Zeitung* newspaper named me Artist of the Year and sent a reporter from Germany to interview me. I took him to the place in Pretoria close to where I had taken the shot. The boy's sister immediately recognized me and called her brother. The boy was ecstatic, as some years back he had seen the image and as a direct consequence had decided to become a photographer (see page 85).

Tommy Sampson and a Mask was photographed in an abandoned school in Pretoria, which I had come across in 1997. The school contained large empty rooms in which I could do whatever I wanted. In particular, there was one space, with very soft light and mid-grey concrete walls, that served as an impromptu studio for many years. In 1999 the school premises were overrun by squatters. For a while, it was still safe to work there, but as time progressed criminal elements moved in. During the

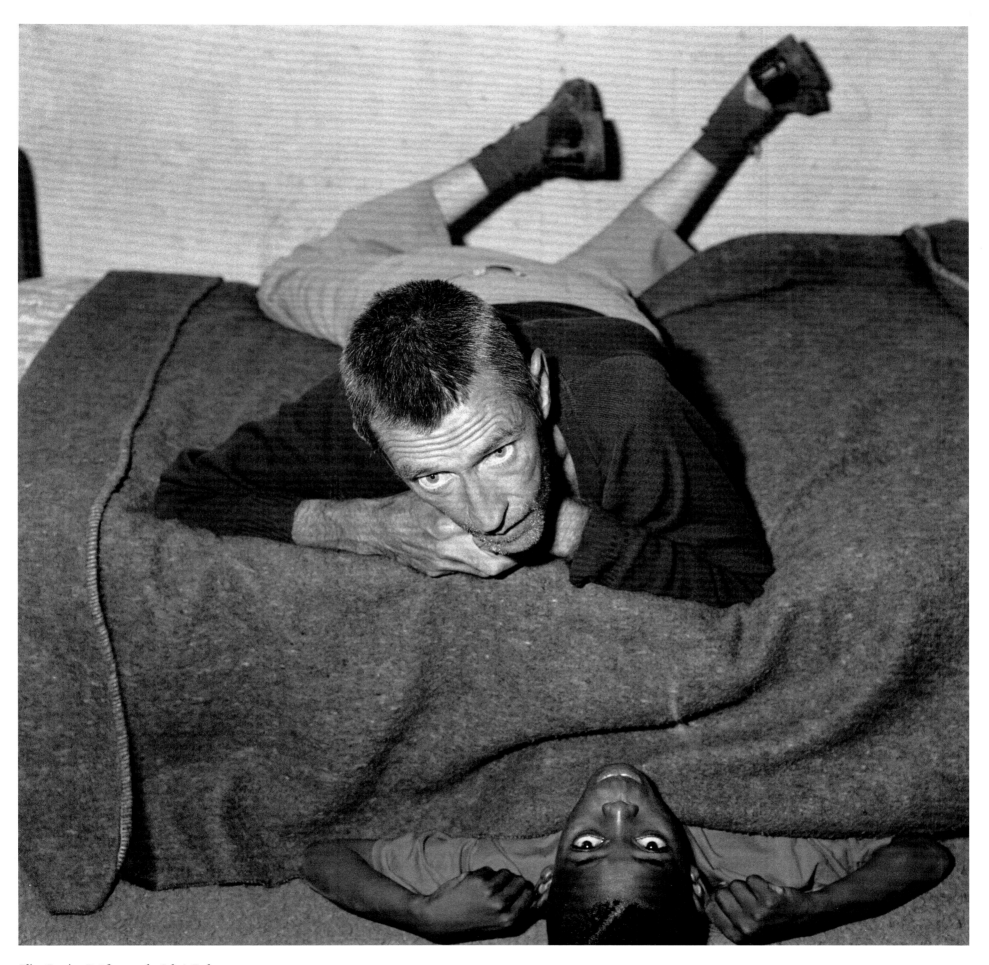

Elias Coming Out from under John's Bed, 1999

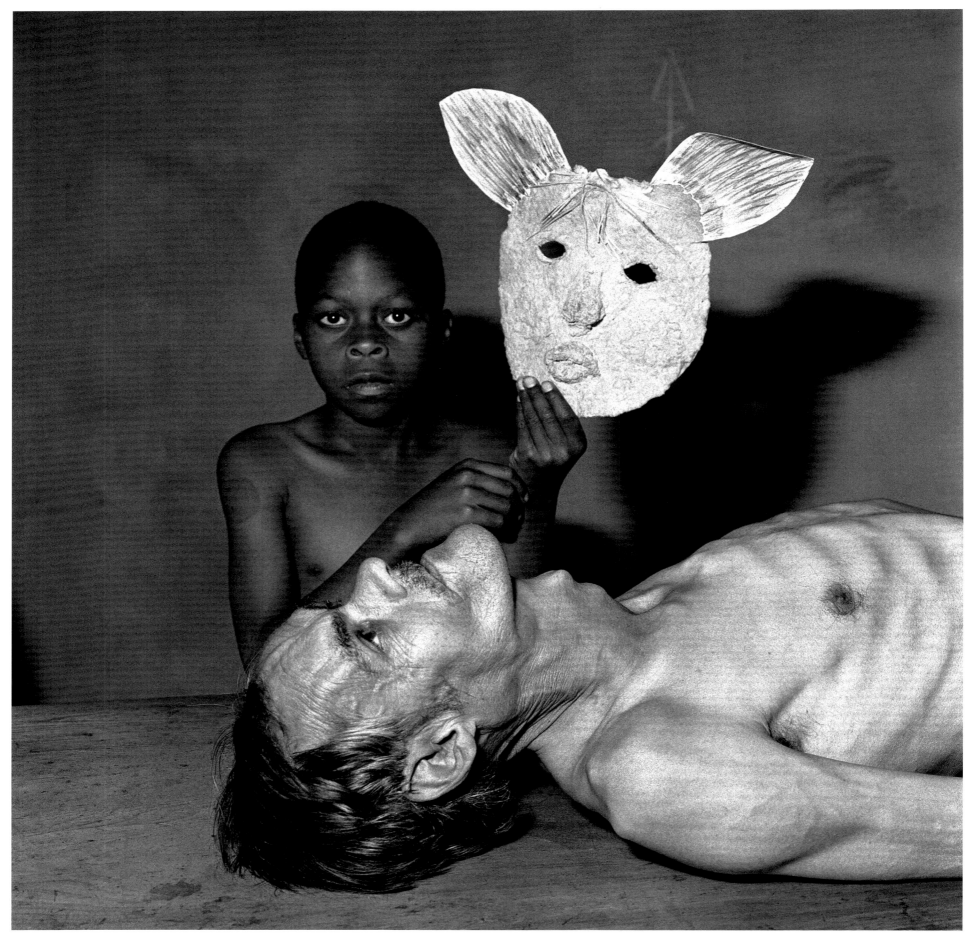

Tommy Samson and a Mask, 2000

winter of 2000 I was working in the school one day, photographing some people who lived just outside the premises, when I was confronted by a number of men brandishing weapons and threatening to kill us. From nowhere, one of the men came up to me, knife in hand, and said, 'You better photo me.' He moved in front of the camera, spread his arms wide, and fell against the wall and bed with his mouth open. He then walked out of the room with the other men to drink an alcoholic beverage of some kind. In a panic, I instructed Jenny and the other subjects to run to my car before the men returned. This was the closest I ever came in my career to being murdered. Ironically, the photograph I took of that man, *Show Off* (page 137), became the cover for the revised edition of *Outland*, published in 2015.

When taking photographs during the *Outland* period, it was a person's eyeballs, more than any other part of their body, that I concentrated on. I tried to find that point where the eyeball reflected the psychological core of the subject. This hidden zone I interpreted as being encased in fear and disorientation, provoking feelings of unease and the absurd that are beyond language. On many occasions I was confronted by a confused, defensive member of the public asking me why I photographed my subjects in such a disturbing manner. I would usually reply by saying that I could, without any problem, all things being equal, put *them* in my photograph. I was confident when I spoke that I could find the point in their eyes that led to their inner being, revealing a stripped-bare essence ... On hearing my answer, the person rarely spoke further.

While working on *Outland*, I began a subseries of photographs of white and black people interacting in a strange, enigmatic and unpredictable way – a project that took me into the start of my next book, *Shadow Chamber* (2005). Whereas most photographs in South Africa up to this point had depicted a political dynamic in which the European exploited the black, these images presented a dynamic in which both the white and the black subjects appear powerless, confused and comic; even enigmatic, problematic and poetic.

It was during my work on this subseries that I met the so-called Beanhead family, which consisted of a young boy, an older girl, a mother and father, and a grandmother whose skin was weather-beaten from standing in the sun begging for money. Jenny and I were driving past an area of broken houses in the shadow of gold dumps near the centre of Johannesburg when we spotted the family. Jenny opened her window and started talking with them, and after a while asked them if we could photograph them inside their house. I remember entering their house and being flabbergasted at the range of drawings all over the walls.

I often acknowledge my debts to the Beanheads, as it was in their home that I received the inspiration to use drawing in my work. For a number of years their home almost became my studio. My first successful still life, *Children's Bedroom Wall* (2000; page 133), was taken in the bedroom of David Beanhead. I shot many other photographs in their home, such as *Hand-drawn Hearts* (2000; page 132), which features a drawing by Madeline Beanhead above a set of drawers in her bedroom. Perhaps this house, more than any of the other locations in which I worked, was the real reason why I began to integrate drawing into my photographs (pages 132–3).

Outland was published by Phaidon in 2001. I had important exhibitions in London, New York and elsewhere. The book won numerous awards, including Book of the Year at Photo España, and I was named Photographer of the Year at Les Rencontres d'Arles in 2002. With people now buying my work, I decided that photography should finally become my profession.

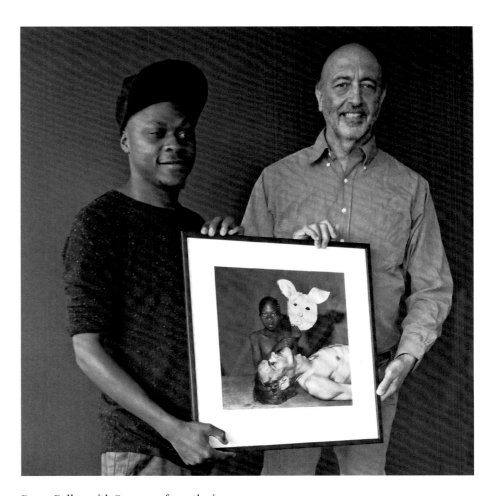

Roger Ballen with Sampson from the image
Tommy Sampson and a Mask (2000; opposite)

dorps, 1986

In the hinterland of South Africa my aesthetic
was born. I have often stated that the book
Dorps: Small Towns of South Africa was my
most important. I went inside, metaphorically
and literally; started using a flash and a
square-format camera; and found the subject
types and motifs that I would work with for
the rest of my career.

House, Philoppolis, 1984

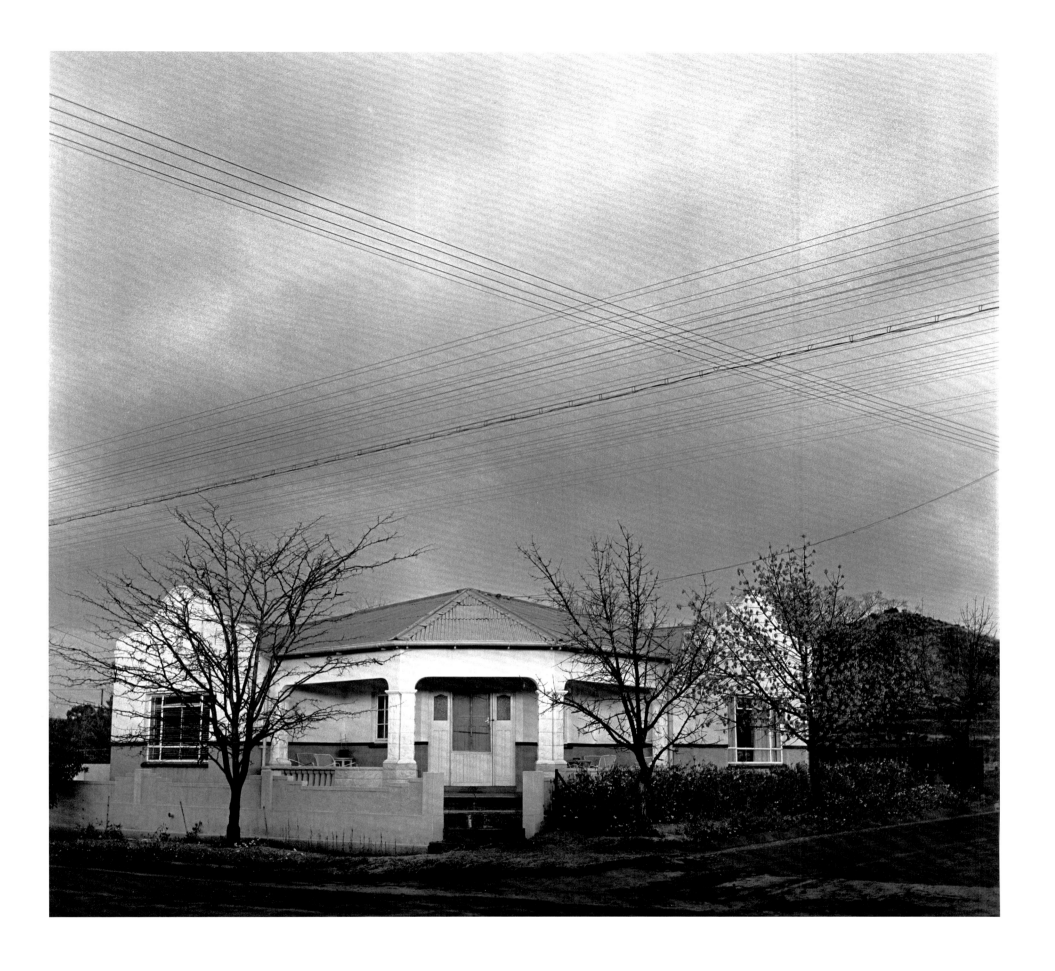

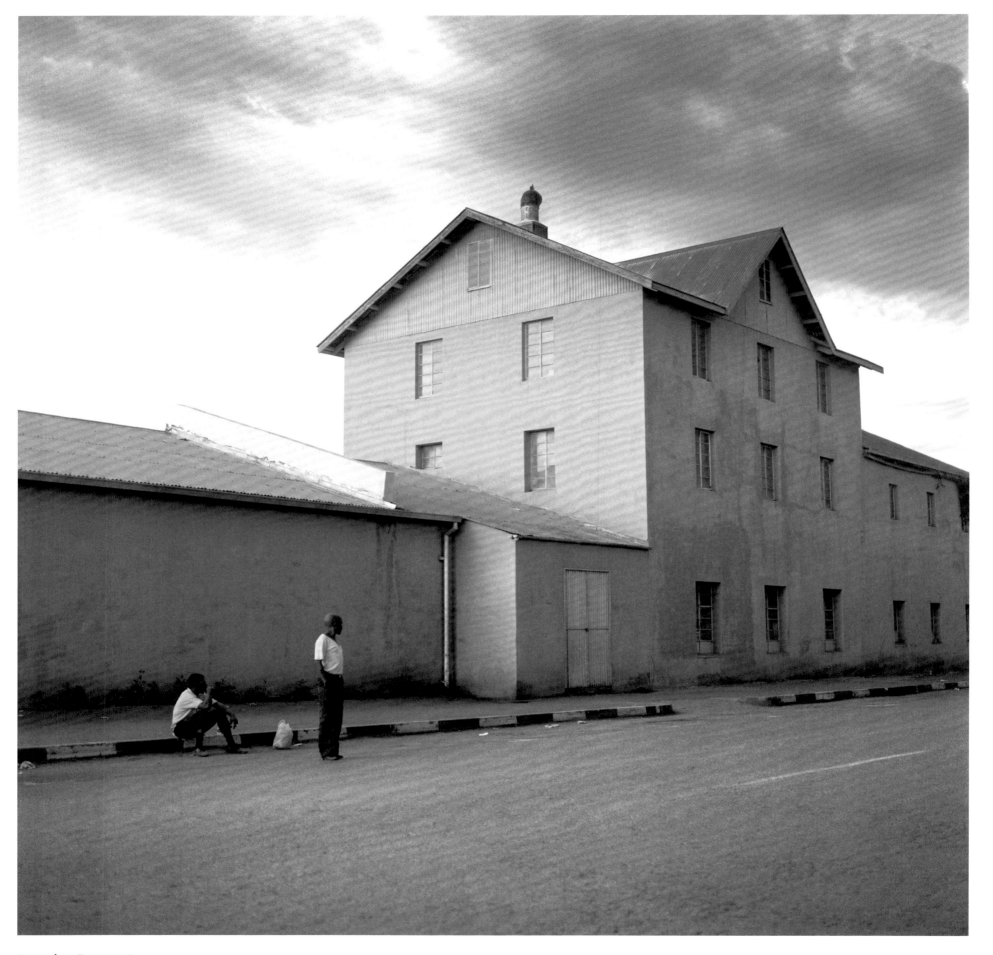

Bystanders, Zeerust, 1983

Early Morning, Napier, 1985

Abandoned House, Smithfield, 1985

Front Door, Hopetown, 1983

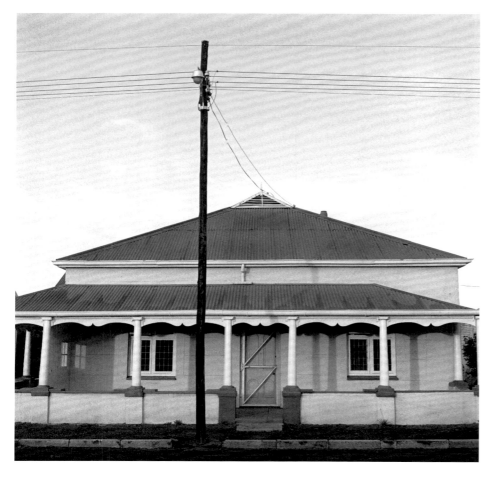

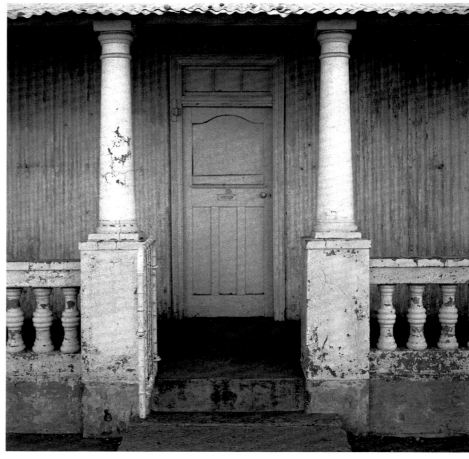

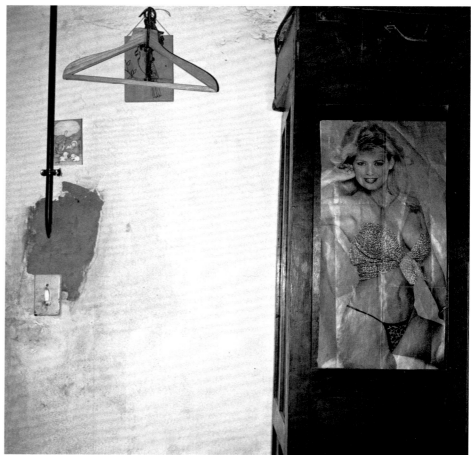

Karoo House, 1984
Living Room, Prince Albert, 1984

Front Veranda, Hopetown, 1983
Pensioner's Bedroom, Hopetown, 1984

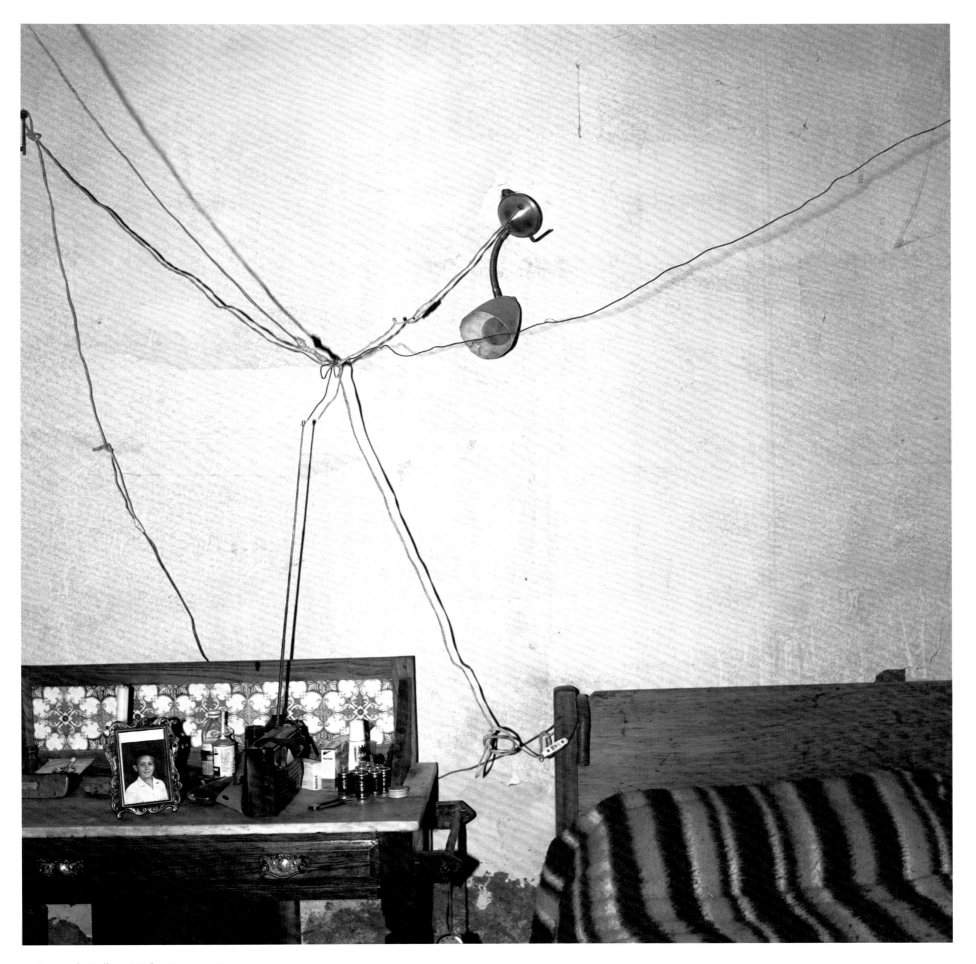

Bedroom of a Railway Worker, De Aar, 1984

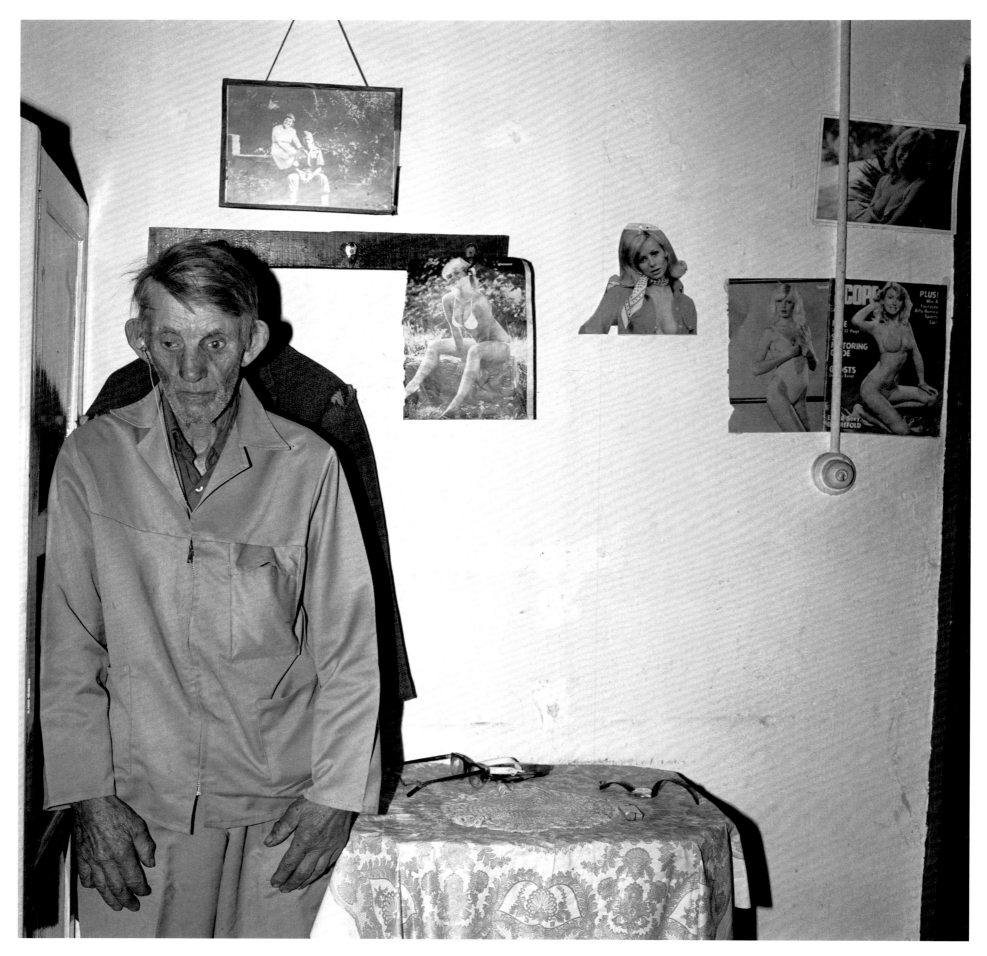

Pensioner, Volksrust, 1984

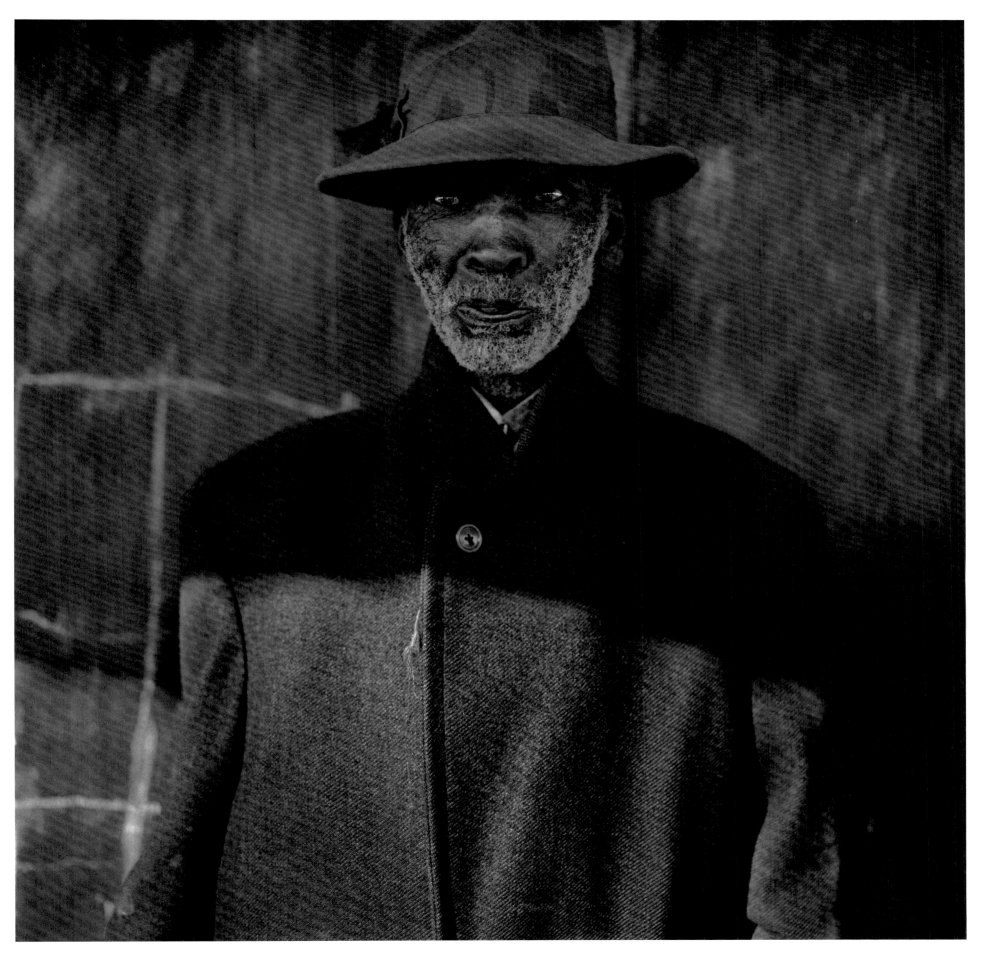

Old Man, Ottoshoop, 1983

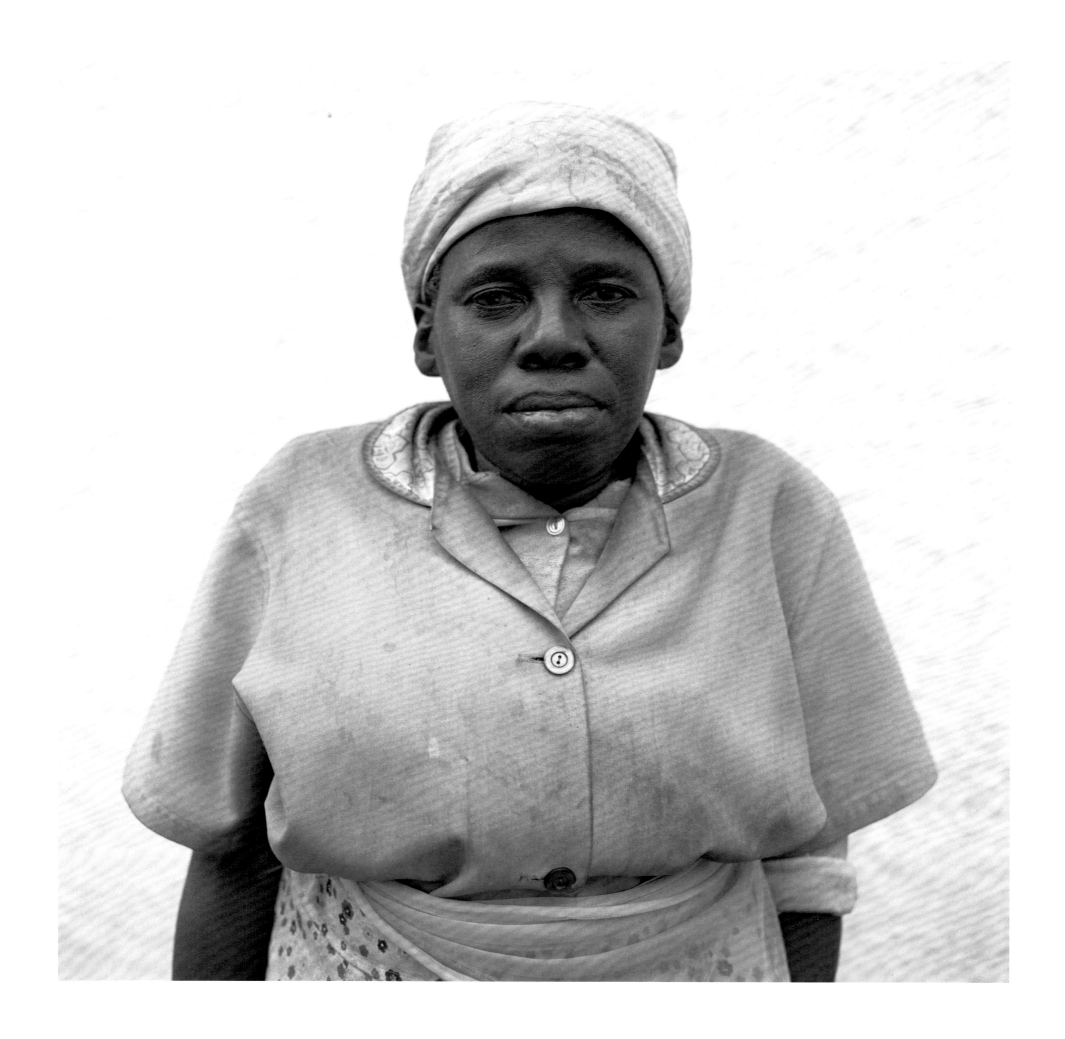

The early 1980s was the end of my so-called
romantic period. During this time, I photographed
people and places in the countryside of South
Africa, capturing a bygone era – people and
places that seemed unaffected by the tumultuous
events around them.

Maid, Balfour, 1985

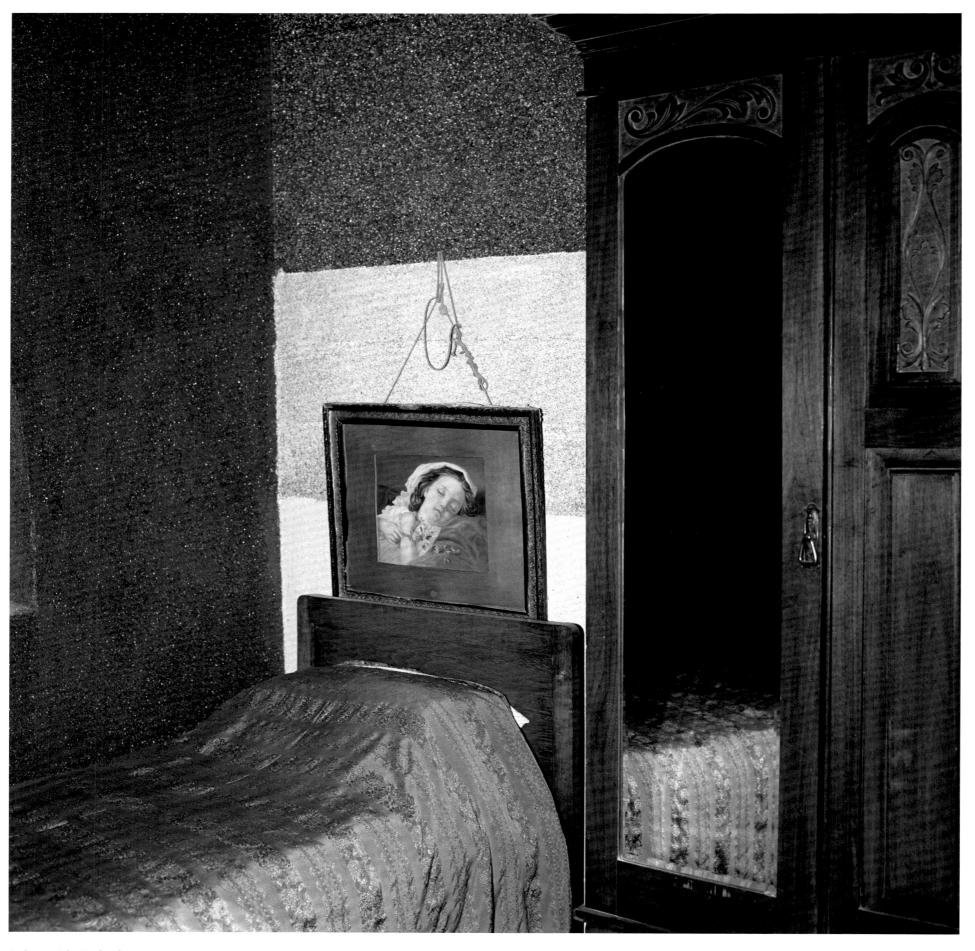

Bedroom, Nieu Bethseda, 1985

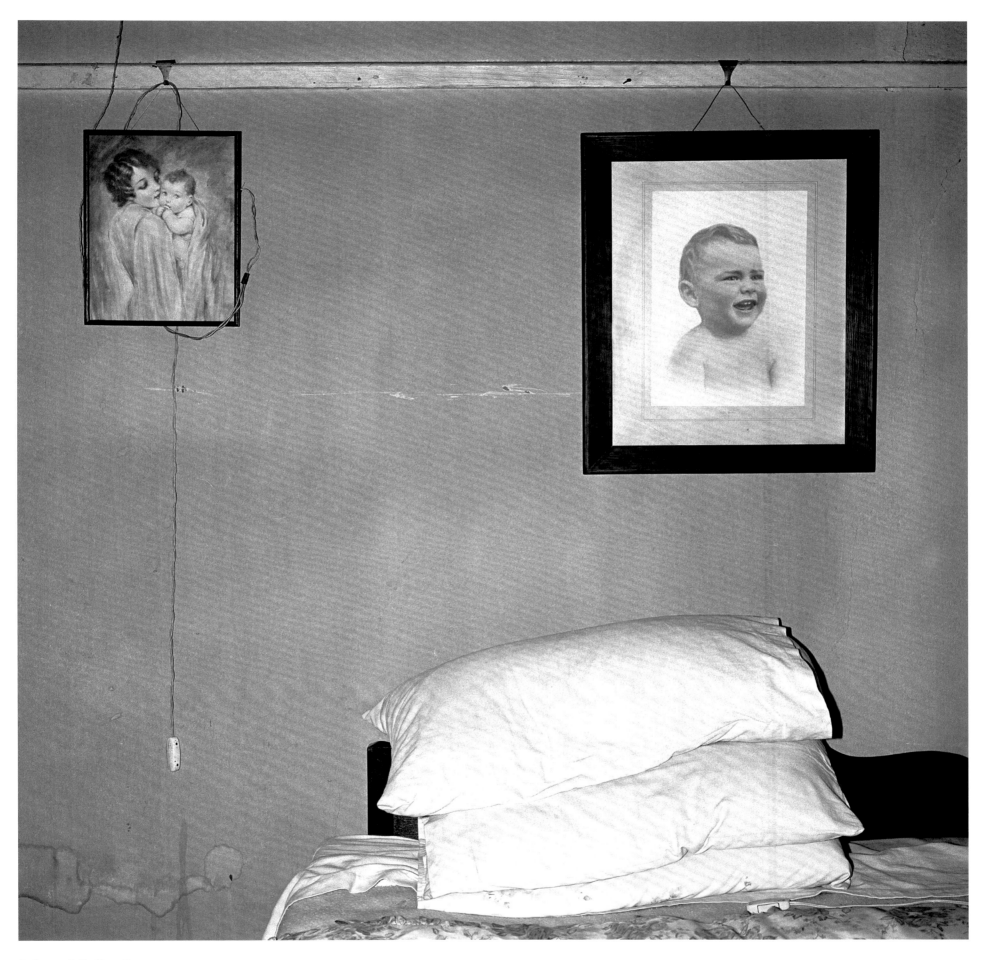

Bedroom, Bethulie, 1984

platteland, 1994

'*Platteland* deals with the connotation of strangeness, of places far away, perhaps even surreal. Ultimately, "platteland" means a state of mind, a psyche, and this psyche is bound up with the whole mythology of the South African countryside. People who have been living with the land, in the land with its people and with its animals and its plant life.'

Roger Ballen speaking on *The South Bank Show*, 1995

Sergeant F. de Bruin, Department of Prisons Employee, Orange Free State, 1992

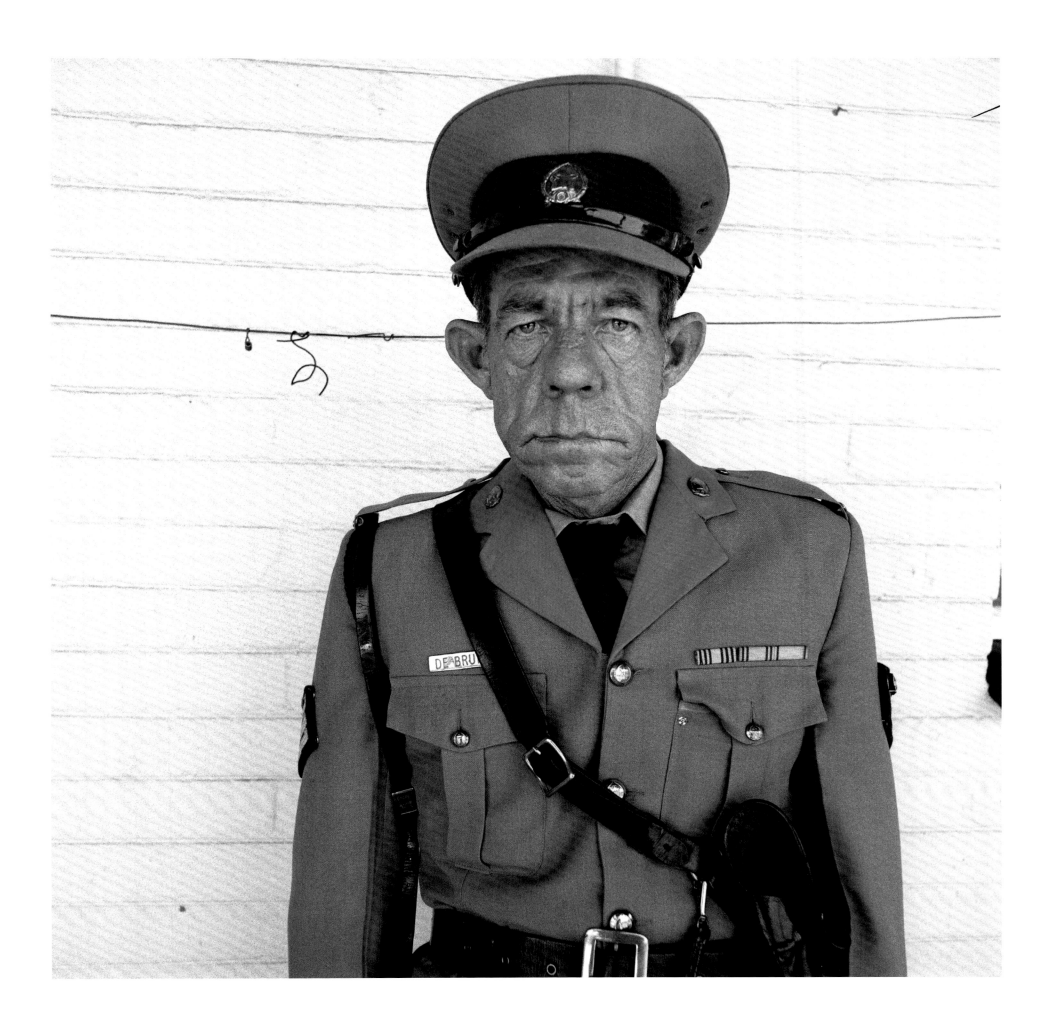

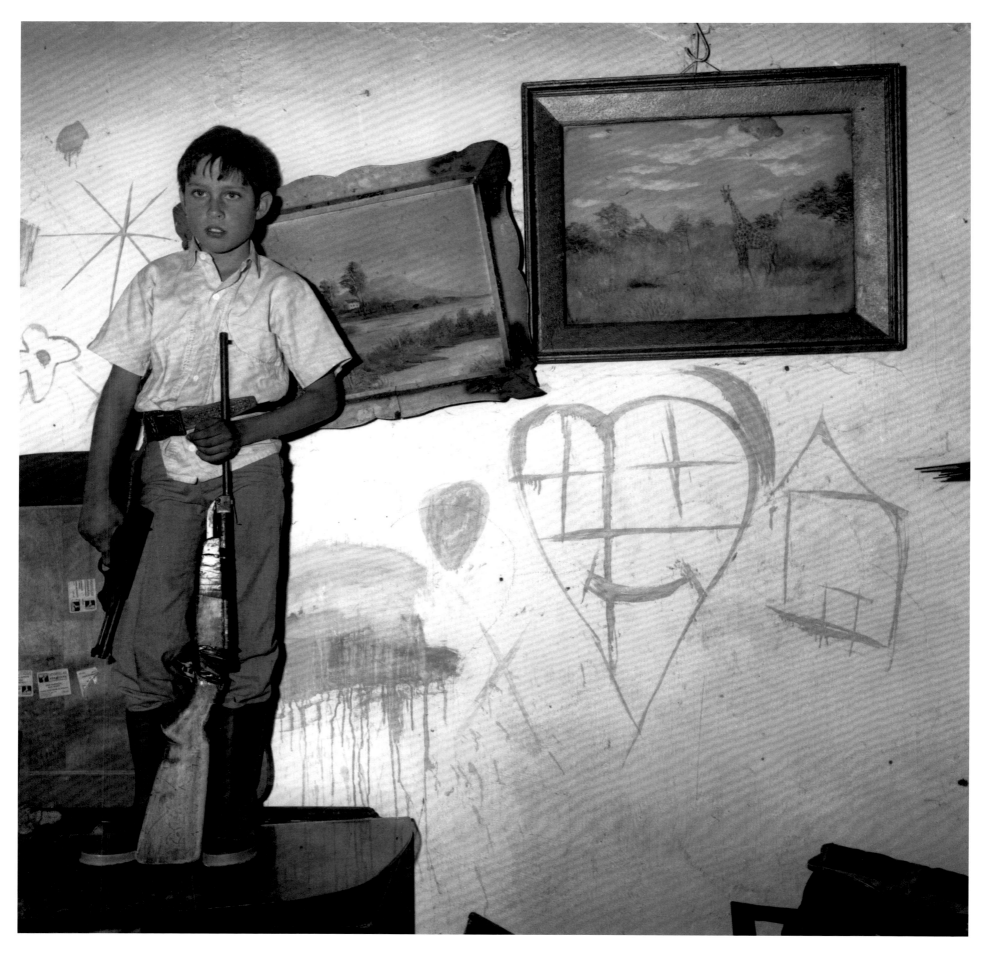

Boy with Guns, Western Transvaal, 1993

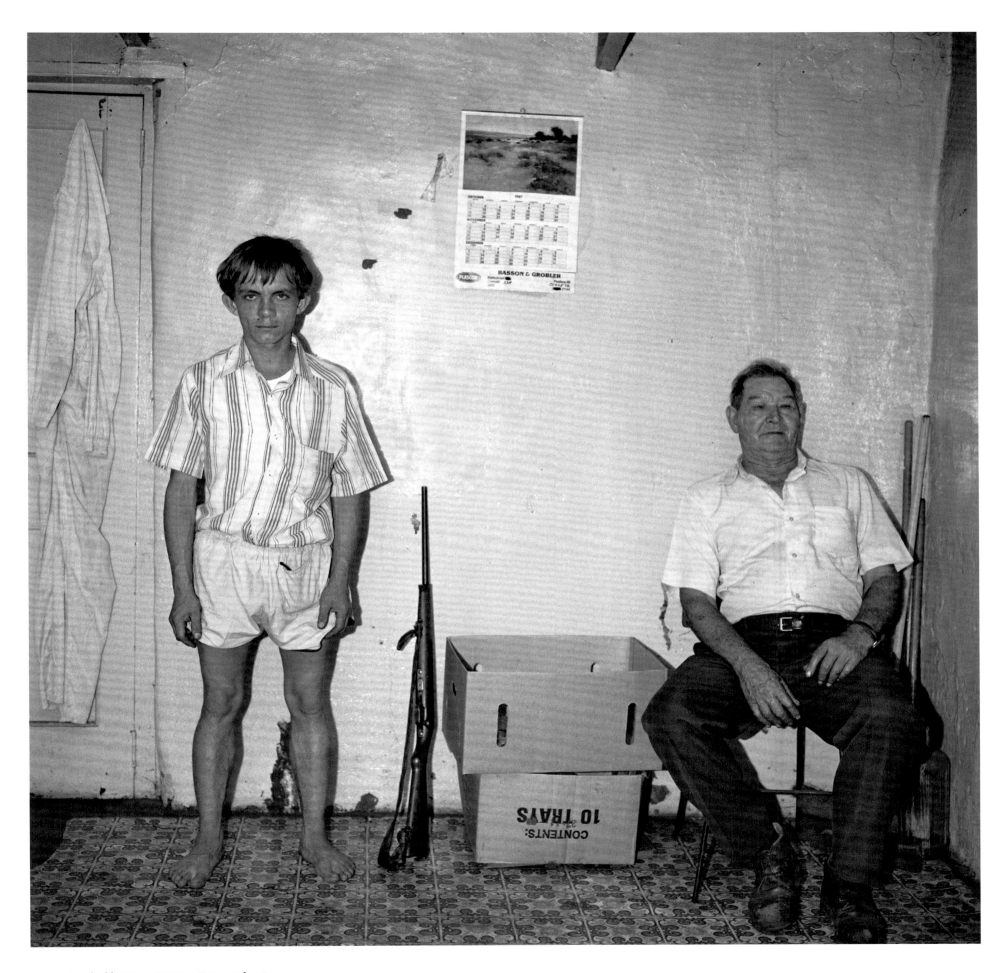

Prospectors inside House, Western Transvaal, 1987

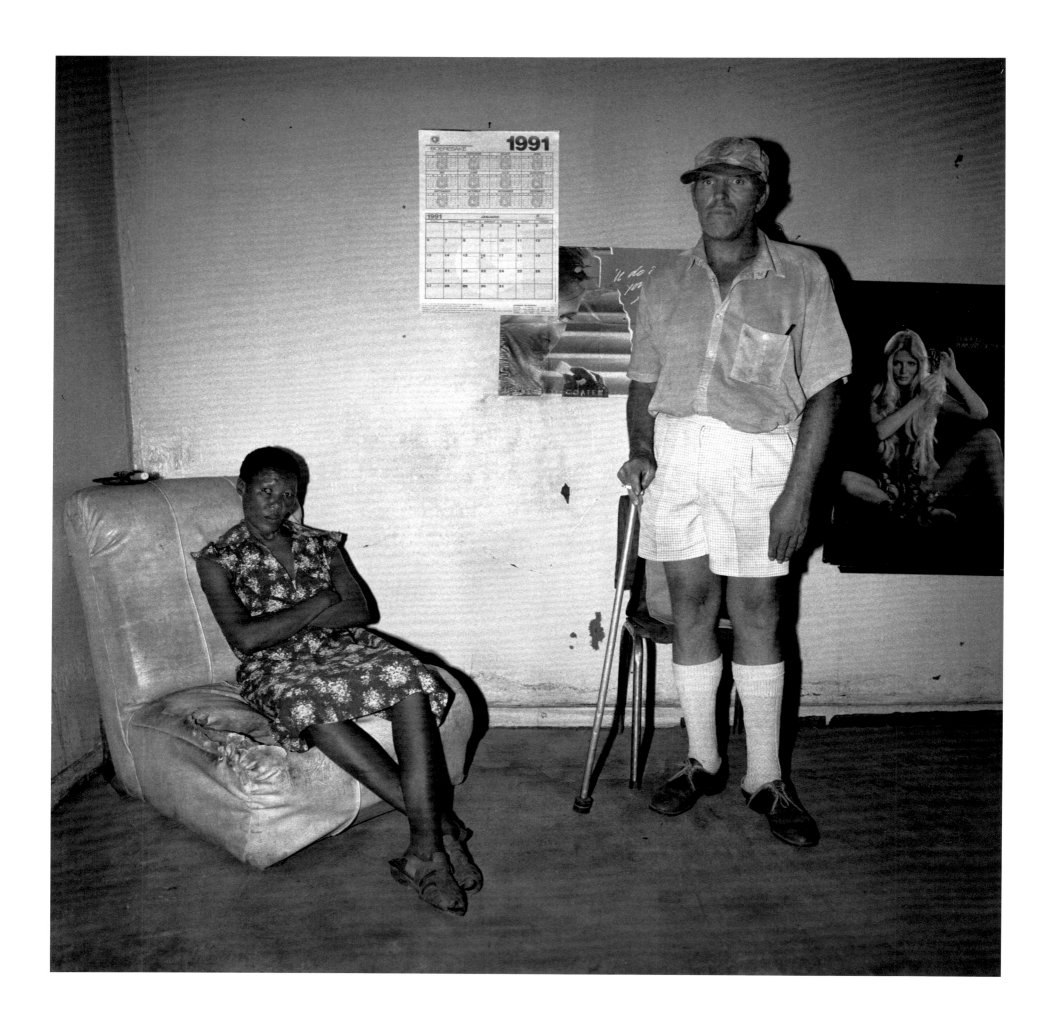

'If each individual in any photograph that is featured in [*Platteland*] can be read, in the unforgettable phrase of Emily Dickinson, as "a loaded gun", then each individual, whether female or male, child or grown-up, black or white, seen singly or as part of a couple or a family or a group, also remains trapped in the forever insoluble mystery of the self. *Humanity itself becomes a mystery.*'

André Brink, 'The Art of Roger Ballen', unpublished essay, 2014

Man and Maid, Northern Cape, 1991

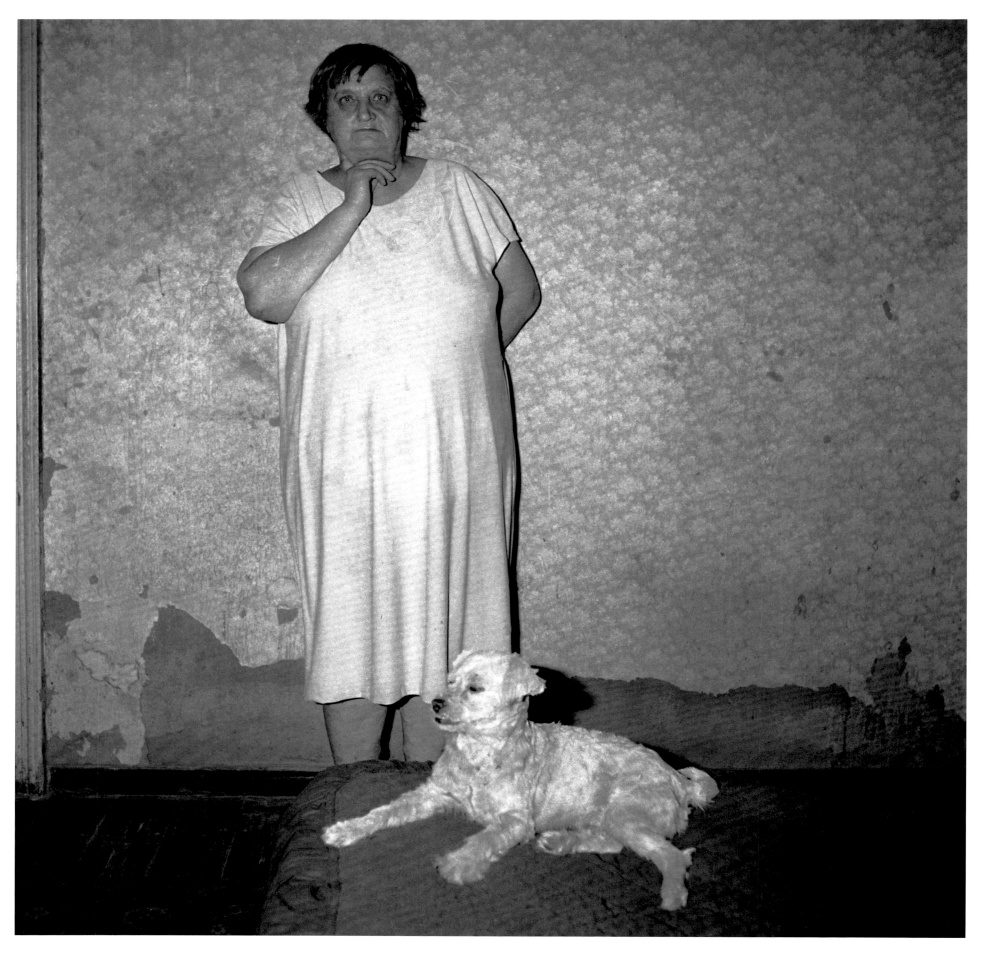

Mrs J.J. Joubert and Dog Dinky in Bedroom., Cape, 1990

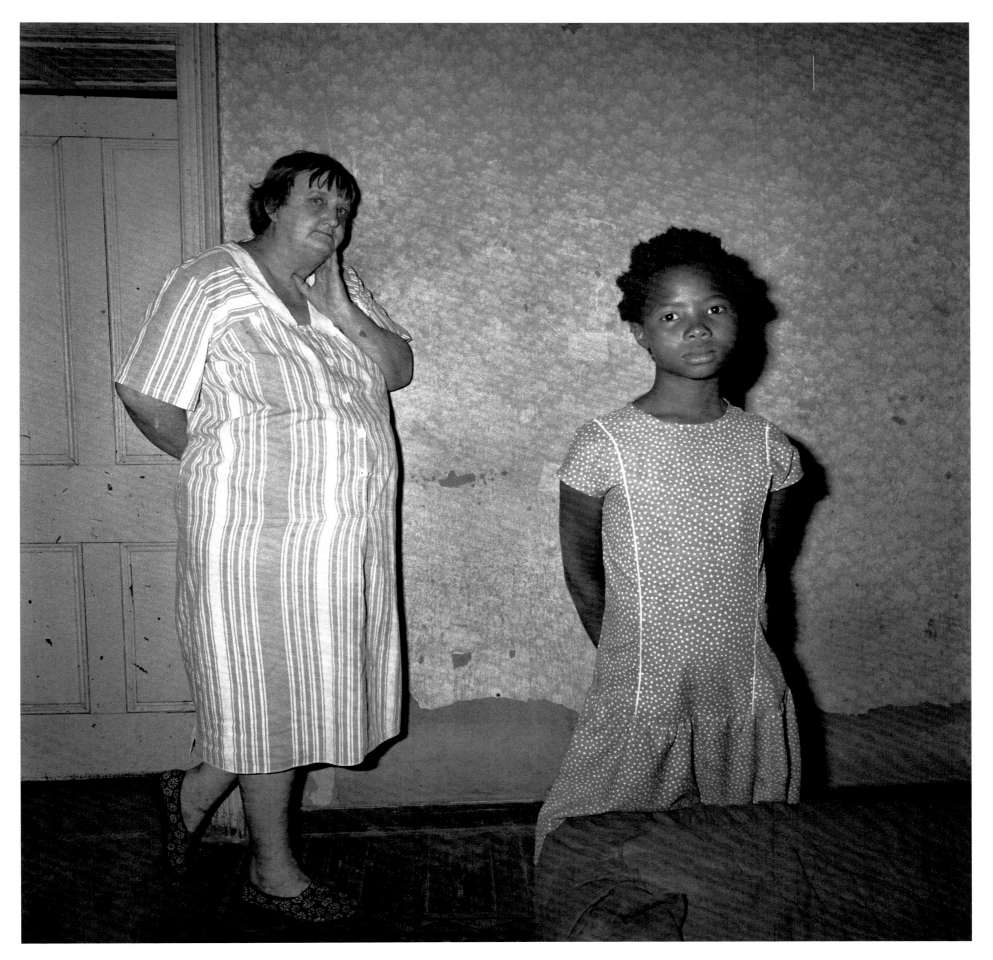

Mrs J.J. Joubert and Her Domestic Worker, 1991

This is the image that I will probably be most remembered for. Millions of people have seen it; few have forgotten it. For some unknown reason, it is able to penetrate the inner mind and lodge itself there. Why and how the human brain responds to this image in this way remains a mystery.

Dresie and Casie, Twins, Western Transvaal, 1993

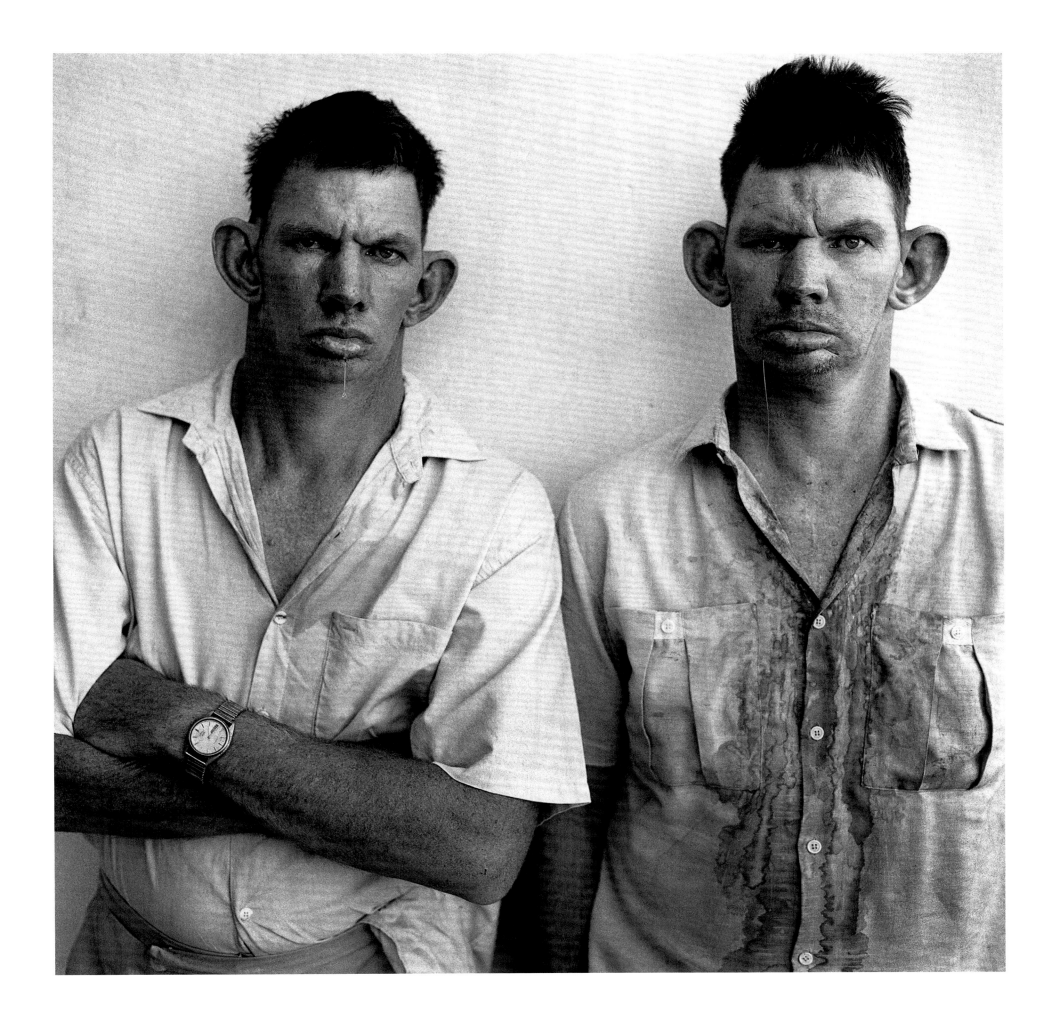

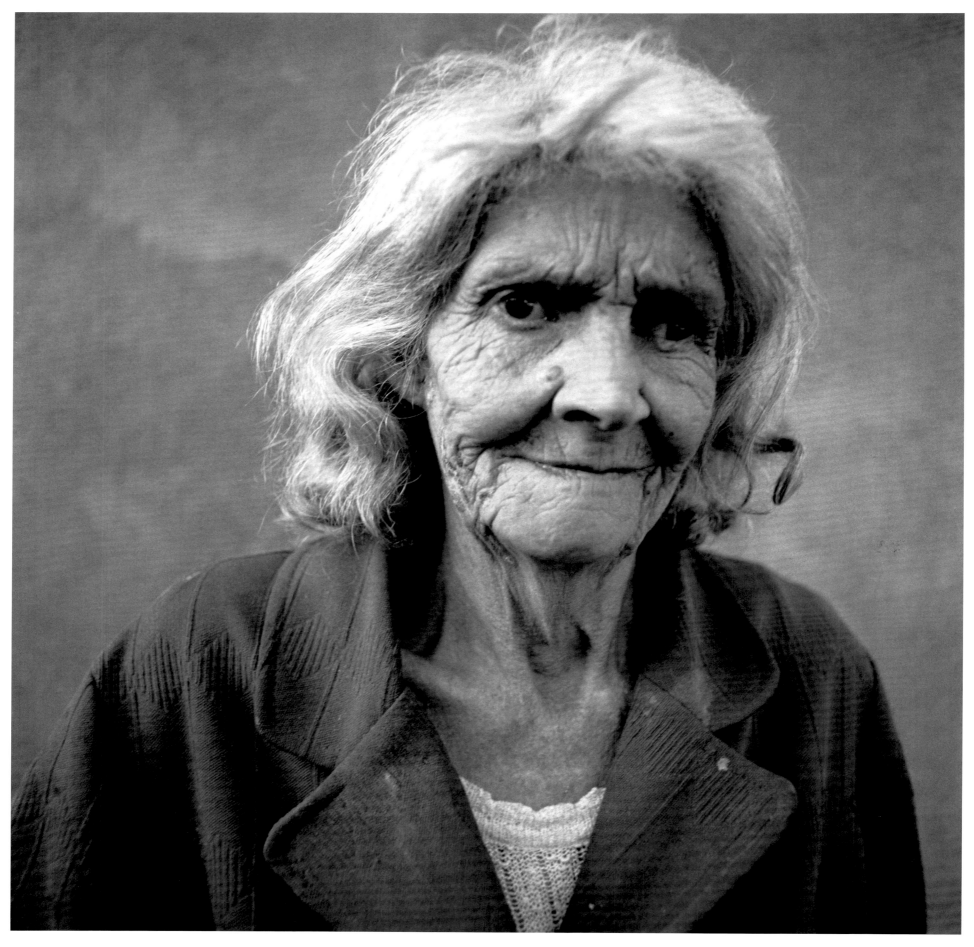

Mrs P.R. Streicher, 1993

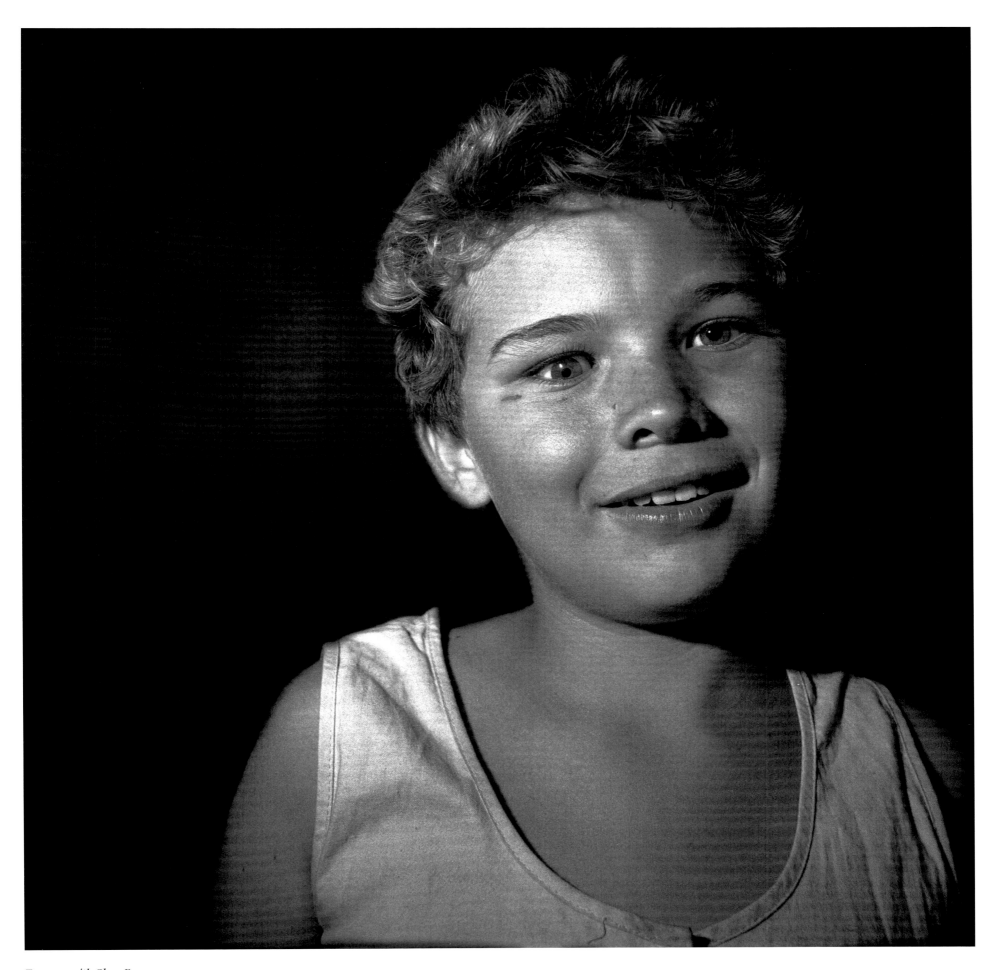

Teenager with Glass Eye, 1994

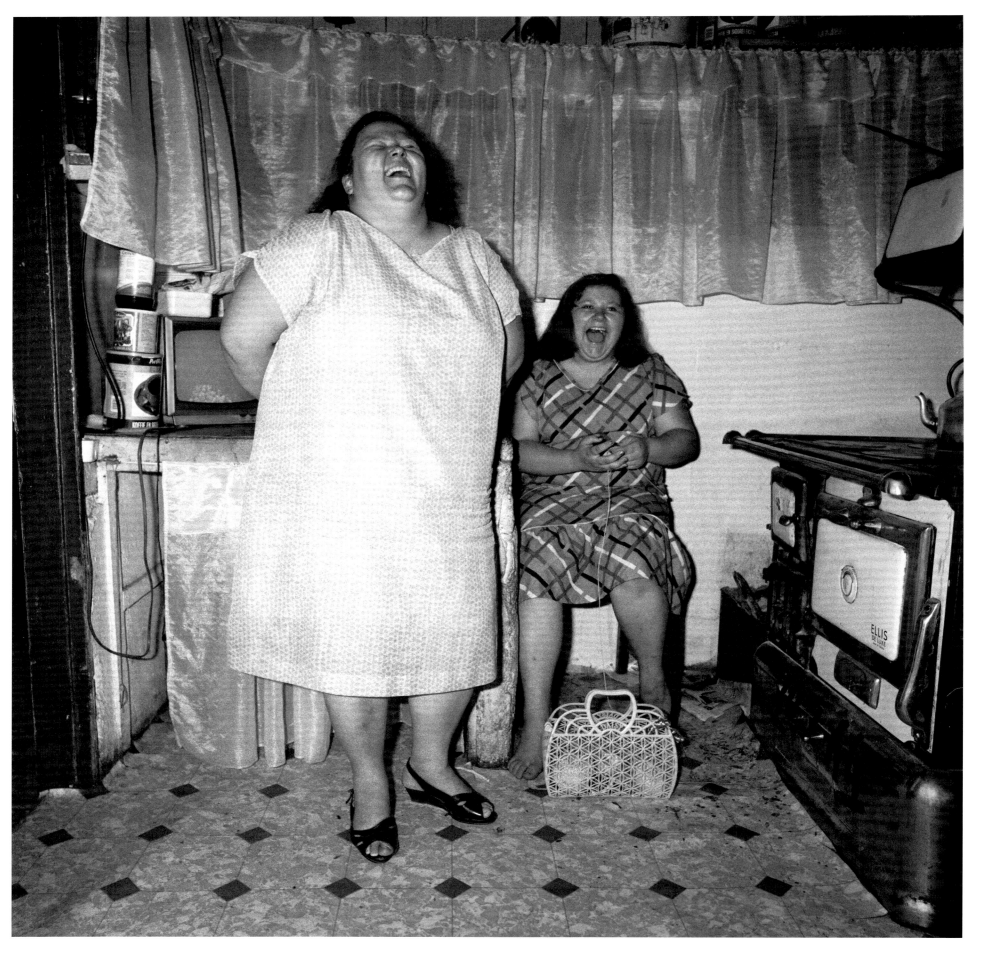

Leah and Illona, Sisters, Western Transvaal, 1986

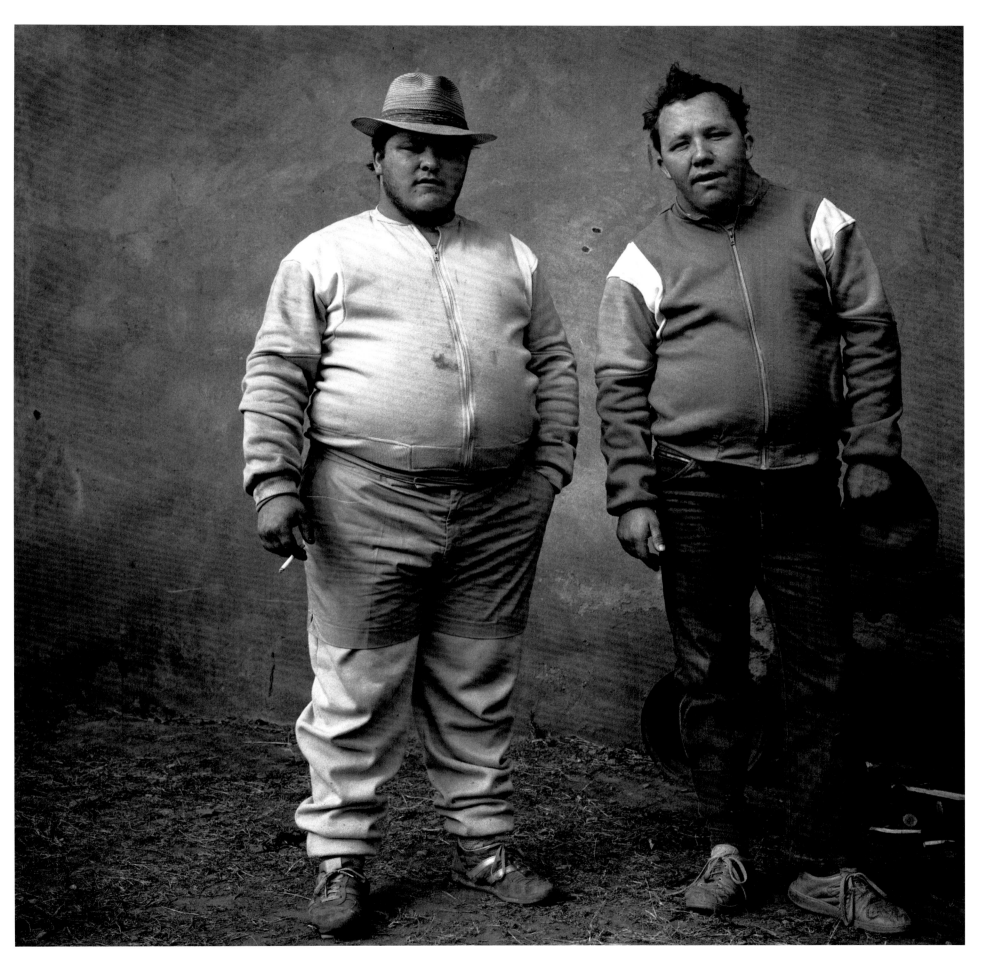

Johan and Bertie, Brothers, Western Transvaal, 1987

Most photographers, both professional and amateur, are obsessed by the foreground of an image, by what the lens is focused on. Contrarily, I have tended to start more with the background, with the express intention of later unifying the photograph. Ultimately, every element in an image, as in nature, must be present for a particular reason, contributing to a larger whole.

Cookie with Wife Tillie, Orange Free State, 1993

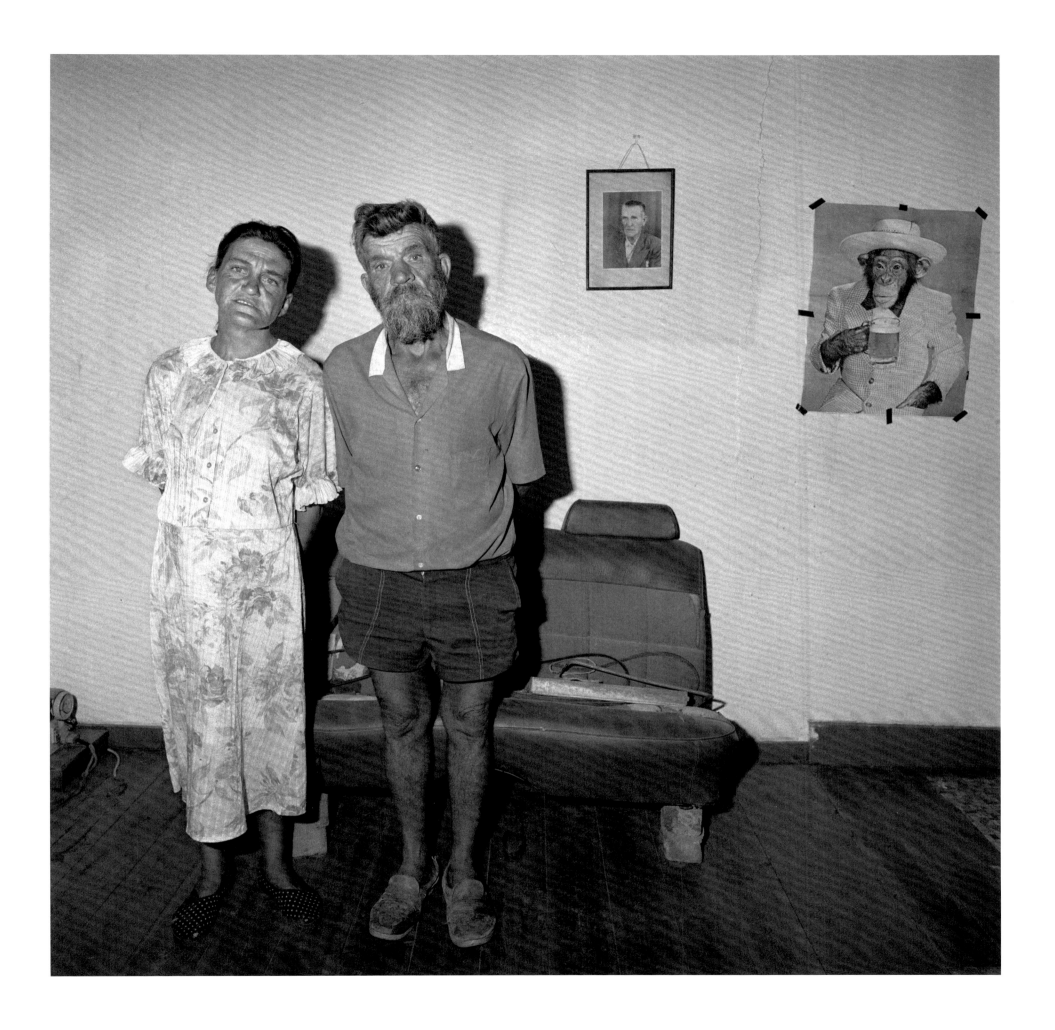

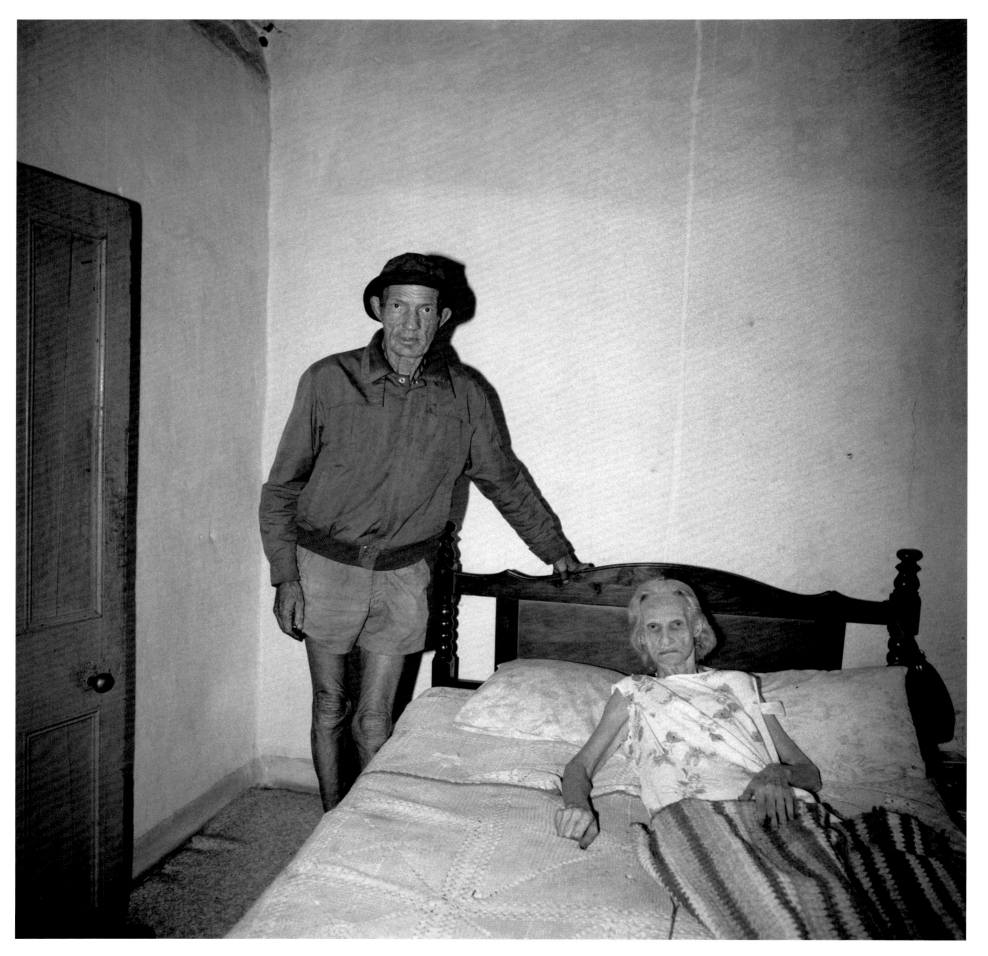

Henk Oosthuizen with Sick Mother, Western Transvaal, 1988

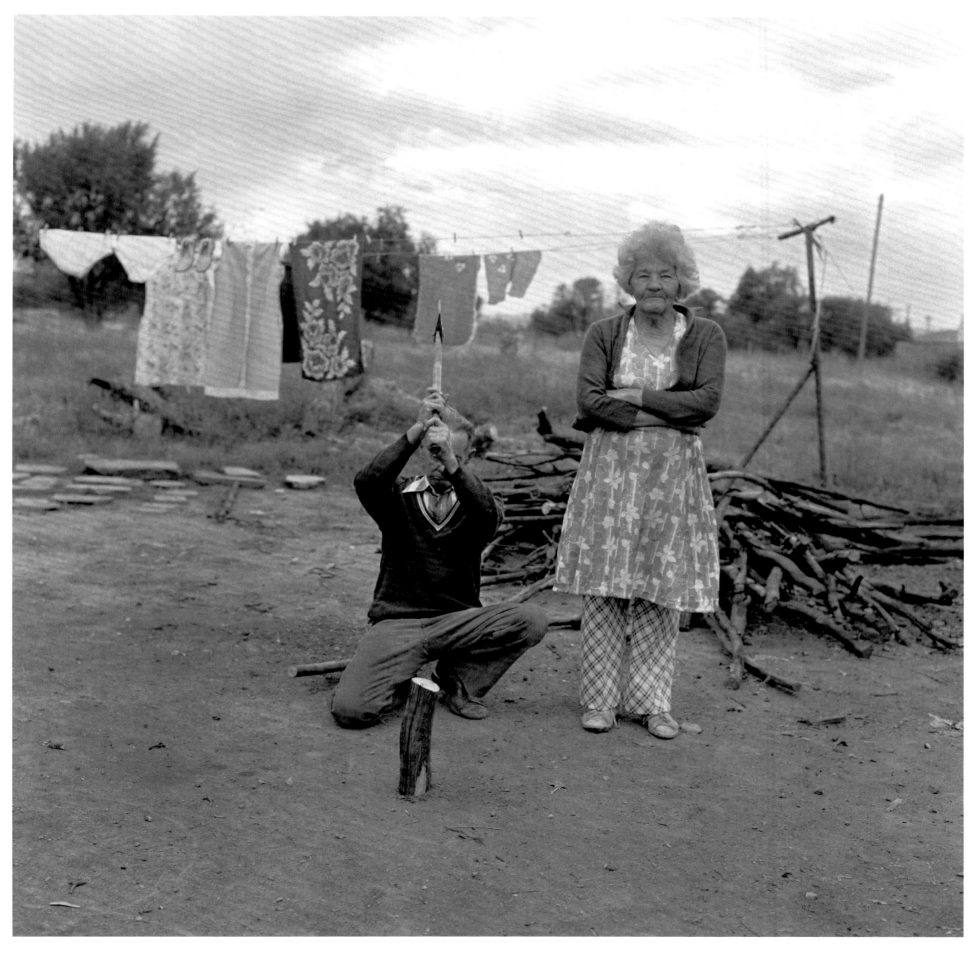

Chopping Wood, 1988

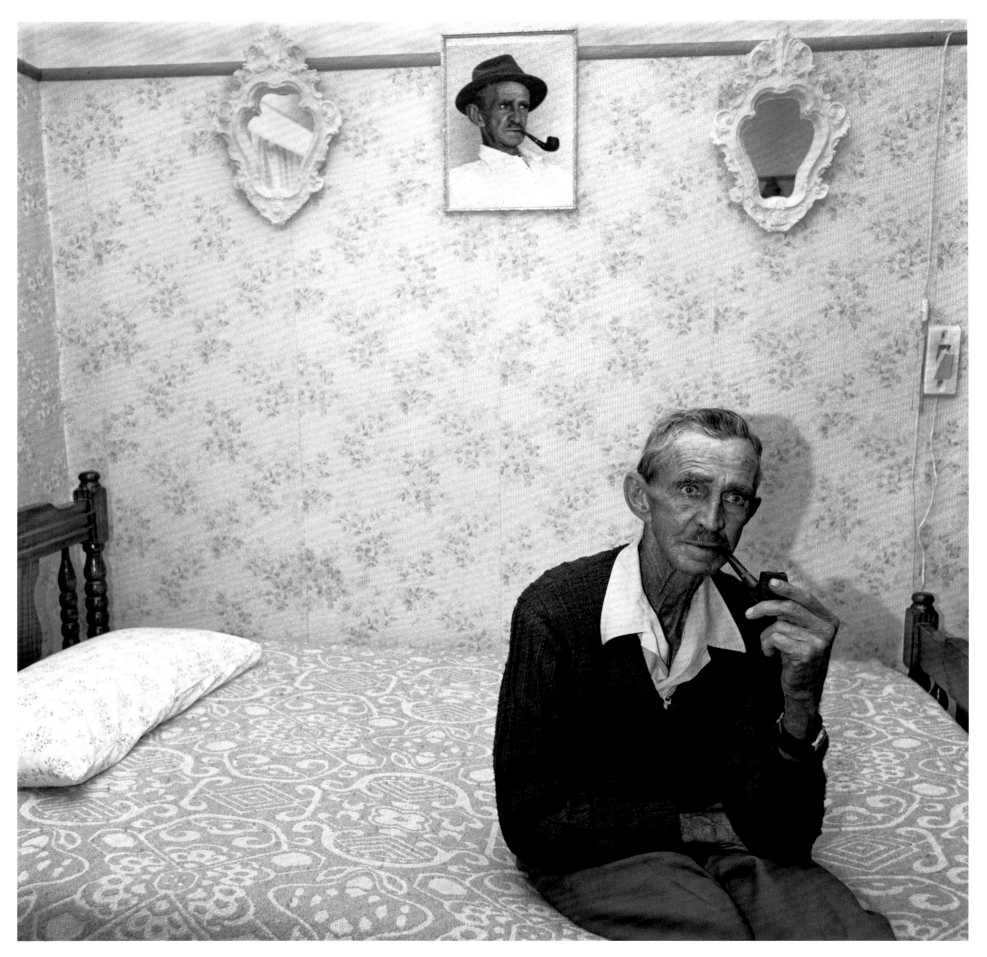

Portrait of Man with Pipe, 1985

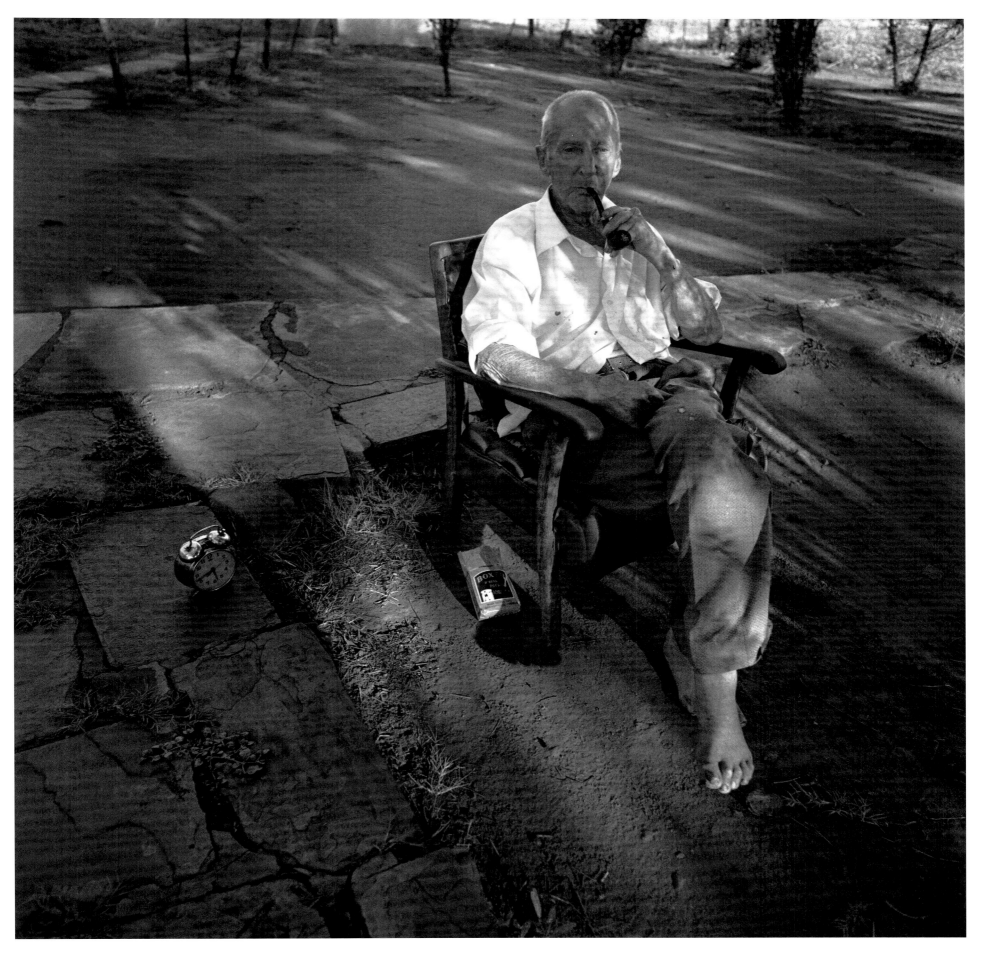

Man with Pipe and Alarm Clock, 1984

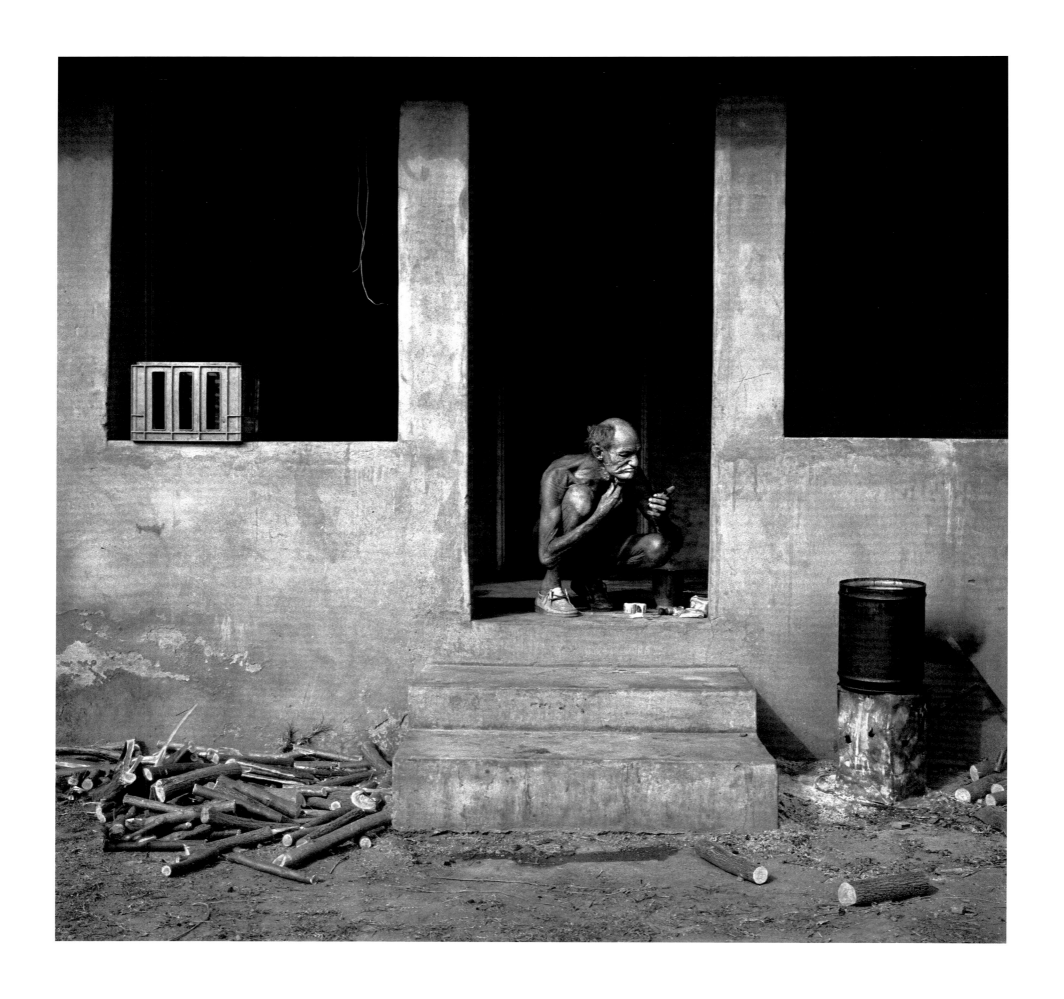

Fundamentally, what drew me to the subject of *Man Shaving on Veranda* was the profound irony that, despite half a century of political privilege, here in the physical heart of white South Africa, even in a system created to secure their political survival, were archetypes of alienation and immobility, victims of political forces and personal circumstances, defending themselves against economic deprivation and psychological anguish.

Man Shaving on Veranda, Western Transvaal, 1986

outland, 2001

'Ballen's *Outland* photographs are not reportage-style social documentaries. They are staged scenes in which the absurdity and alienation of the situations are intensified. What holds our attention is not the specific nature of the lives of these South Africans, but the compelling drama provided by the characters themselves.'

Peter Weiermair, 'Portraits as Still Life', in *Outland*

Puppy between Feet, 1999

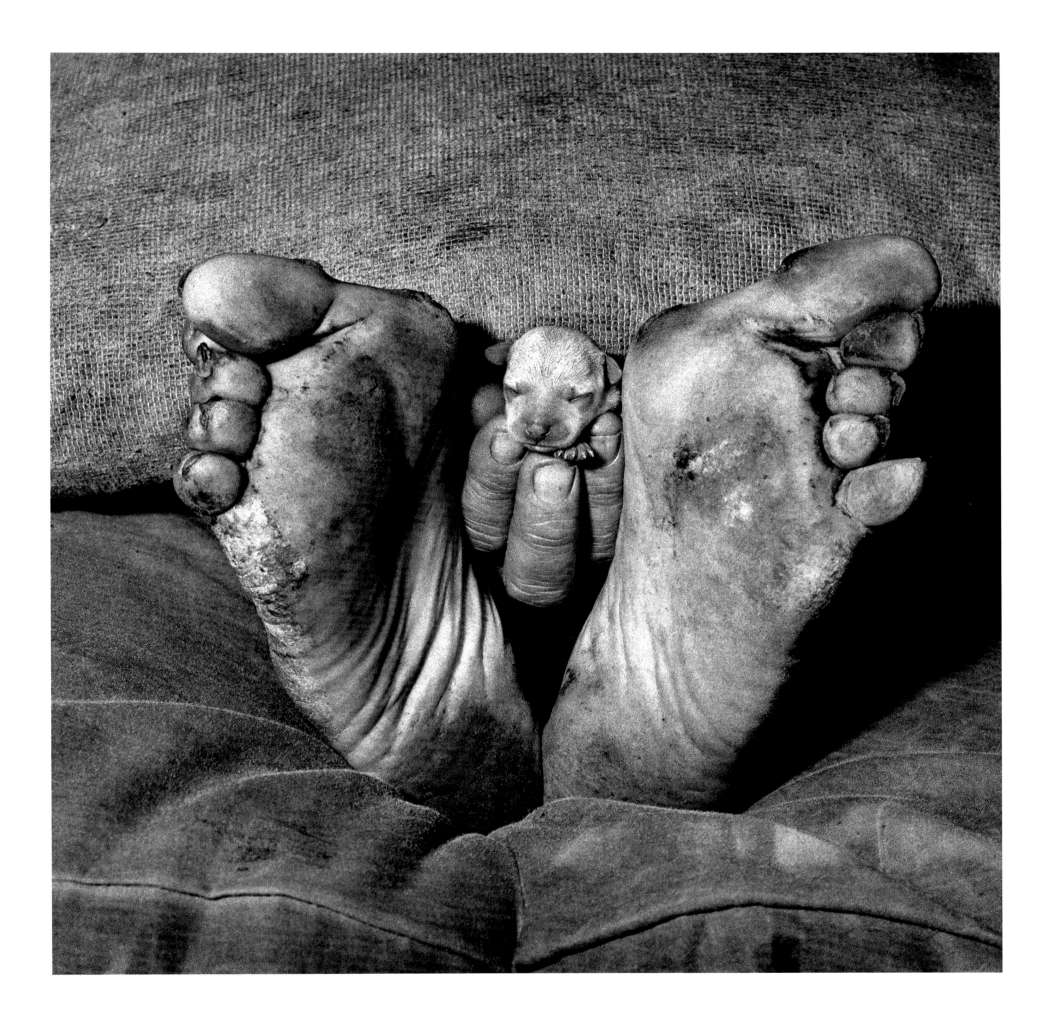

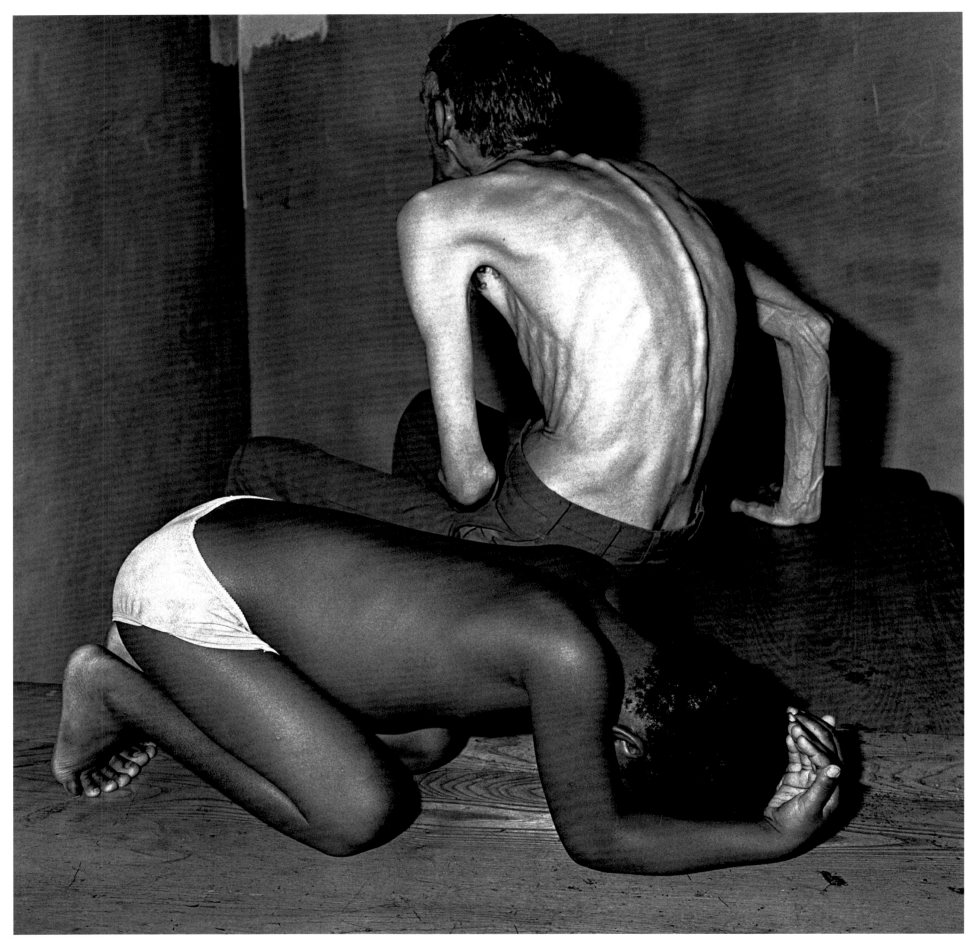

Two Figures, 2000

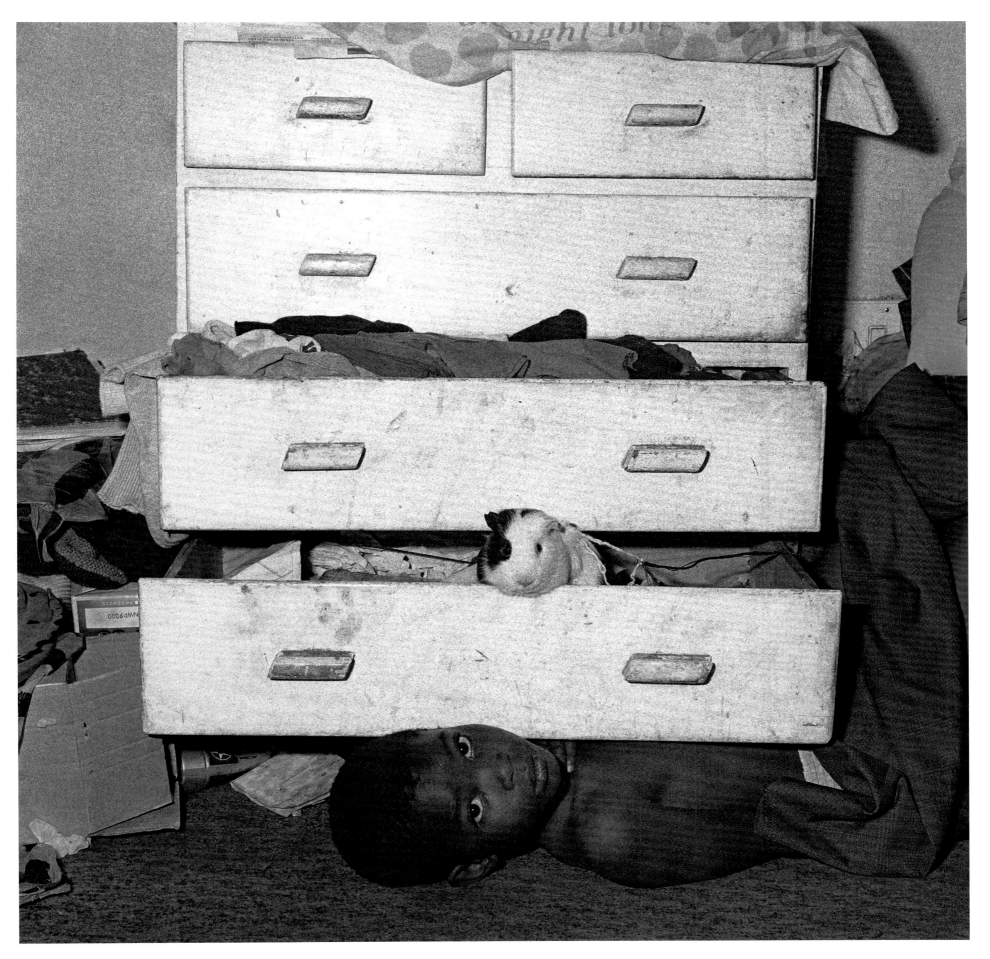

Child under Chest of Drawers, 2000

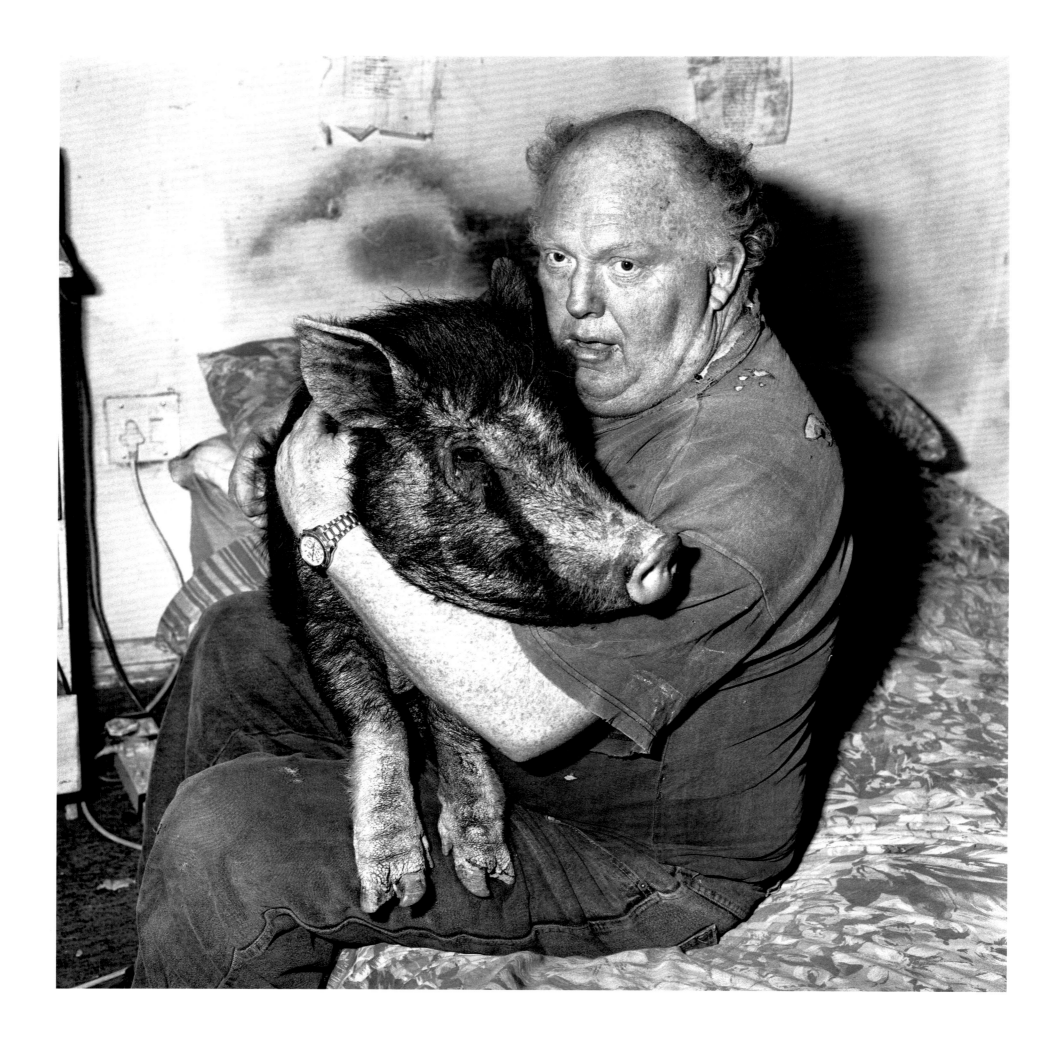

A photograph can confirm what we implicitly understand but cannot express. In my opinion, the best images are those for which we cannot find words.

Brian with Pet Pig, 1998

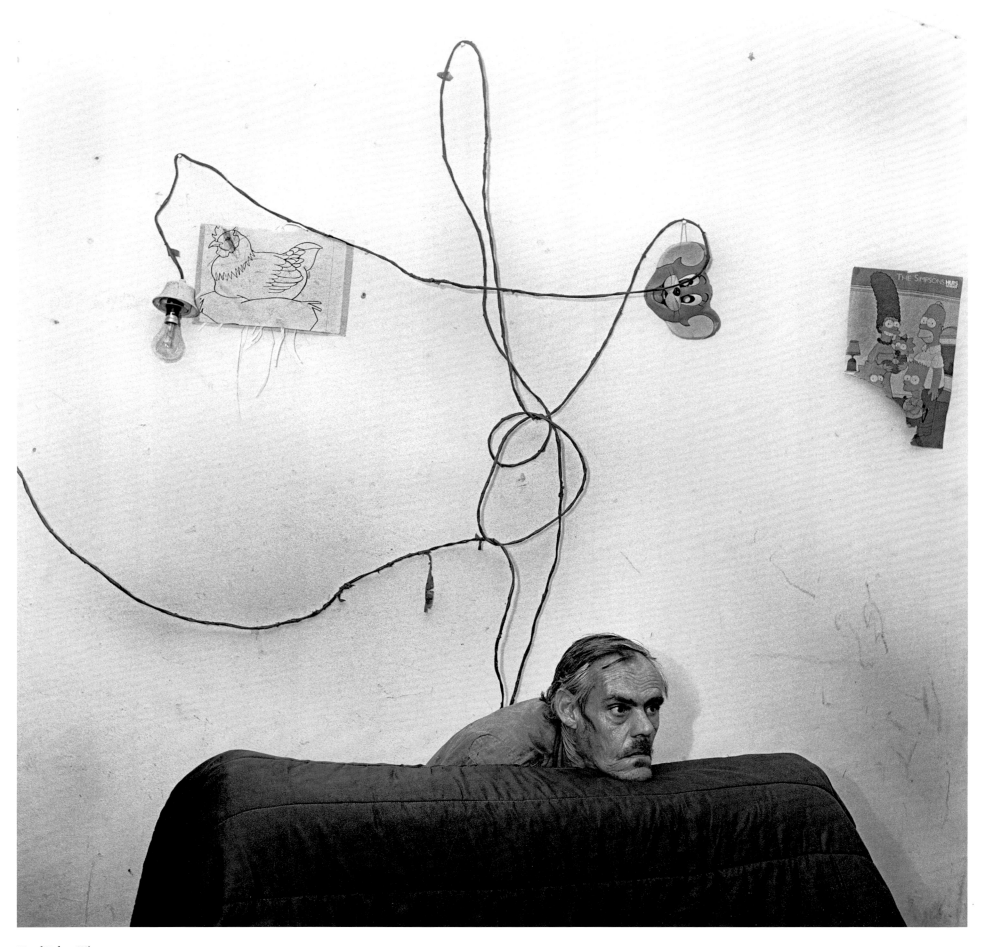

Head Below Wires, 1999

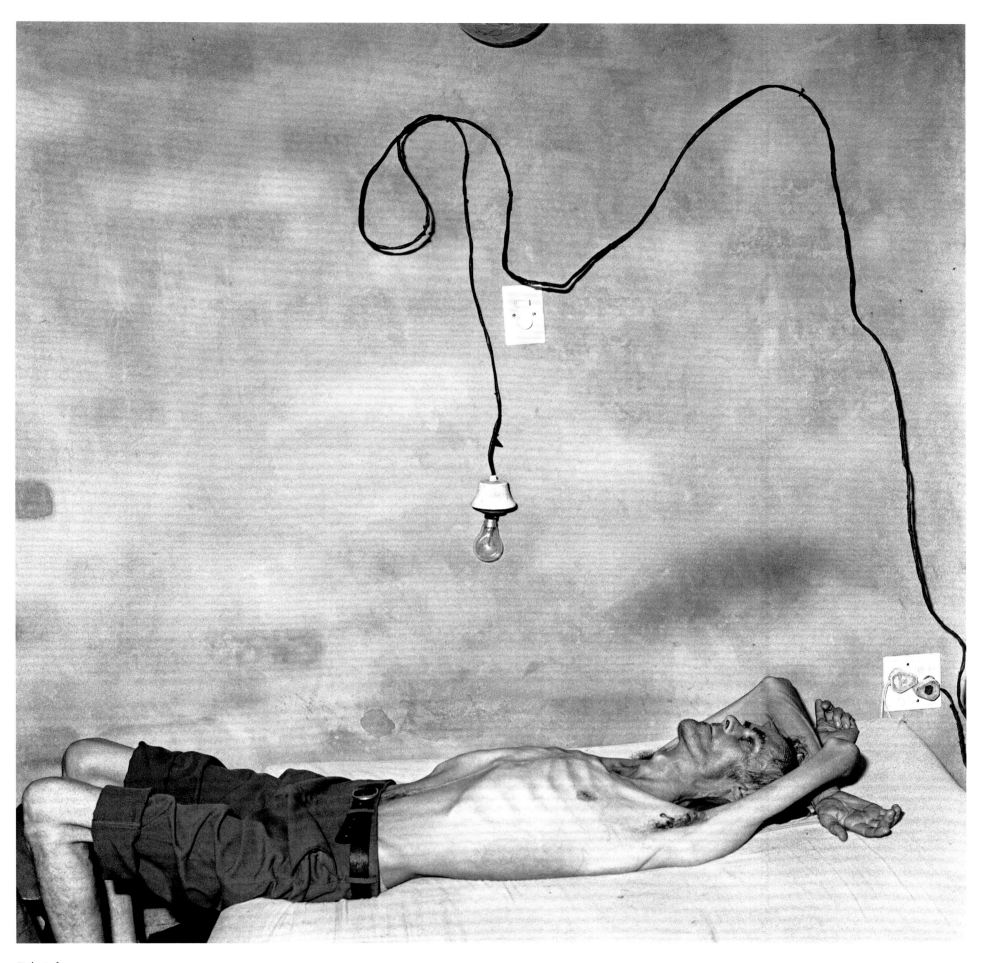

Dejected, 1999

The idea of using drawing in my photographs came about as a result of interaction with my subjects, many of whom would regularly draw on the walls of their rooms. I would then place these individuals against their drawings, hoping that a visual relationship would appear. In *Man Drawing Chalk Faces*, the subject was unaware that his drawings mirrored himself.

Man Drawing Chalk Faces, 2000

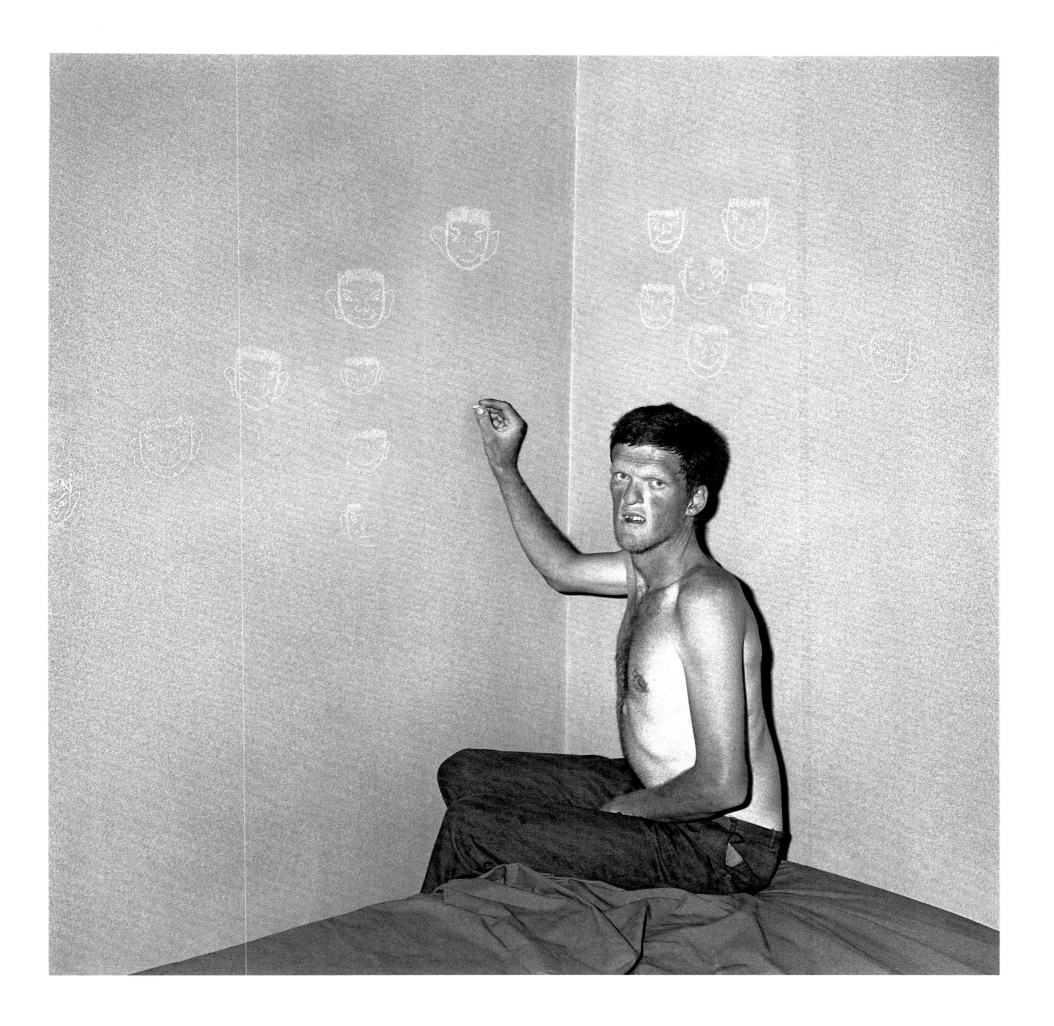

131

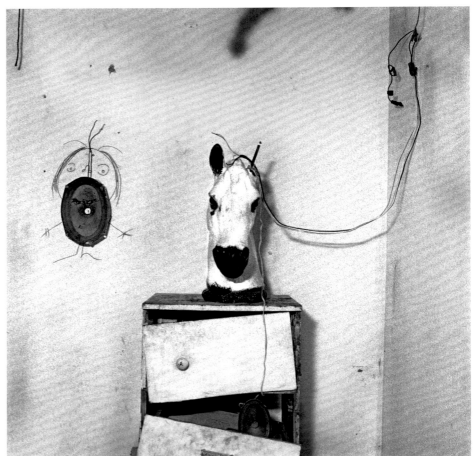

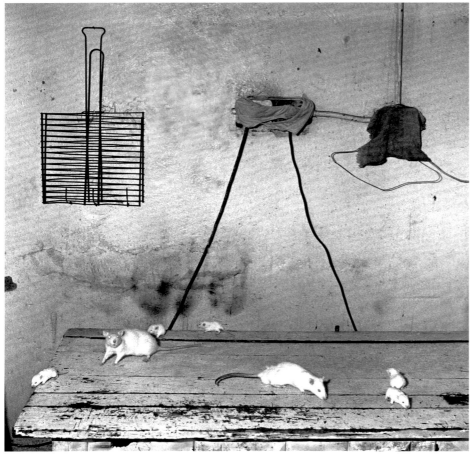

Hand-drawn Hearts, 2000
Rats on Kitchen Table, 1999

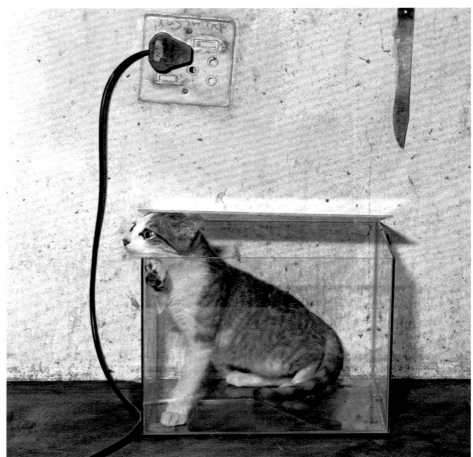

Horse Head on Drawers, 1998
Cat in Fish Tank, 2000

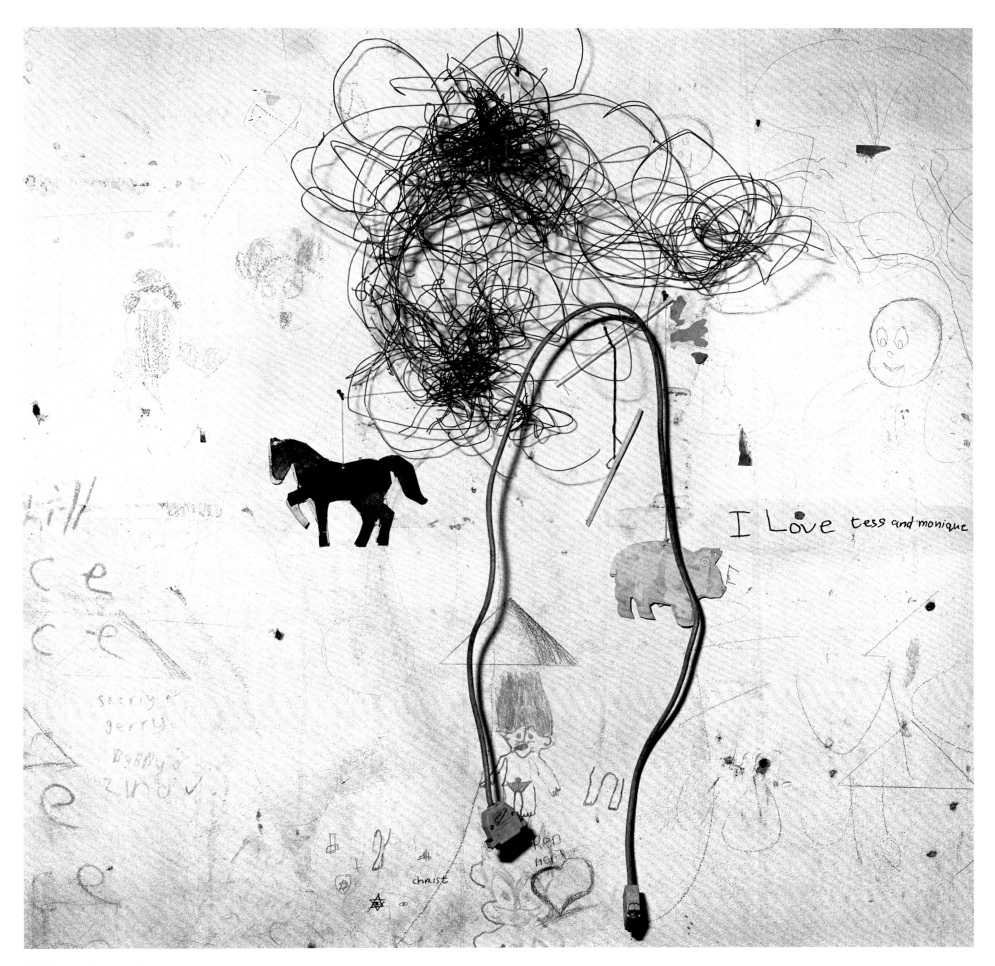

Children's Bedroom Wall, 2000

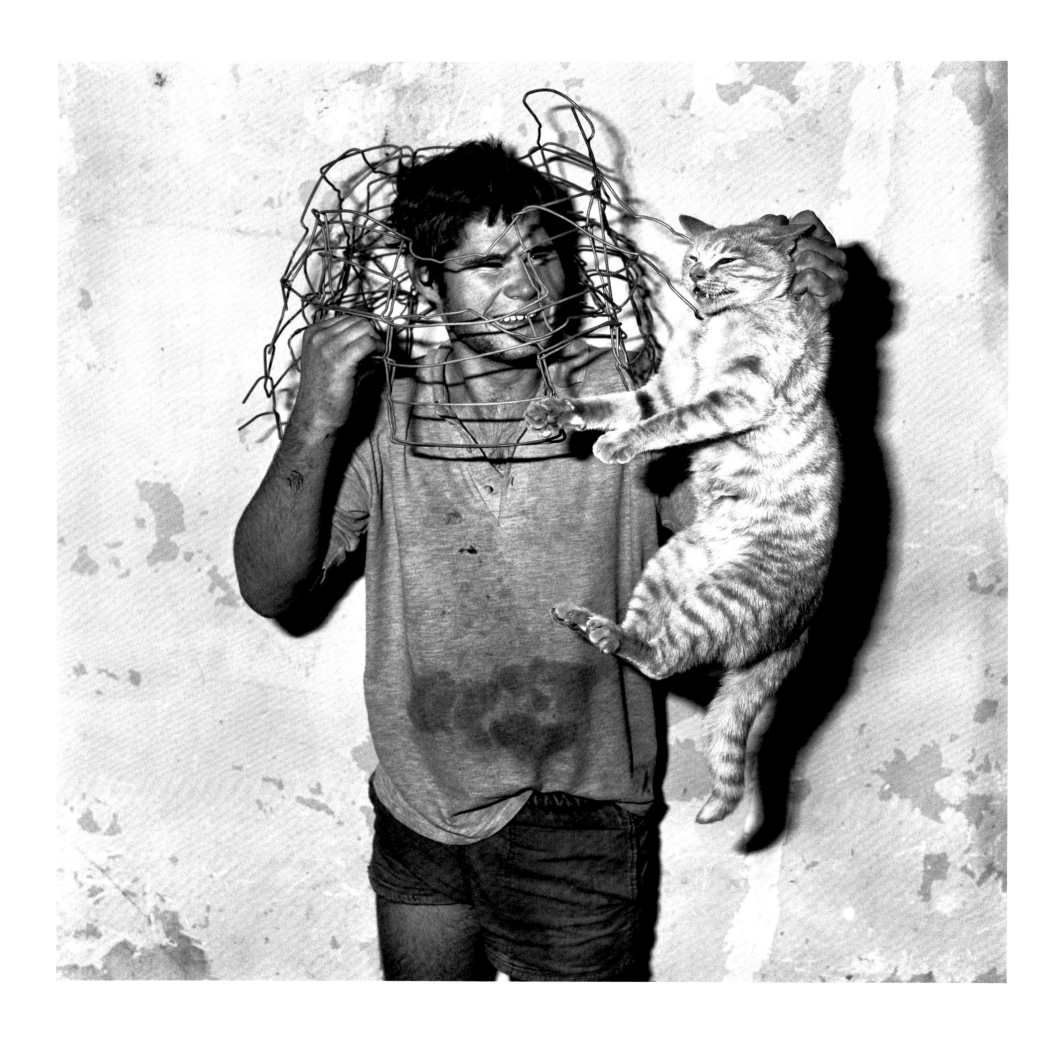

A central challenge in my career has been
to locate the animal in the human being and
the human being in the animal.

Cat Catcher, 1998

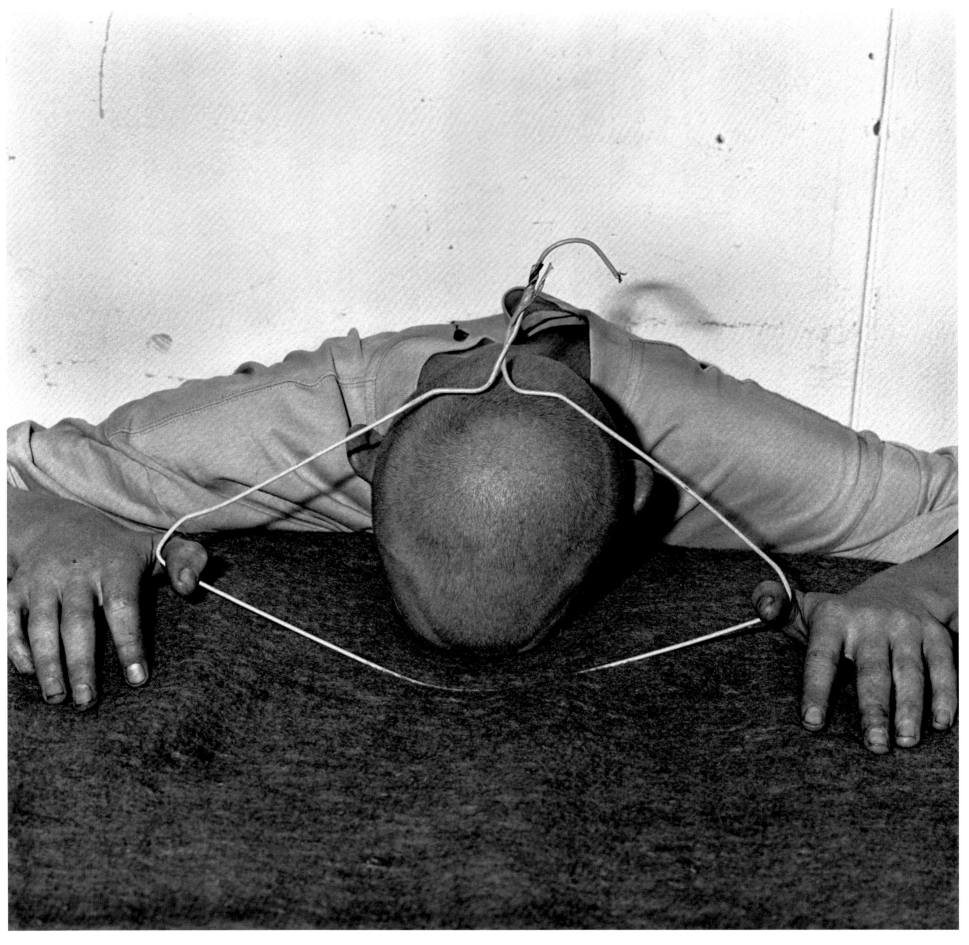

Hoodwinked, 1996

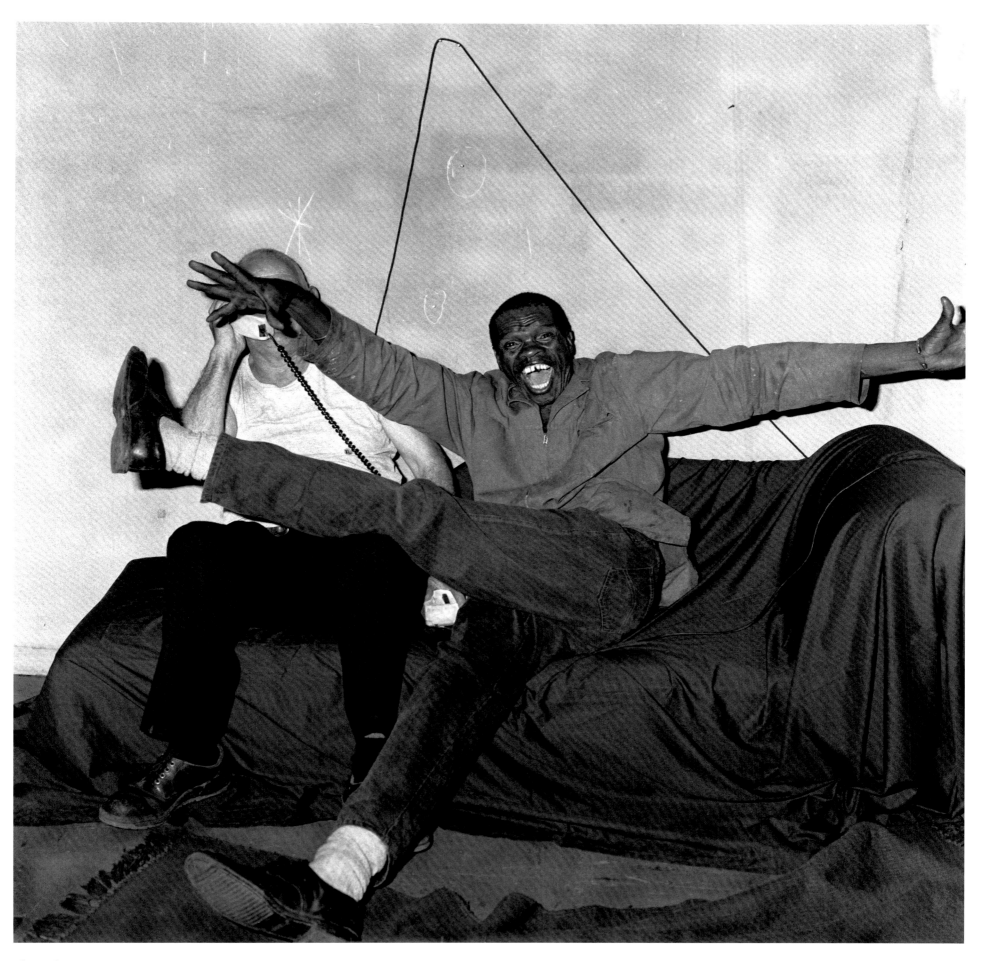

Show Off, 2000

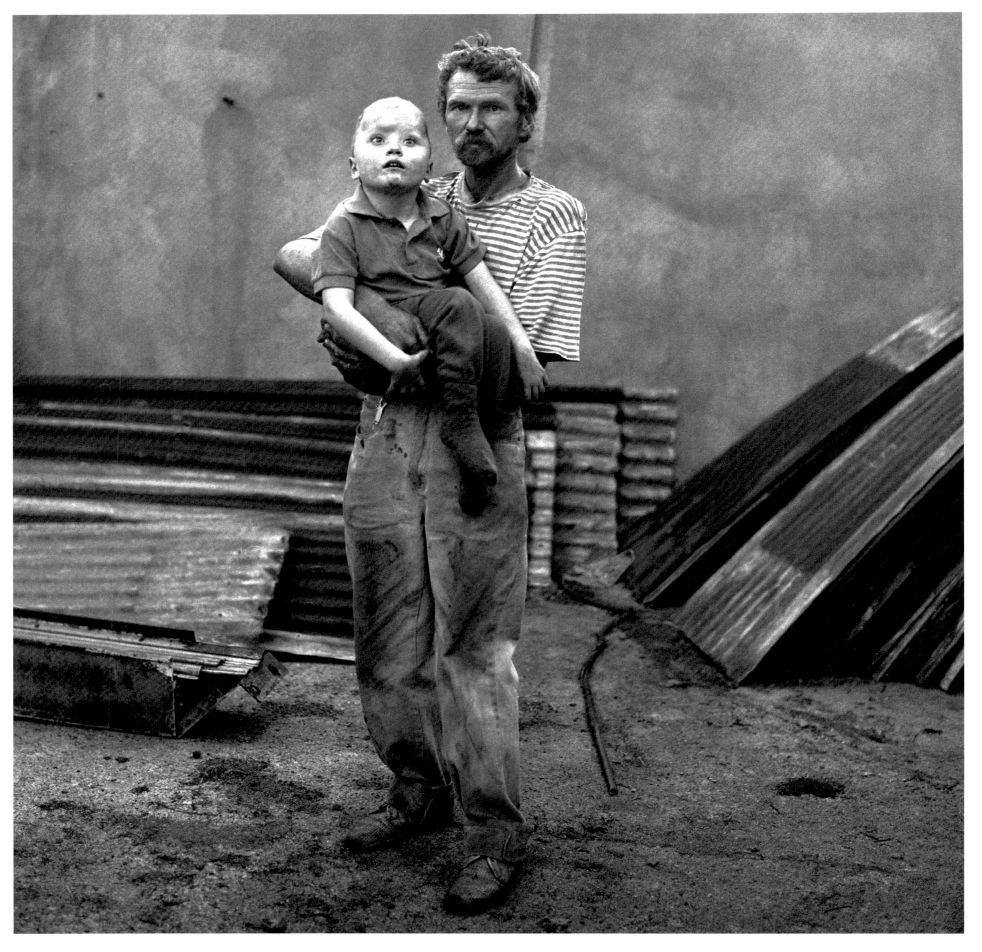

A Boy Named Gary, 1998

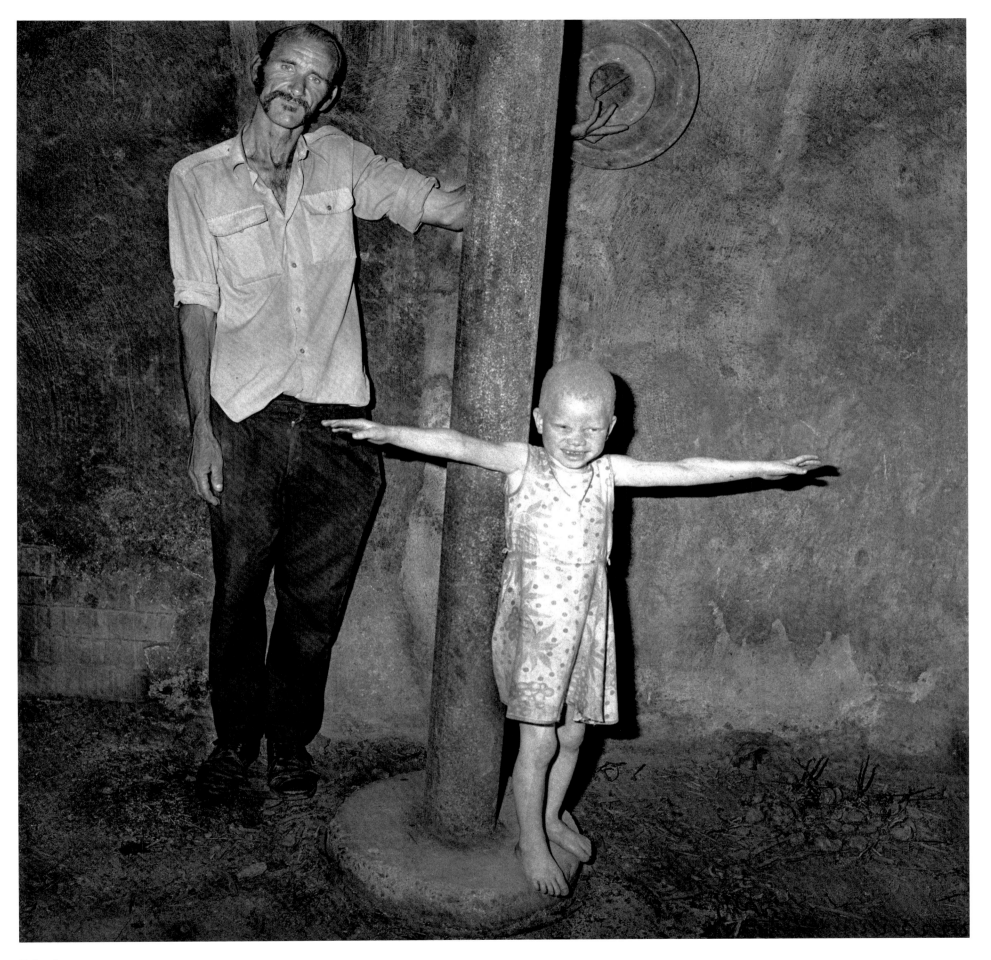

Balancing, 1997

A photograph is perceived as authentic
if the viewer believes that the photographer
has captured a moment that can never be
repeated. If the subconscious mind does not
believe in the veracity of the image, it will
have little or no impact on the viewer.

Eugene on the Phone, 2000

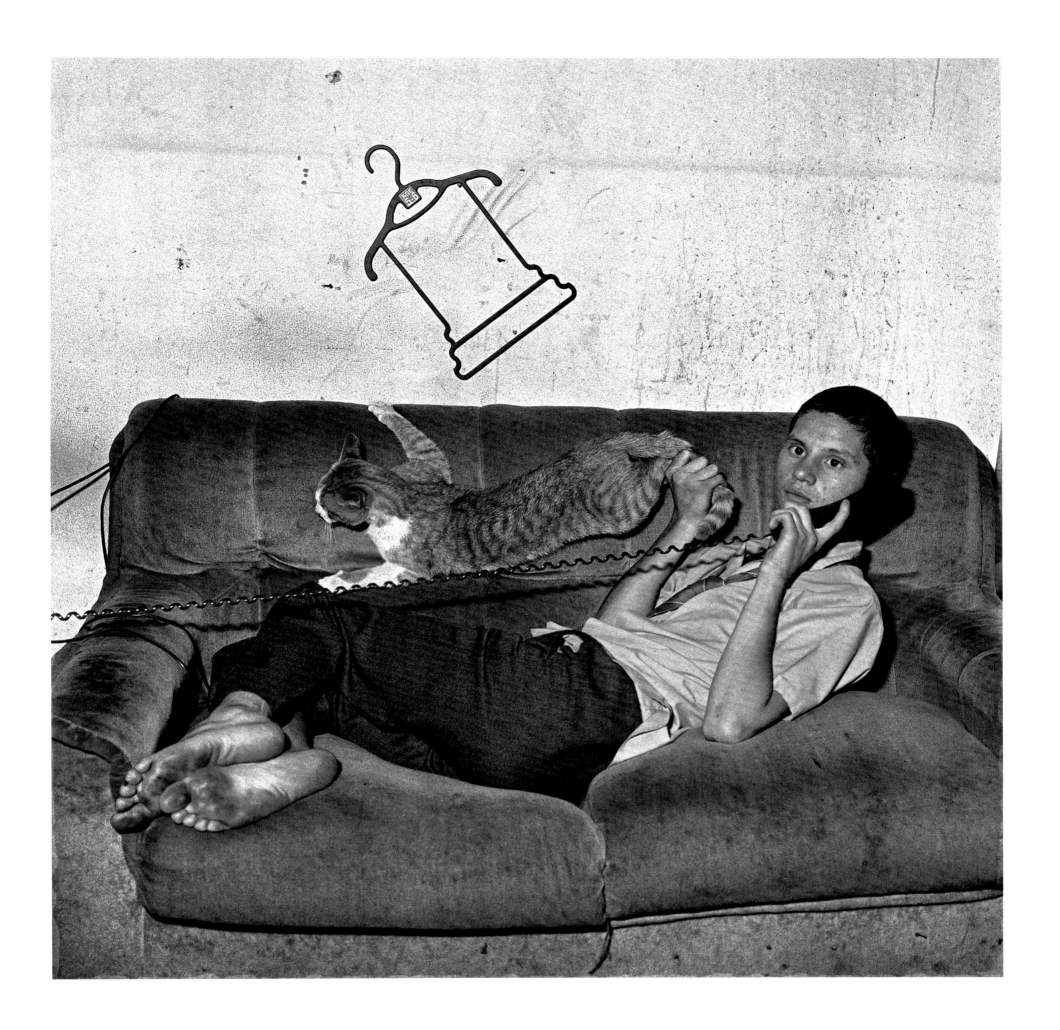

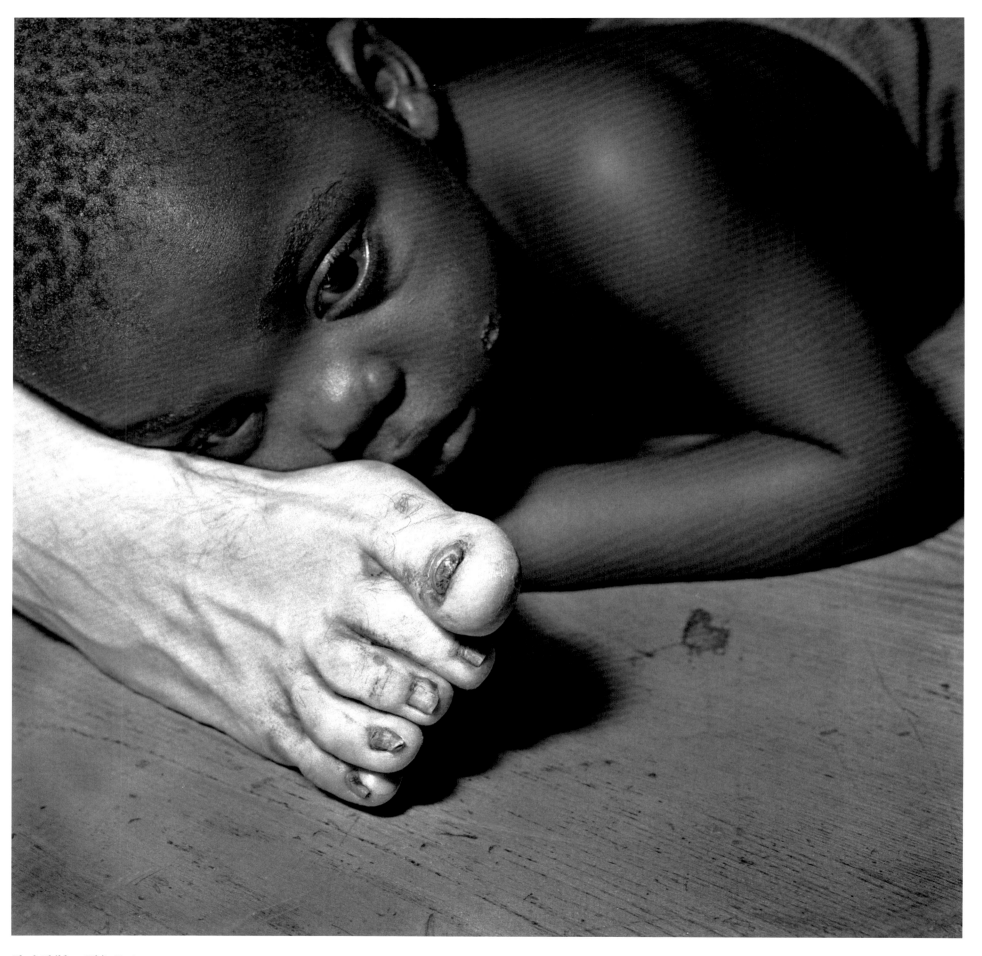

Black Child on White Foot, 1999

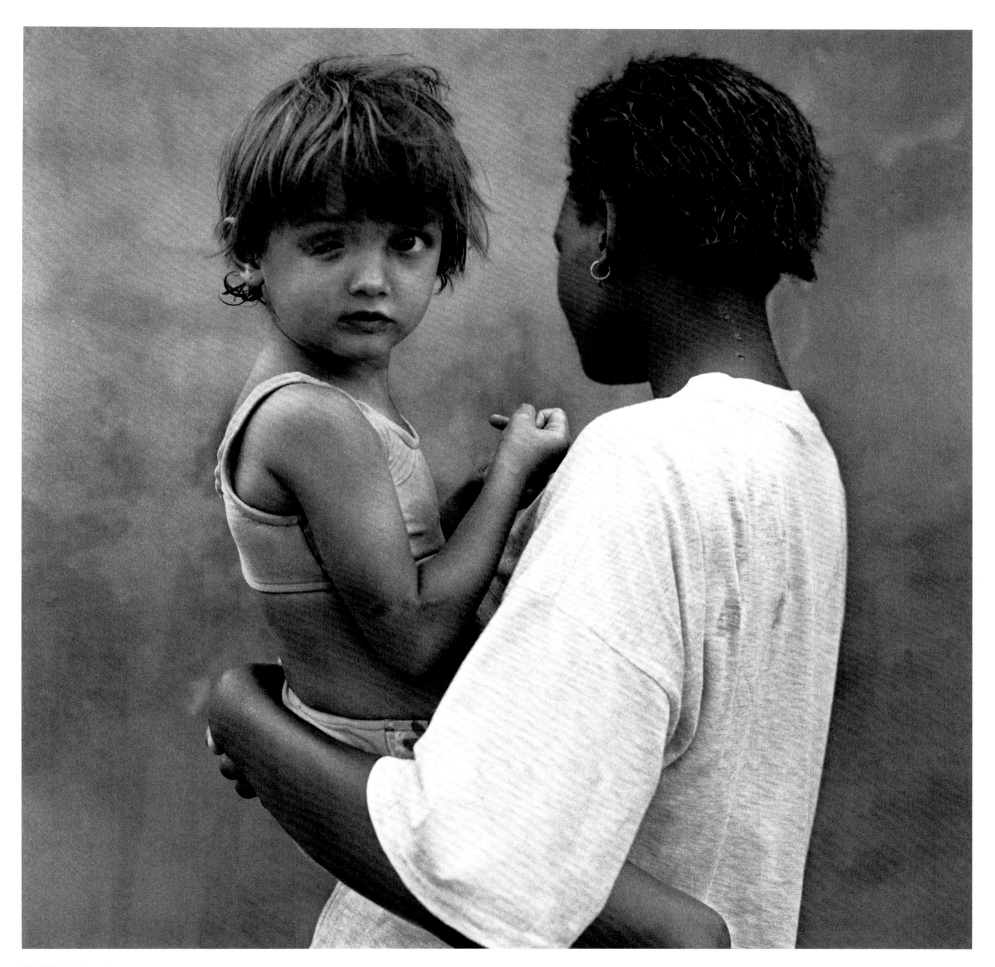

Half Blinded, 1996

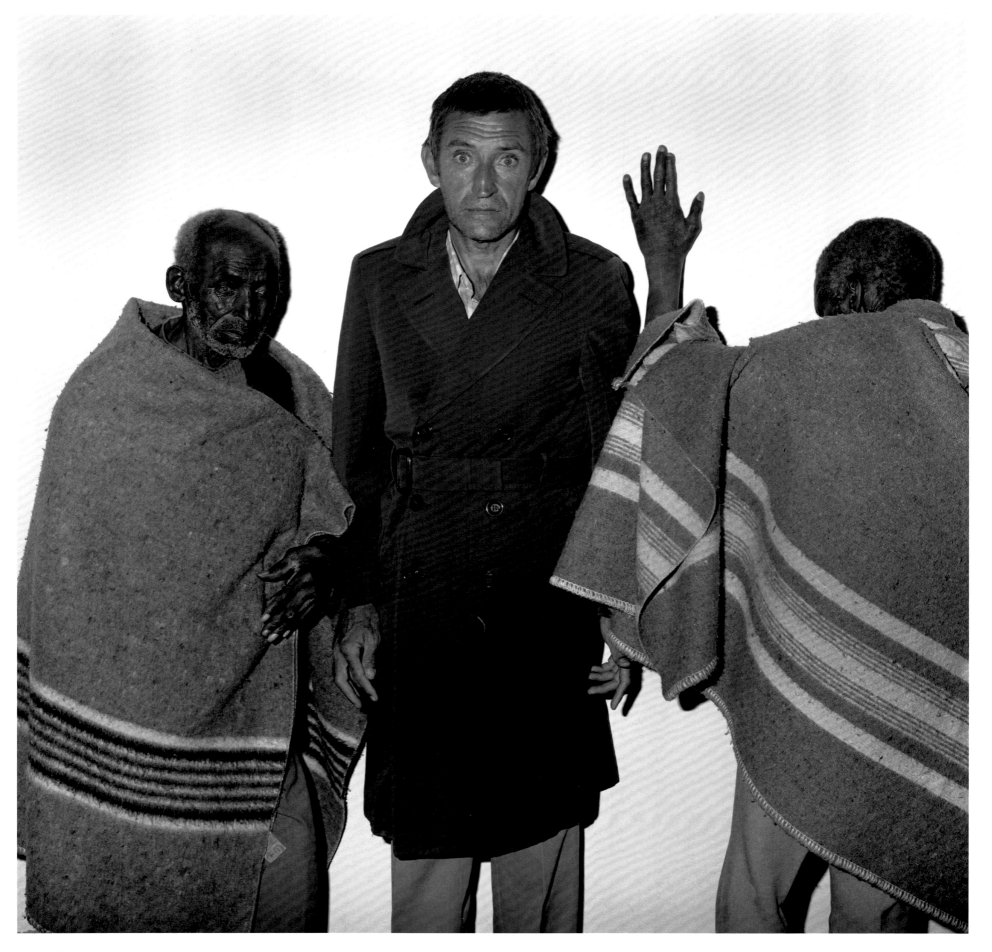

John and Room-mates, 1998

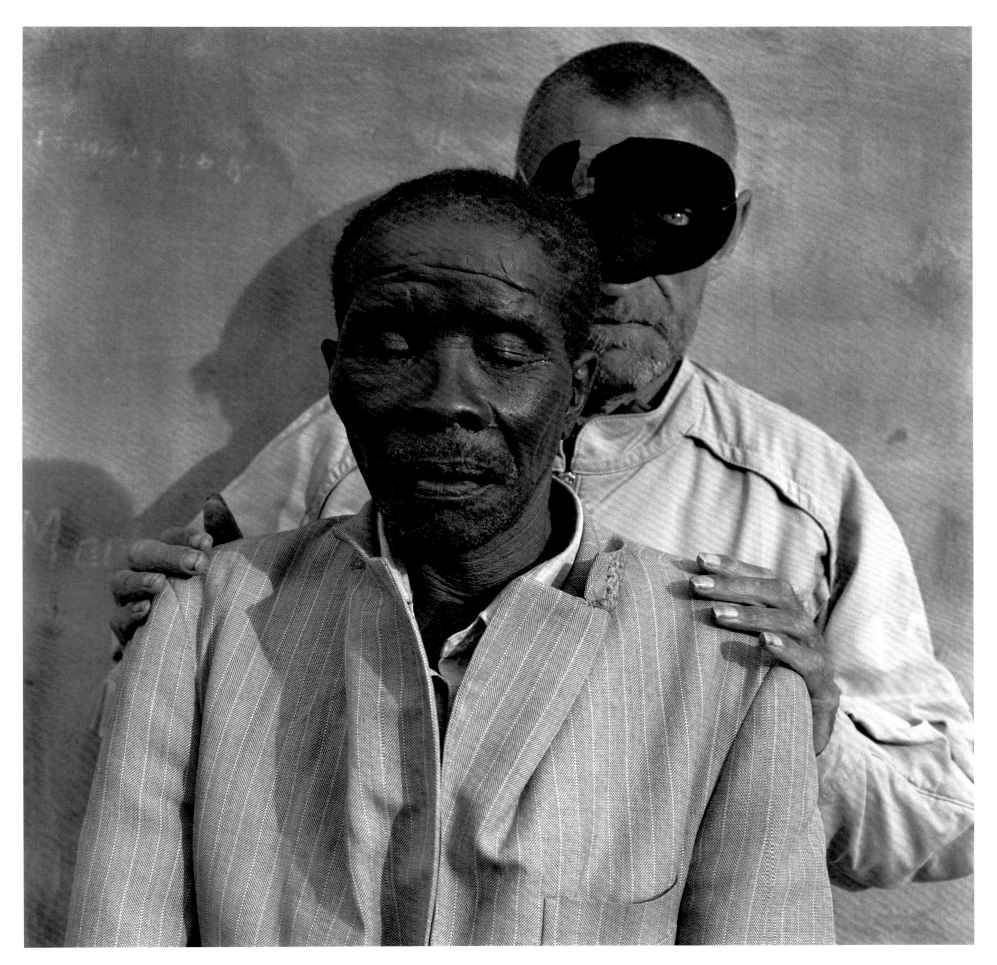

John behind a Man called Mashillo, 2000

Portrait of Sleeping Girl was the last
photograph I took for *Outland*. It was the
beginning of what I have referred to as
my 'intermediary stage', which would be
characterized by portraiture and drawing.
This period lasted approximately three years,
by which time the human face had almost
completely disappeared from my work.

Portrait of Sleeping Girl, 2000

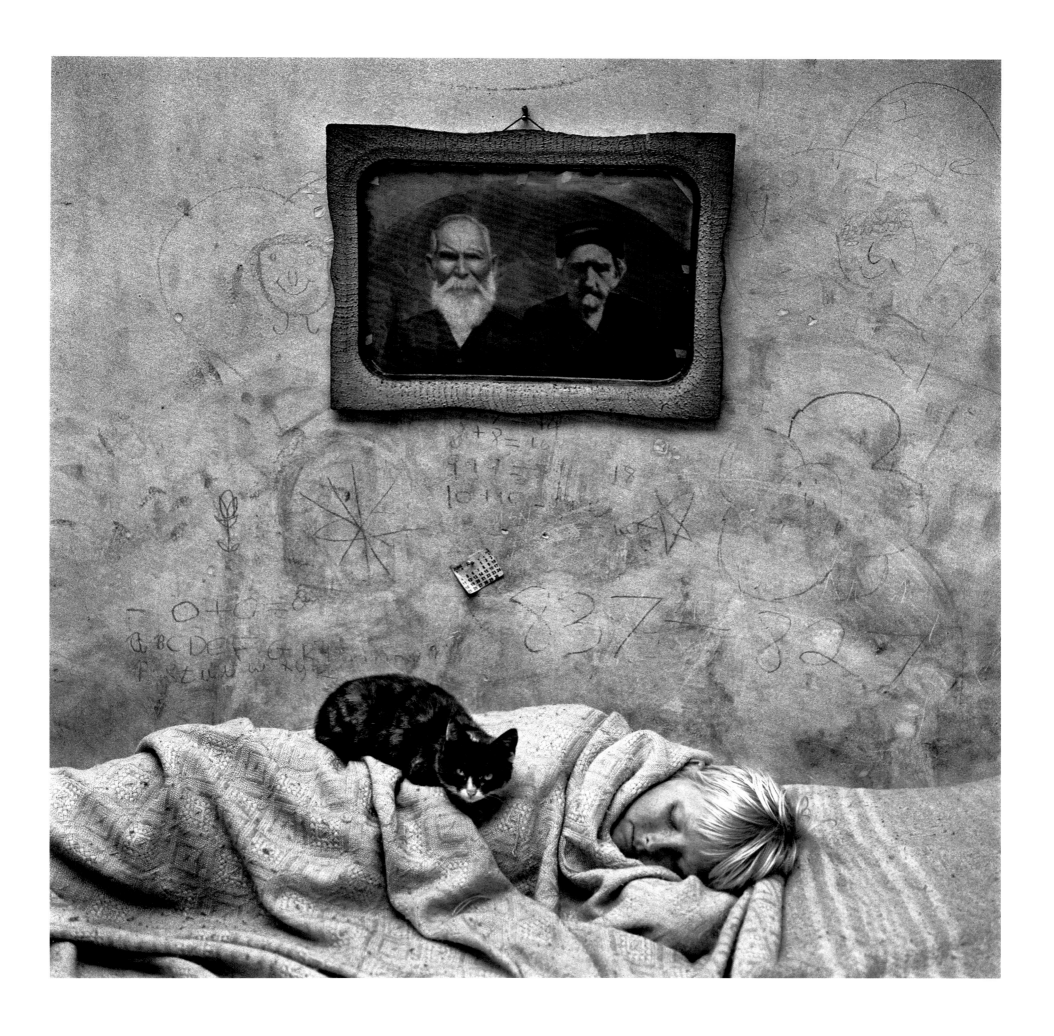

chapter 3 **refining and expanding**

shadow chamber

boarding house

asylum of the birds

The period from 2000 to 2013 was a time when my focus shifted dramatically from a gaze on the physical world to one on the mental, from the external to the internal. The locations I worked in, whether for *Shadow Chamber, Boarding House* or *Asylum of the Birds*, became the grounds for the transformation of my aesthetic, and the places where my vision could expand into previously unknown realms.

The *Shadow Chamber* project started in early 2001 and was completed in 2005. There were two distinct periods to the project; the first, which I refer to as the 'transitional', saw portraiture being blended with drawing. This period extended into 2003, and was the last time that I regularly included the faces of my subjects. Such photos as *Skew Mask* (2002; page 178), *Roar* (2002; page 180), *Room of the Ninja Turtle* (2003; page 188) and *Puppies in Fishtanks* (2000; page 193) were taken during this time.

Most of the photographs in *Shadow Chamber* were taken in a building on the outskirts of Johannesburg that was purportedly constructed at the turn of the twentieth century to house workers from the gold mines. I had learned about the place from a number of people who at one time or another had called it home. The building consisted of three floors, on each of which was a series of small rooms or chambers. There was no electricity in the building, the roof leaked, and it was infested with rodents, wild cats and insects. The basement was a place where few ventured to go; it was rumoured that a number of people had been locked up in there and left to die. Given the nature of the building – a place without electrical power, where human beings had revealed the darker side of their personalities – I named the place the Shadow Chamber.

The building's cell-like rooms were attached to long, dimly lit hallways. Some of the rooms had doors; others were permanently open. Inside, I would often come across figures lying on stained and torn mattresses, faces appearing out of holes in boxes, people screaming manically, foreboding wires stretching from one side of the room to the other.

Most of the paint on the building's walls had long since peeled off, leaving a textured, plastered backdrop that was ideal to photograph my subjects against. However, many of the inhabitants of the Shadow Chamber – like those of some of the other places I have worked in – preferred to decorate their rooms using a shiny, glossy paint, as it was cheaper and easier to clean.

One of the few photographs of this period that was not taken in the Shadow Chamber was the image *Twirling Wires* (2001; page 167). The subject of the photograph was sleeping in an old barn just outside the main building, and I took this well-known photograph a short time after meeting him. I left for an overseas trip that same week, and on my return to South Africa heard that he had locked himself in the building and been found dead sometime afterwards.

The simple, whitewashed backgrounds that had dominated the photographs of my previous series underwent a transformation during the *Shadow Chamber* project. Walls covered in scribbles, smudges, drawings and cut-outs, as well as broken frames, masks and wires of all kinds, began to be an essential part of the imagery. What had originally been background increasingly became the subject of the photographs; the visual elements on the walls gradually became an aesthetic in themselves.

Enclosed within the barren and dilapidated rooms of the Shadow Chamber, my aesthetic developed layer by layer, photograph by photograph. Wires started to take on sculptural qualities, graffiti became painting, and residues and marks became metaphors, adding a new level of complexity to the work. Through this interaction, I was able to expand my vision of the world inside and outside of me. In this impoverished, claustrophobic space, I found my inspiration.

Looking at my photographs from the beginning of 1997, taken during the *Outland* project, you can begin to see that nearly every image incorporates wires. In the houses in which I was working, you just had to turn your head and everywhere there was a wire. At first the wires were simply part of the photograph; later on, however, they started in a more abstract way to enhance the meaning of the pictures, becoming subjects in themselves through their interaction with the other subjects of the photo. Unlike in abstract painting, a wire is still a wire in photography, but it also has multiple meanings that extend beyond the merely functional. Thus, in the late 1990s and early 2000s, the wire became another form of drawing, linking one part of the image to the next. In a way, the wire was a precursor to the more elaborate drawings that came later.

In 2003 a radical shift occurred in my photography. The faces of my subjects, which had so dominated my work for decades, faded away. First, I had grown weary of questions that focused only on this aspect of my imagery, leaving the rest unnoticed or unattended. I had always seen my photographs as being organic, holistic, where every form resonated with every other; if one aspect of an image was removed, then the photograph would implode. Secondly, I no longer felt the need to probe the lives of my subjects through portraiture. I felt I had to 'move on'. For me, photography has always been a means to find the pieces of the puzzle that is life. More specifically, my goal in taking photographs has been to make sense of my identity. If the puzzle ever came together, I would retire.

At the same time as the faces started to disappear, there was a move towards capturing body parts. Bits of arms, legs, feet and hands pervade. The images are deliberately enigmatic; unravelling one layer leads only to the next. Many viewers found the photographs provocative or disturbing, with individual elements breaking through the mind's defences and nestling in the subconscious, possibly transforming consciousness in a non-verbal way.

I had my first big show in the United States in 2002, at Gagosian in New York. It was a great success, with articles in the *New York Times*, *Village Voice* and other media. Elton John, a keen collector of my photographs,

came to the opening and purchased a number of works. During these few days, I spent some of my spare time looking at books on the artist Cy Twombly, fascinated by the link between his use of texture, line and form and my own work.

At the same time, I became increasingly interested in art brut. The subjects I was working with were true outsiders, having spent time in mental asylums, in prison, or drifting from place to place. I was attracted to those socially estranged individuals who were not attempting to make fine art, but who were still able to produce provocative, psychologically intense work. In fact, in all the time I have worked with these so-called outsiders, I cannot remember one person ever telling me that they had been to a museum or art gallery. While each of them had a unique style, taken together, their drawings and paintings harmonized with my aesthetic. It is somewhat ironic that, when looking at my photographs, it is difficult to say which are my drawings and which are those of my subjects. In other words, my own drawings are visually inseparable from the people I have worked with.

The term 'art brut' (raw art) was coined by French artist Jean Dubuffet (1901–1985) to describe works 'created by people outside the professional art world … from their own depths and not from fashionable art'. In short, he believed that only art brut remained untarnished by prevailing cultural values, which, by assimilating new developments in art, took away whatever power they might have had. The result was to asphyxiate genuine expression. Art brut was Dubuffet's solution to this problem; only art brut was immune to the influences of culture, immune to being absorbed and assimilated, because the artists themselves were not willing or able to be assimilated.

I suppose my interest in art brut actually stems from what I experienced in the houses I was visiting. In many cases, instead of having paintings or posters on the walls, the children – and even the adults – would simply make drawings directly on to the walls. This I found extremely interesting and exciting. Many people, on walking into a house like that, would probably think that its occupants were slightly mad. But why, I often ask, does everyone have to have a green lawn? Why does everyone's lawn have to look the same? Many years ago, when I was a student in Colorado, I refused to cut my lawn. The neighbours called the police and I got a summons … It seems as though we've arrived at a point where there is a liberal attitude to letting people express themselves, but when they *do* express themselves in certain ways, it is labelled insanity. To return to the notion of the house, why is it that everyone wants white walls in their homes? What subconscious and social needs are white walls fulfilling?

The period from the end of the 1980s to about 2003 is a very interesting one because I was still doing portraits. But around 2000,

drawing began to enter the photographs with a vengeance. In 1973, following my mother's death, I had painted passionately for a period of six months. Then that side of me went dormant, and I thought I would never be involved with the medium again. Since 2003, however, some thirty years after I stopped painting, my work has been dominated by my passion for drawing.

The concept of using drawing in my photographs evolved initially as a result of photographing subjects against walls in homes saturated with their lines, marks and drawings – in other words, from street photography, from 'real life'. As time progressed, I began to interact with my subjects and sometimes asked them to make drawings on the wall. I then made photographs integrating what they produced with other aspects within the frame of the camera. The drawings may not have been on canvas, but they were still works of art of a kind – direct links to the people who made them. Eventually, I started to shoot more photographs of the drawings than of the people. You see a few of these in the *Outland* book. There is one of a boy's room called *Adolescent's Bedroom* (1998); this is the first still life I ever took.

My camera does not draw. My camera is basically an instrument that captures light from what is already there. I have to figure out how to take the lines – the drawings, scribbles, scratches and scrawls – and create something coherent from them. The drawings are usually in the background of my work, so the most challenging part of my job, in some respects, is integrating the form and content of the drawings with the other aspects of the photographs, such as the animals, objects and people.

I think my intention is to create imagery that challenges what might exist in the recesses of the mind, that brings up imagery people have lost, forgotten about, or are scared of. I see my images as 'revealers', like reflections in the water that are somehow connected to shadows of the self. The pictures I draw for the photographs I take are not made for the viewer. Rather, they are predominantly ways of connecting one part of myself to another.

Delving into the deepest parts of one's subconscious is like going down the mine, down the shaft. You get there, and now you are on level ten, whether in the mine or in the mind. Things are not going to manifest themselves down there, so I have to go from level ten back up again and make visible what I have found, bring them to the surface. That is the hard part.

During the *Shadow Chamber* period, there were certain subjects whom I would visit regularly. I developed long-lasting friendships with many of these individuals, friendships that I have maintained up to the present.

I often think of the film-maker Ingmar Bergman, who would make psychologically intense films year after year with the same cast.

I got to know Stan, for example, in the mid-1990s; at that time, he was sleeping in an abandoned railway building. He was born with a short, crippled arm and suffered from epileptic fits, which he claimed were the result of his mother taking forty birth-control pills every day. He walked with a limp and spent much of his spare time either catching rats or waiting in hospitals for medicine that would keep his epilepsy at bay. He often called me his second father, as my assistant Jenny Da Silva and I regularly brought him food; I was also able to get his father released from prison. I bought Stan a number of pets to keep him company, but, according to him, they were all stolen and flushed down the toilet by a woman who lived in his house. I asked him to make drawings for me; I would cut out pieces of grey cardboard and leave them with him. In some odd way, his drawings resembled himself.

In 2015, when *Outland* was republished with forty-five additional photographs, I decided to create an accompanying film, with Stan playing the lead role – a man who has spent the last twenty years of his life working as a rat catcher, bringing the animals home and then letting them go (see page 153). It was a very nostalgic project, as many of the actors in the film were people I had worked with intensively during the shooting of both the original *Outland* book and *Shadow Chamber*, such as Michael, Stephanis and David. It was probably the last time that we will all be together in the same place.

At around the time I met Stan, I also met Dirkie, a blind, gay man of Afrikaans background who ran a mission for the poor in his backyard. There was a concrete wall at the mission that I would find myself taking photographs of again and again; as the building filled up with people, however, it became increasingly hard to photograph. As I began saying at the time, as a young man the world was my stage; but as I get older, I go back to the same wall to try to drive the nail in deeper each time.

During the *Shadow Chamber* period, I took numerous photographs not only of Dirkie but also of his mother, his sisters and his sister's children, all of whom were born blind. I was drawn especially to Dirkie's deep-black eyes, which would dart from side to side. I often photographed Dirkie alone, or with various boyfriends against that same concrete wall I had used for so many of my other subjects. The relationships were transient, usually not lasting more than a few months. On one occasion, I discovered that one of Dirkie's boyfriends had hung himself from a wooden girder outside Dirkie's bedroom.

Michael lived a few blocks away from Dirkie; in 2000, I remember joking to my secretary that Michael should have been named *Time* magazine's Man of the Year. I had met Michael in 1992, during the *Platteland* project, in a place where people gave away clothes to those

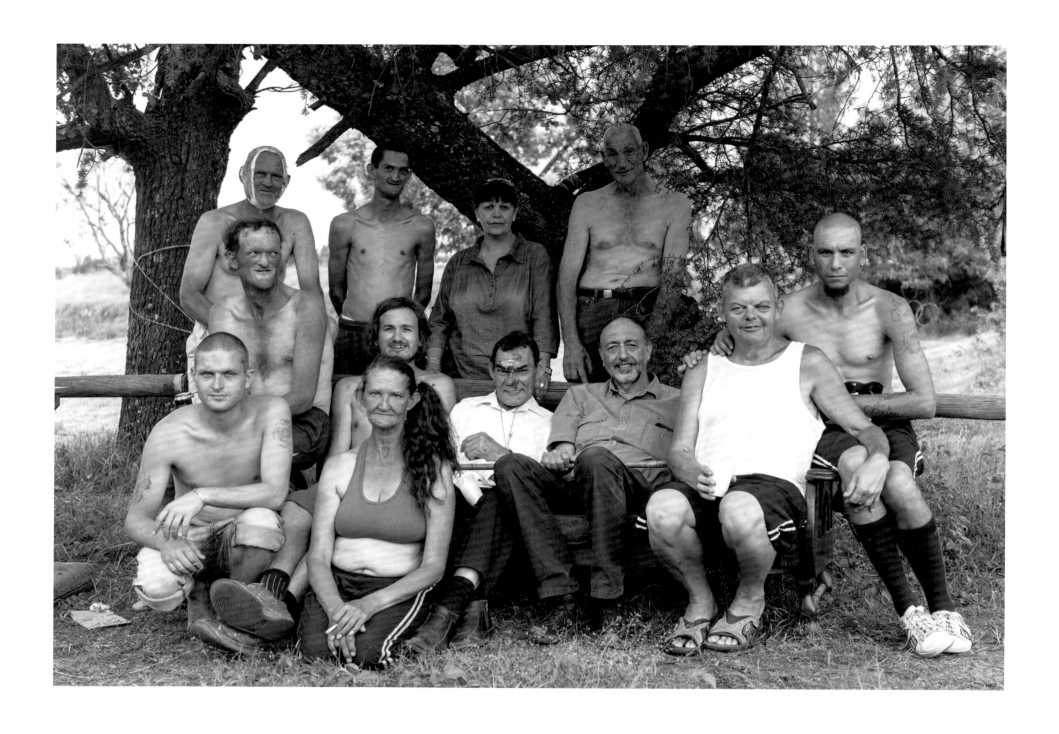

The cast of *Outland*, 2015
Back row: Hercules, David, Jenny, Michael;
centre row: Stephanus, Ben, Stan, Roger, Dirkie,
Kobus; front row: Little Dirkie, Susan

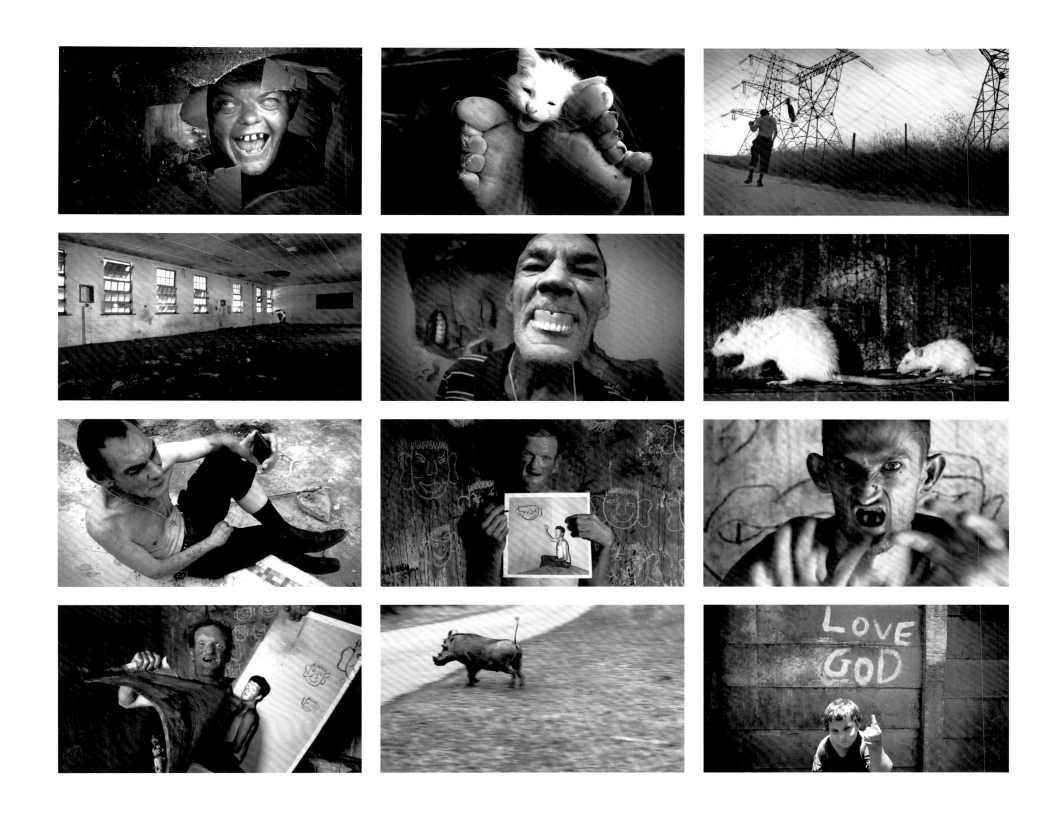

Selection of stills from *Outland*, 2015

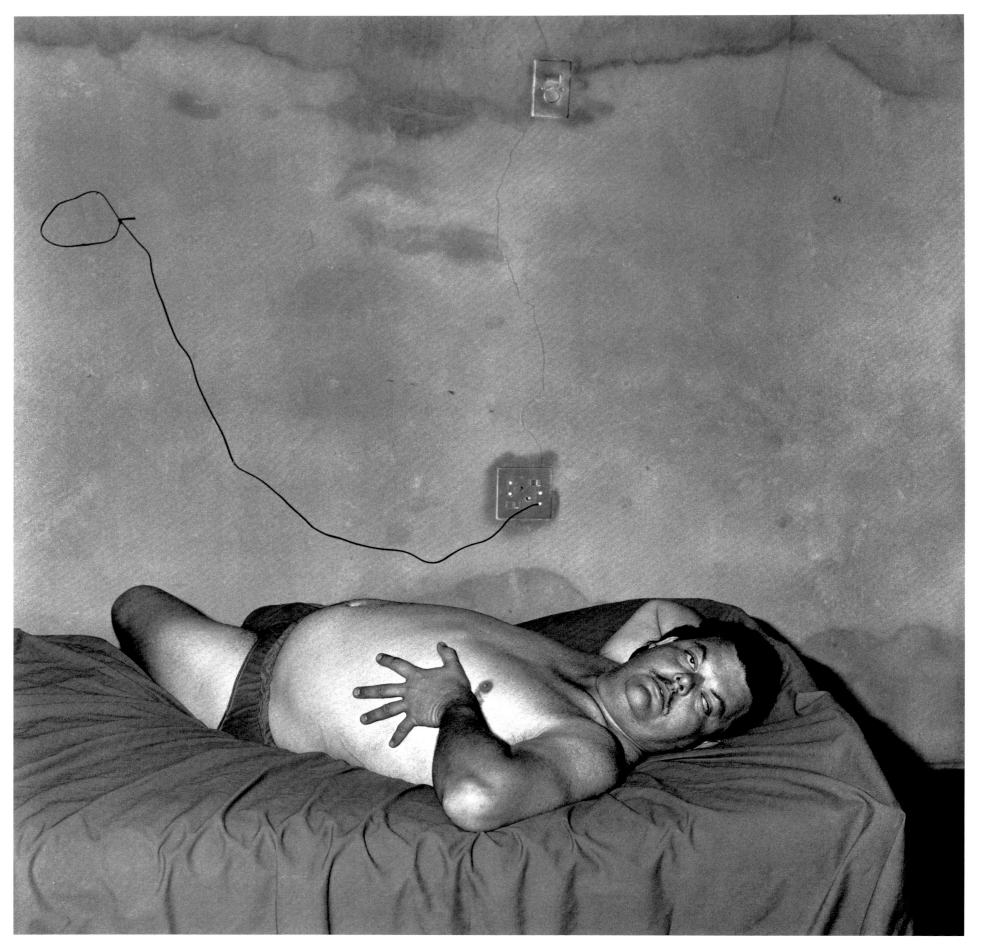

Dirkie, 2000

in need. I immediately empathized with him and drove him home. Very soon, I became friends with his family: his three brothers, Gerrie, Hans and Ole, and his sister, who spent her days knitting colourful string rugs. Their house was full of damp laundry – sometimes piled as high as the ceiling – full of cockroaches, and stank of cat urine. The backyard was littered with various items that had been collected over the years, providing a 'treasure chest' of objects for me to work with.

In 2005, towards the end of the *Shadow Chamber* period, my work started to incorporate aspects of both art brut and surrealism. One could begin to find in my photographs not only such raw elements as drawings and the various objects associated with my subjects and the spaces they habituated, but also an ordered aesthetic intended to bring about strong emotional responses in the subconscious. In fact, I remember defining my imagery as somewhere between art brut and surrealism. It might be more valid, however, to state that my work consists of elements of art brut and surrealism transformed through the Ballenesque ...

Also in 2005 the *New York Times Magazine* asked me to photograph the American actress Selma Blair for its annual fashion shoot. I informed the magazine that I wanted to work in an old building and use animals as props. Eventually, with the assistance of my cousin Ed Ballen, I found the perfect venue: an abandoned psychiatric centre on the outskirts of New York City. Feeling immediately at home there, I went on to create a body of work that won some of the most important awards in fashion photography, producing images that presented an alternative version of beauty, elegance and happiness (see page 156). In fact, I remember a senior editor from the *New York Times* saying that the paper had been hesitant about printing a number of the images because they were not advertiser-friendly ... With all the acclaim and attention I received from these photographs, I was never offered another job in fashion photography.

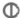

The so-called Boarding House became my studio from the time I finished shooting *Shadow Chamber* in 2004 to the completion of the project in 2008. I learned about the building from a number of people who had stayed there before moving on to the Shadow Chamber.

Almost half the world's total gold production occurs in and around Johannesburg. Gold dumps the size of small mountains form a symbolic backdrop. Dotted among these edifices stand abandoned machinery, structures that pulled the ore to the surface, and tin-roofed shacks where the jobless and marginalized live. Up to the mid-1990s, the Boarding House was an enormous warehouse used by the mining companies for

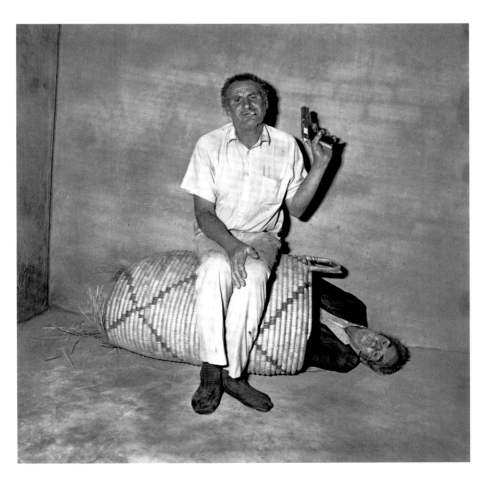

Captor and Captured, 1997

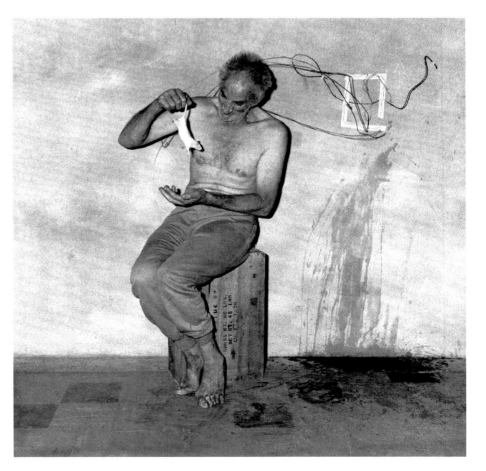

Michael with Rat, 2002

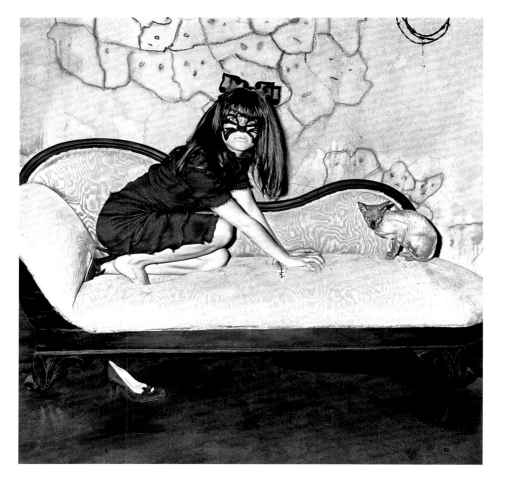

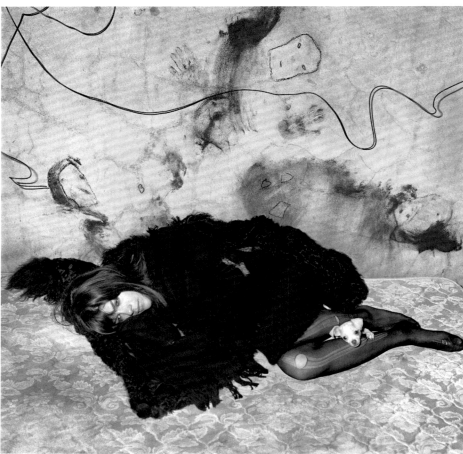

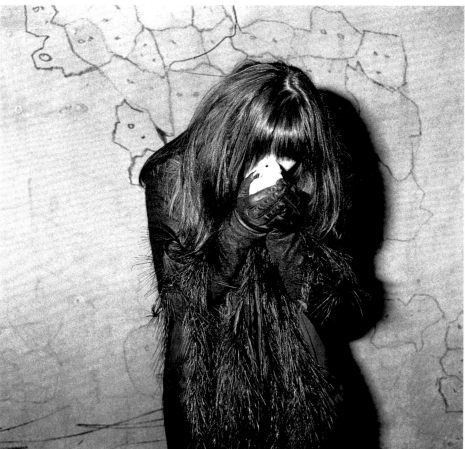

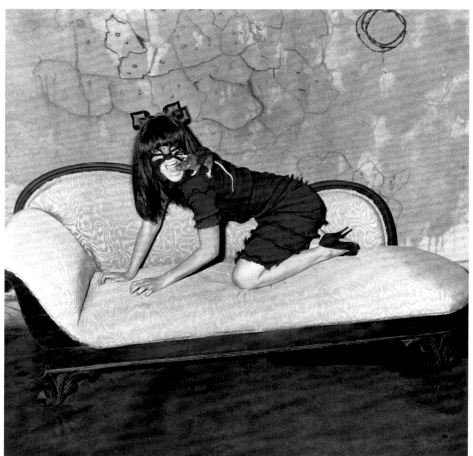

Selma Blair and Sphynx, 2005
Selma Blair and Whitey, 2005

Selma Blair and Scruffy, 2005
Selma Blair and Ratex, 2005

the storage of such equipment as ropes, explosives, jack hammers and drills. By 1998, having been abandoned by the mining companies, the building was taken over by squatters. Inside, the squatters transformed the warehouse into a series of rooms using whatever materials they could find – metal sheeting, plywood and, in cases where nothing else was available, cardboard.

In November 2006, midway through my work on *Boarding House*, Jenny decided to stop working for me after eleven years. I felt quite lost, wondering if I would ever be able to replace her, since she had been so instrumental to my success. A fellow photographer whom I had known for many years suggested I contact Marguerite Rossouw, who had studied photography under him. I interviewed her in January 2007, and remember mentioning that many people found my images dark and disturbing. Marguerite responded by saying that she was attracted to these darker aspects of the human condition. I decided immediately that I would hire her.

Initially, Marguerite's job was to find subjects and props, and to translate Afrikaans into English. Very soon, however, after showing her my contact sheets, I noticed that she had an excellent eye. She drew my attention to images that I had either ignored or not noticed, helping to select photographs that would otherwise have been forgotten. She also convinced me to purchase large-scale strobe lights, replacing the Metz flash that had been fixed to my Rollei for nearly twenty-five years. This change made perfect sense: my images were becoming formally more detailed, and greater luminosity was required to produce an ideal print.

After some months, Marguerite started to develop enough confidence to make suggestions during the creative process. When taking the photograph *Predators* (2007; page 223), for example, I distinctly remember Marguerite finding the twisted screw that gives the work its sense of coherence.

In 2009 I invested in a Flextight scanner and an Epson printer; at the same time, Marguerite started to learn and master Photoshop. Prior to this, all my scanning and digital printing had been sent to the company Silvertone, which I had started with Dennis Da Silva in 2001. Although I was still taking photographs exclusively with a film camera, I was now able to participate in every detail of the printing process, thanks largely to the skills of Marguerite and her son Gerald, who became my digital printer. Over a period of a few years, the quality of my prints increased dramatically, to the point where I no longer felt the need to exhibit silver gelatin prints.

The *Boarding House* images, taken between 2005 and 2008, were the last of my series of photographs printed using the silver gelatin process. Beginning with the *Asylum of the Birds* project, and despite the fact that I was still using a 6 x 6 cm film camera, I decided that the image quality

I could obtain through digital printing in most cases surpassed the quality I could achieve using traditional darkroom procedures.

In addition to making the switch to digital printing, I began to use a tripod. The reasons for this change to my practice were twofold. First, the sets were becoming more complex and required more elaborate lighting systems. Secondly, my neck was becoming increasingly inflamed as a result of bearing the weight of my camera. In addition, the square format is difficult to work with. For one thing, the image you see in the viewfinder is flipped over, such that if you move to the left, the image you see moves to the right; with a 35 mm camera, by contrast, the image is the right way round. It is also difficult to get the right proportions, so that the picture is not distorted or out of line. This is especially true if the camera is hanging round your neck and there is a heavy flash attached to it. That I have been able to create thousands and thousands of successful pictures this way never fails to surprise me. Nevertheless, over the past few years, my success ratio of good shots to bad ones has been much greater.

The pictures in *Boarding House* (2009), and the more recent works in *Asylum of the Birds* (2014), continued the trend in my work that had started in 2003: they rarely feature the face of a live human subject. When I look back, I ask myself, how and why did this come about? As I have stated on many occasions, small things make big things. When someone looks at a photograph, the first thing they will look at is a face. In photography, the face is an all-encompassing factor in the process of trying to understand the general meaning of a work. Thus, if there is no face in the image, the other elements in the photograph have a better chance of being noticed. As long as my images contained a face, this was not possible. Basically, I wanted to move on. That is my job – to keep finding things that expand my consciousness of Roger Ballen. There is no point in taking pictures of the same old thing. For what? Life passes by; time is short.

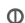

I first met Yolandi Visser, vocalist in the South African rap group Die Antwoord, in 2006, when she travelled to Johannesburg from Cape Town to discuss with me how we might collaborate on a video. She was very keen to learn more about my artwork, and was very committed to expressing herself through music and video. In her quiet way, I had the impression that she was consumed with every detail of my images, and remember telling a friend of mine that, at the time, she knew my images better than anyone.

Yolandi and I met each other subsequently, but were unable actively to work together, mainly due to the fact that she was living in Cape Town and I in Johannesburg. Nevertheless, we met on many occasions

in the latter city, and I remember taking her to one of my lectures at the Johannesburg Camera Club, around the time that *Shadow Chamber* first appeared, as well as an exhibition of my work at the Johannesburg Art Gallery. It was during this period that Yolandi teamed up with Ninja to form Die Antwoord. In the introduction to the book *Roger Ballen/Die Antwoord: I Fink u Freeky* (2013), Ninja and Yolandi wrote:

> When we saw Roger Ballen's photographs for the first time it was like being punched in the face. 'What the fuck?' 'Who are these people?' 'Where do they live?' and 'Jesus! Who the hell took these pictures?' When we found out that these pictures were taken by a photographer called Roger Ballen in South Africa we couldn't believe it! We had never seen photographs that made us feel such violent excitement, and the fact that these images were 'Made in South Africa' was just the best thing in the world … So fascinating, so disturbing, so unfuckingbelievably fresh! These were no ordinary photographs. They were highly complex surreal artworks in the exact same league as Salvador Dalí, Hieronymus Bosch and Lucian Freud …

> Suddenly all the music and imagery we had been working on up until this point seemed fuckin' wack in comparison to Roger Ballen's freak mode zone. We also wanted to make heavyweight 'Punch You In the Face'-style art like this. So we threw all the music we had been working on for so long away, and started from scratch … Instead of trying to work out how to fit into society, we decided to make our own breed of 'Fuck You'-style pop music. We called this new dark pop group Die Antwoord …

> On an artistic level Ninja and Yolandi are kinda like Roger Ballen's little punk protégés, and it would be accurate to say that Roger Ballen accidentally spawned Die Antwoord.

I took my first photograph of Ninja and Yolandi in 2008, in the garage of my office, and titled it *Die Antwoord* (see opposite). Ironically, this image, of all the images I took of the group, remains my favourite. In 2009, after releasing a number of videos into cyberspace, Die Antwoord the band went viral. All of a sudden, I received an avalanche of communication asking about my relationship with a group that was actively using my textures, iconography and visual syntax. At first I was baffled – I had never even watched a video on YouTube – but as the Die Antwoord fan base grew exponentially, it became clear to me that there was a large number of young people who were identifying with both me and the band.

On 31 December 2011, I photographed Die Antwoord at a New Year's party for the *New York Times*. Ninja had written the word 'Fuk' on the background to some of the shots, as well as putting his hand in the head

of a nude doll. The paper would not consider any of the images in which the word 'Fuk' appeared, but eventually agreed to the photograph with Ninja's hand in the doll's head (see below).

A few days into January 2012, as I was helping to shoot *The Asylum* (2013) – a short film directed by Saskia Vredeveld – Ninja and Yolandi called me up and pleaded with 'Mr Ballen' to co-direct a video for their latest song *I Fink u Freeky*. After several meetings with them, I agreed to participate using a cameraman I had worked with before on a number of other films.

The video was structured around sets based on my photographs. Ninja, Yolandi and I went through my images and agreed that the various scenes should take place in a Roger Ballen-style kitchen, bathroom, living room and shack. Following this decision, I set about making a series of installations in these constructed spaces that reflected my aesthetic. Die Antwoord and the rest of the cast then performed to Ninja's and my direction as they sang sections of the song.

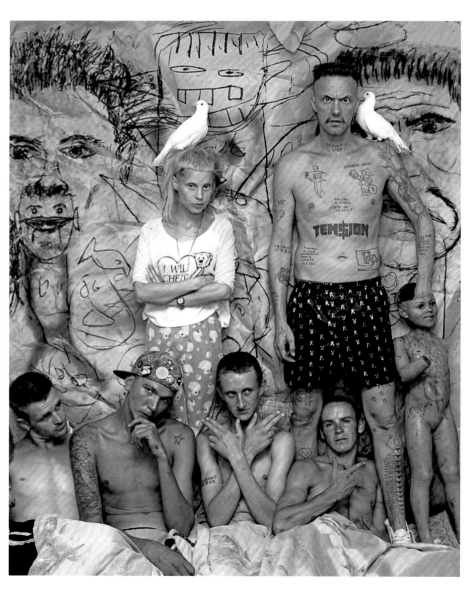

Die Antwoord, New York Times, 2011

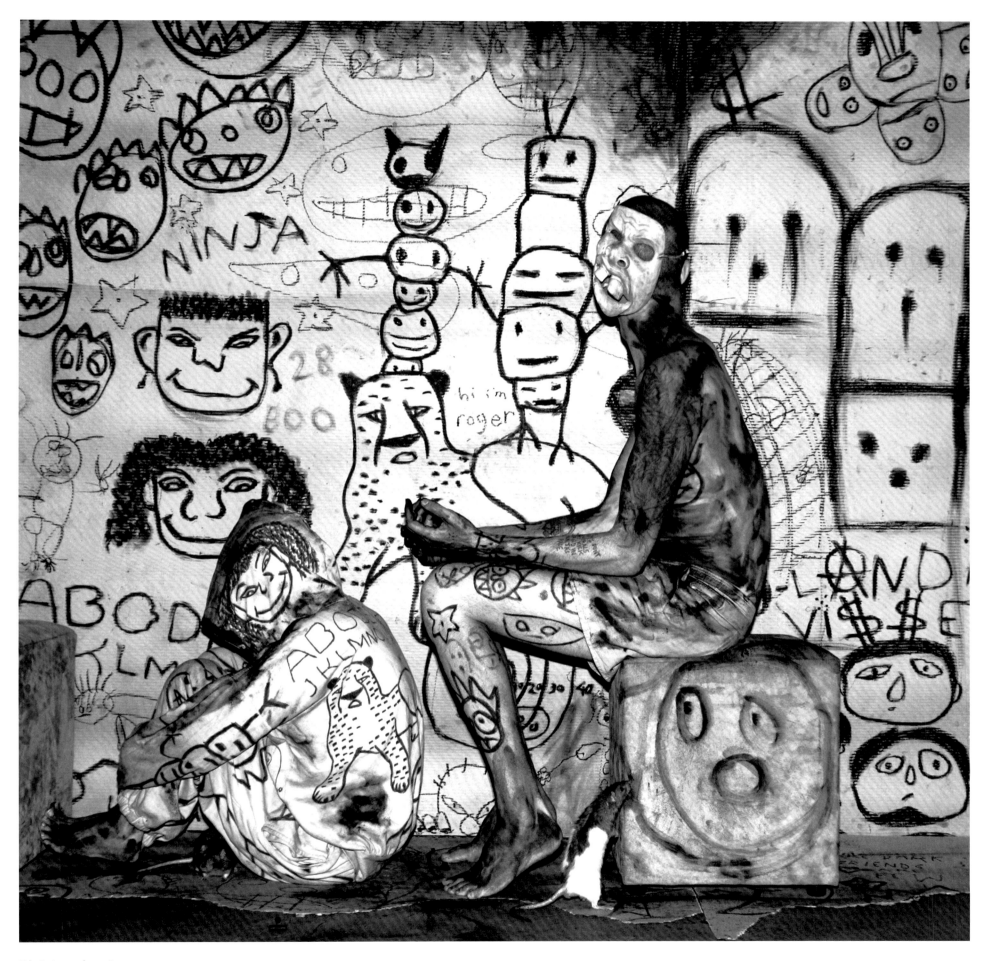

Die Antwoord, 2008

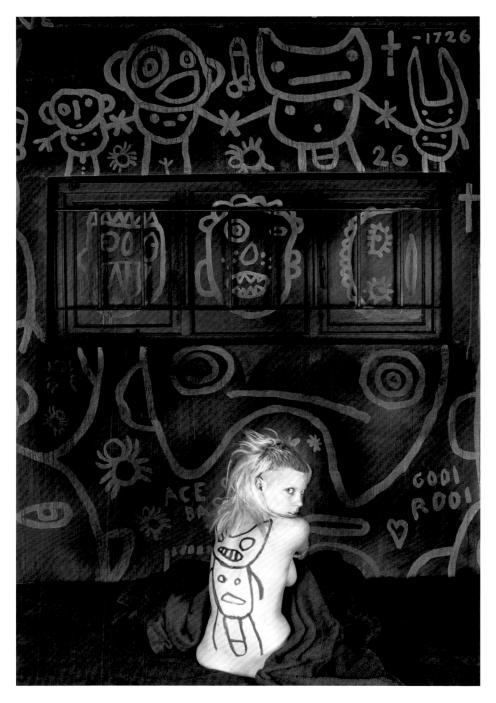

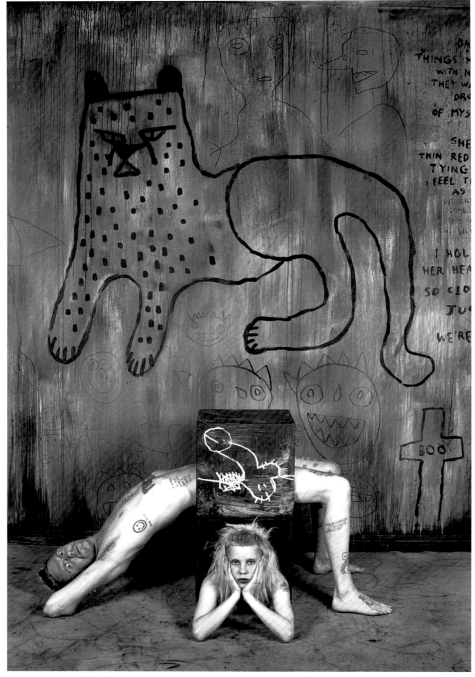

Gooi Rooi, 2012

Pielie, 2012

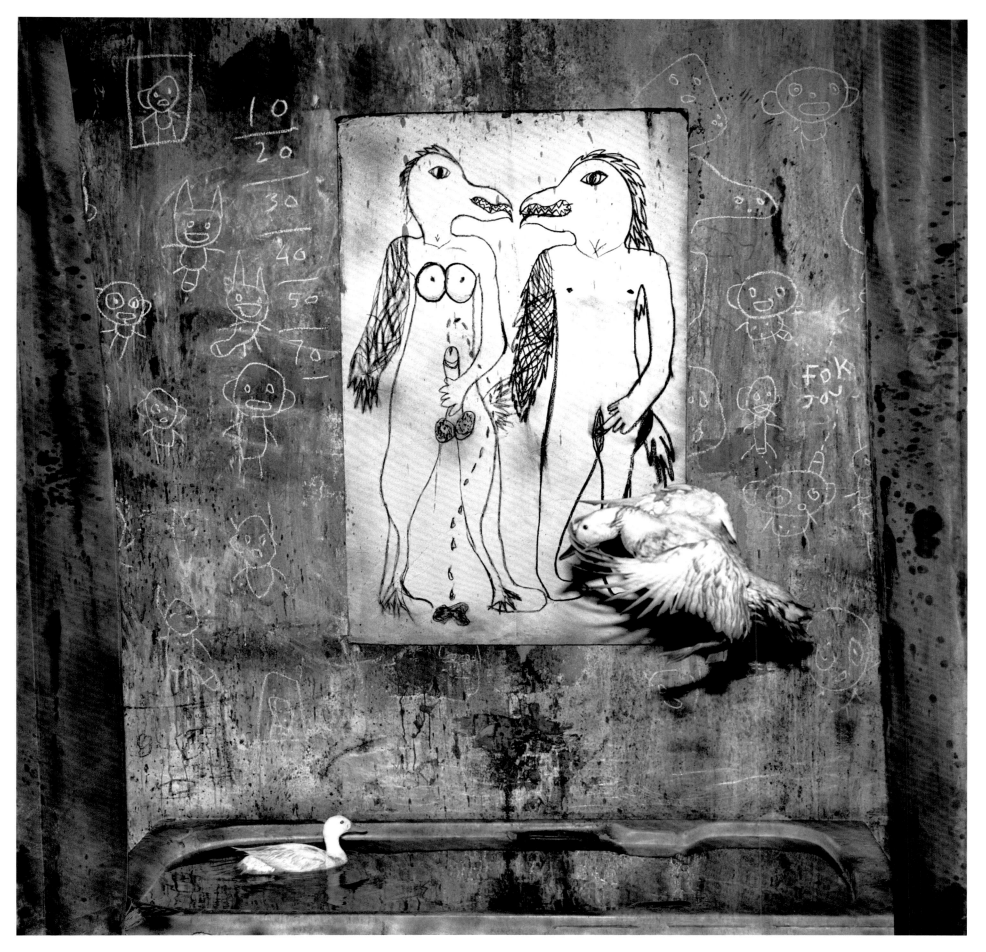

Rendezvous, 2012

Within a few days of its release, the video had received more than a million hits on YouTube. It was difficult for me to comprehend the enormity of the audience that was experiencing my aesthetic. Within months, the video was being referred to as one of the most unique music videos of the twenty-first century. I quickly realized the potential of the medium, not only as an art form, but also as a means of introducing my vision to those people who had never seen my imagery. Because a video has both a documentary and an artistic purpose, I could expand what I was trying to achieve. I wanted to give people an idea of the way I worked, and to document the landscapes and the city in which I had practised for so many years. Still photography takes you to one place, film to another; they complement each other very well. I therefore decided that, whenever possible, I would produce a video to accompany my images. In 2014 I worked with Ben Crossman, who I had met during the production of *I Fink u Freeky*, on the *Asylum of the Birds* video (see opposite). The following year, Ben would direct the *Outland* video.

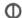

My first bird photographs emerged during the *Outland* period. In particular, I remember taking the image *Child in Bird Coop* (1998), in which a boy is holding a bird close to his chest. This was followed by other important bird photographs taken during my work for *Shadow Chamber*, namely *Harnessed Dove* (2000), *Birdwoman* (2003), *Judgement Day* (2003), *Juxtaposed* (2004) and *One Arm Goose* (2004; page 197). Most of my projects have started in this fashion, whereby I capture something unexpected, unplanned, and then become fascinated with the photograph. In this case, *Tethered Dove* sparked a lengthy period of interest in the metaphorical aspects of birds. From this time on, birds for me were no longer confined to the heavens, occupying instead a place full of chaos, ambiguity, violence and death.

For the *Asylum of the Birds* project, I photographed birds in a space characterized by discarded objects, other animals, and smudged and ghost-like drawings that could have originated in a cave or been part of a funeral ceremony. The contrast between the purity of the birds and the space in which I photographed them, known to me as 'the Asylum', evolved into the primary metaphor of the project. Unlike my earlier images, human identities have been reduced to body parts; there is hardly a face to be seen. Meaning and metaphor in these images come into being as a result of the interaction of the birds occupying this haunting, complex space.

The location for the images in *Asylum of the Birds*, including the video by Ben Crossman, was in fact a rambling house made of tin sheets and other used materials. It was located on the outskirts of Johannesburg, nestled between two large gold dumps. The inner and outer walls of the building were covered with scribbled drawings, stains, dangling wires and a series of bizarre objects. Unsettling and profound, the house was a place in which the core human condition was revealed – a place of both refuge and insanity.

The owner of the house was obsessed with animals, allowing them to wander in and out. He had a particular fondness for birds, and would let them fly around uncontrolled, leaving a messy trail behind them. The most common birds in the house were doves, pigeons, ducks, chickens and ibis.

Birds are difficult to photograph: they move incessantly, get nervous at the click of a camera, fly away through open windows. One cannot begin to understrand what goes through their minds, give them instructions, or expect them to be interested in being photographed. Where did this obsession with birds come from? Perhaps it was chirping that I heard in 1950 as I lay in my mother's womb. As a child, I was baffled by the fact that birds could fly while I was stuck on the ground. I thought of them exclusively as creatures of the heavens.

My personal belief is that the relationship between animals and humans is essentially adversarial and exploitative. Most societies try to deny this fact, but it is clear to me that the destruction of the natural world continues unabated. In the years I spent photographing *Asylum of the Birds*, I became more and more convinced that human nature is the ultimate culprit, responsible for the worst of all holocausts. The links that bind us to the planet are tangled and broken. What terrible things do the birds see as they look down from the sky? It is becoming difficult for them to find nests to return to.

I have always been intrigued by the fact that most viewers of my *Asylum* images never ask about the state of mind of the birds that occupied the Asylum space. Their questions always centre on the plight of the people who were living in that strange, enigmatic location. What did the people think, what did they do, how did they survive? It almost seems as if the viewers are blind, that they have no empathy towards the birds or animals in these photographs. This oblivious attitude to other species is indicative of the general lack of concern for non-human organisms that live on the planet. My question would always be, what do the birds think? They dominate these photographs. The black eyeball of the bird never once revealed the mind behind the eye.

Thus the endless rooms that I photograph full of birds, representing the schizophrenic relationship between civilization and nature, where opposites attract and break apart in a world built not on logic but on irrationality. Delirium, mirage, dreams and nightmares coexist and cannot be categorized as light or dark. The birds and other animals that live alone or alongside human beings inside these so-called Ballenesque spaces come to be symbols of more instinctual, archaic states within

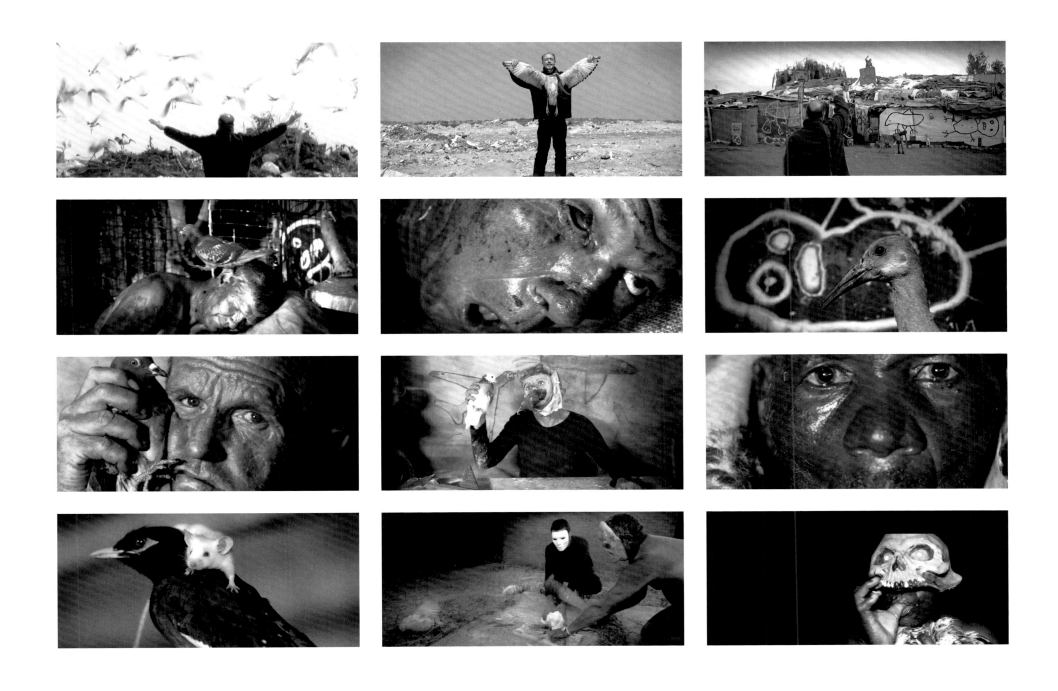

Selection of stills from *Asylum of the Birds*, 2014

Girl in White Dress, 2002

the human psyche. In other words, the animal comes to exist as a psychological state and mode of consciousness somewhere inside the human subjects themselves.

Planks pulled from dismembered buildings and houses, rusted sheet metal from township hovels, toys and paintings from flea markets, beds and sofas with rusted springs found on the side of the road – all these and more began to dominate my images, first in *Boarding House*, then with increasing density in *Asylum of the Birds*. Detritus and debris become metamorphosed, find a new lease of life, and become one of the hallmarks of the Ballenesque aesthetic. Objects from the environments in which I work are used in an unintended way, beyond any utilitarian function, to create a transformed reality.

As the images in these works are a product of my unconscious mind, time should not figure. Nor should they be seen as a product of South Africa. Robert Young, in his introduction to *Lines, Marks and Drawings: Through the Lens of Roger Ballen* (2013), makes the following point:

> *Ballen's photographs speak to us beyond the place of their production, signaling something deeper and more far reaching than their local milieu. The dislocated spaces in which they situate us hint at a condition far more disturbing and global, namely, a breakdown of the relationship between human beings and their environment. Here animals do not live in natural surroundings, but rather in the strange rats' alleys of the windowless boarding houses. In other ways though, humans live here in a closer alliance with nature: what might look to us like dirt, for them is just the earth. In negative and positive ways, connections with ecology have been inverted, while human and animal alike cower under the penumbra of chaotic forces that seem beyond their control … The place of the human is as marginal as that of the mice and rats that scurry across the floor.*

As the *Shadow Chamber* period evolved into that of *Asylum of the Birds*, it became increasingly clear to me that my images were fundamentally psychological in nature, since they were products of my inner psyche. There is no way accurately to describe this place, other than to say that it exists in one form or another in most people's minds. It is a hard place to get to. It took me many years not only to reach it, but also to define it visually.

By 2005, the year in which *Shadow Chamber* was published, the style and content of the lectures I was giving had started to change from factual and documentary to theatrical. I have never prepared for any of my talks, and my monologues began to interweave fact, fiction and dream sequences. Those attending my lectures would often comment on my deep, penetrating voice, asking me whether I had ever considered acting. As my performance became more theatre-like, so too did my photographs.

In the upper left-hand corner of the photograph *Girl in White Dress* (2002; opposite), there is a drawing of a smiling face; under the drawing is the word 'Me'. During my lectures, after showing this photograph on a viewing screen, I would ask the audience, 'How would you express your core being?' Very rarely would I receive an answer.

Another question that obsessed me during the years from *Shadow Chamber* to *Asylum of the Birds* was whether chaos or order dominates the human condition. It became clear to me, and is now permanently fixed in my mind, that chaos pervades. No matter how hard we try to order our lives, no matter how much we depend on science to provide certainty, unpredictability and chance play the dominant roles in life. Having reached such a conclusion, I thrived in places characterized by chaos. Out of the disorder in such places, my visual aesthetic evolved. I was able to transform visual chaos into visual coherency.

By the time *Asylum of the Birds* was published in 2014, my profile had completely changed. I was no longer seen as a documenter of strange, marginalized South African white people. The questions that were being asked of me included, 'Who did the drawing?', 'What was it like to be in these places?', 'Will you be directing another music video?' Rather than having to address the question, 'Why do you photograph such people?' I started to hear, 'It's a great honour to meet you', and to read such descriptions of myself as 'one of the most original image-makers of the twenty-first century'. Subsequently, I began to realize that my aesthetic was different from that of others working in art and photography, and that more and more people were aware of my imagery. It became clear to me that, compared to any other photography I knew of, the images I was creating were in a different zone. I felt confident that my practice had reached a place from which I was ready to go deeper in my search for the person that I know as Roger Ballen.

shadow chamber, 2005

One of the central questions that occupied me during the *Shadow Chamber* period was, 'Is chaos or order prevalent?' After spending nearly five years on this project amid chaos, xenophobia and absurdity, it was clear to me that chaos dominates the human condition.

Twirling Wires, 2001

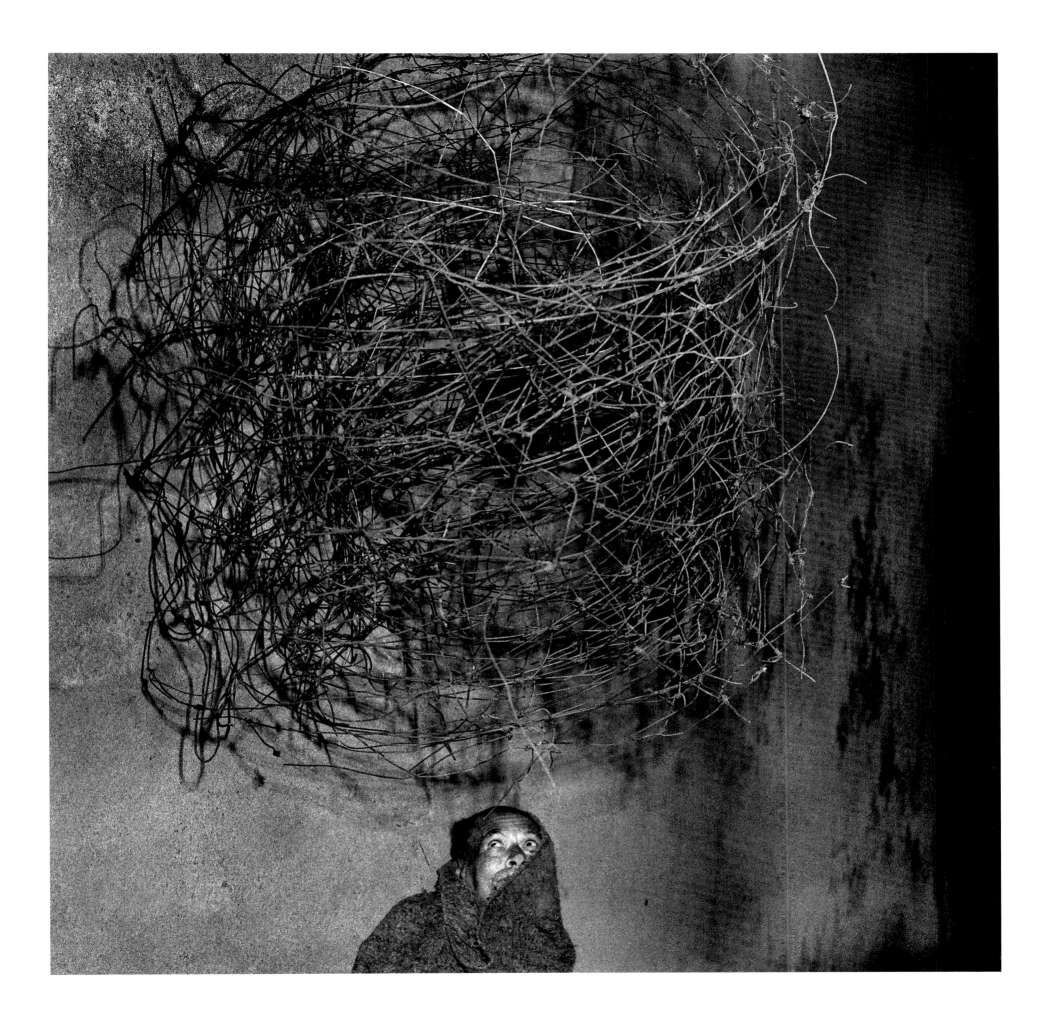

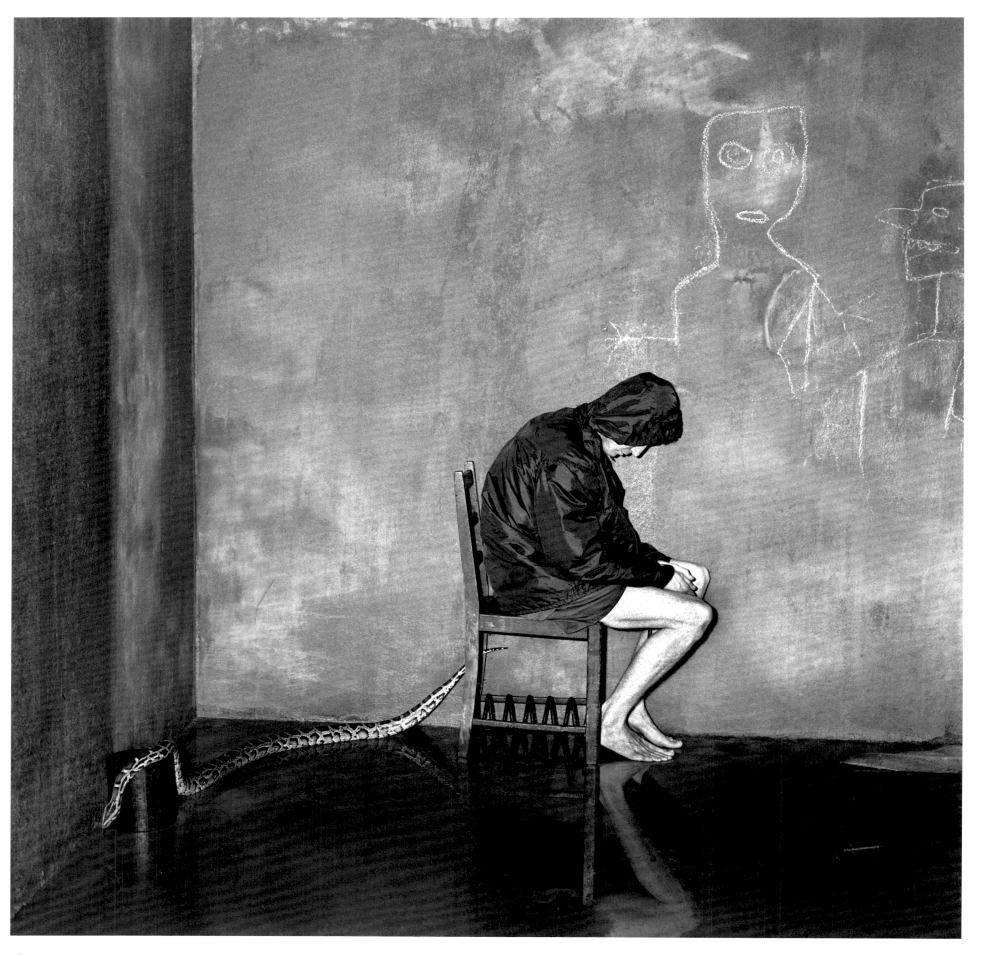

Bitten, 2004

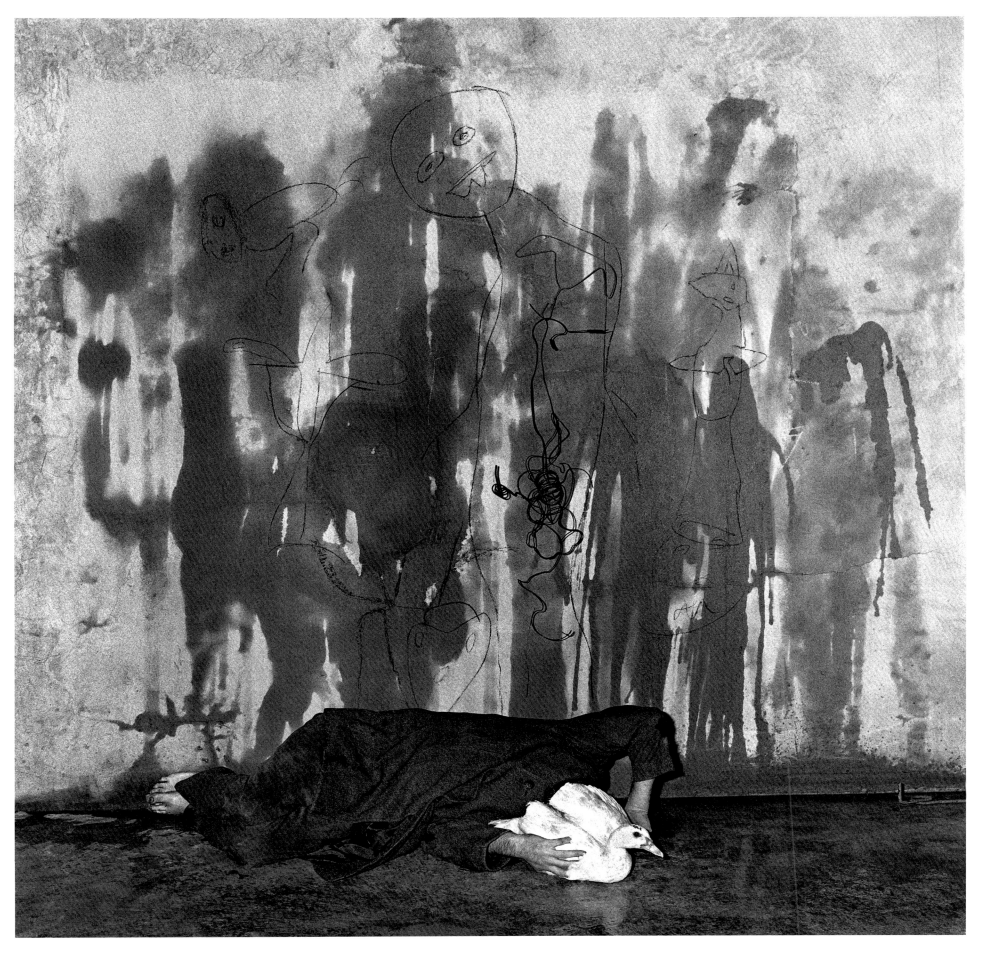

Wall Shadows, 2003

169

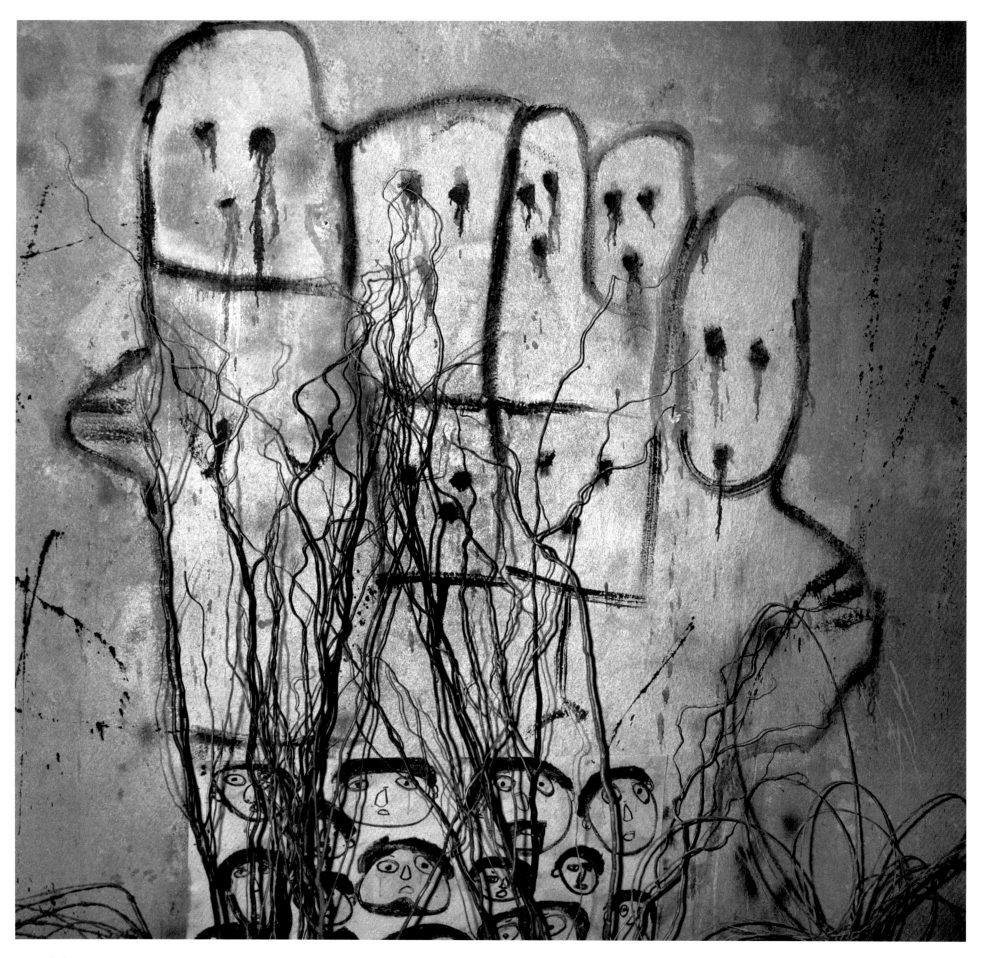

Funeral Rites, 2004

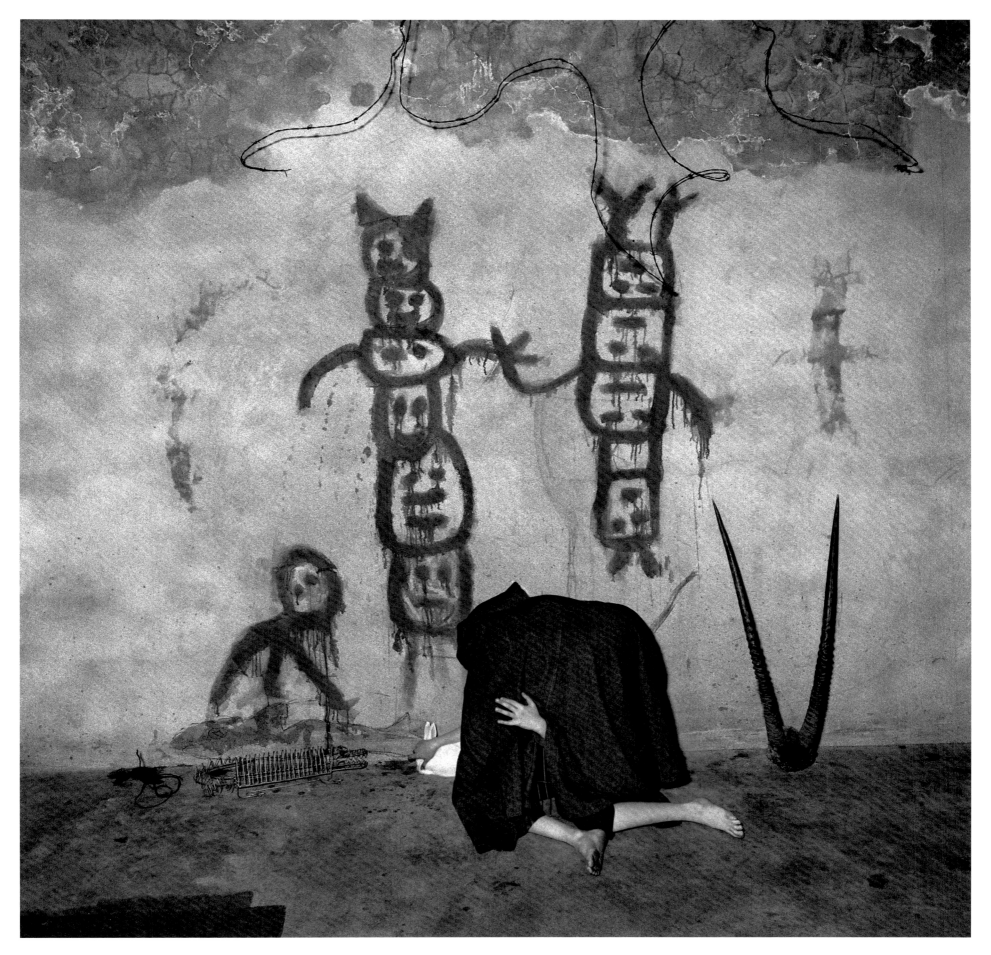

Cloaked Figure, 2003

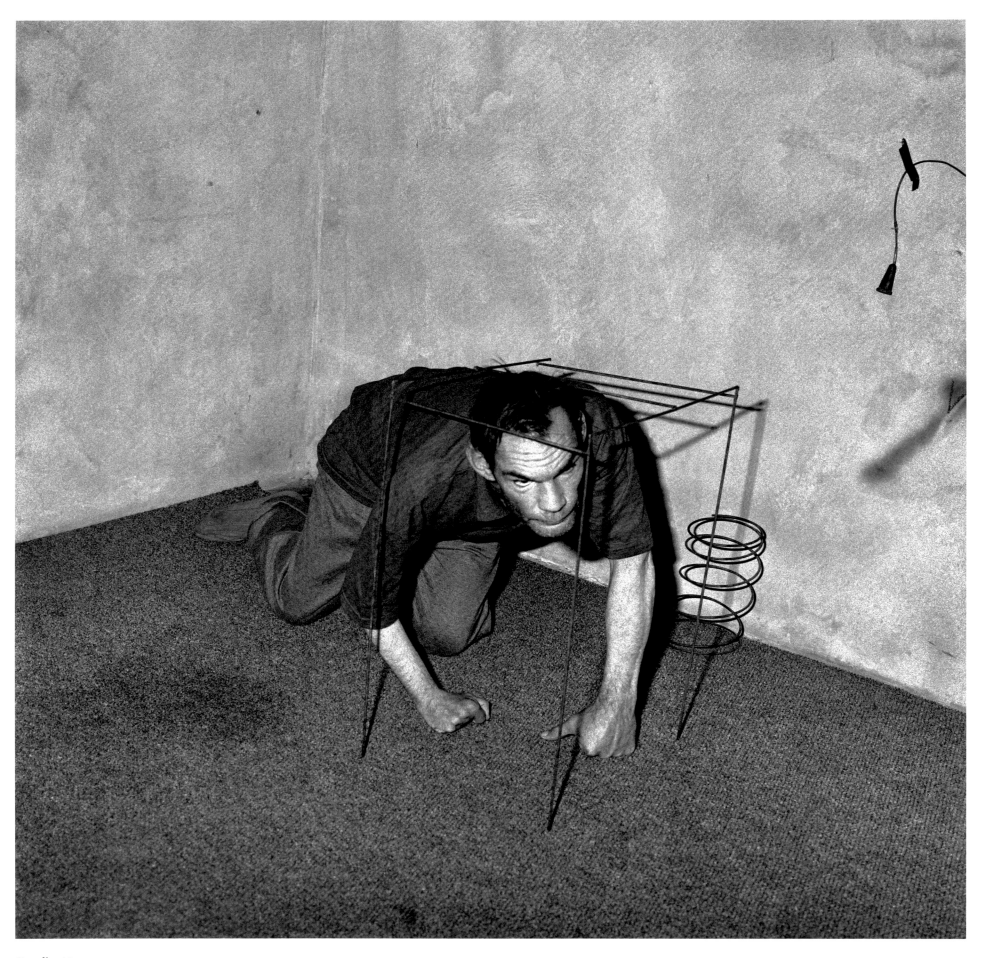

Crawling Man, 2002

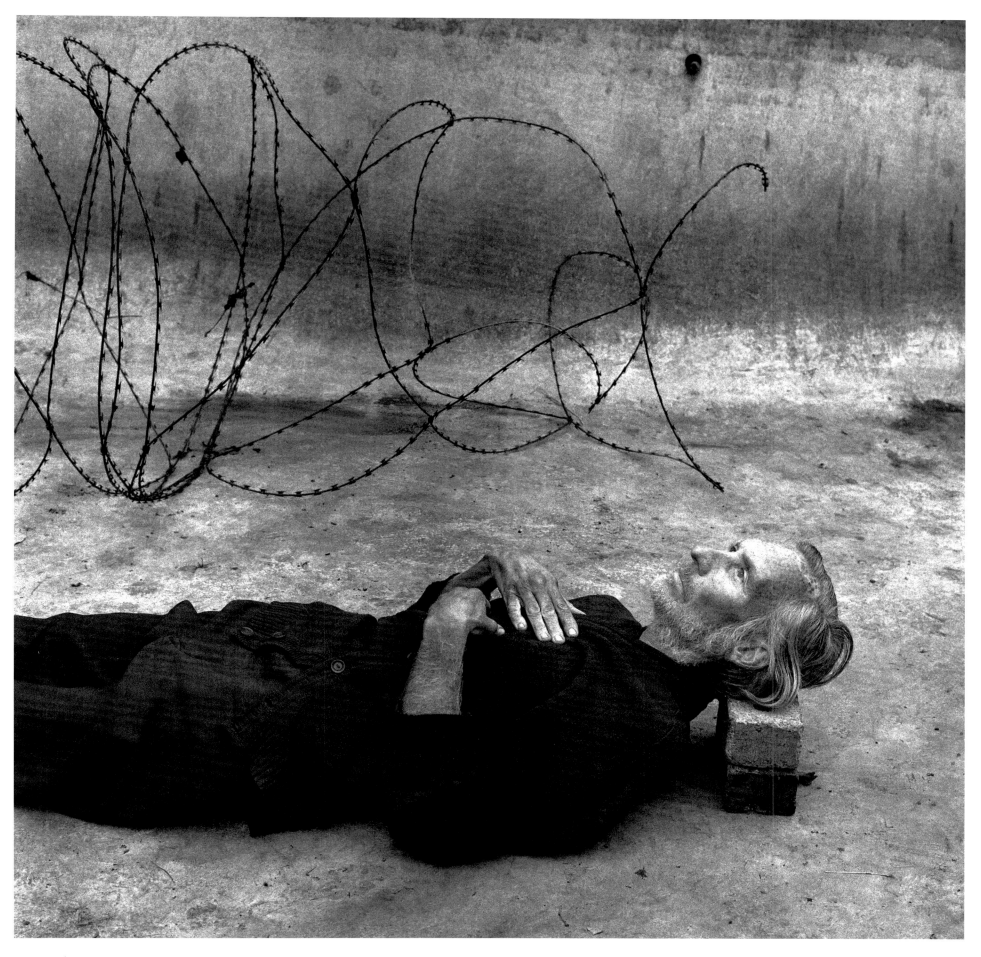

Introspection, 2001

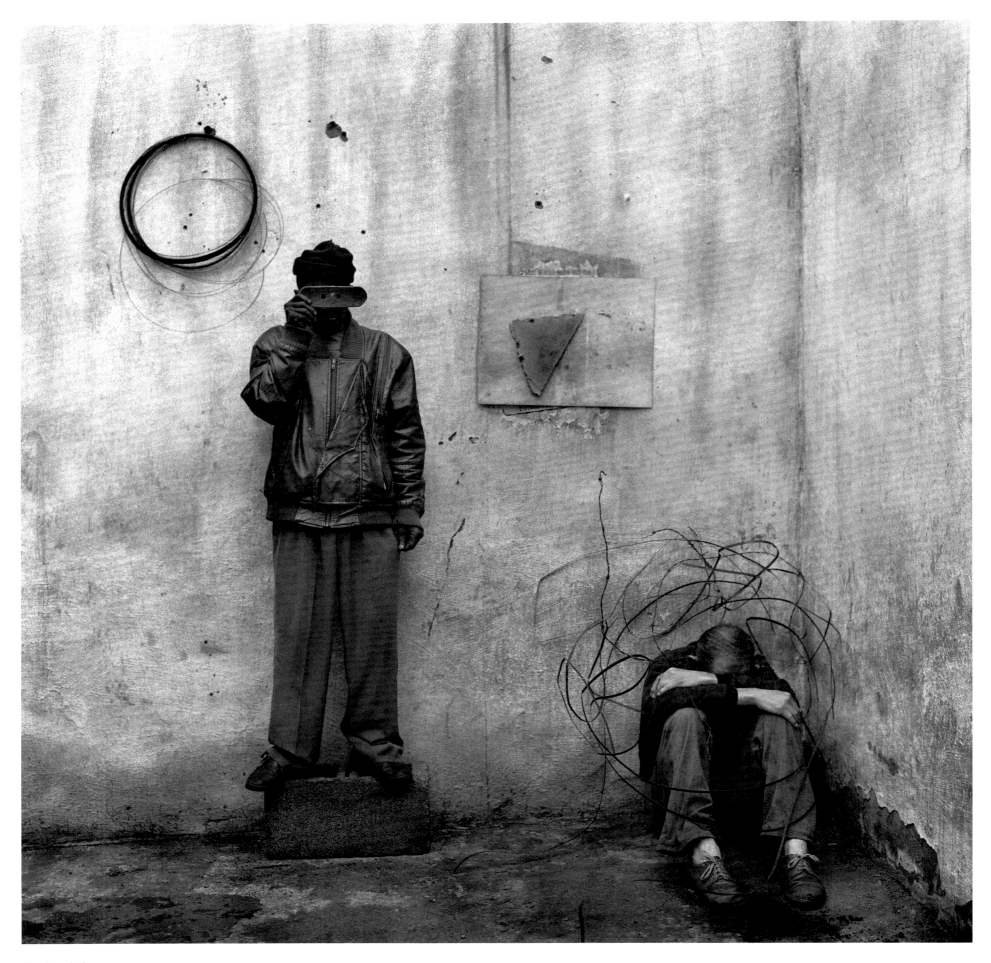

Courtyard View, 2001

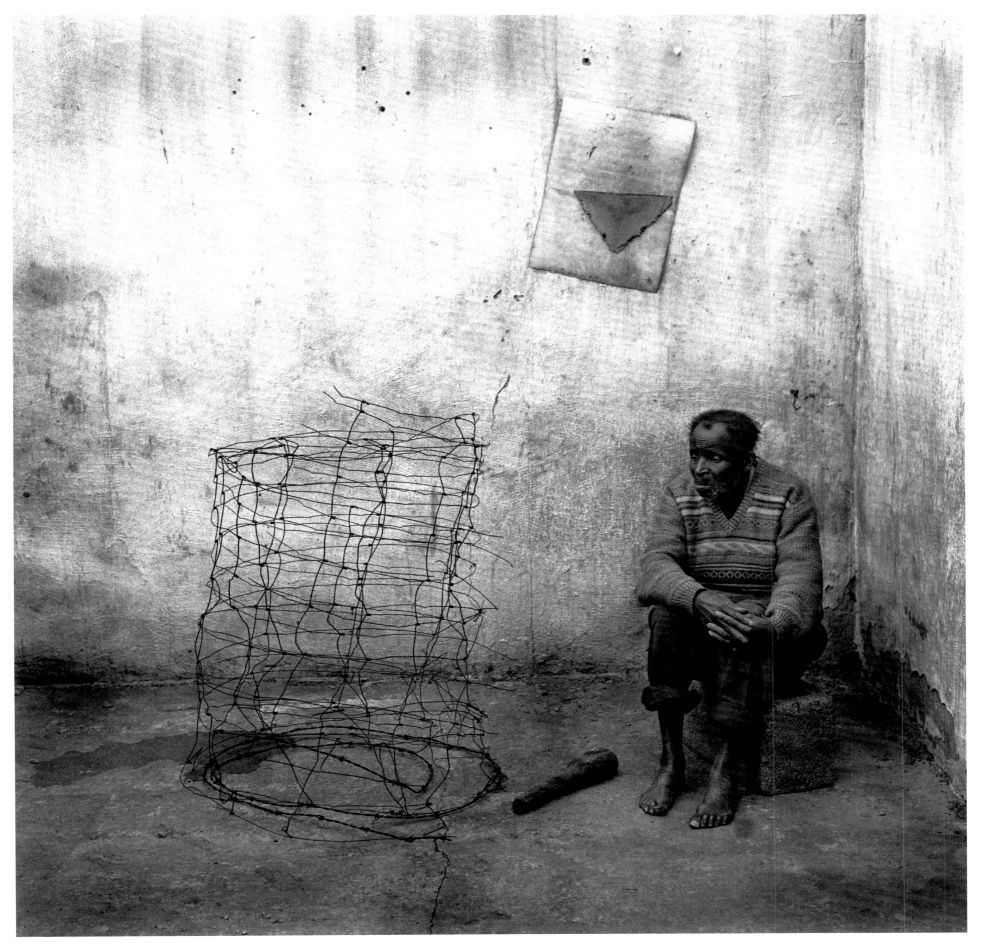

Farmworker, 2001

'"Relentlessly meaningful, yet resistant to logic", the characters are actors without audiences, acting out their distress, reduced to the "forced extroversion of all interiority". This is no longer documentary expression in the classic sense; Ballen now explores the truly unphotographable margins of the human condition in his work, where anything is possible.'

Robert A. Sobieszek, introduction to *Shadow Chamber*

Hanging Pig, 2001

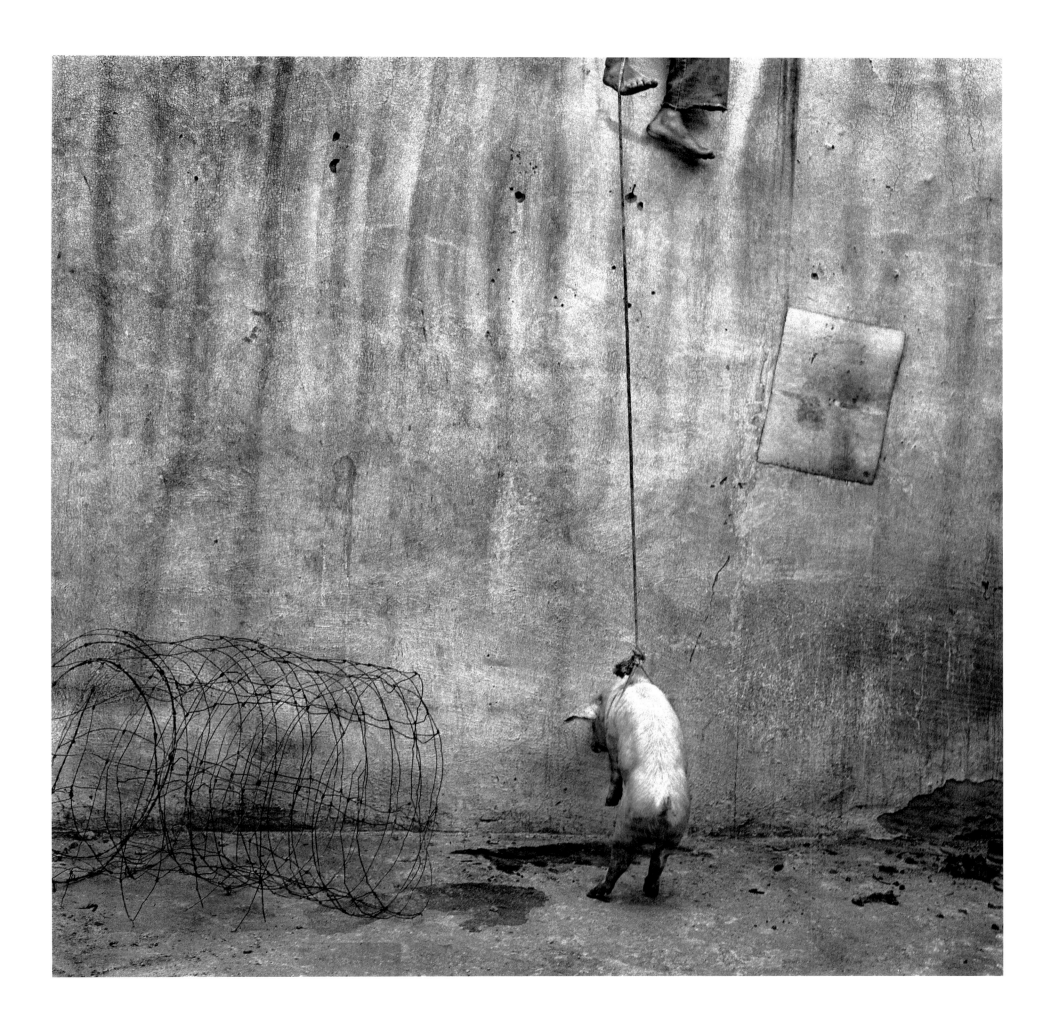

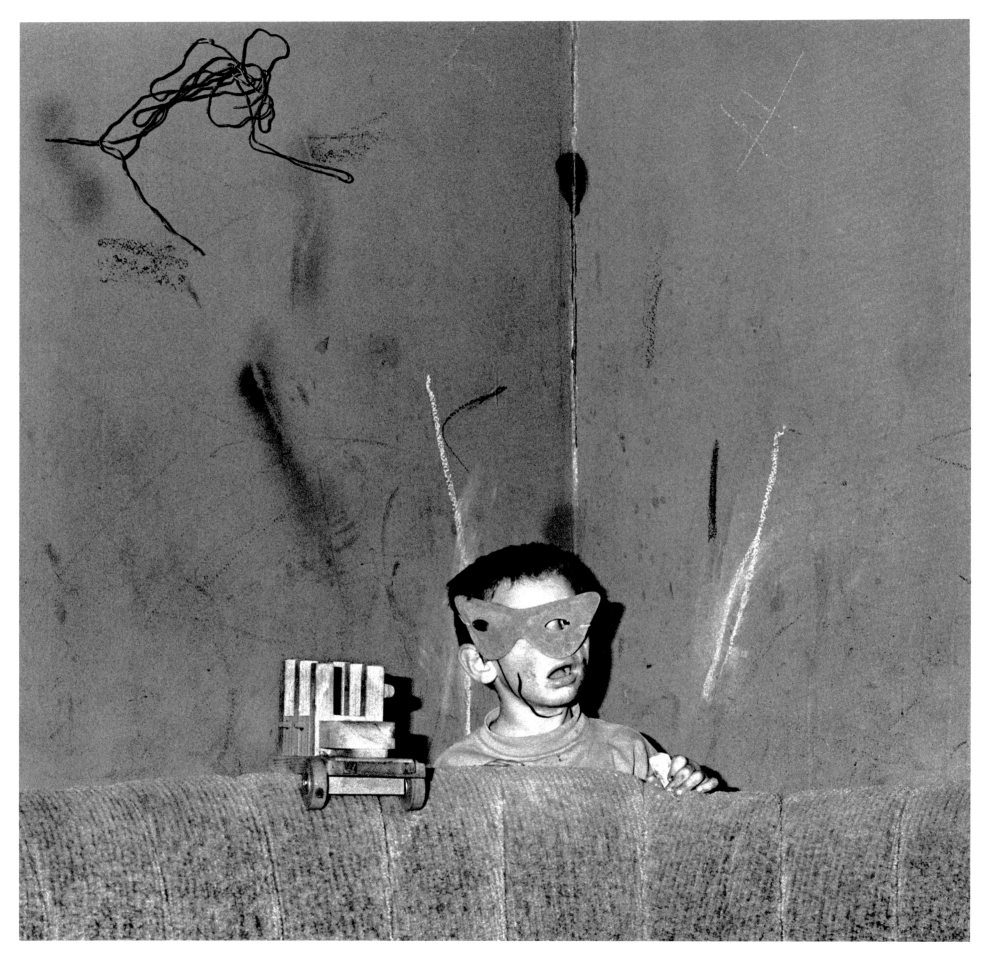

Skew Mask, 2002

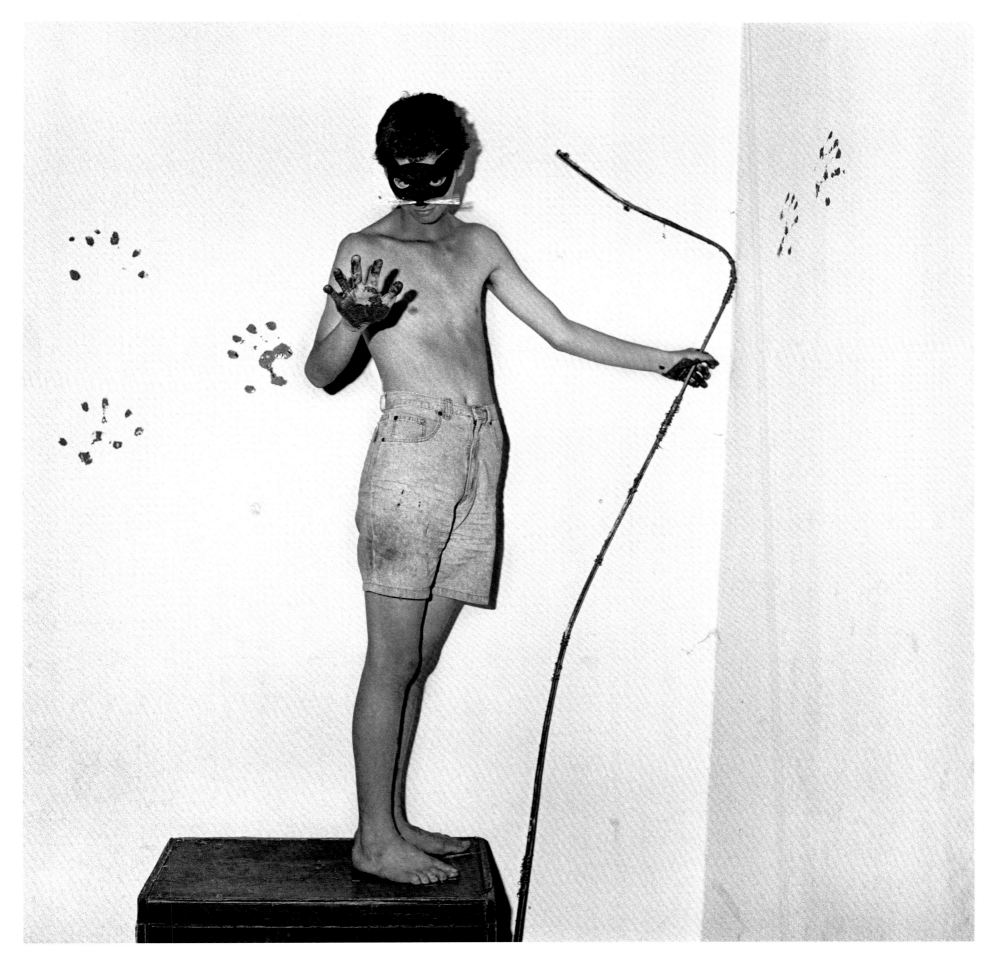

Prowling, 2001

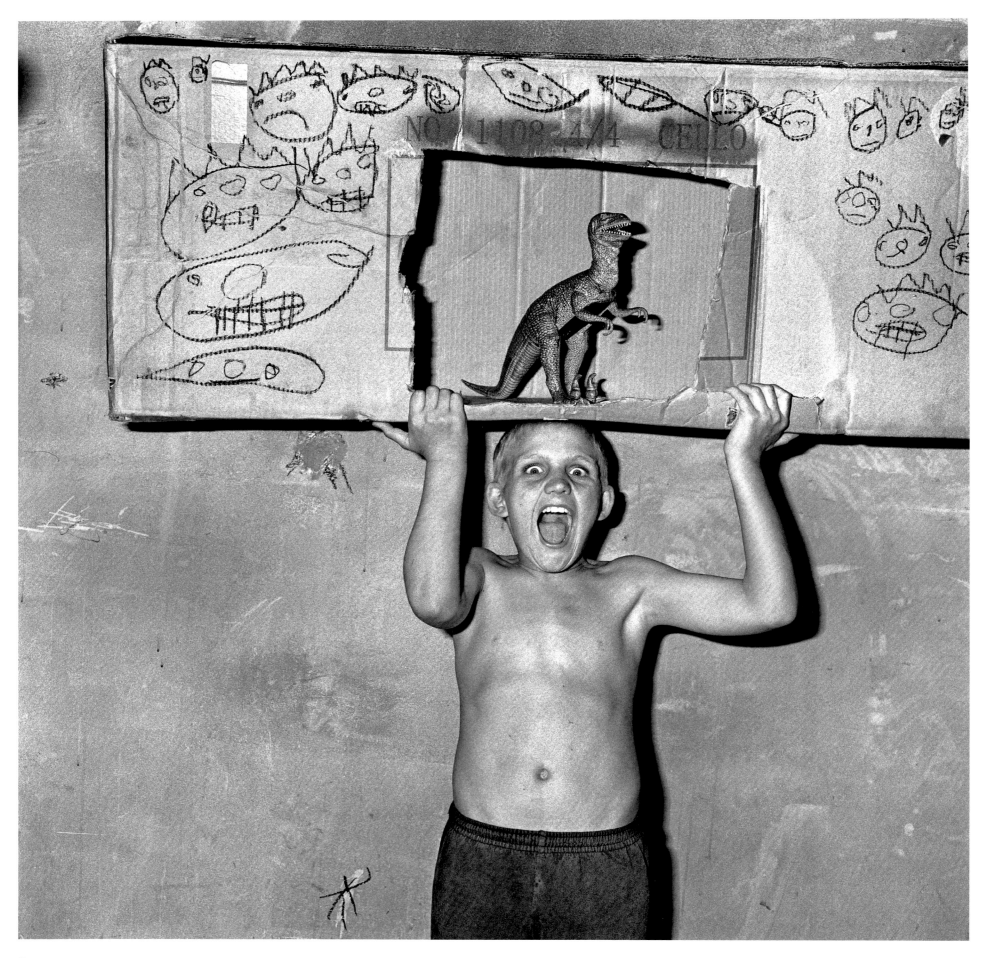

Roar, 2002

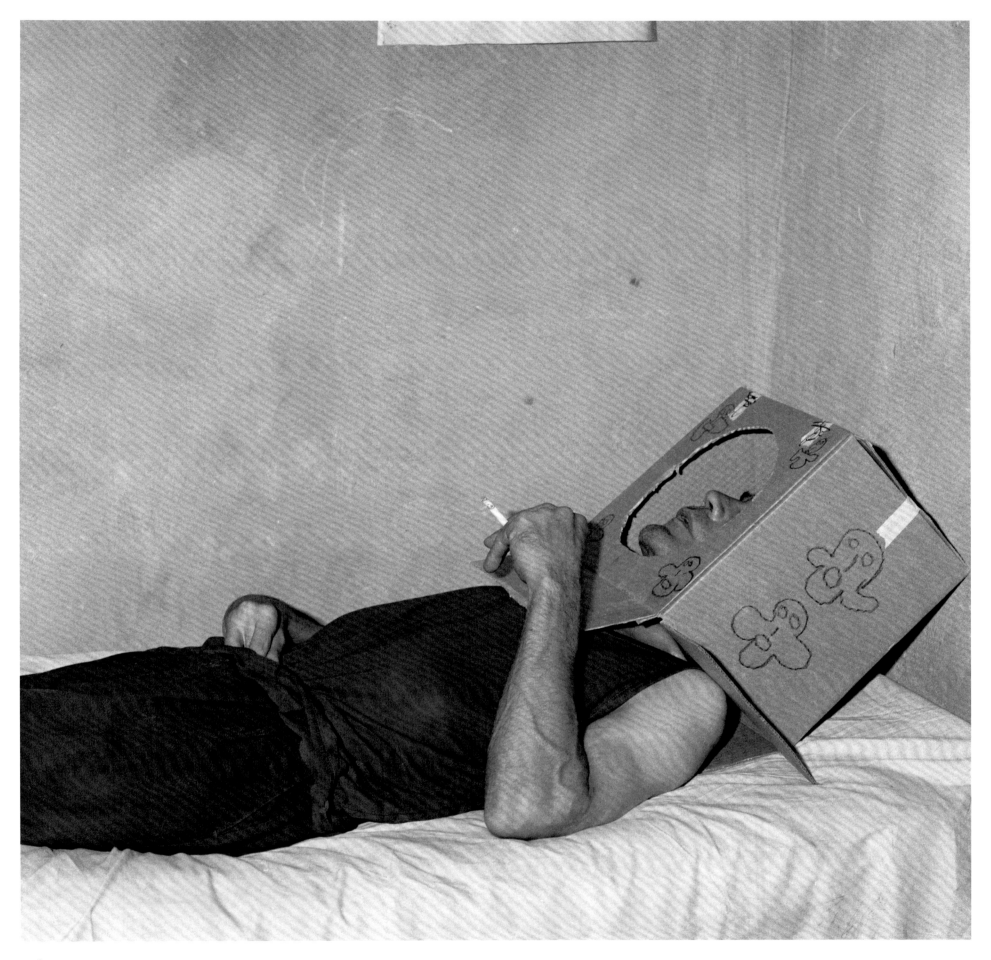

Recluse, 2002

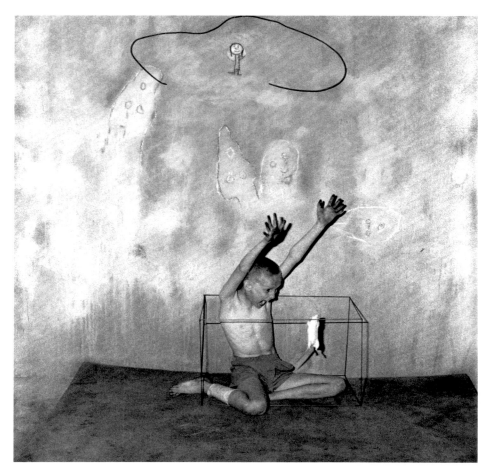

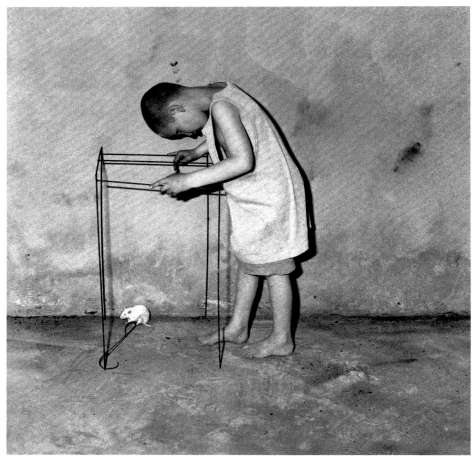

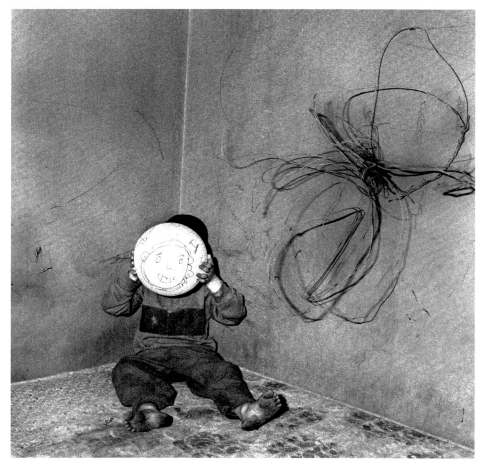

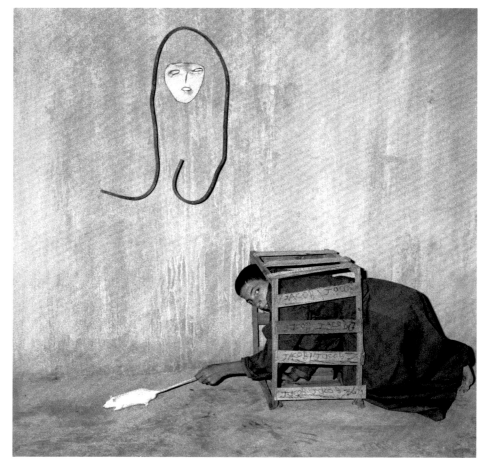

Boo, 2002
Boy with Balloon, 2002

Contraption, 2001
Yank, 2005

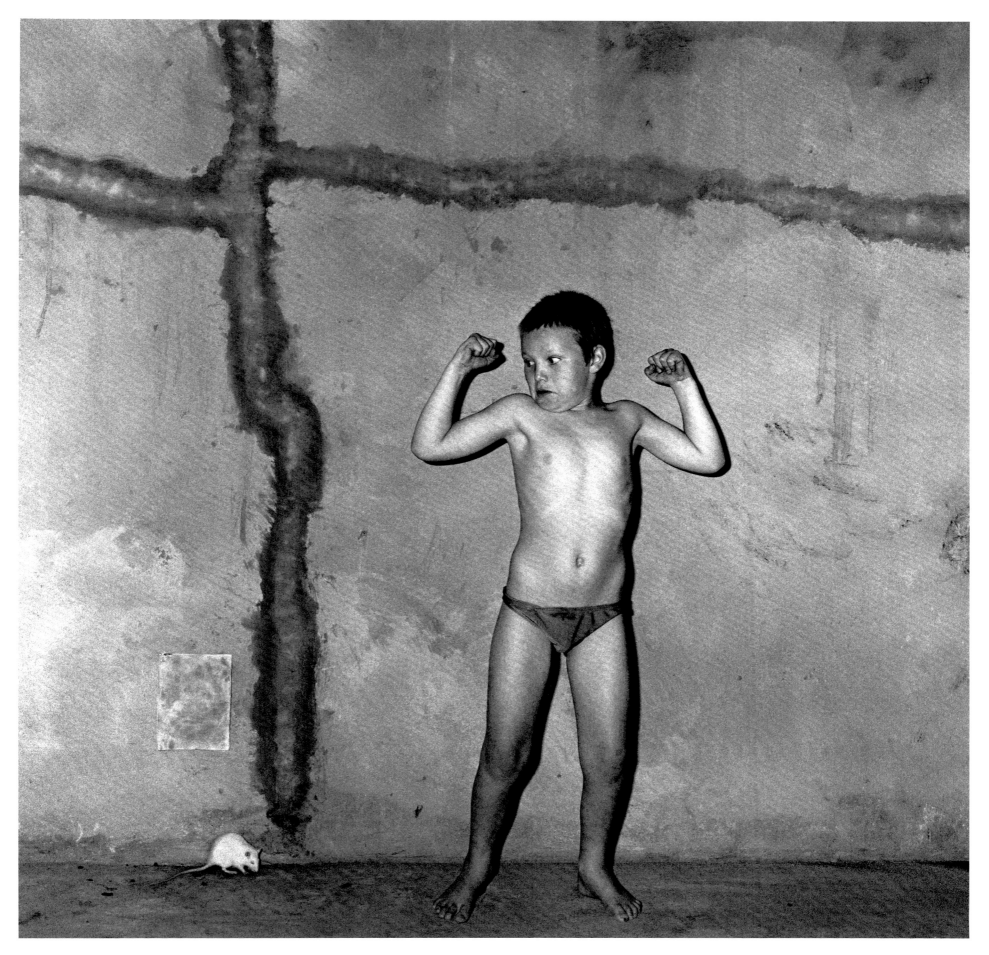

Face Off, 2001

In *Loner*, the dog's eye formally relates to the eye of the doll and the 'o' in the word 'God', the crucifix mirrors the form of the dog against the man's body, and the word 'God' spelled backwards is 'Dog'. Form without content leaves an image vacuous. This photograph poses a profound question: is any one notion of God more correct than any other?

Loner, 2001

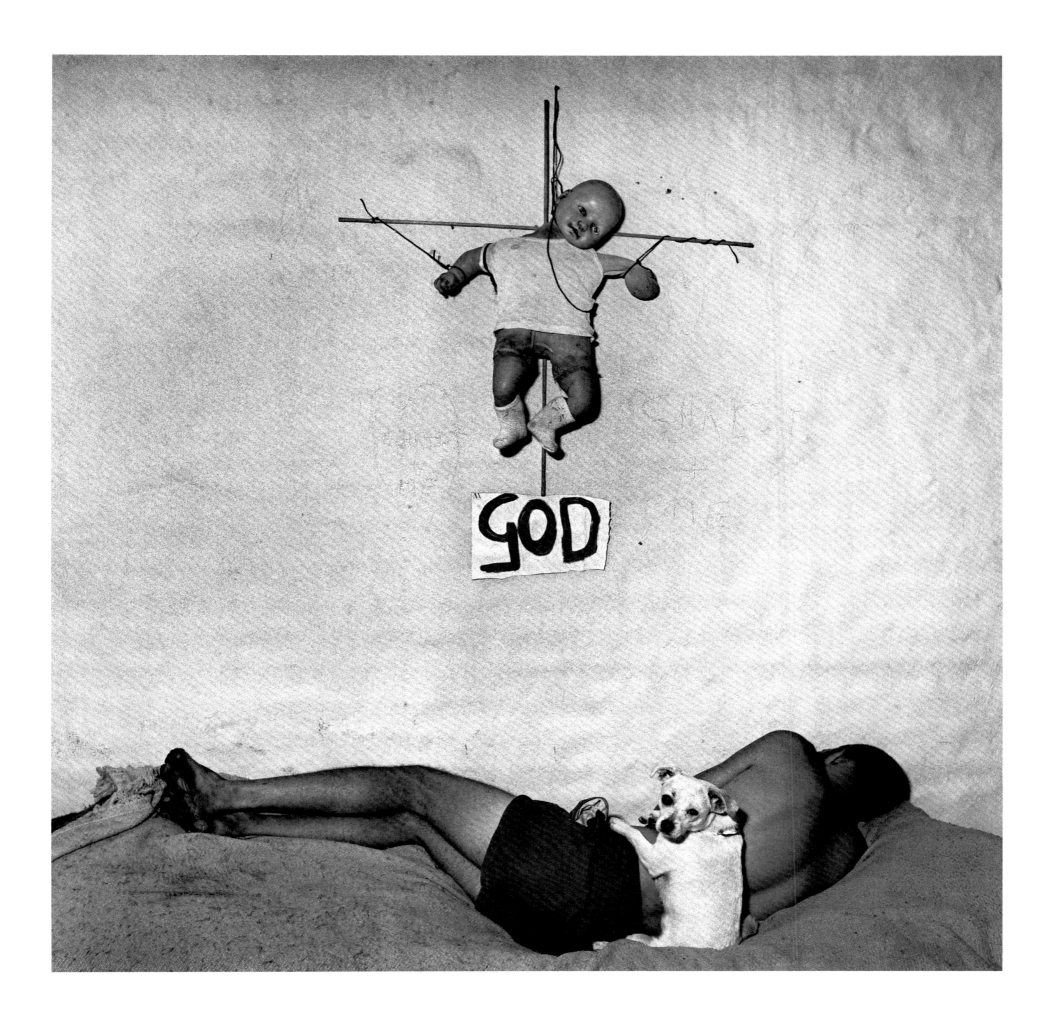

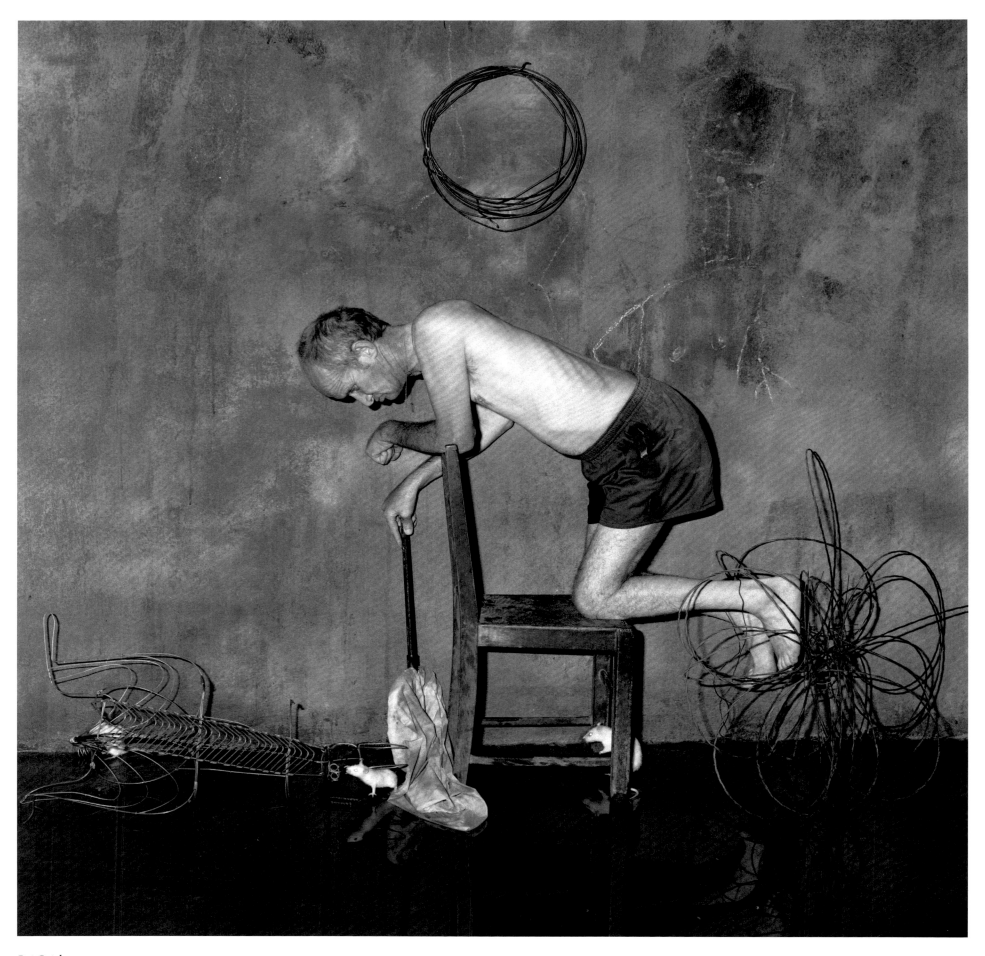

Rat Catcher, 2004

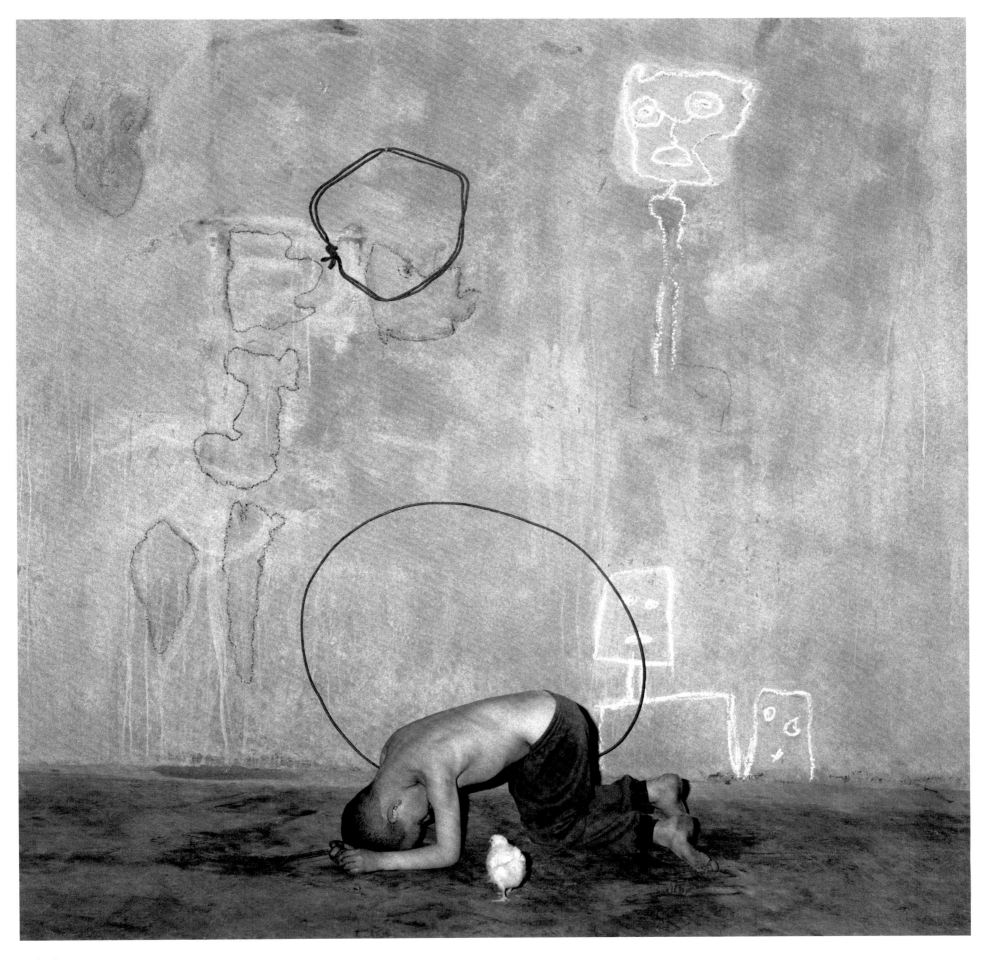

Invitation, 2003

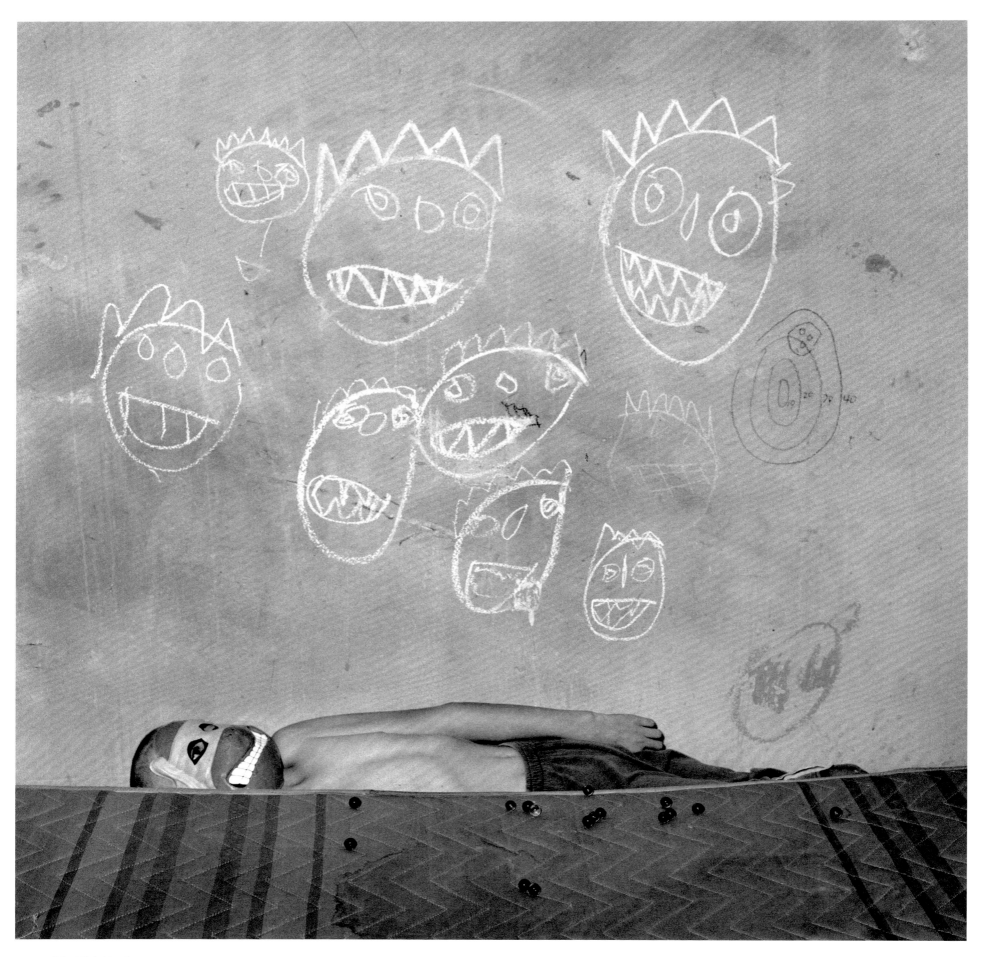

Room of the Ninja Turtles, 2003

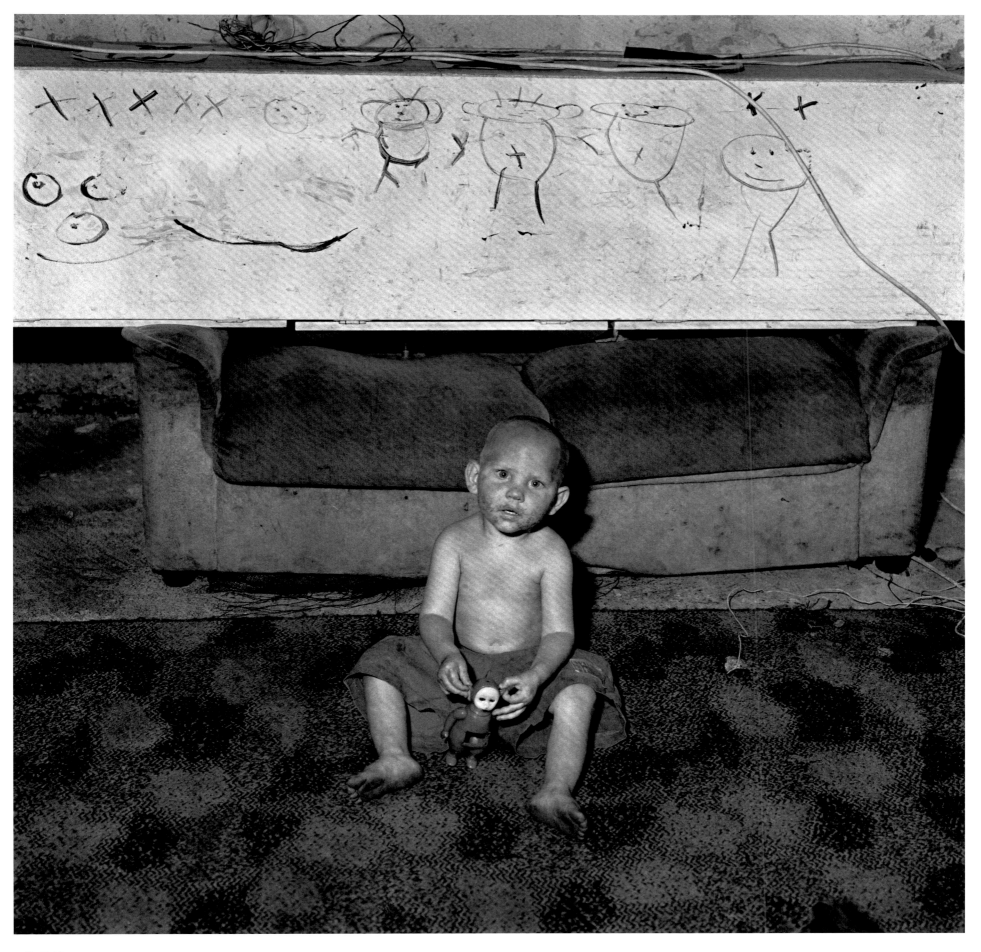

Telly Tubby, 2001

'Animals – ducks and chickens mostly, but also puppies, dogs, cats and mice – range freely through the cells. Like strange mysterious talisman, the animals appear as isolated, estranged and lost as the humans, and as strangely empowered as well.'

Robert A. Sobieszek, introduction to *Shadow Chamber*

Place of the Upside Down, 2004

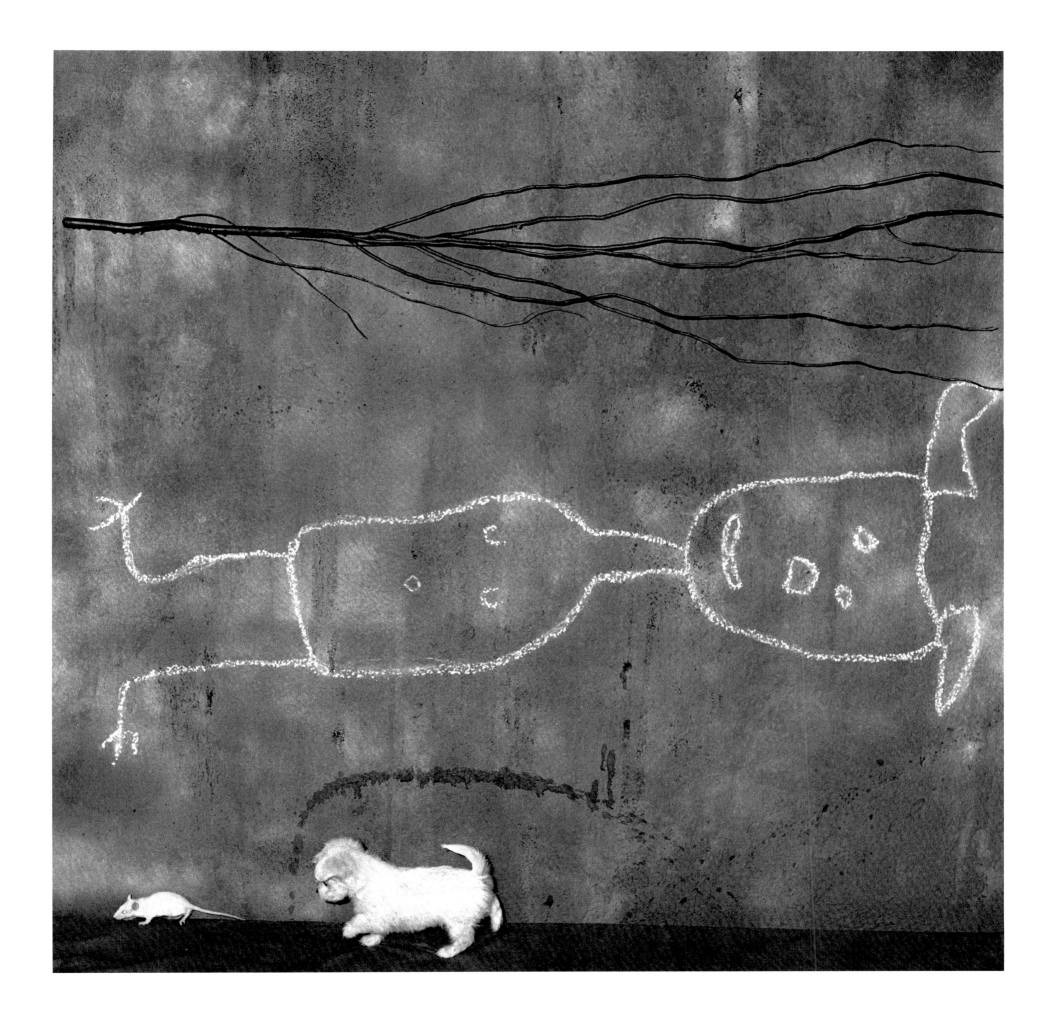

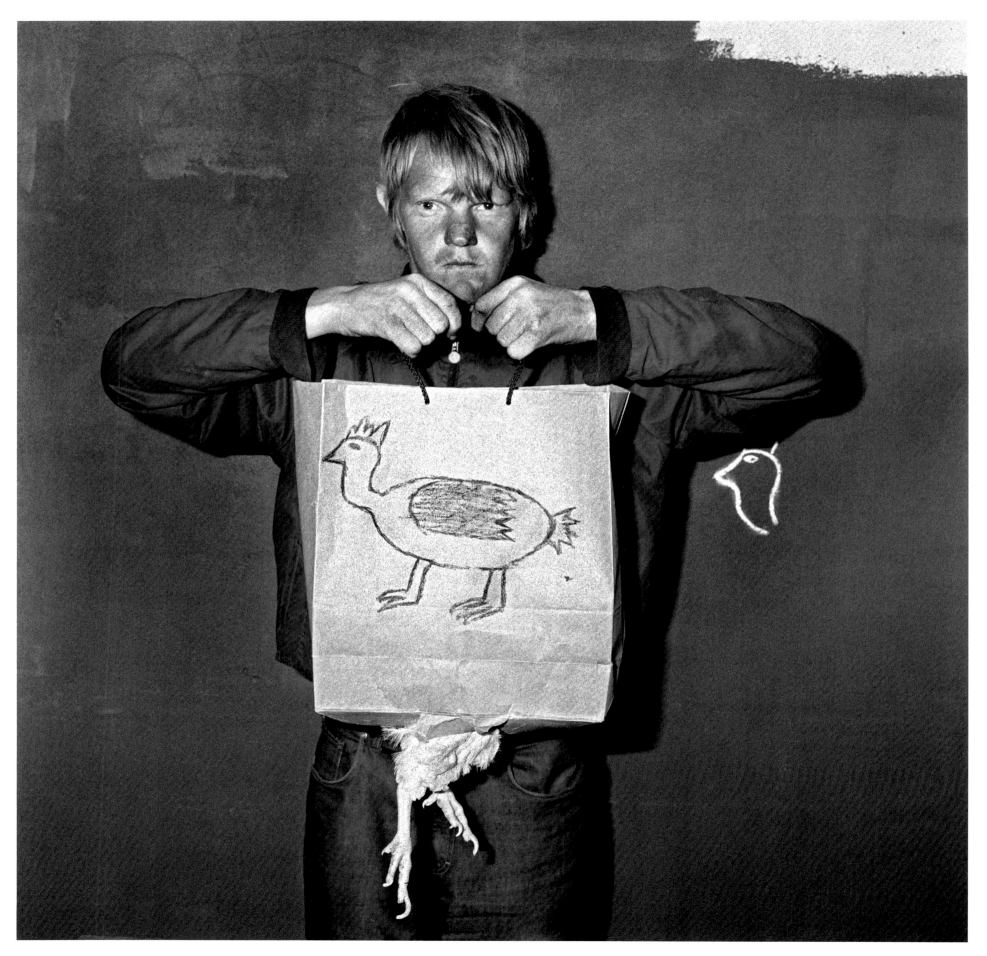

Broken Bag, 2003

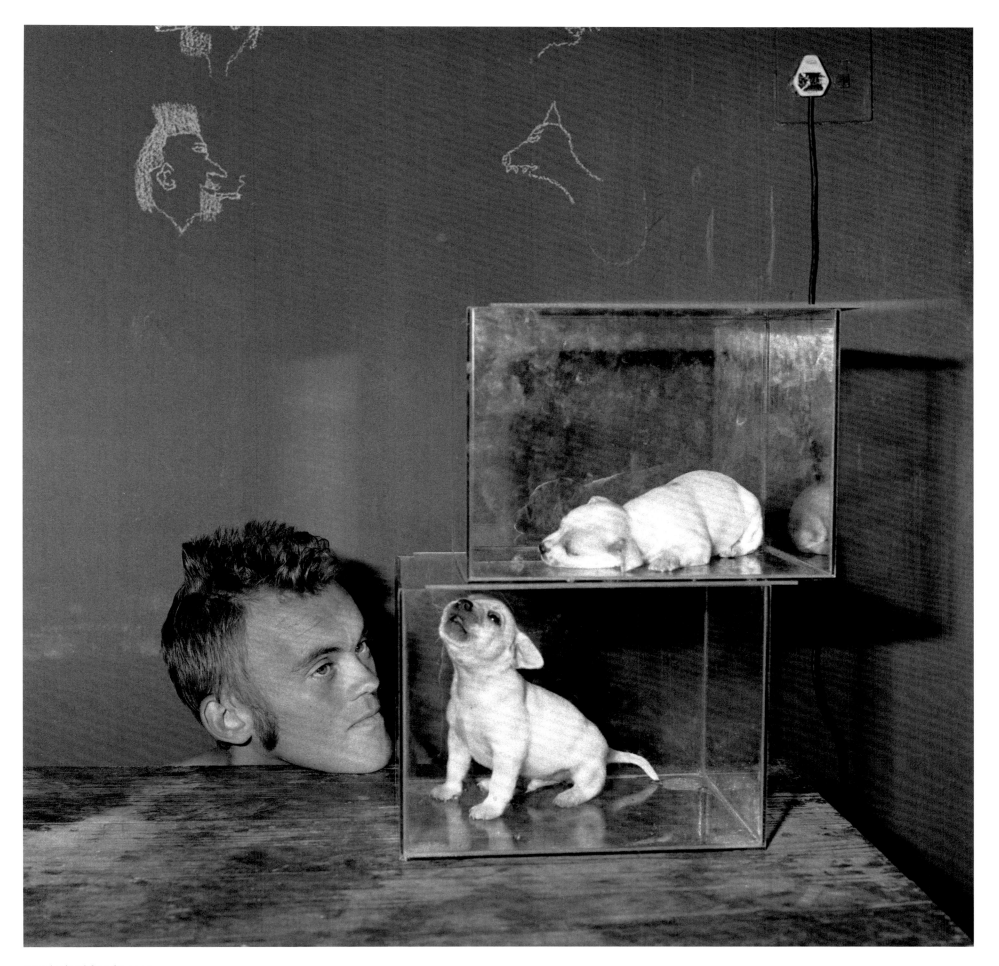

Puppies in Fishtanks, 2000

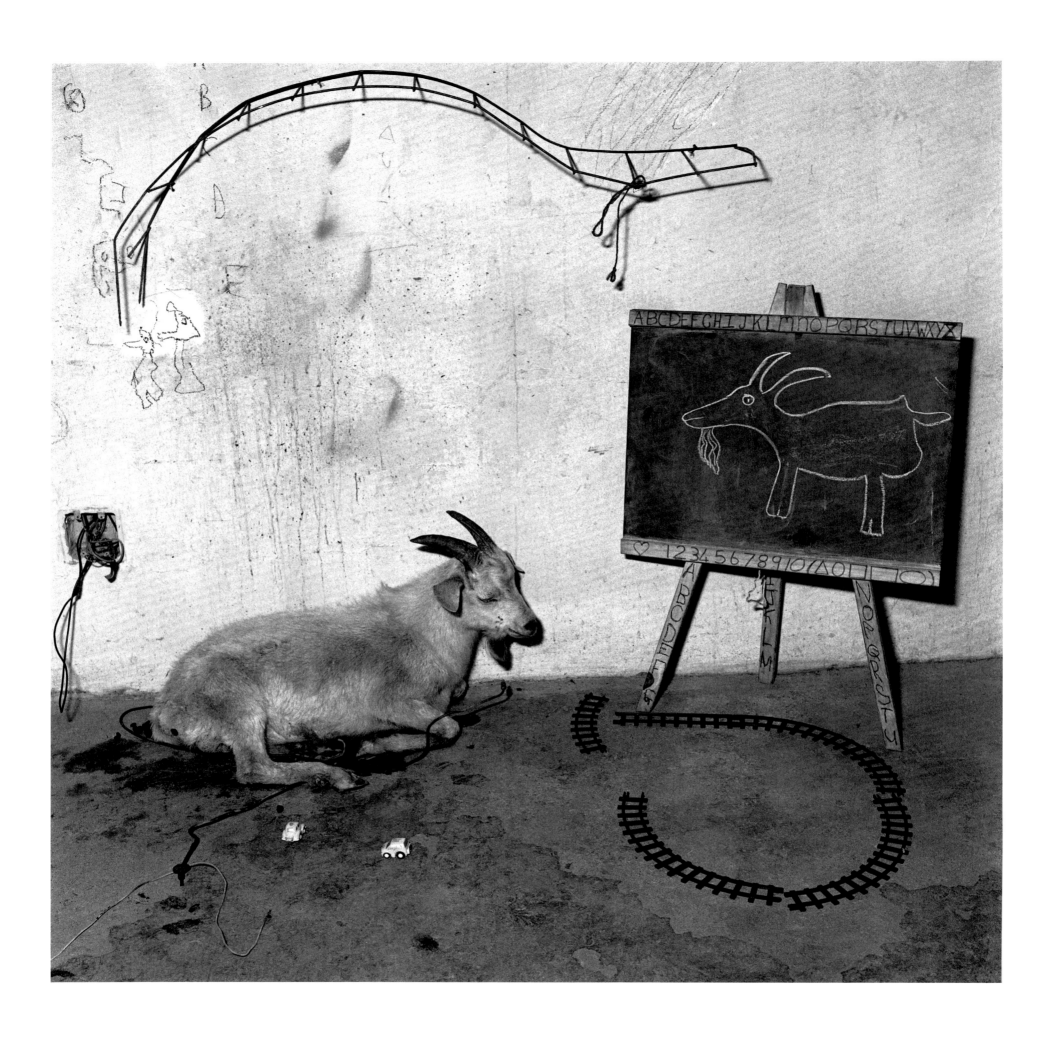

' The cells in Ballen's panopticon are fraught with things, bizarre artefacts and obliquely dysfunctional stuff … well arranged and visually orchestrated stuff. Walls are covered with archaic or "outsider" drawings of faces, masks, and animal cartoons. Wrenches and wires, nets and baskets, metal grids and metal clothes hangers are equally strewn about like primitive artefacts.'

Robert A. Sobieszek, introduction to *Shadow Chamber*

School Room, 2003

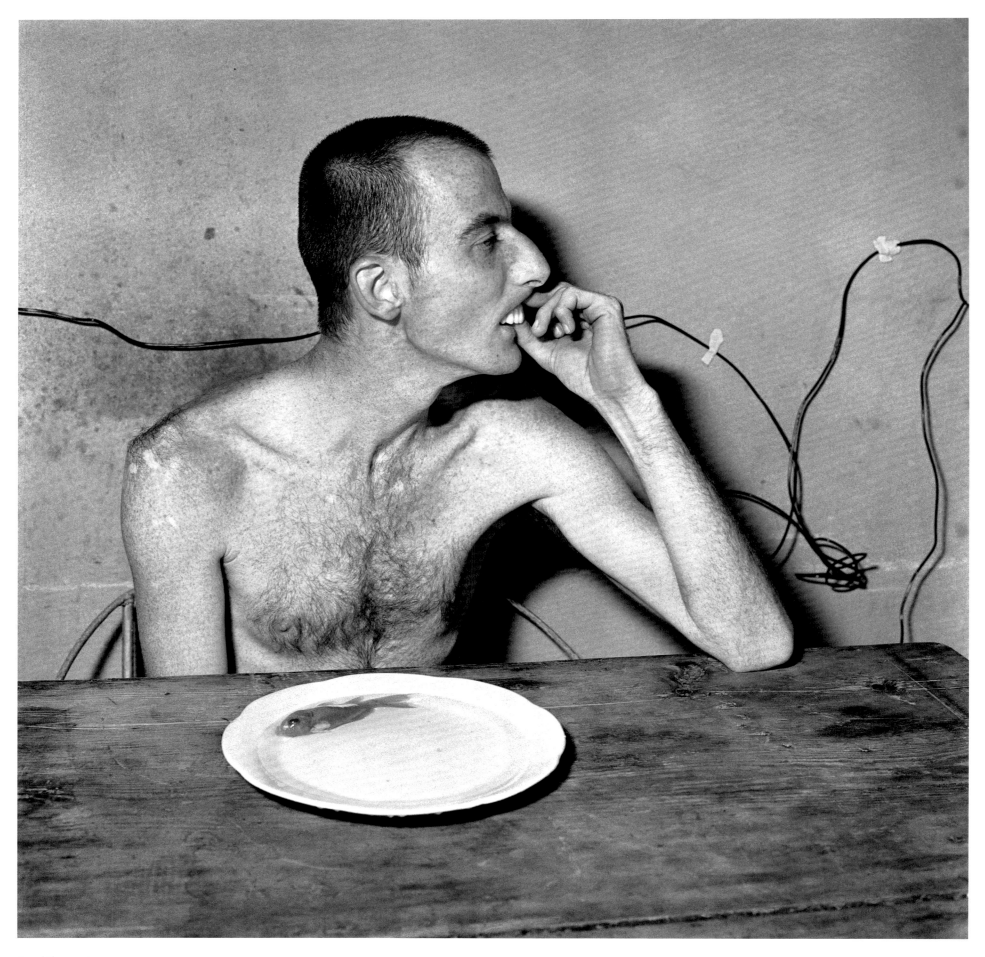

Lunchtime, 2001

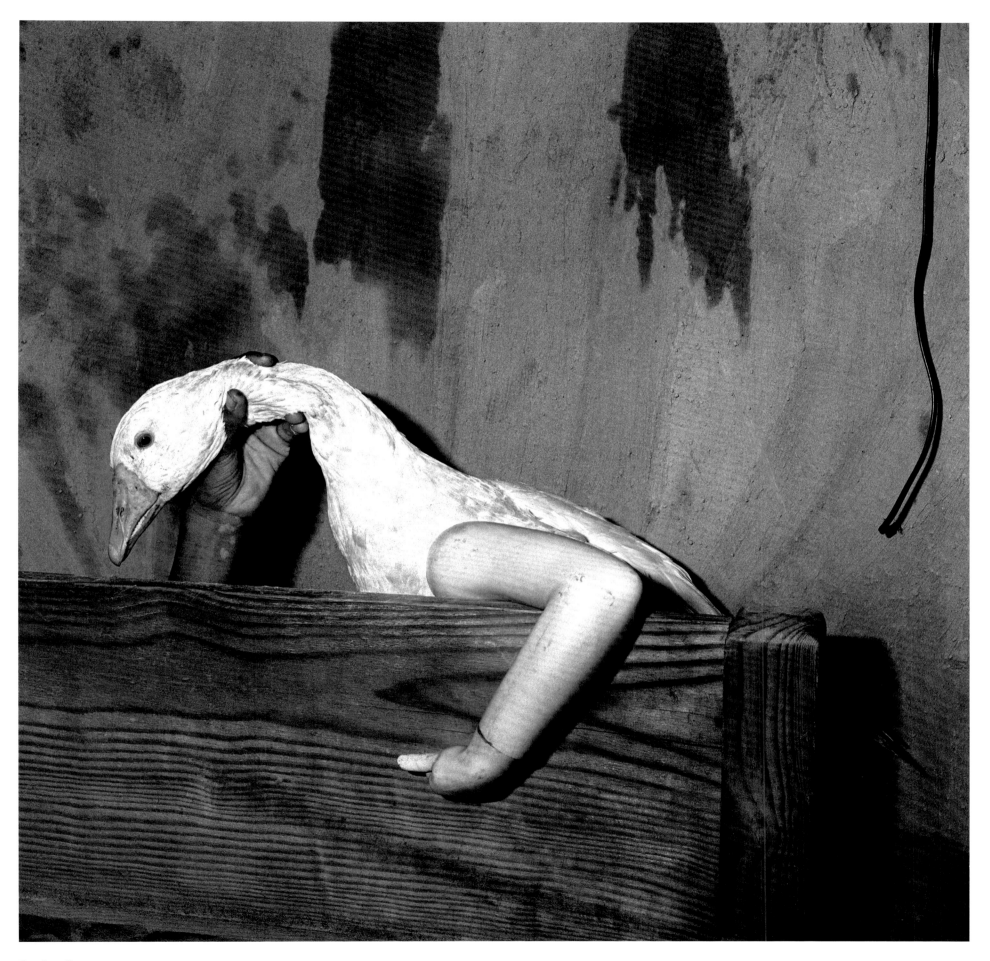

One Arm Goose, 2004

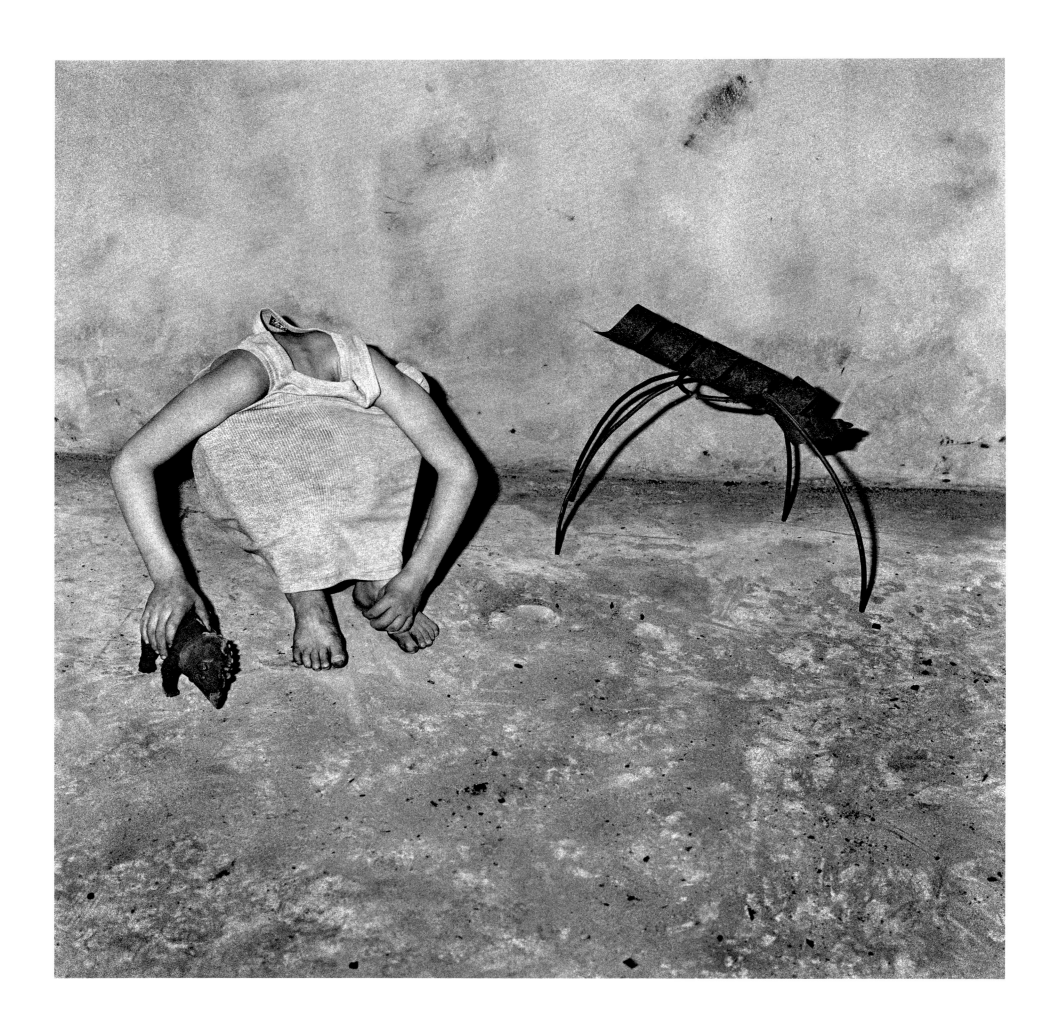

Head Inside Shirt was the first image in which I was able to integrate sculpture with photography. While the classical form of the boy mirrors the assemblage to his left, the meaning of the image is derived through photography as the boy's head disappears inside his clothes and the assemblage takes the form of a tripod-mounted gun. What we are ultimately viewing is a creation transformed through Roger Ballen's mind and camera into something photographic, rather than remaining an installation.

Head Inside Shirt, 2001

boarding house, 2009

During the making of *Boarding House*, I broke
through into a part of my mind that I never
knew existed. It was quite enthralling to find
and be in this place. It is difficult to explain,
except to say that I think it exists in most
people's minds.

Boarding House, 2008

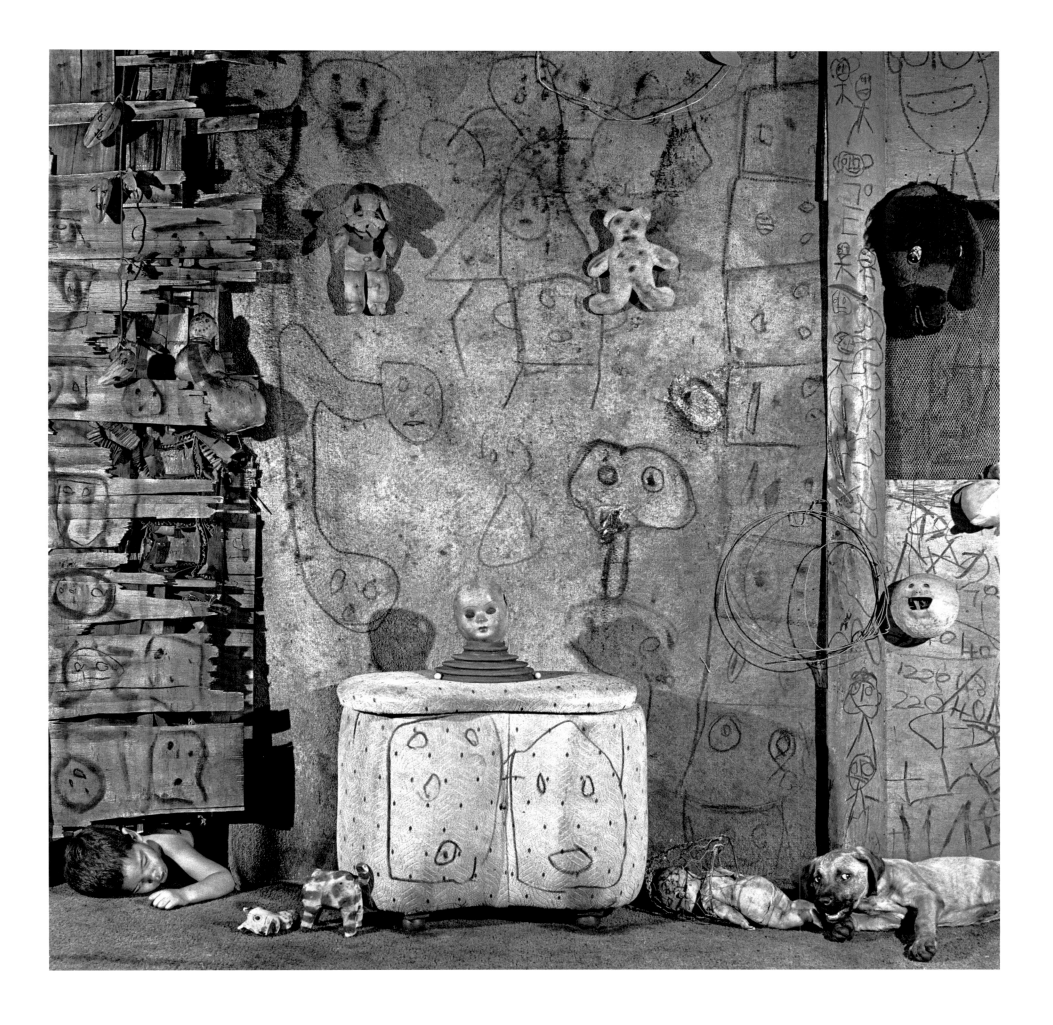

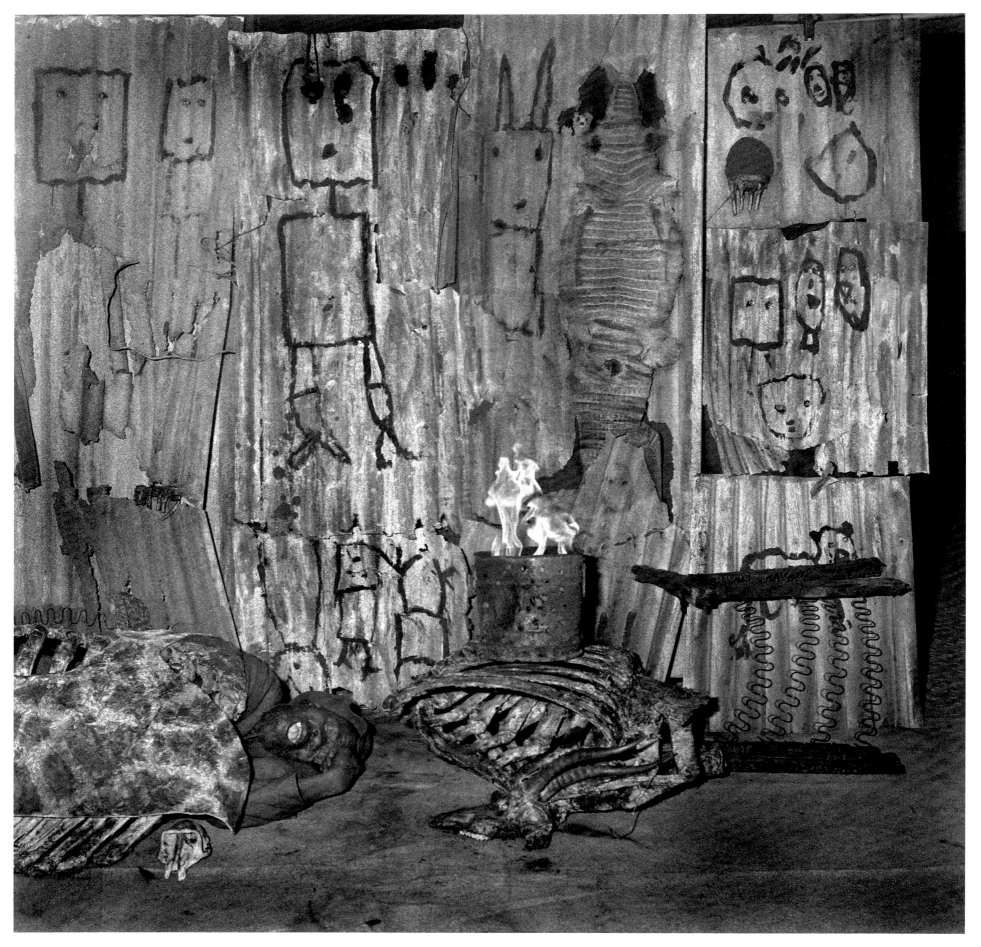

Giraffe House, 2007

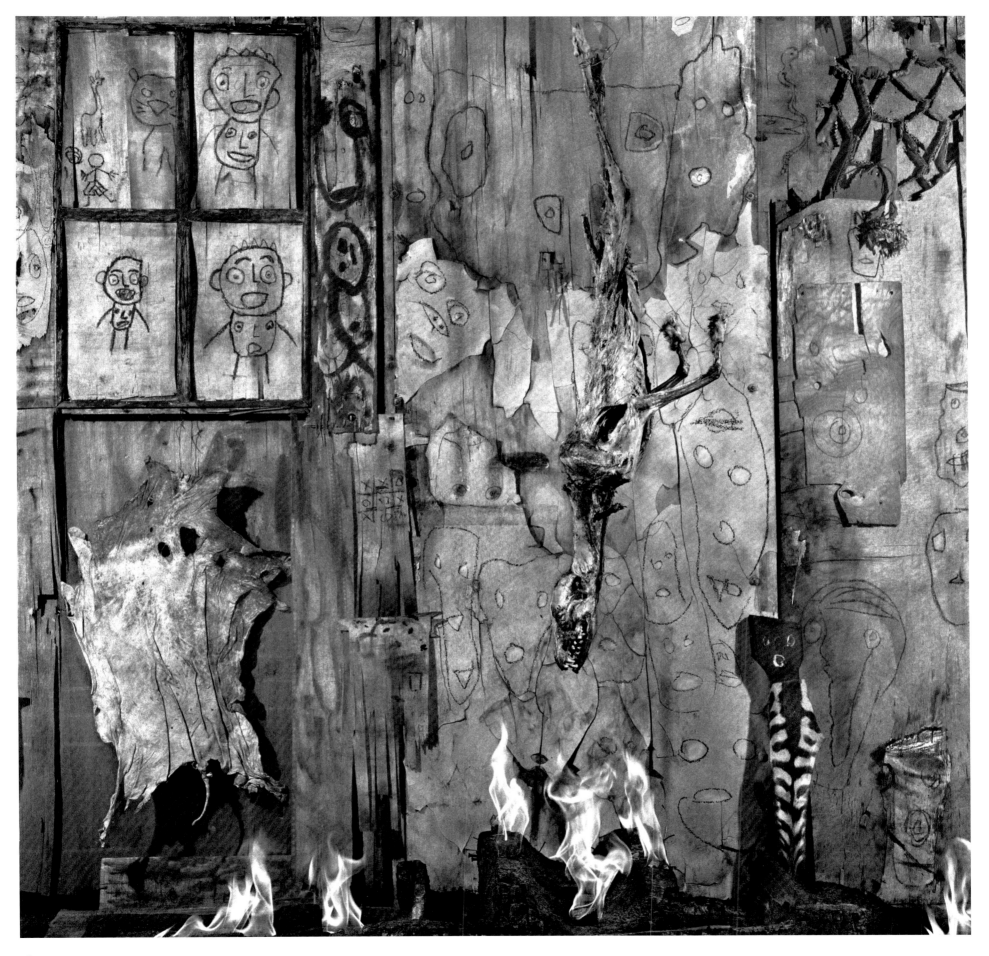

Flame, 2007

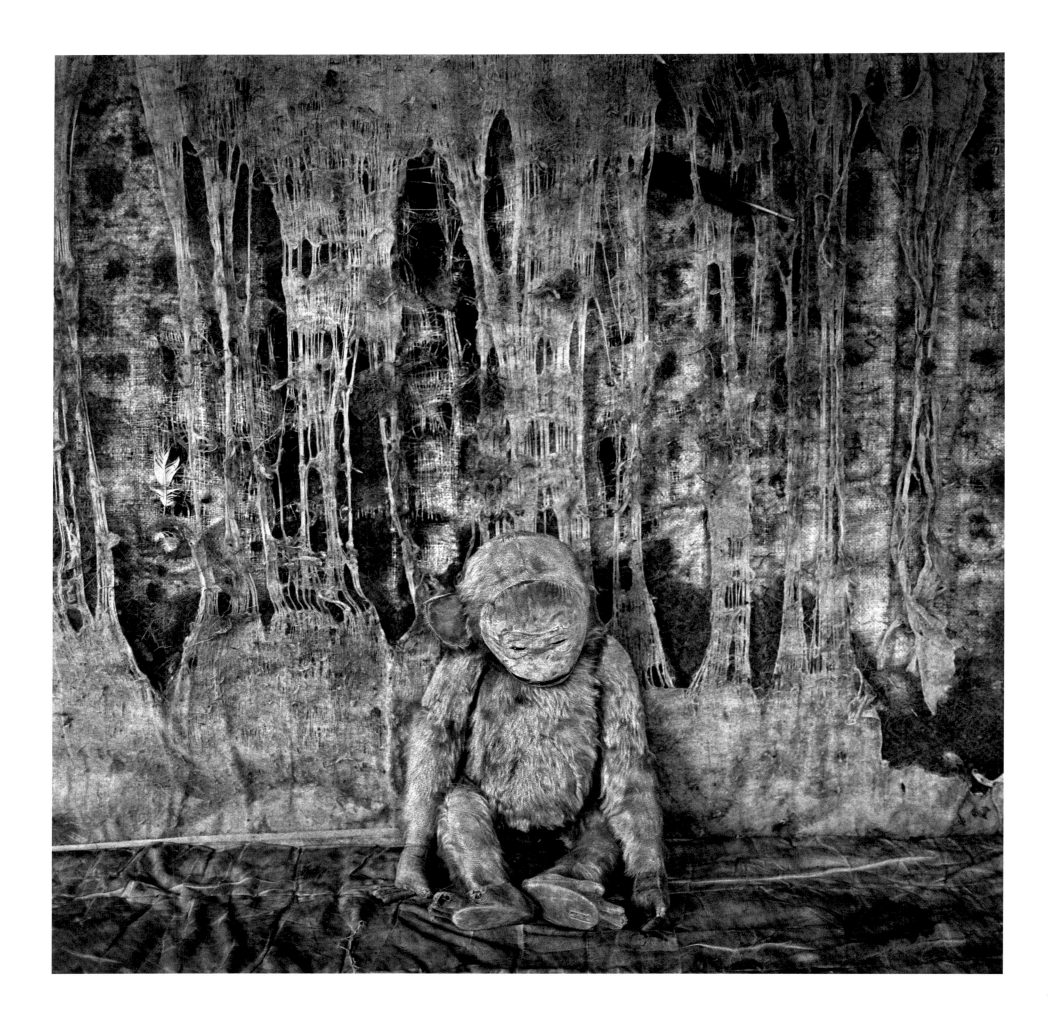

Pathos is a quality that causes people to feel sympathy and sadness. It evokes a deeply felt pain, and is an inherent part of the human condition; we all know we will eventually die. To reveal this emotion in a photograph is to get to the core of our existence.

Pathos, 2005

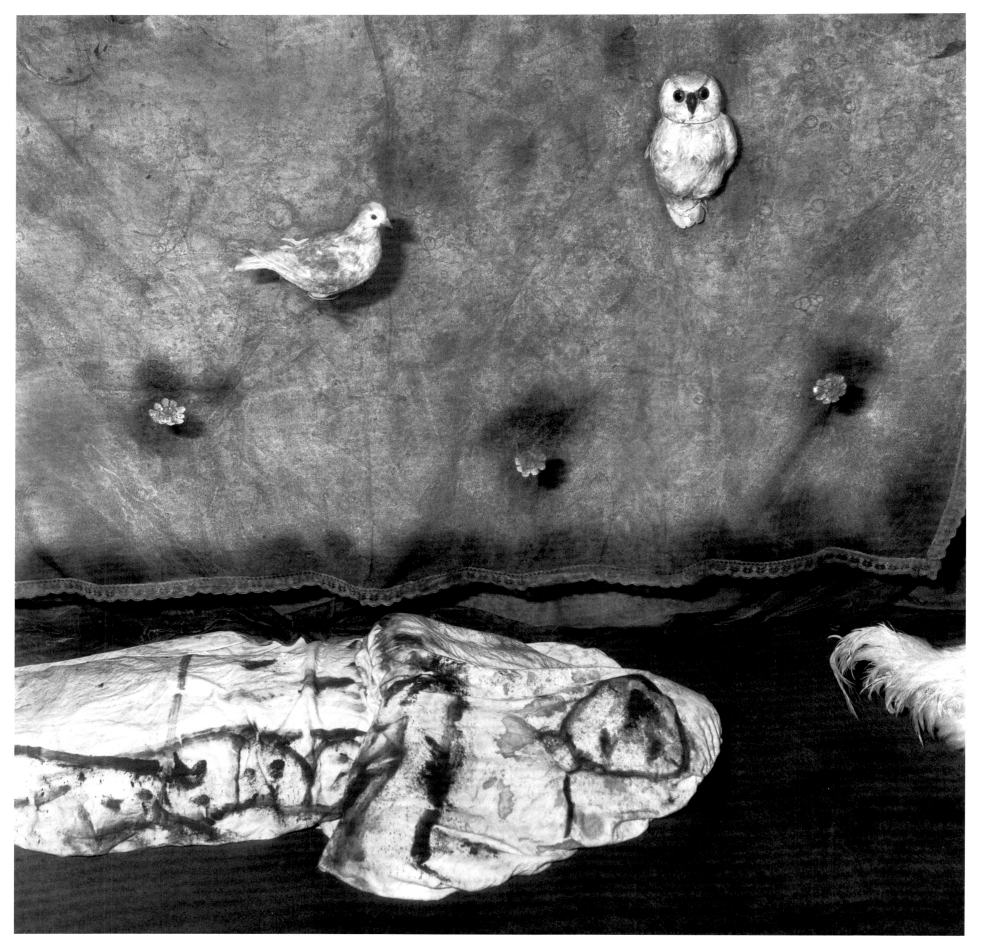

Mummy, 2009

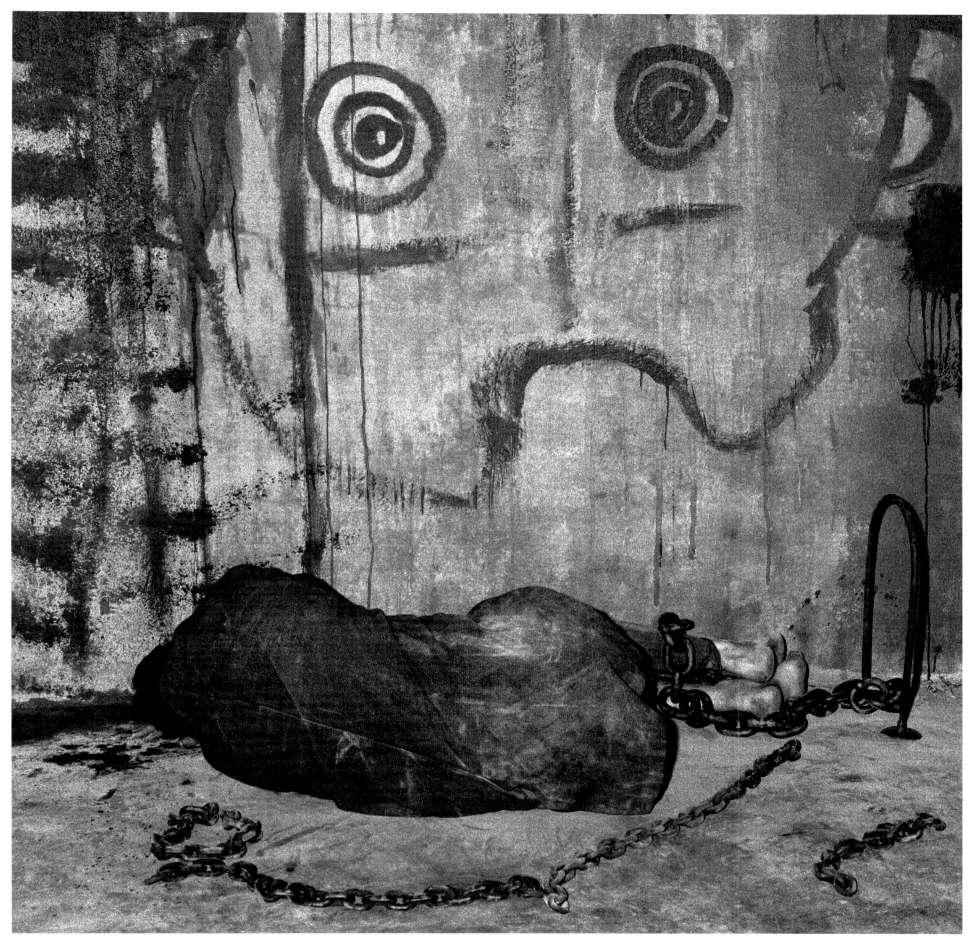

Confinement, 2003

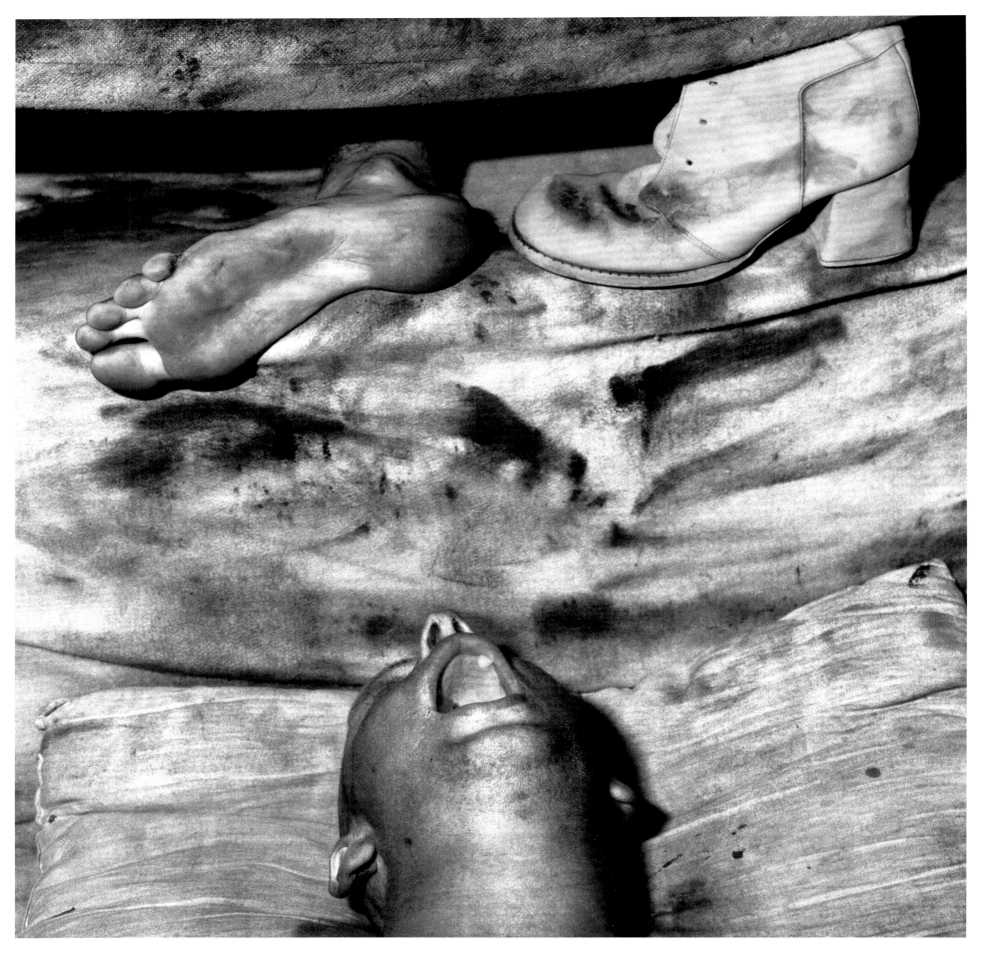

Exhaustion, 2006

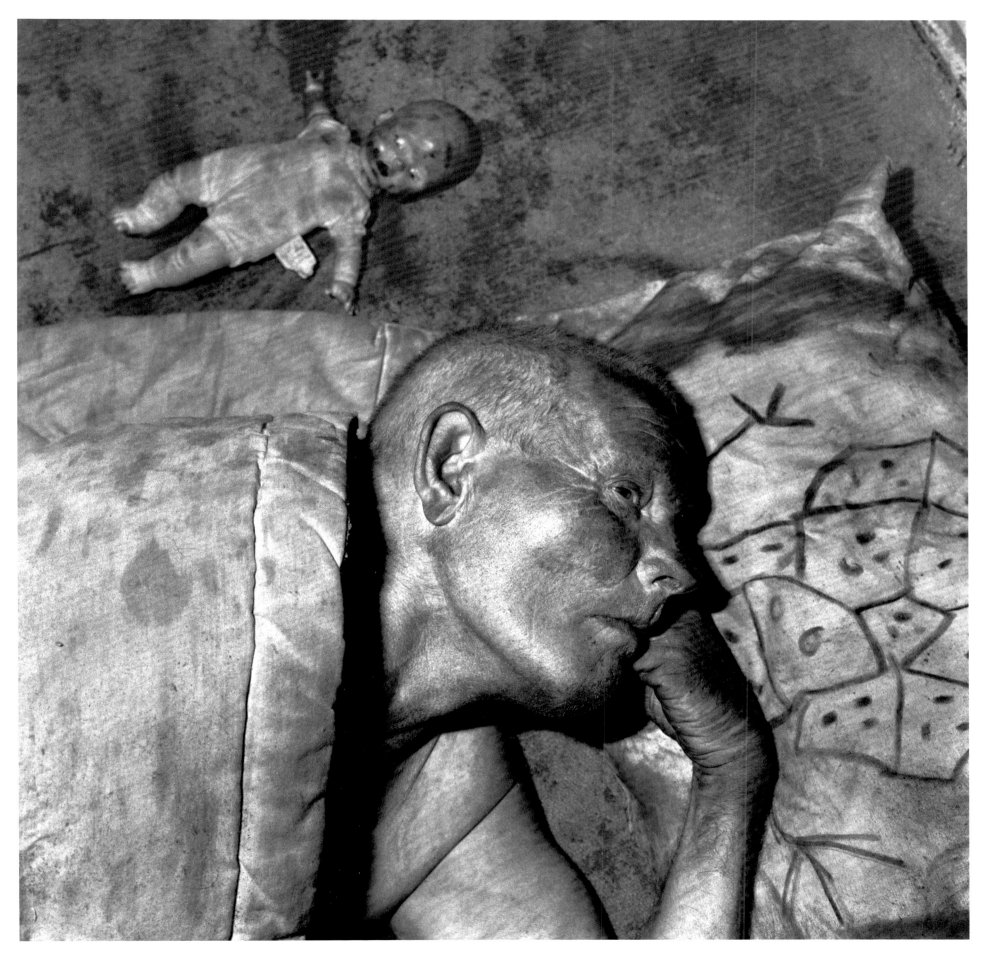

Boarder, 2005

'In *Boarding House*, the perspectives and images become more two dimensional, more avowedly pictorial though at the same time with greater violence. This is a private interior imaging the necropolis of a world outside that is only too present and too real.'

Robert J.C. Young, introduction to *Lines, Marks and Drawings*, 2013

Fist, 2007

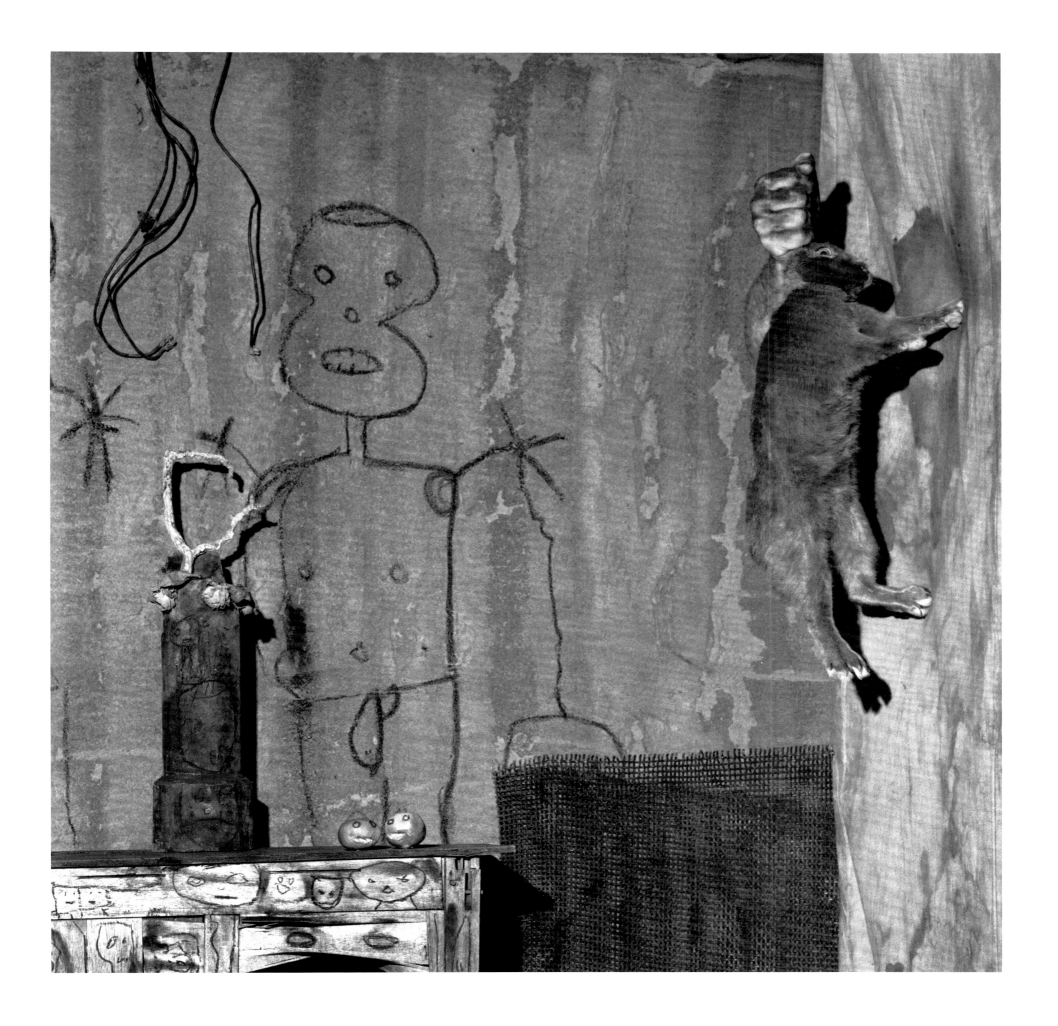

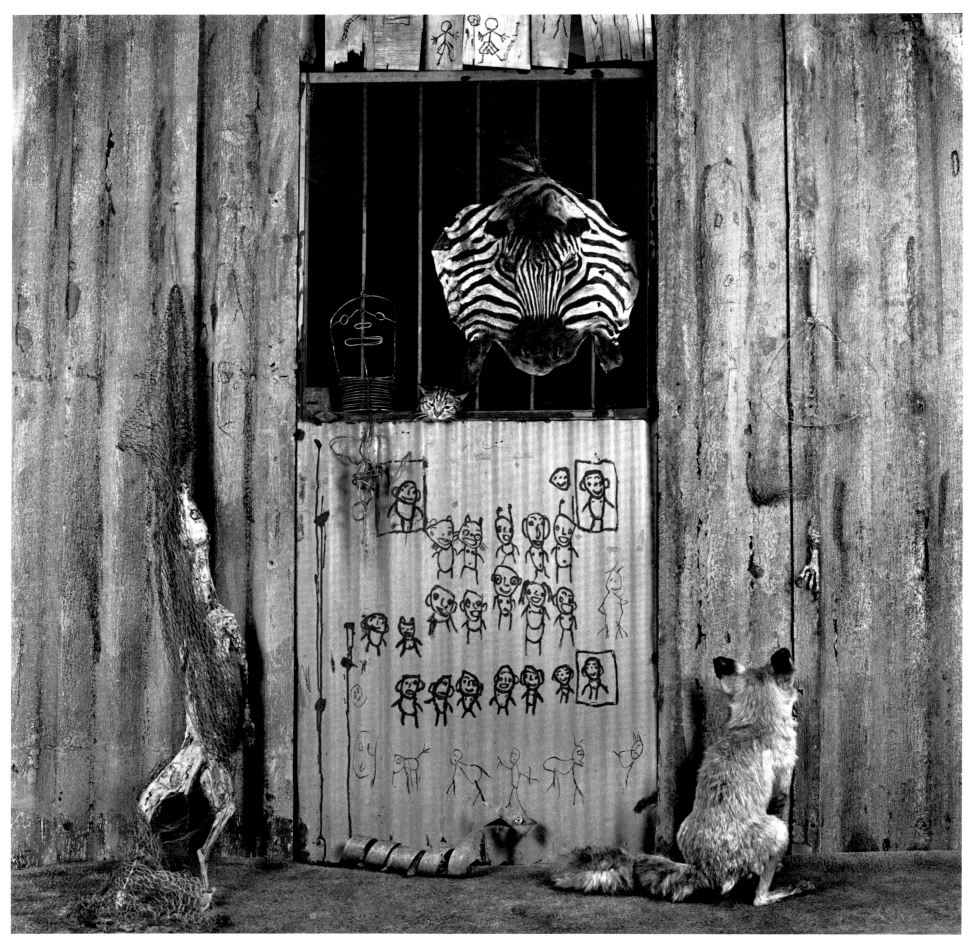

Zebra Room, 2007

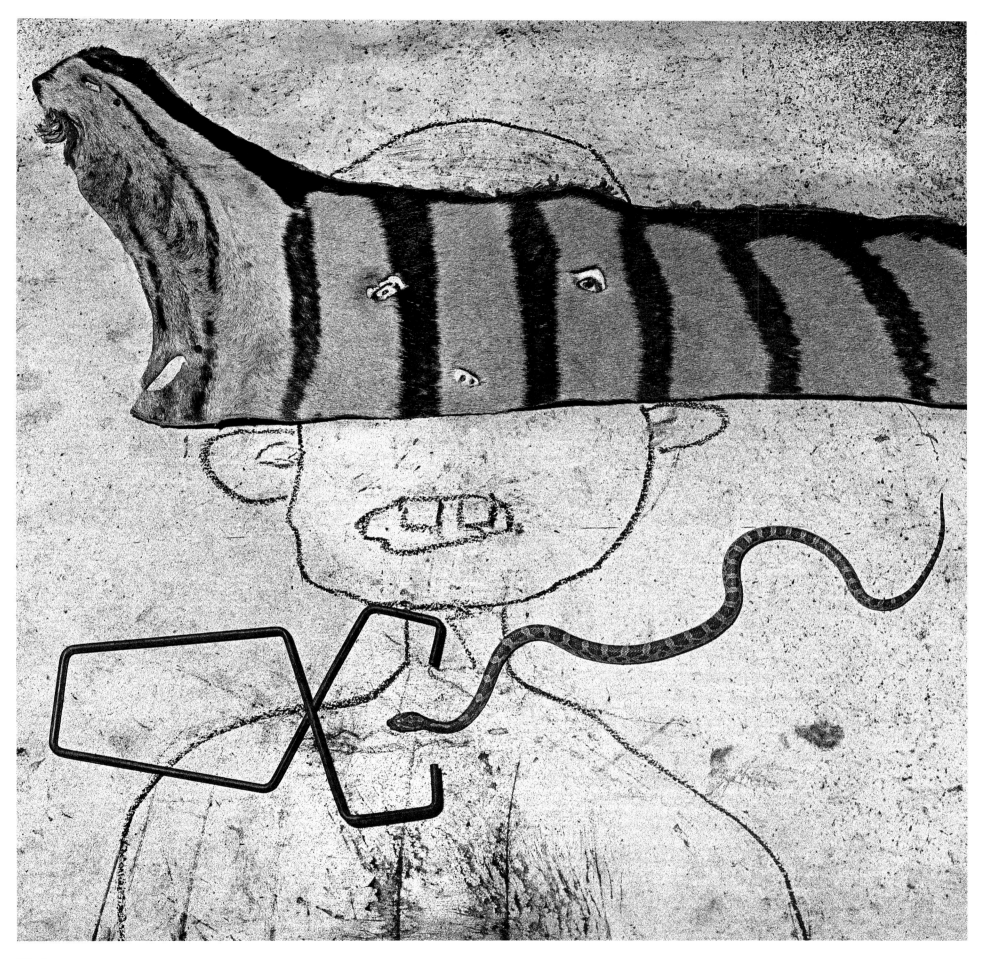

Wiggle, 2007

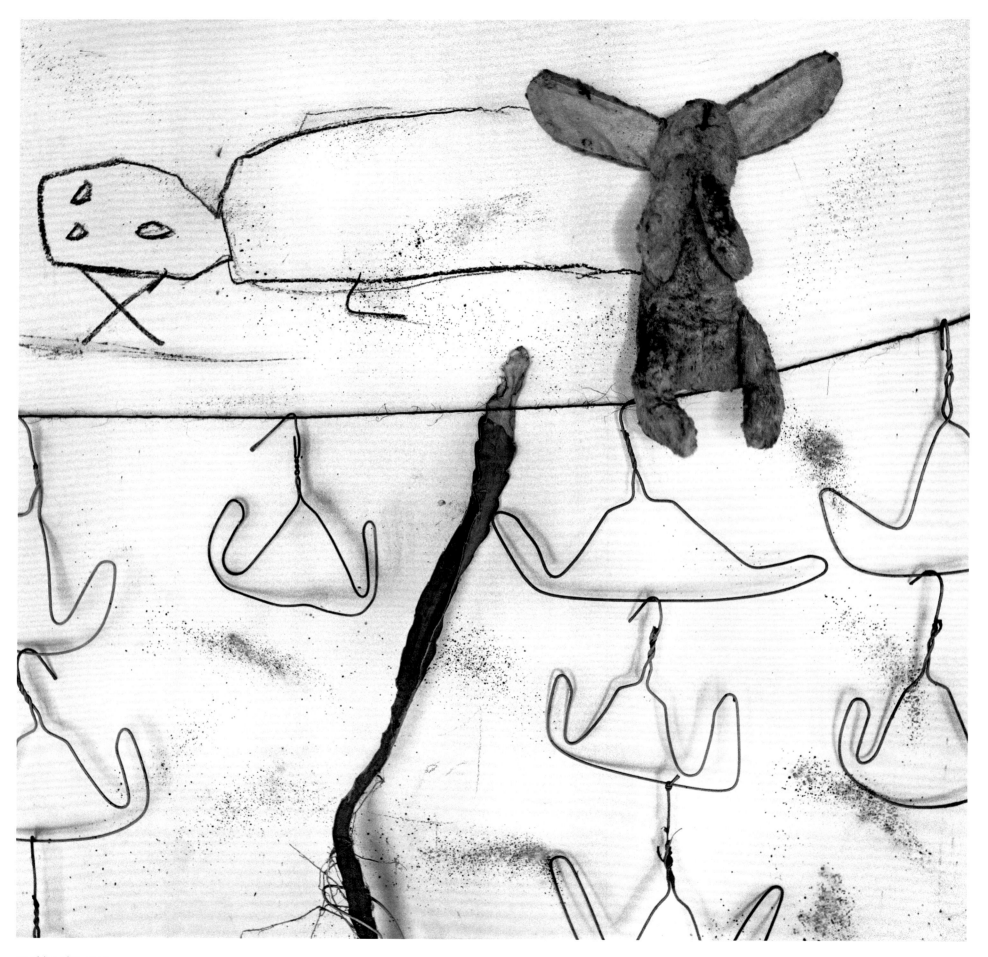

Washing Line, 2005

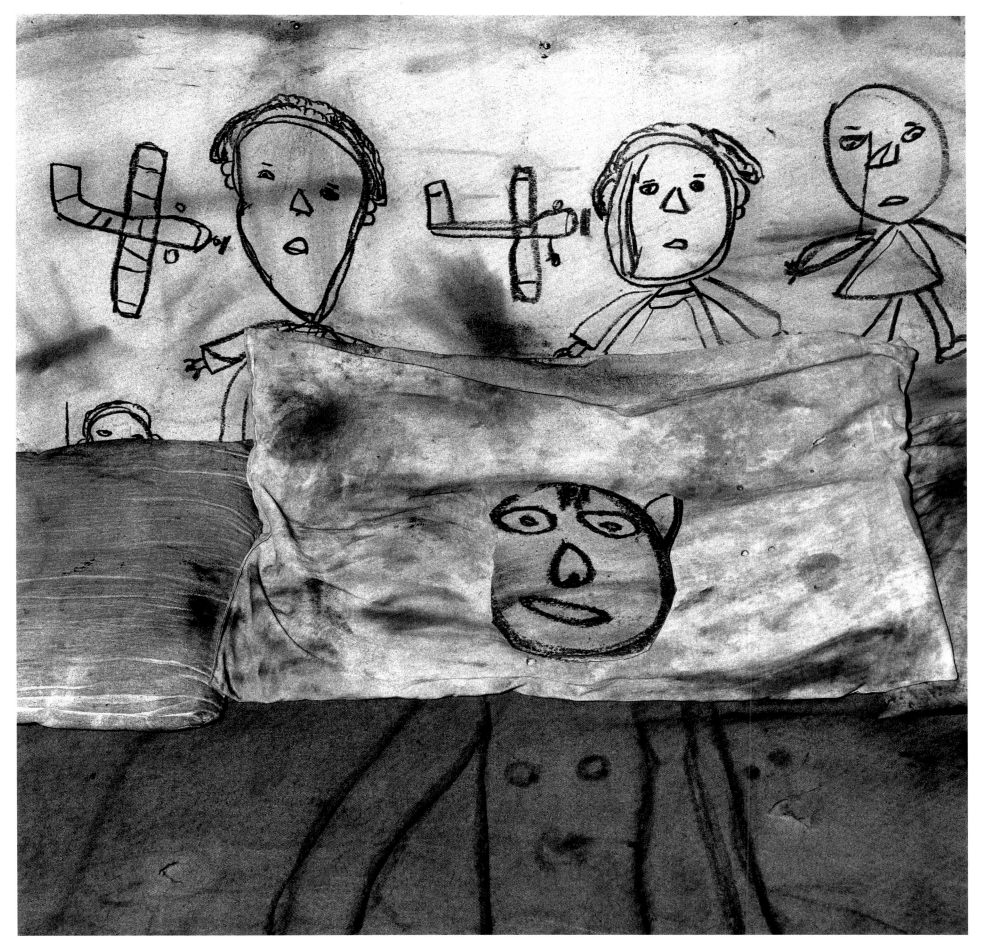

Collision, 2005

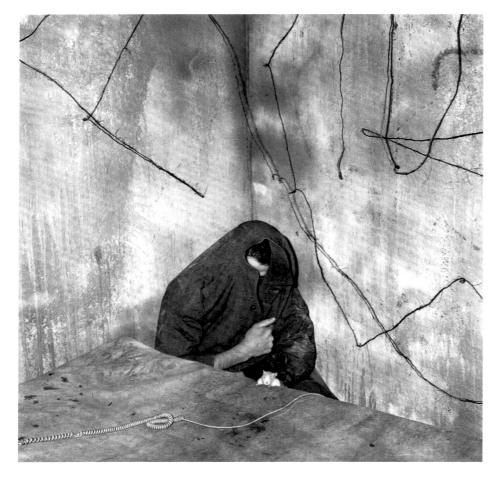
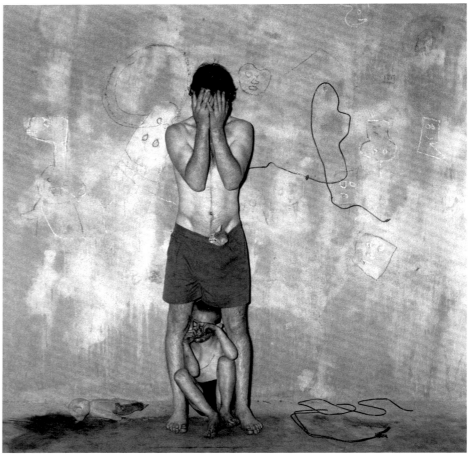
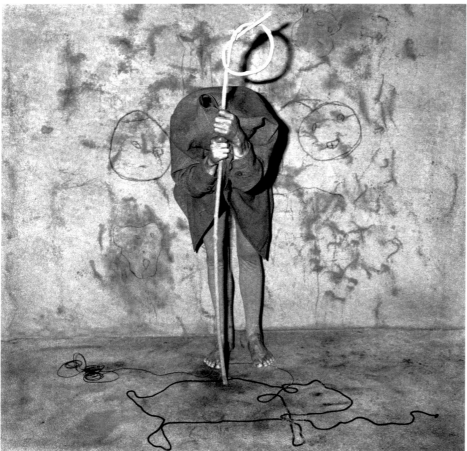
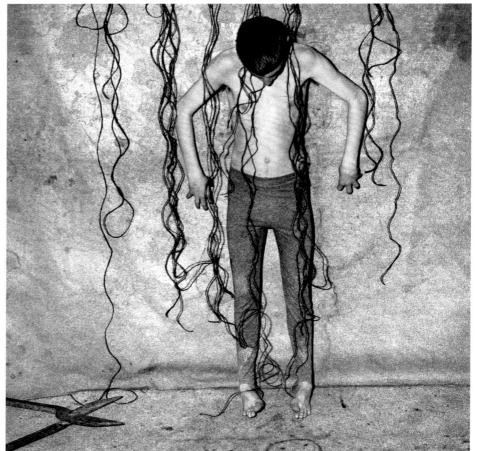

Cornered, 2004
Shepherd, 2004

Concealed, 2005
Cut Loose, 2003

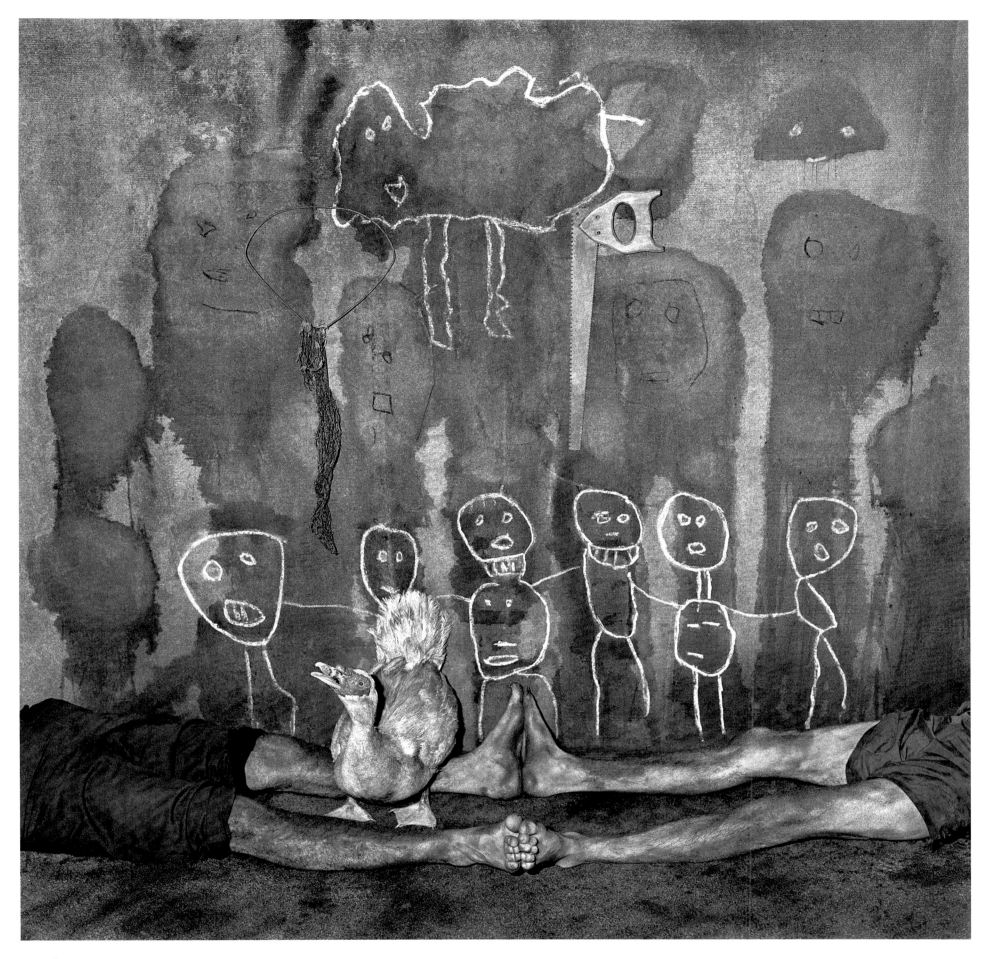

Squawk, 2005

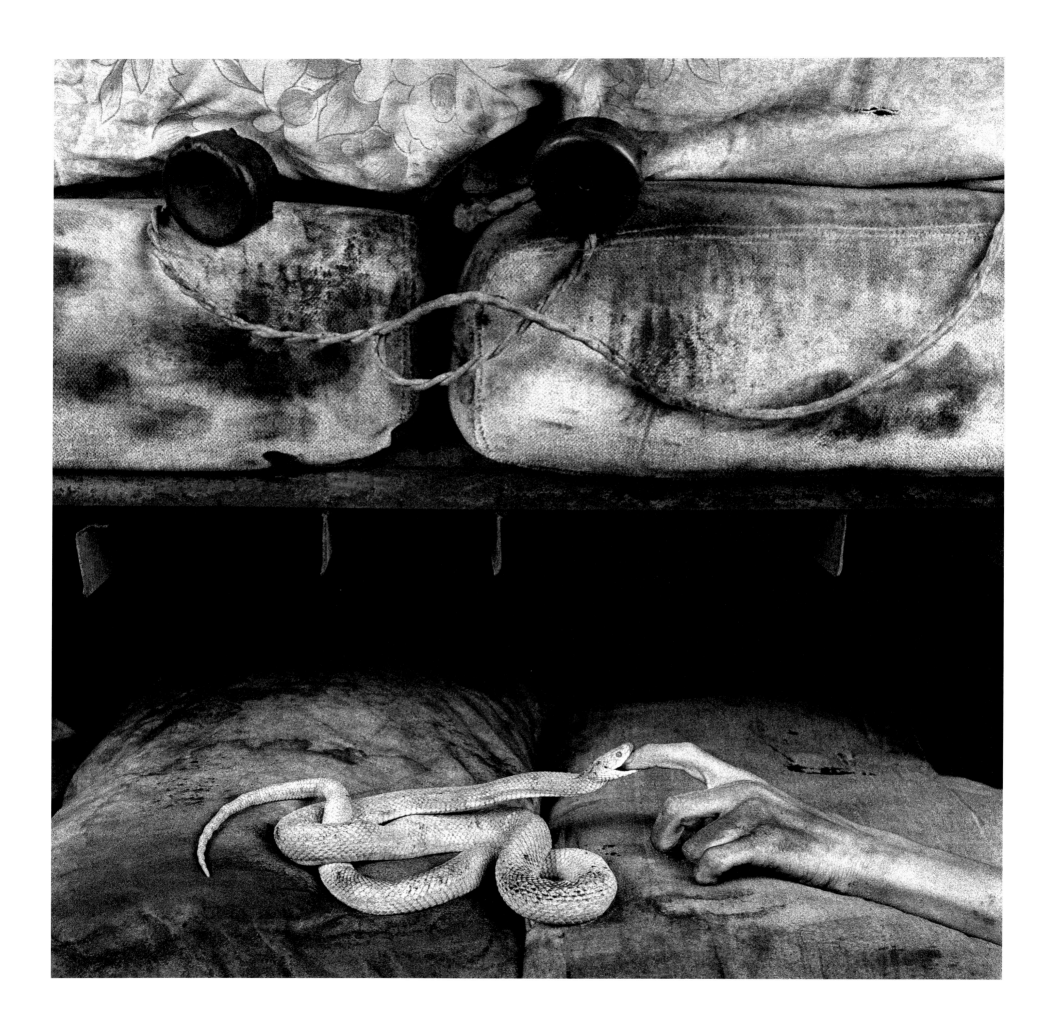

The boy in the photograph *Bite* decided to put his finger in the snake's mouth and, to his chagrin, received a nasty bite, for which he had to be taken to hospital. Most people who hear this story feel sorry for the boy. Almost no one thinks about the snake's feelings – about what it must be like to have a finger stuck down your throat.

Bite, 2007

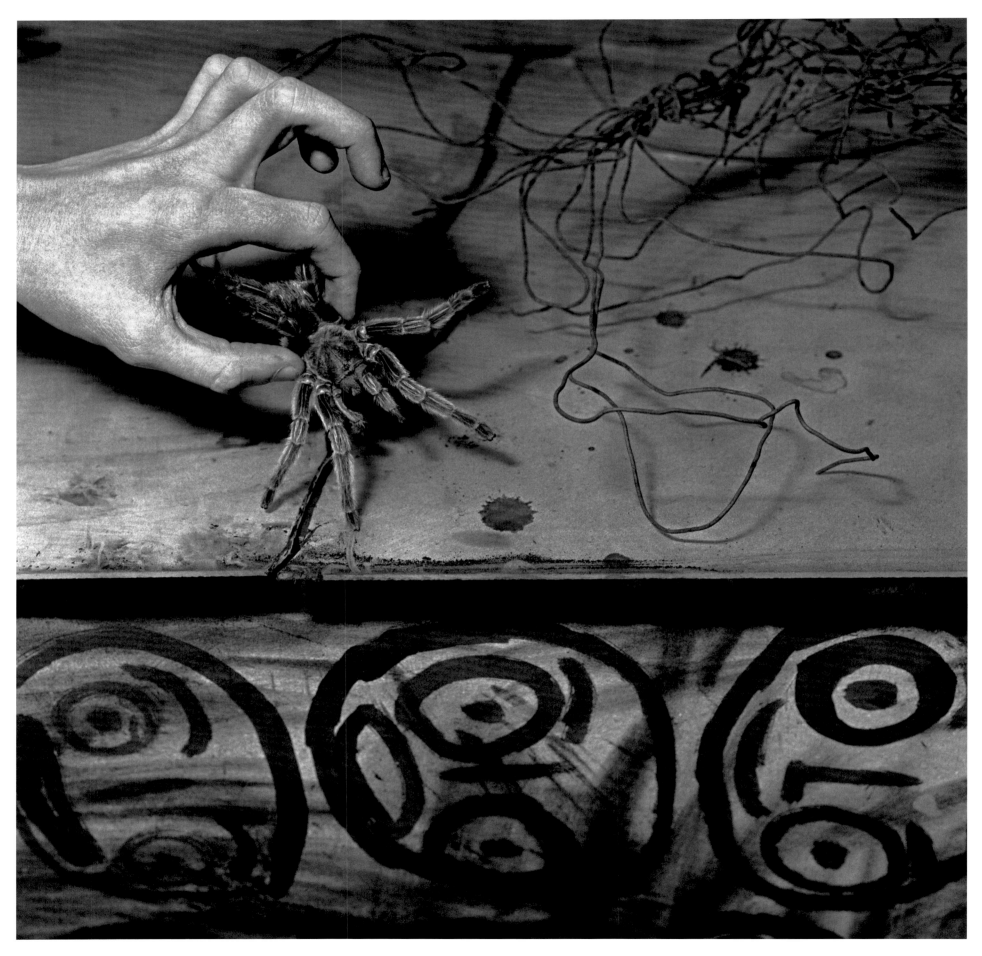

Pinched, 2006

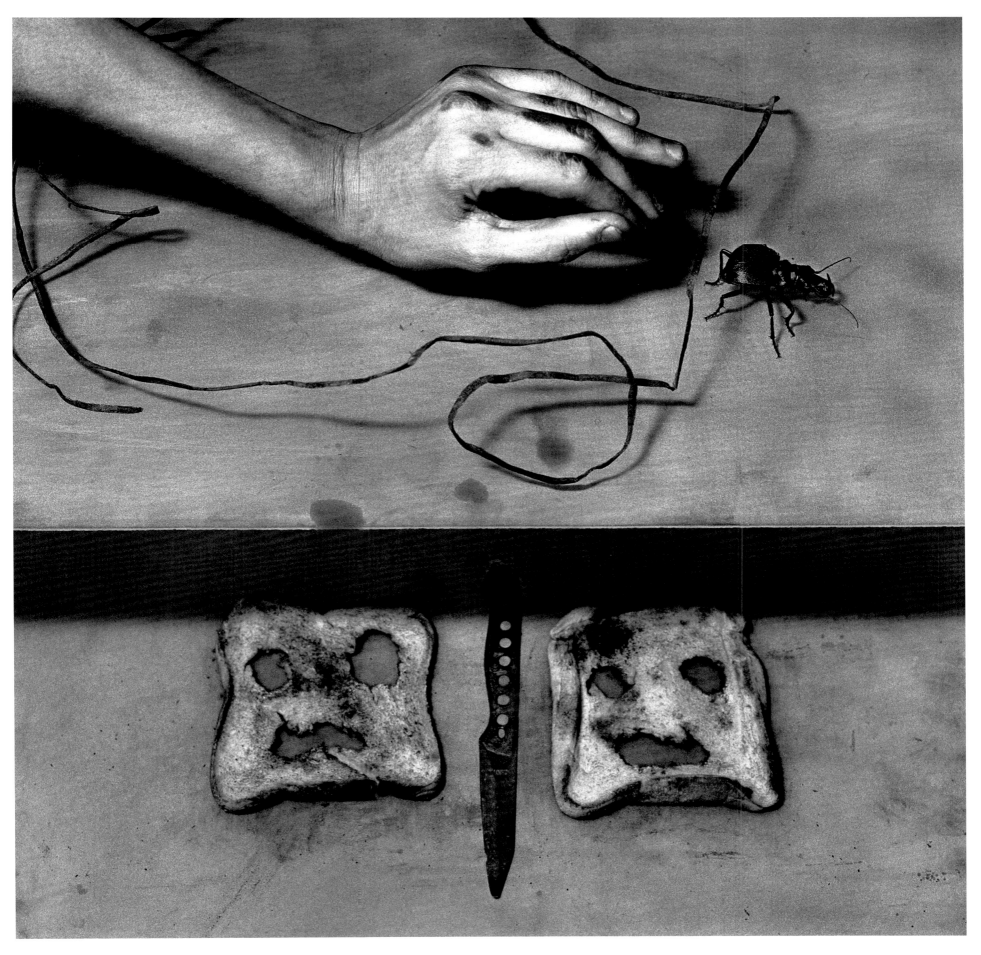

Culprit, 2006

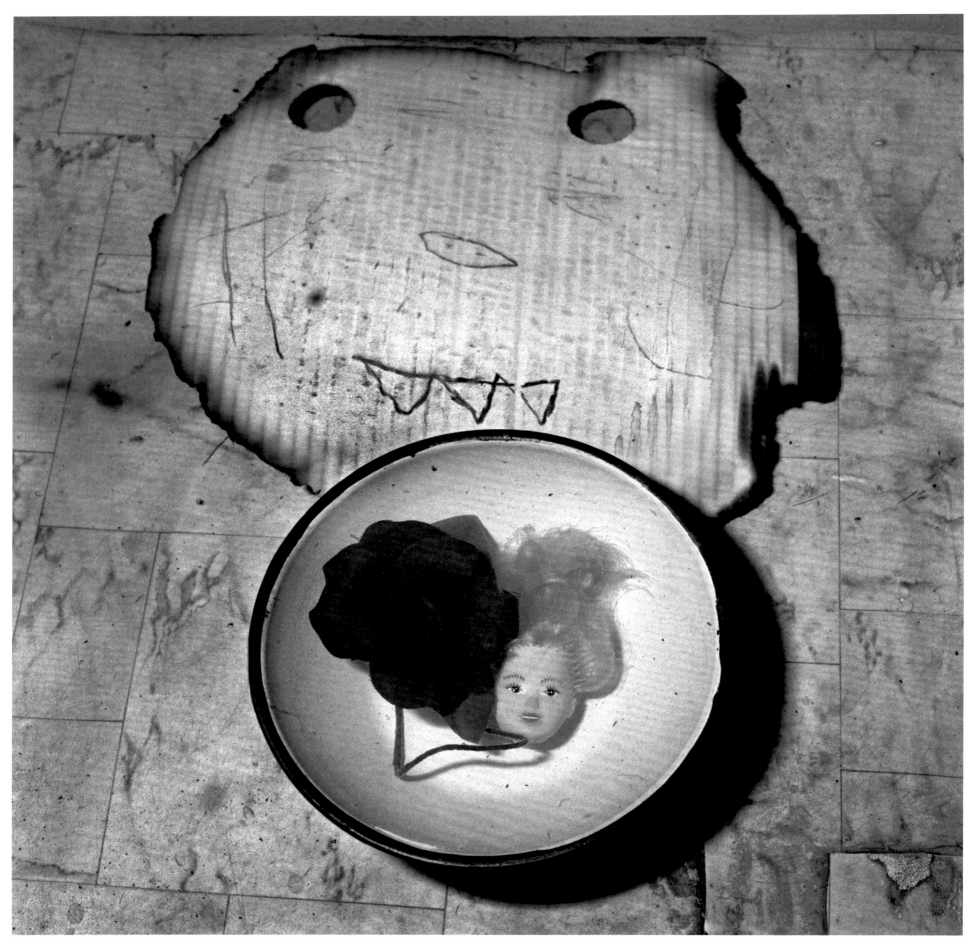

Memories, 2006

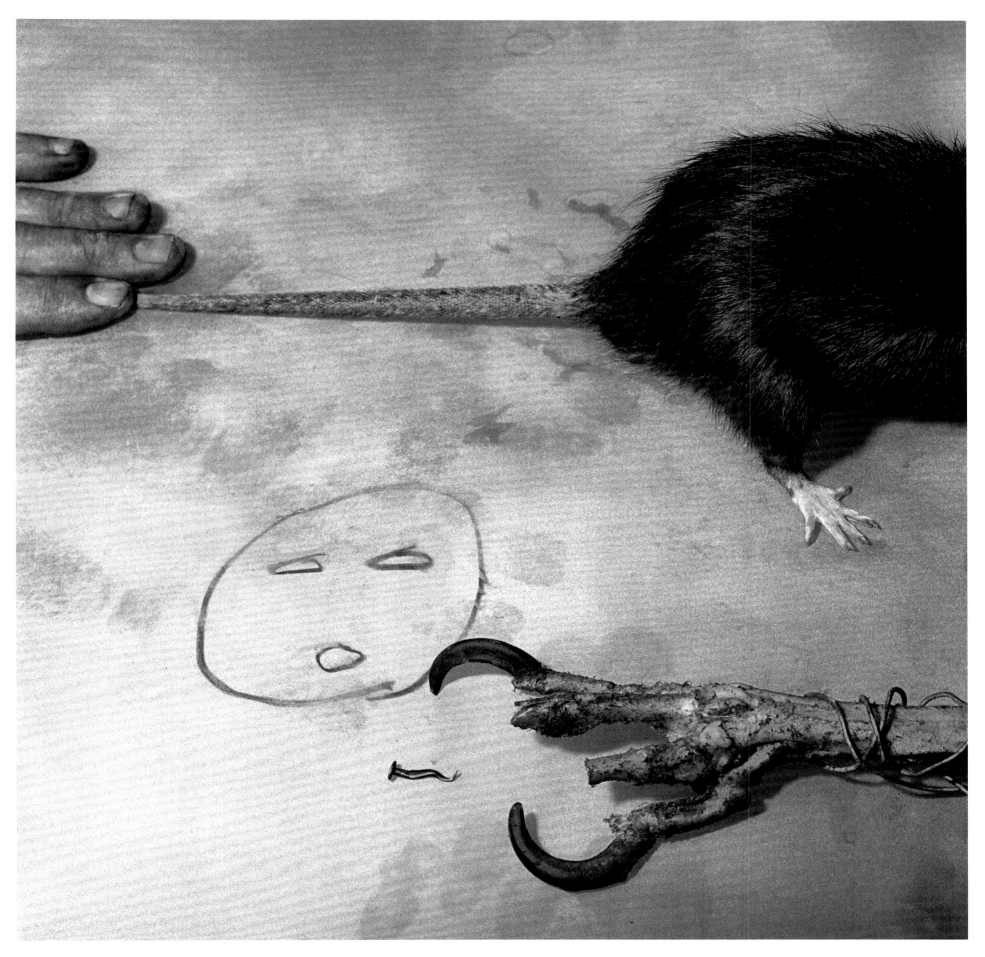

Predators, 2007

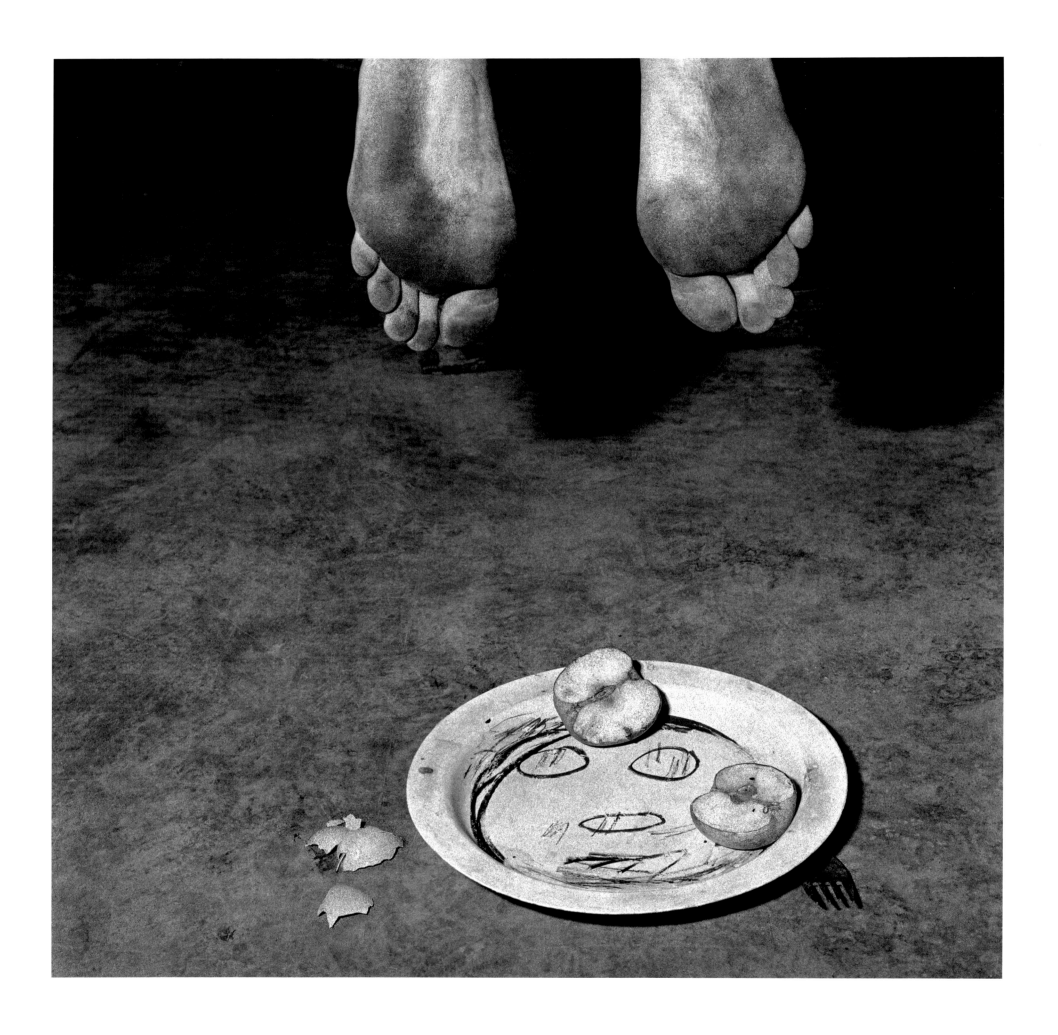

One of the young men who lived in the
Boarding House would often assist me with
various odds and ends. He was an orphan and
was very diligent and helpful. One day I heard
that those in charge had decided for some
unknown reason that he had to vacate the
premises. I arrived a few days later and found
to my dismay that he had committed suicide.

Fragments, 2005

asylum of the birds, 2014

'The imagination finds more reality in
what hides itself than in what shows itself.'

Gaston Bachelard

Headless, 2006

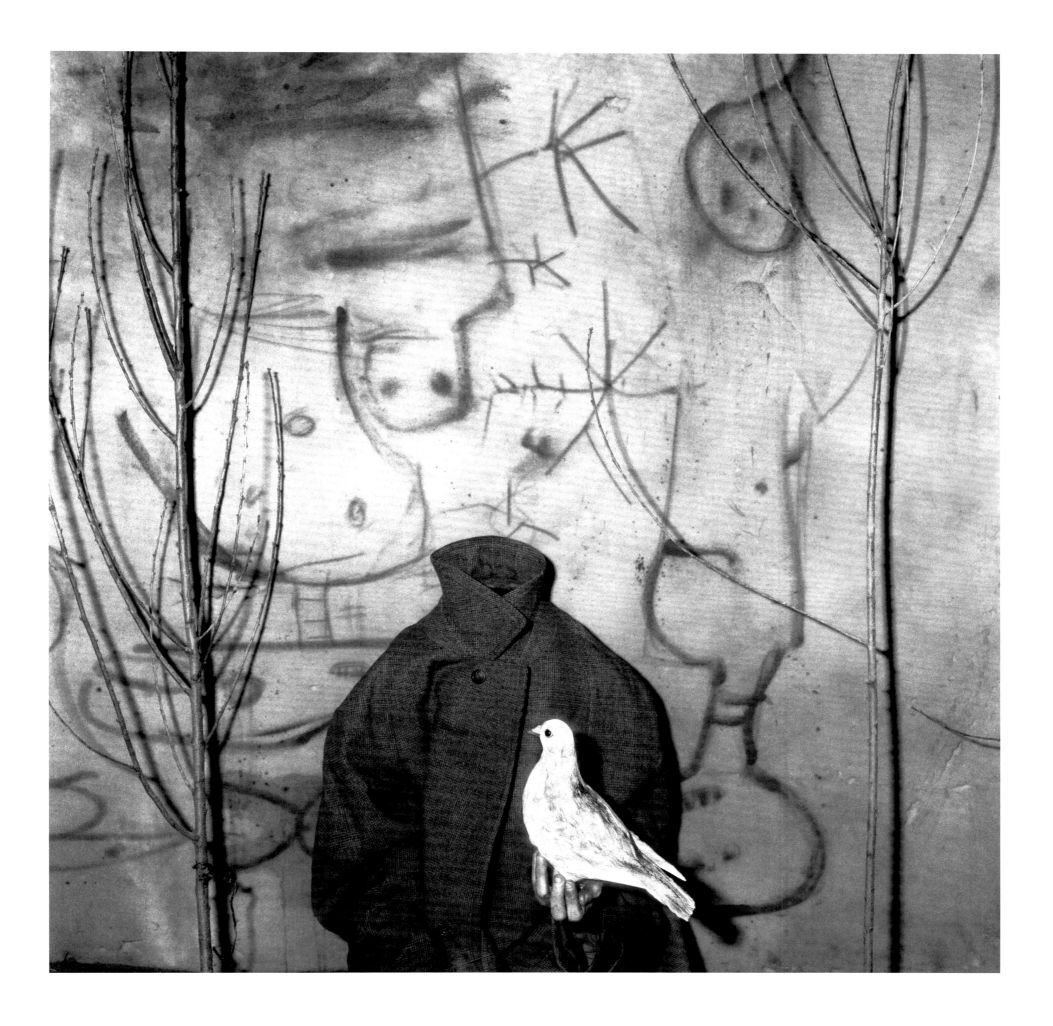

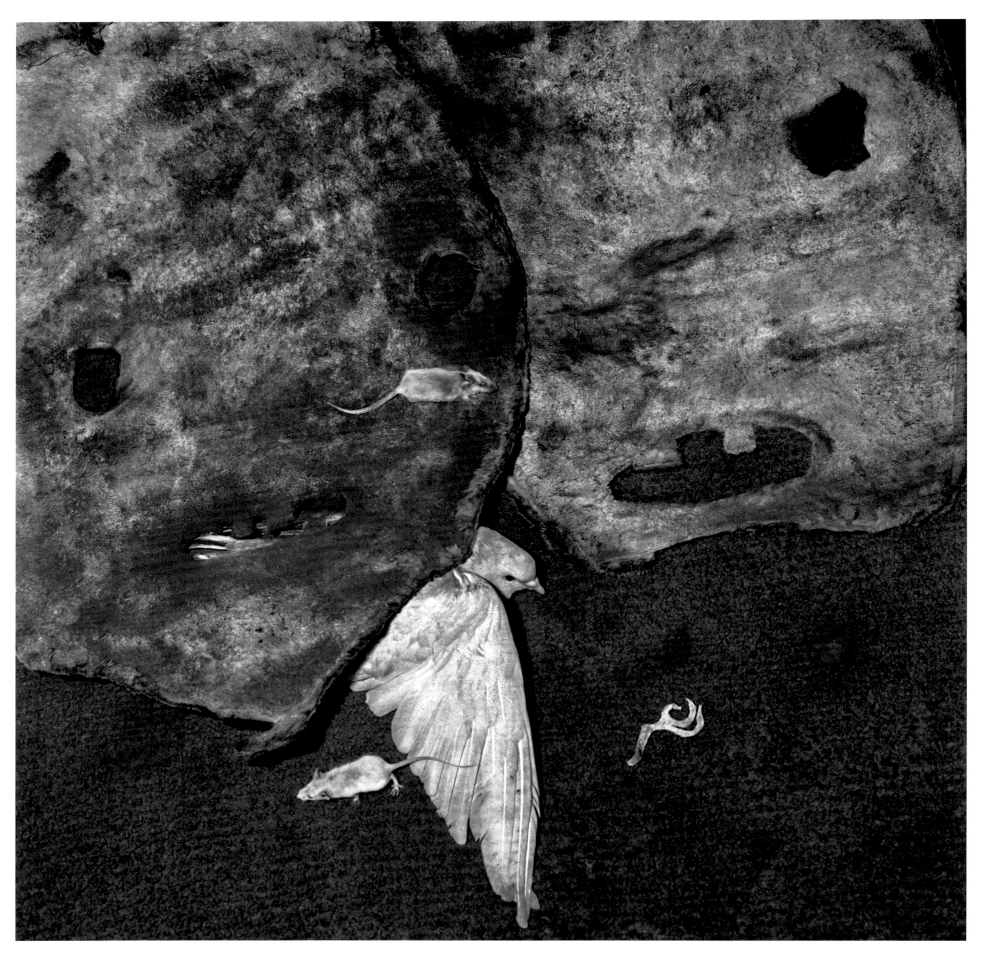

Impounded, 2006

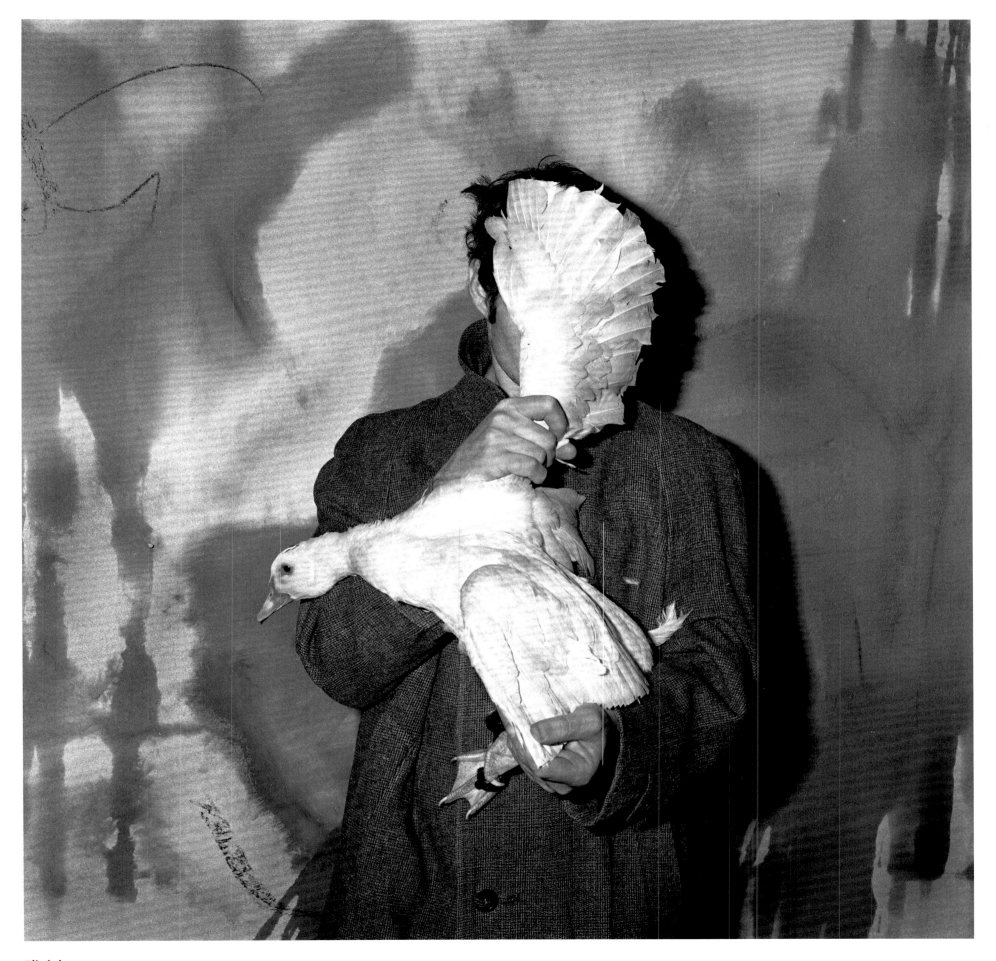

Blinded, 2005

The black-and-white images featured in *Asylum of the Birds* were photographed within the confines of a house in a Johannesburg suburb. Looking back, the image of a disorientated dove against a wall, *Five Hands*, was the starting point for the project. From this time on, birds were no longer confined to the heavens, but to a space dominated by chaos, ambiguity, violence and death.

Five Hands, 2006

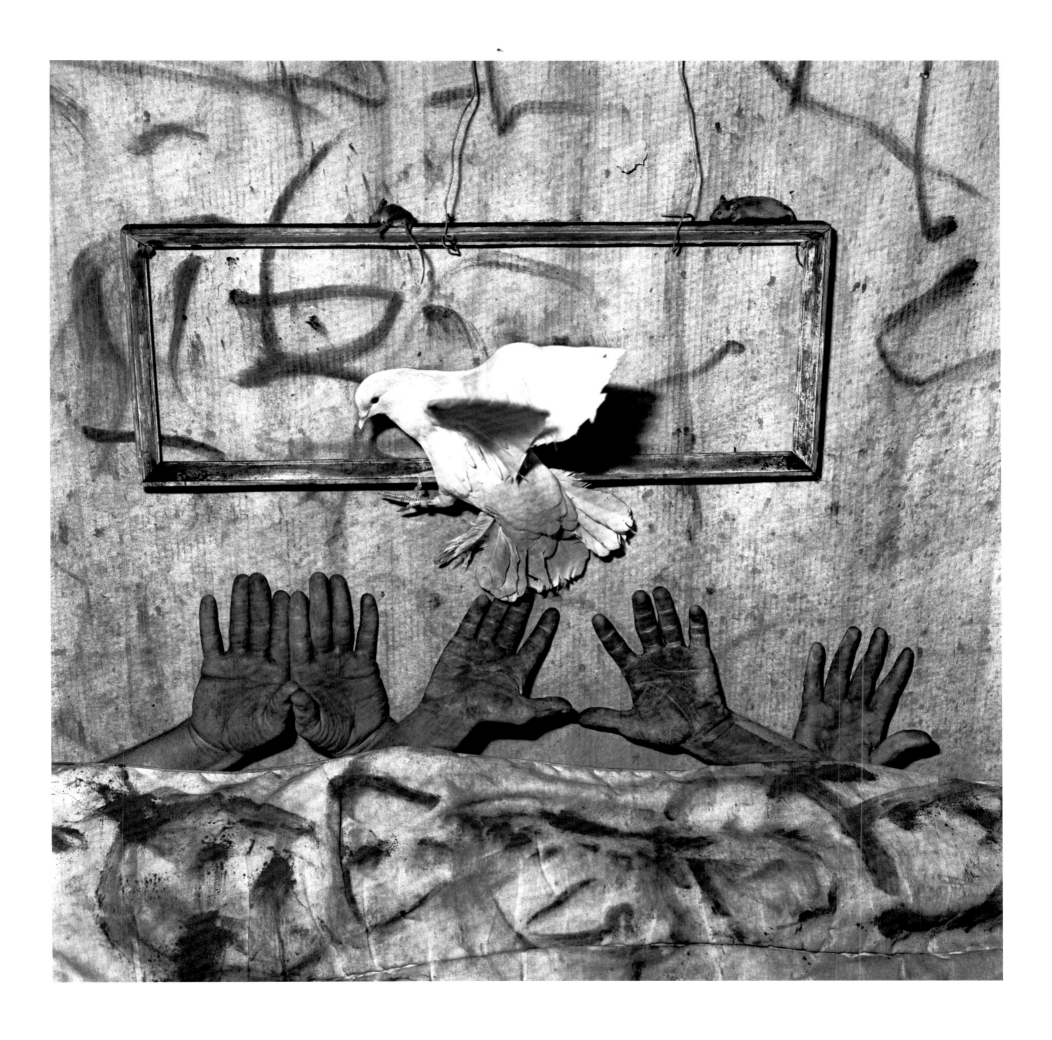

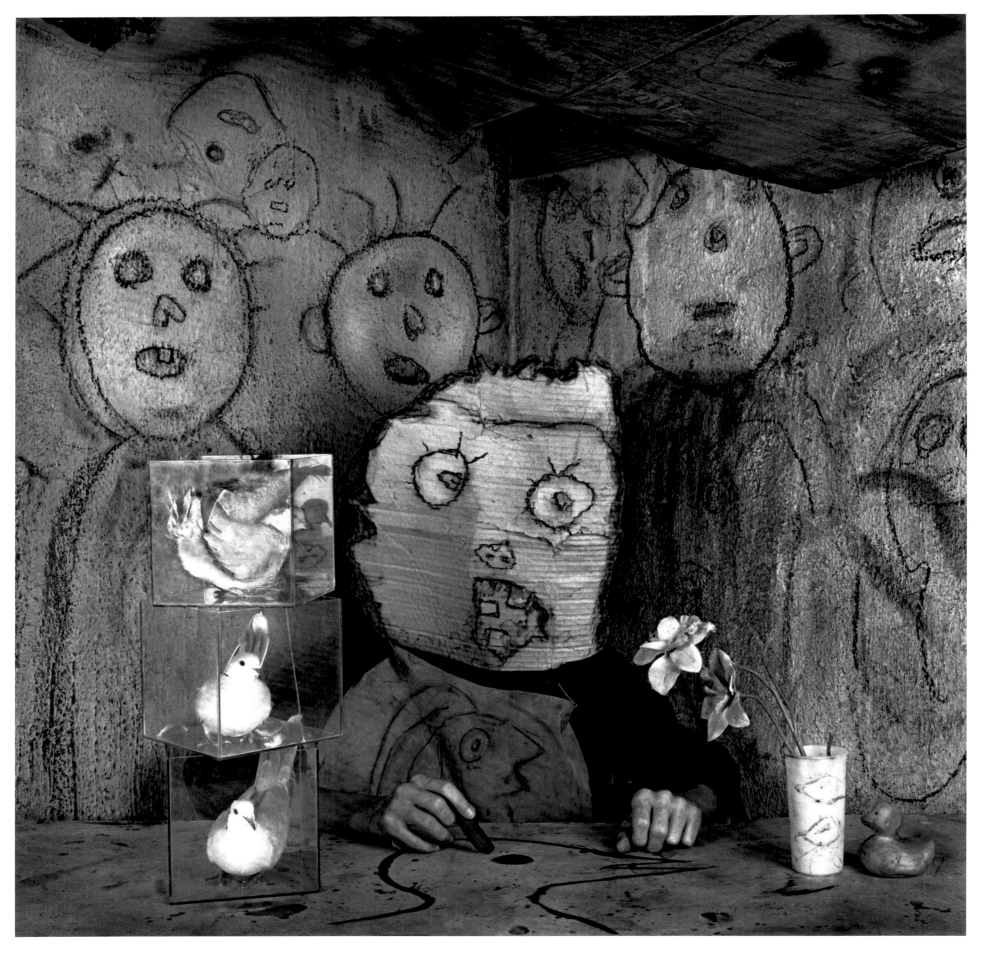

Artist, 2013

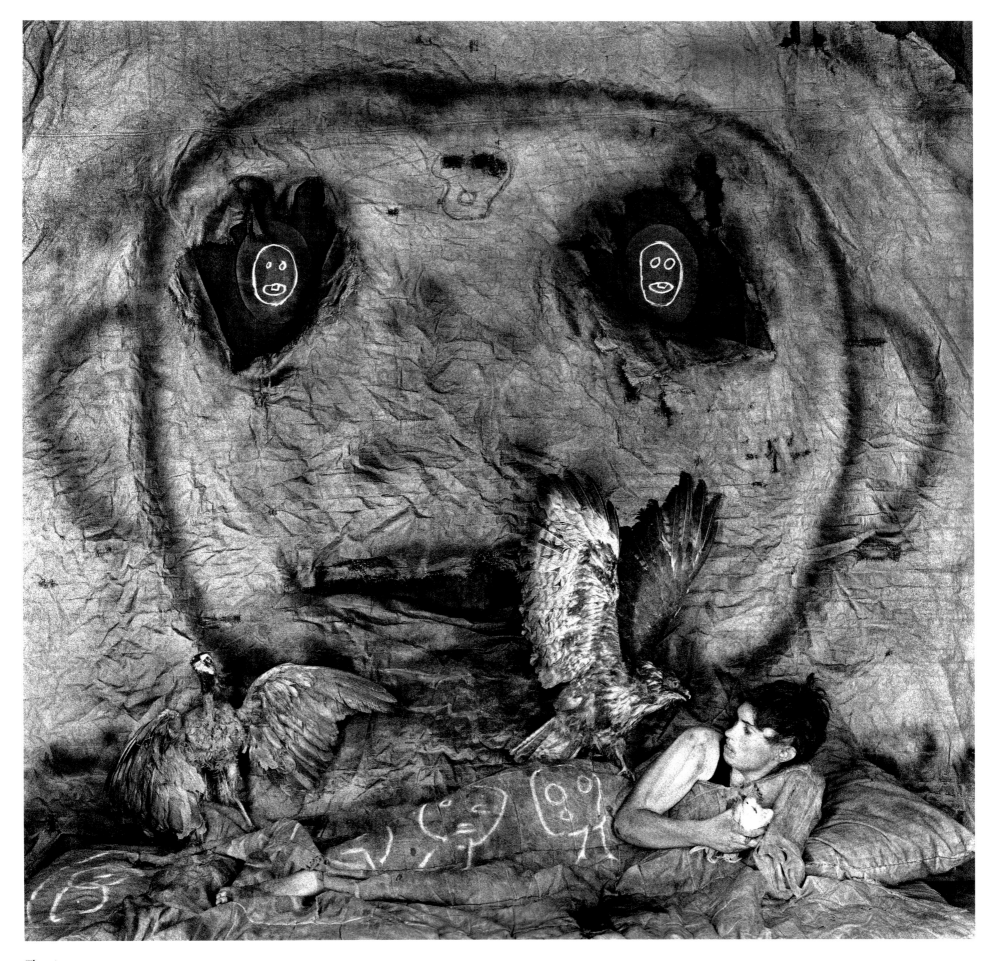

Threat, 2010

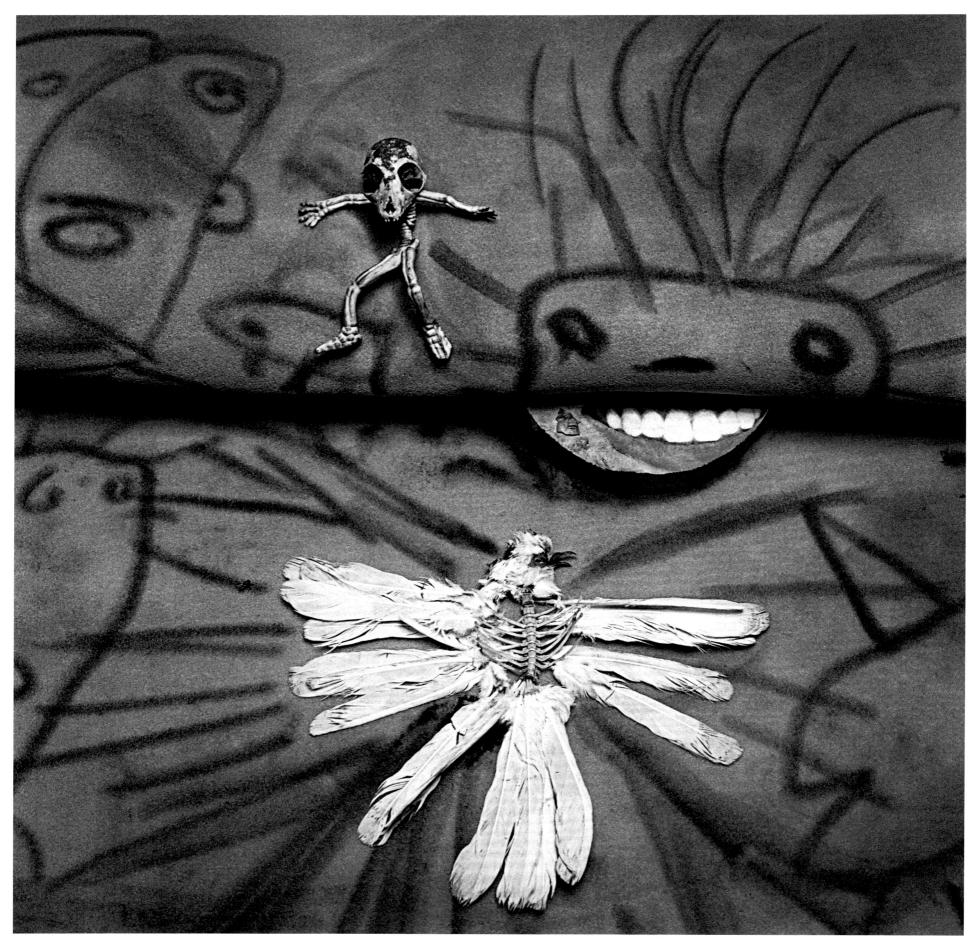

Smirk, 2009

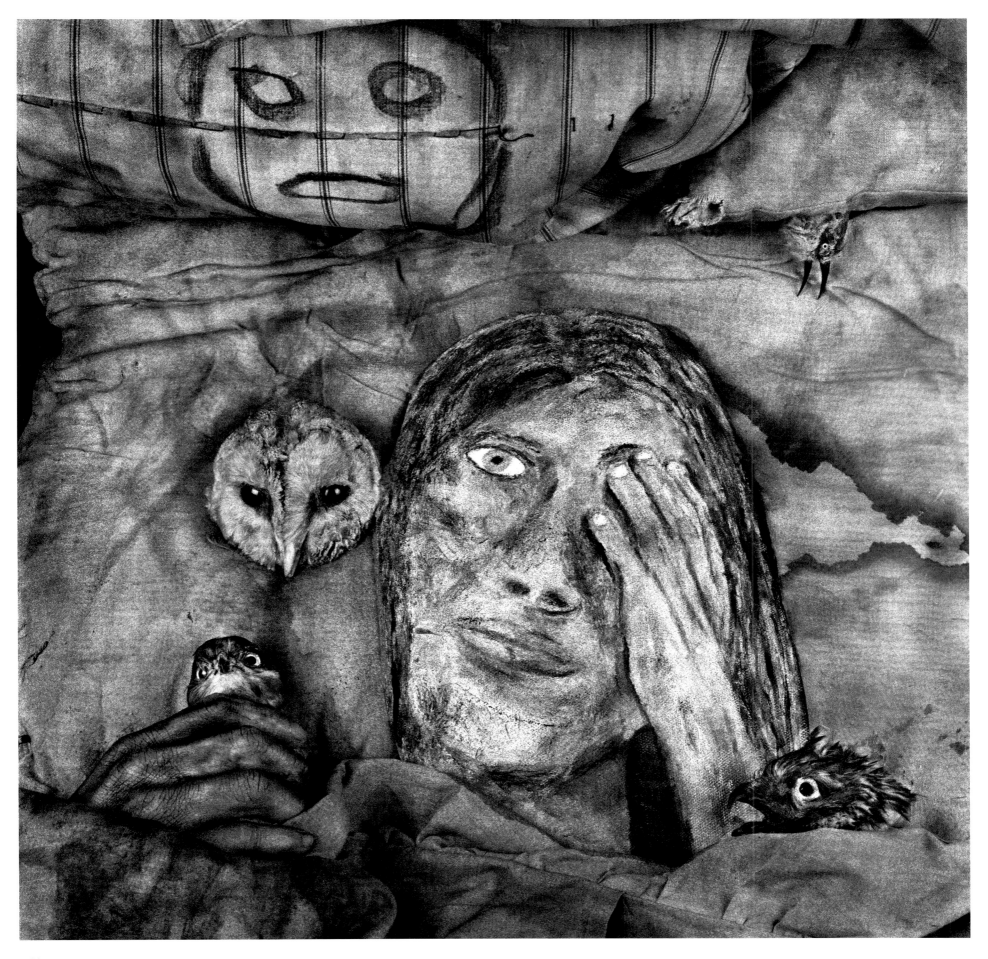

White Eye, 2011

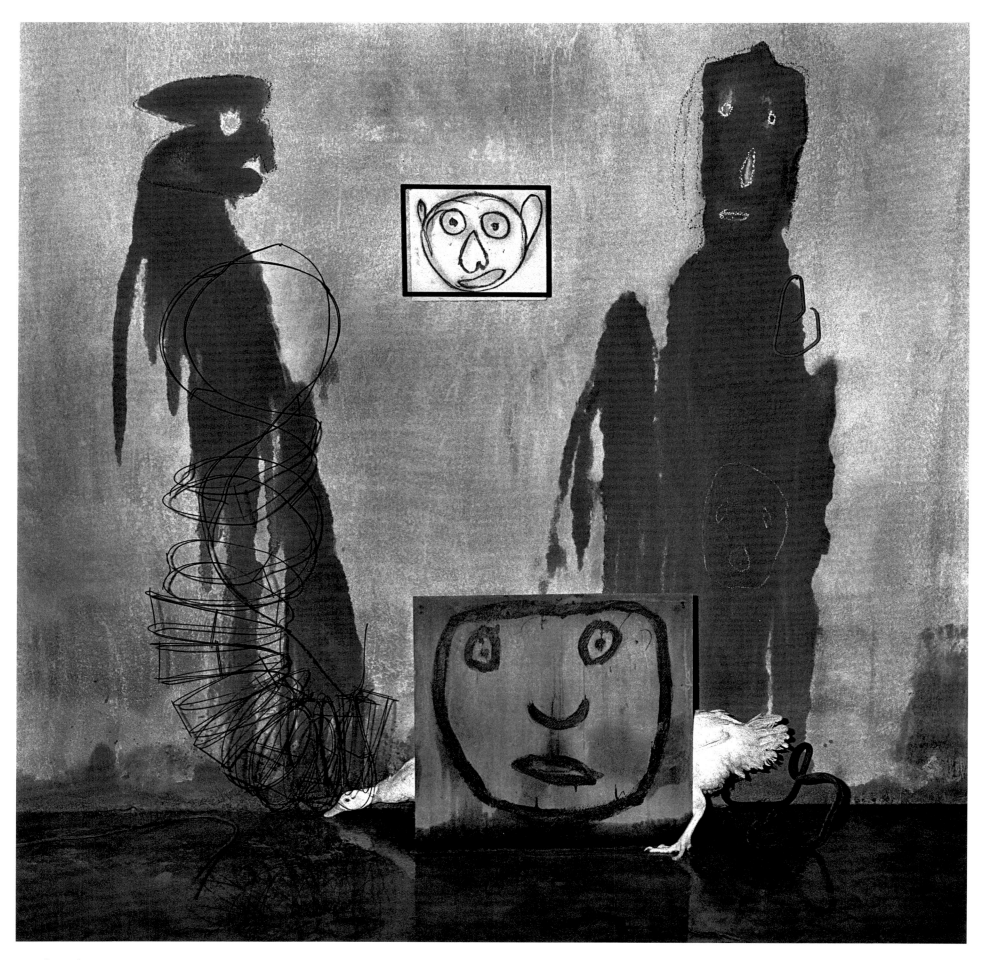

Transformation, 2004

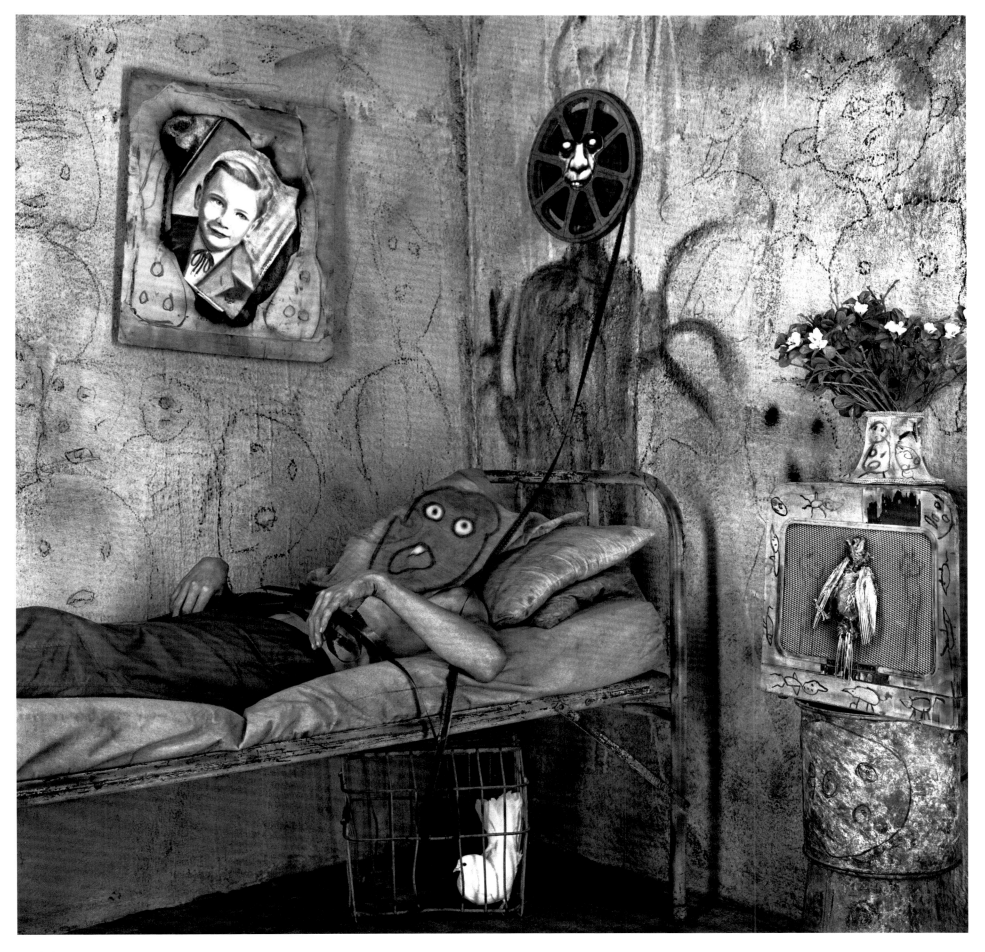

Unwind, 2013

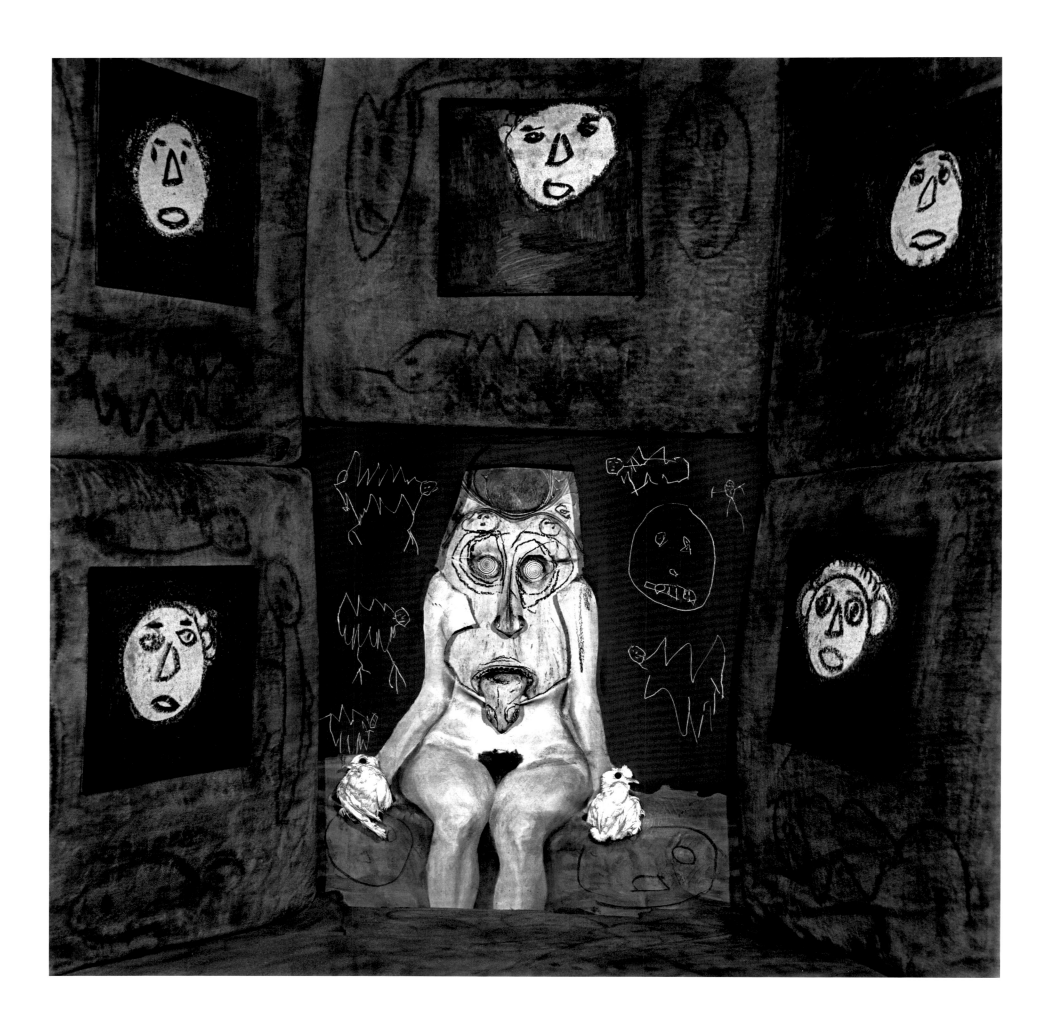

When I create photographs, I often travel
deep into my own interior, a place where my
dreams and many of my images originate.
I see my photographs as mirrors, reflectors,
connecters that challenge the mind.

Serpent Lady, 2009

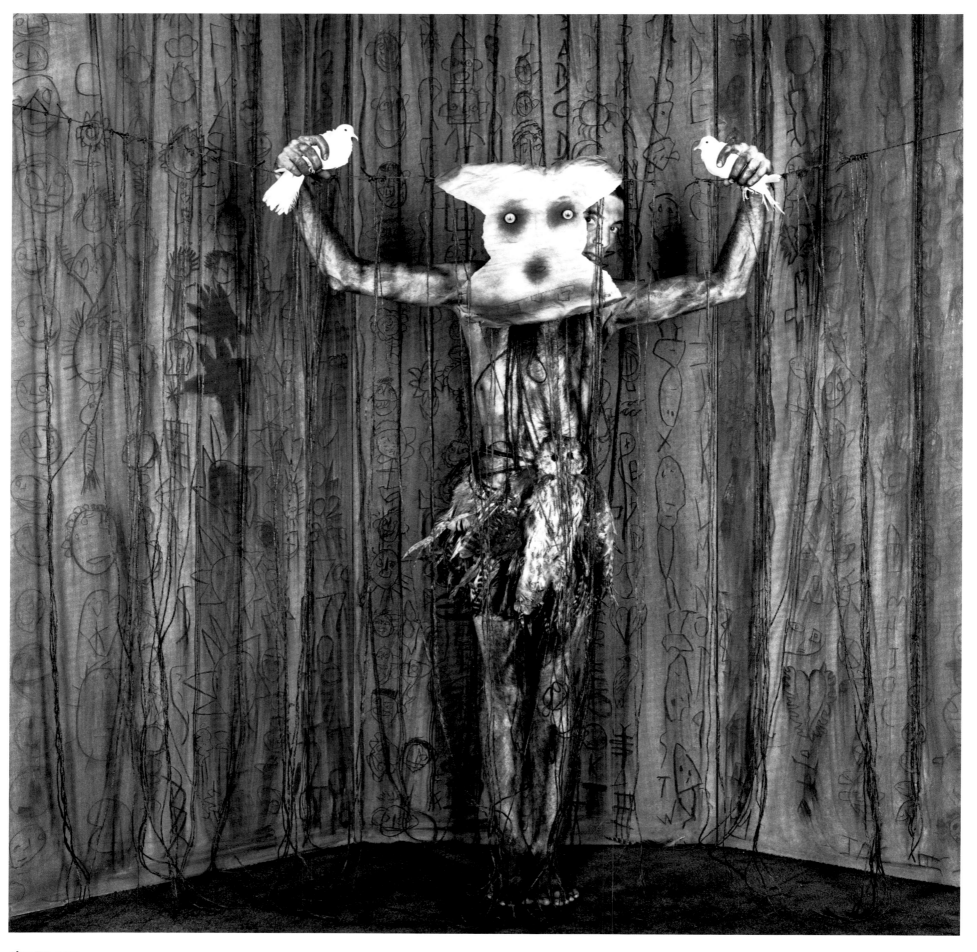

Alter Ego, 2010

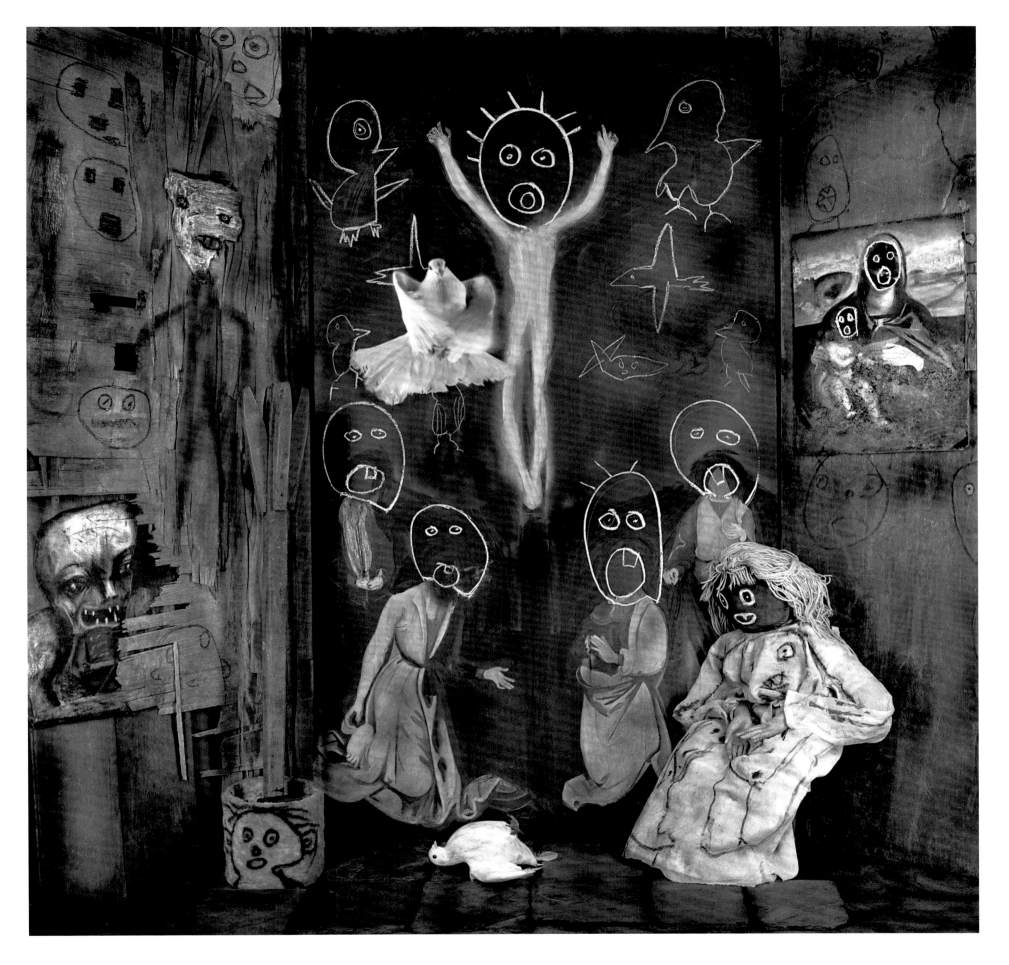

Ascension, 2013

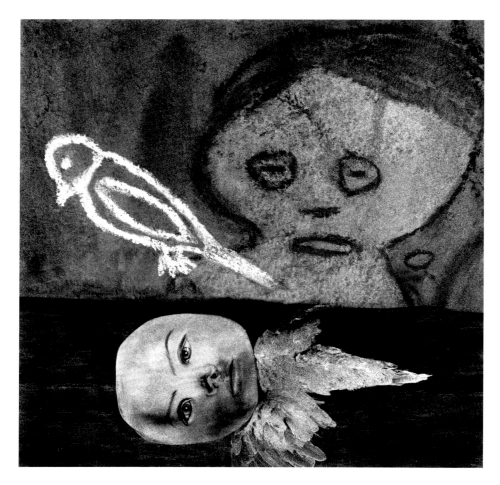

Ethereal, 2011

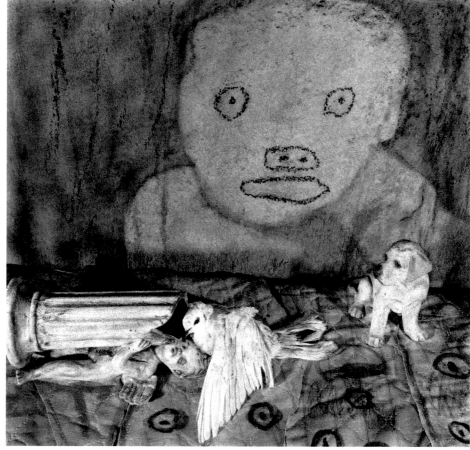

Befallen, 2011

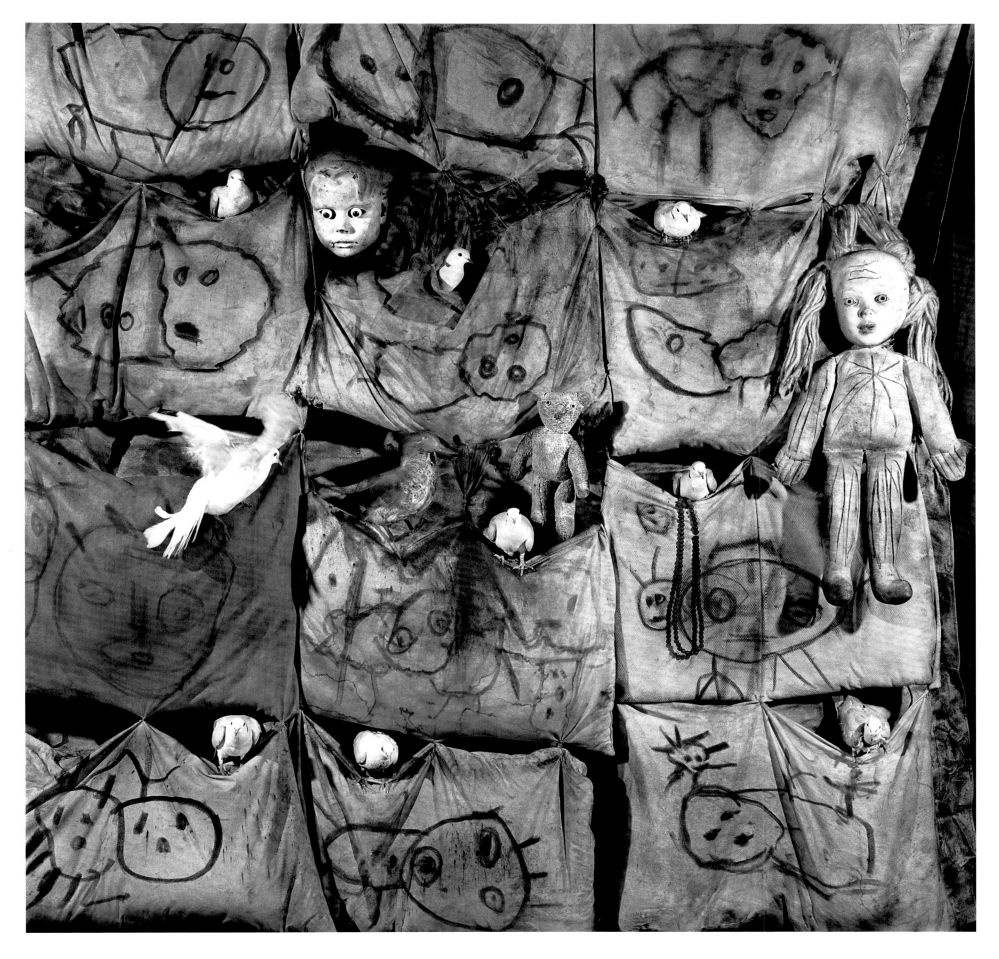

Nine Birds, 2009

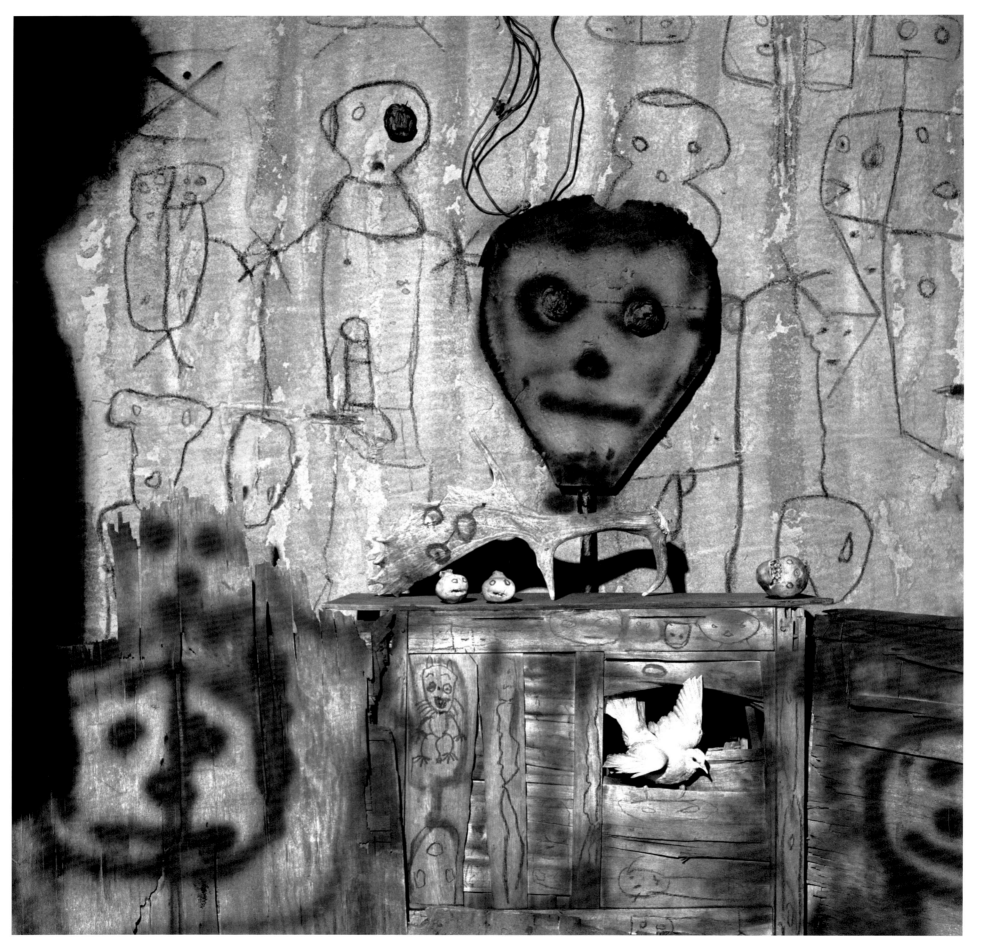

Backroom, 2007

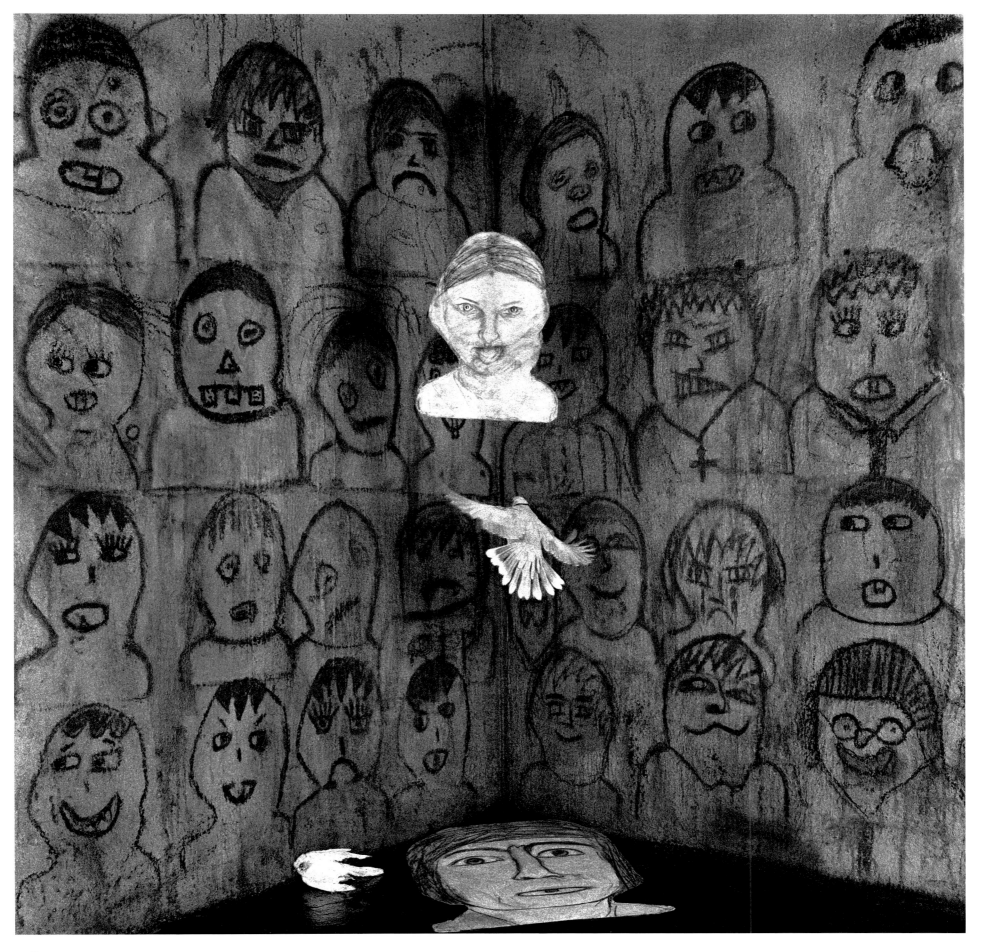

Audience, 2011

245

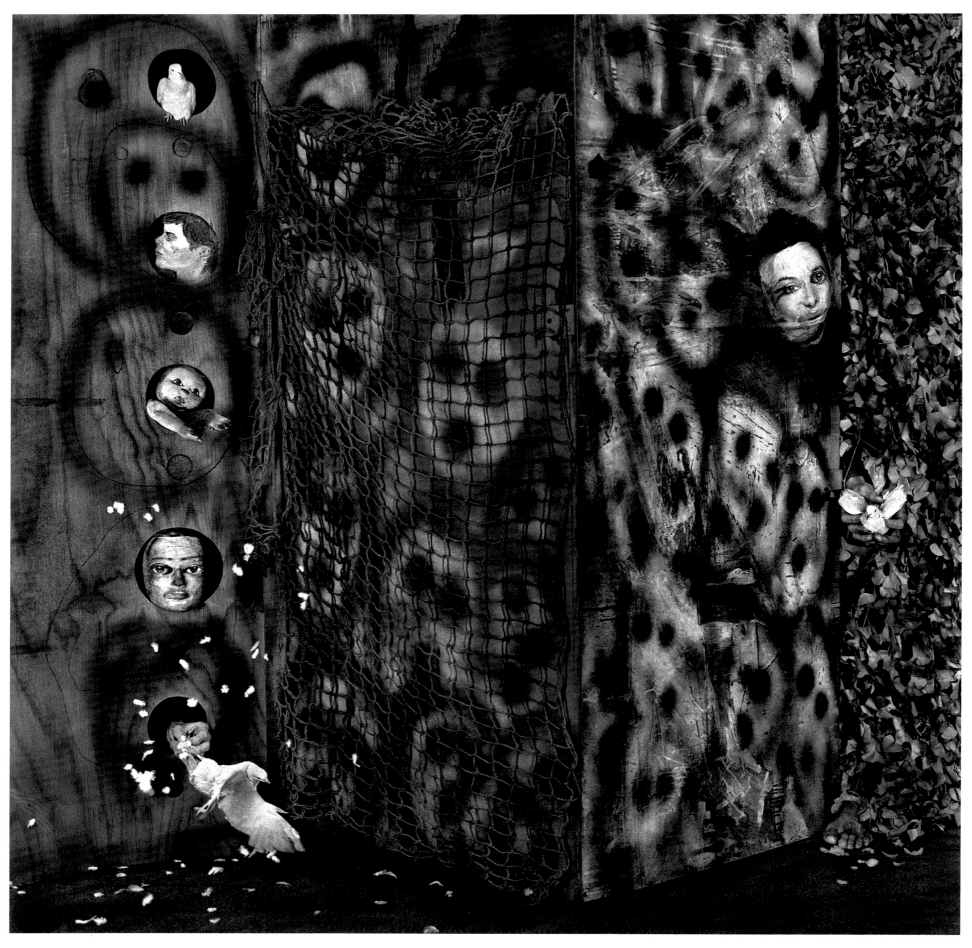

Ambushed, 2010

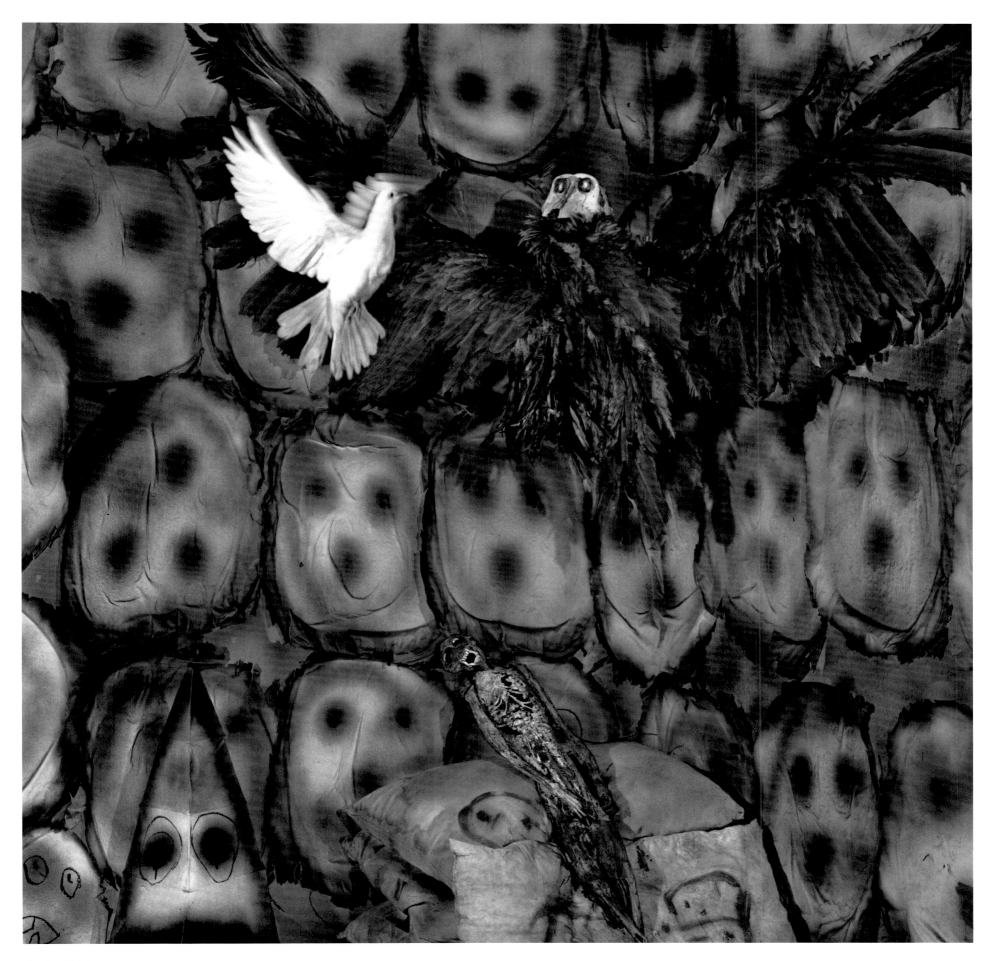

Good and Evil, 2009

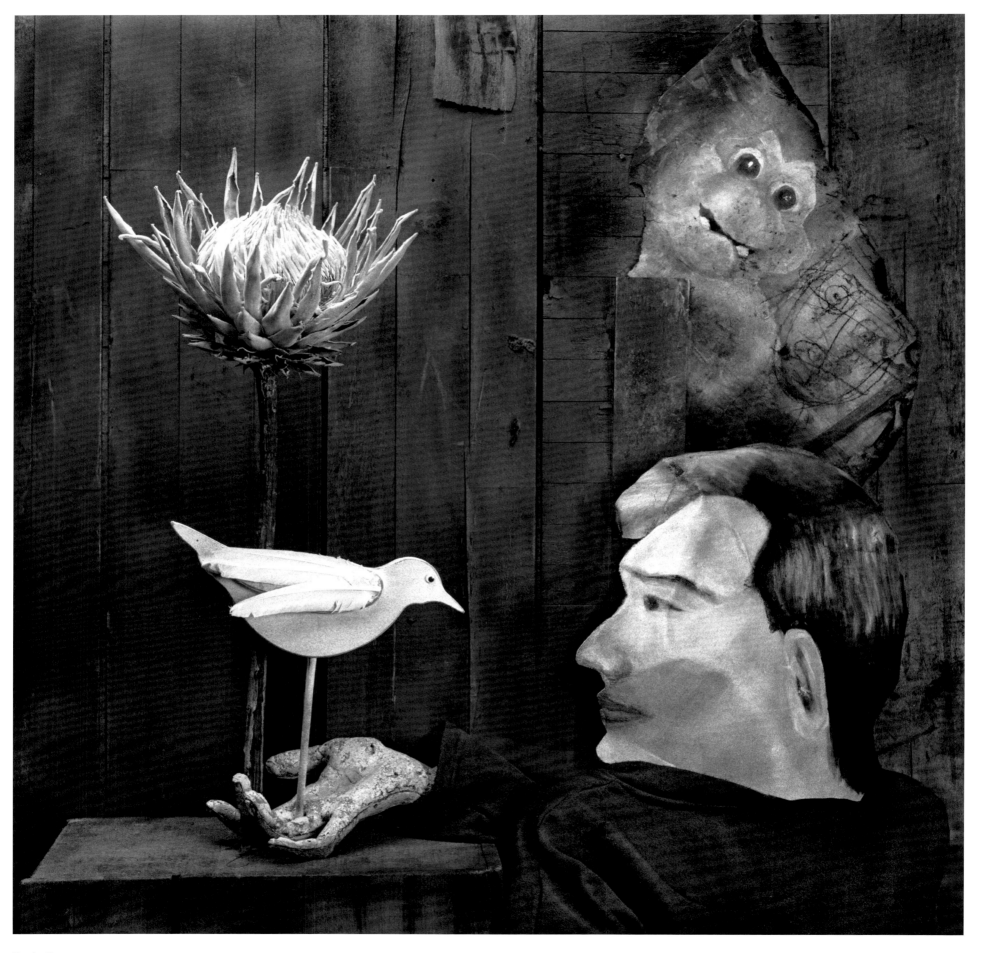

Eye to Eye, 2011

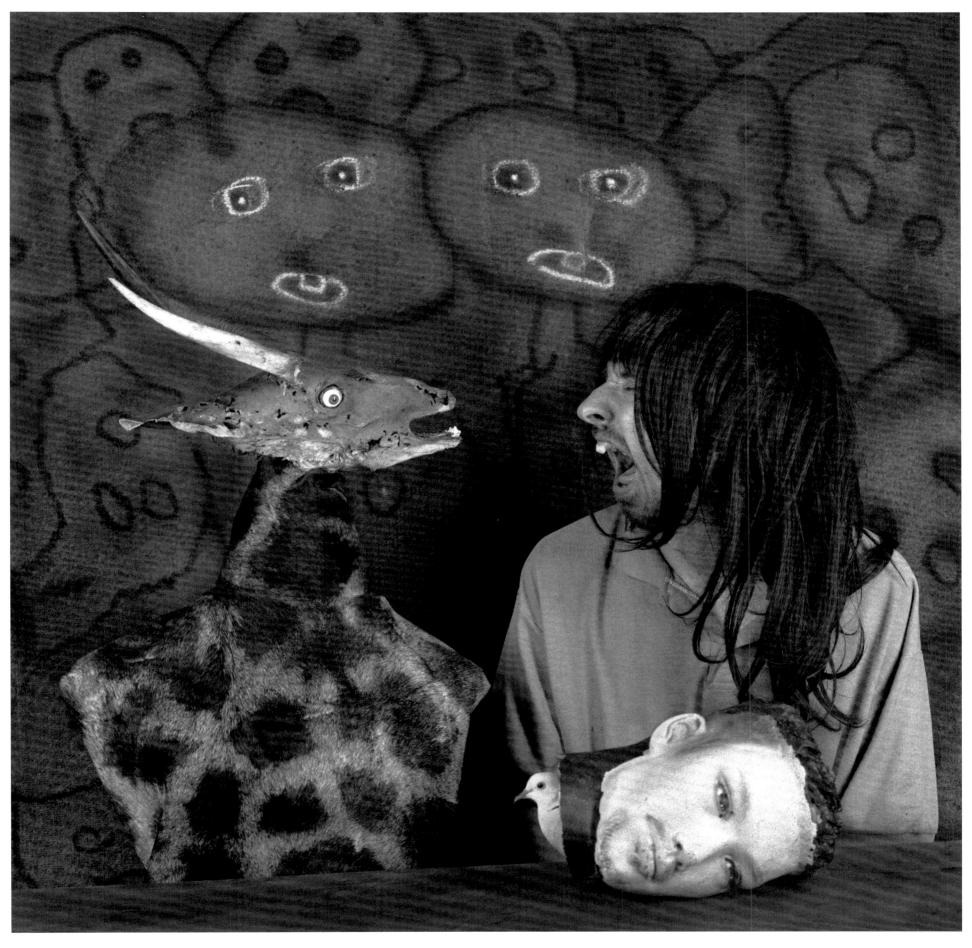

Altercation, 2012

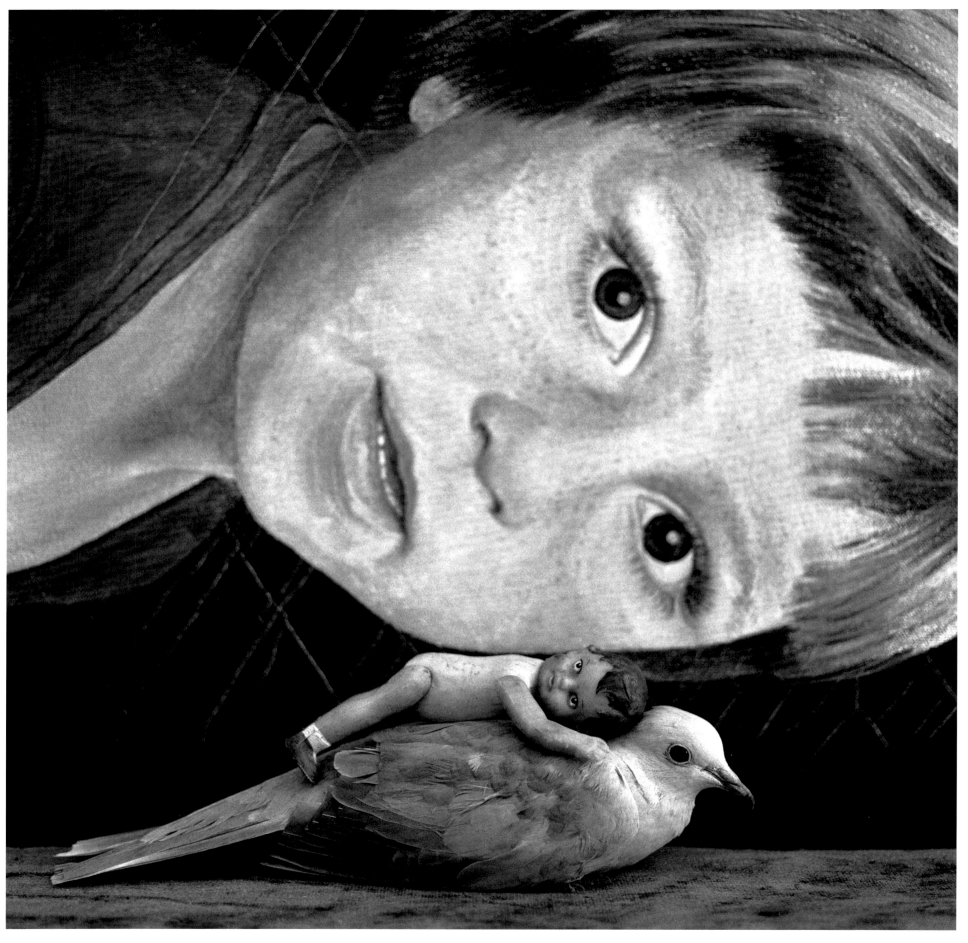

Mirrored, 2012

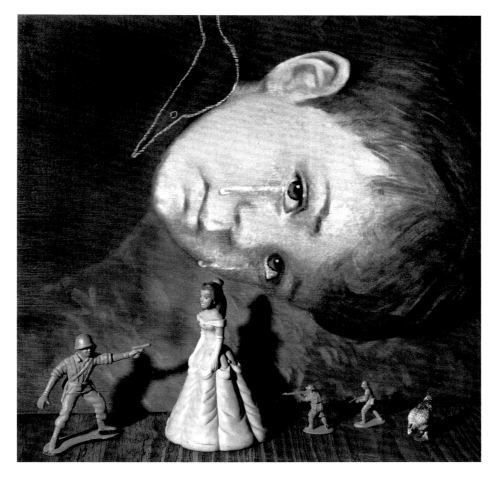
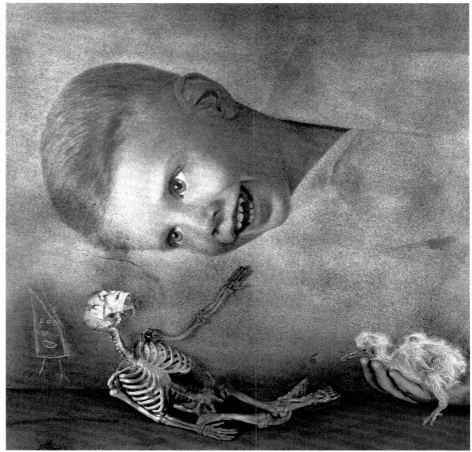
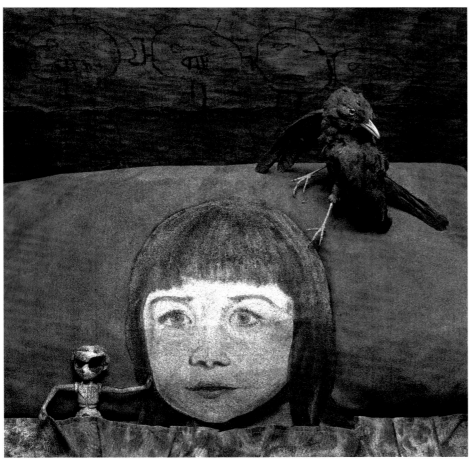
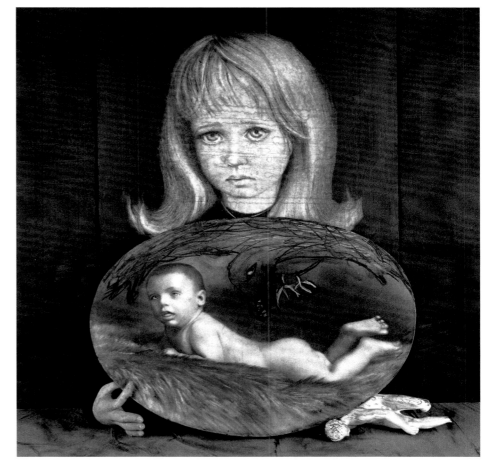

Crying Boy, 2012
Omen, 2011

Consolation, 2011
Bereaved, 2012

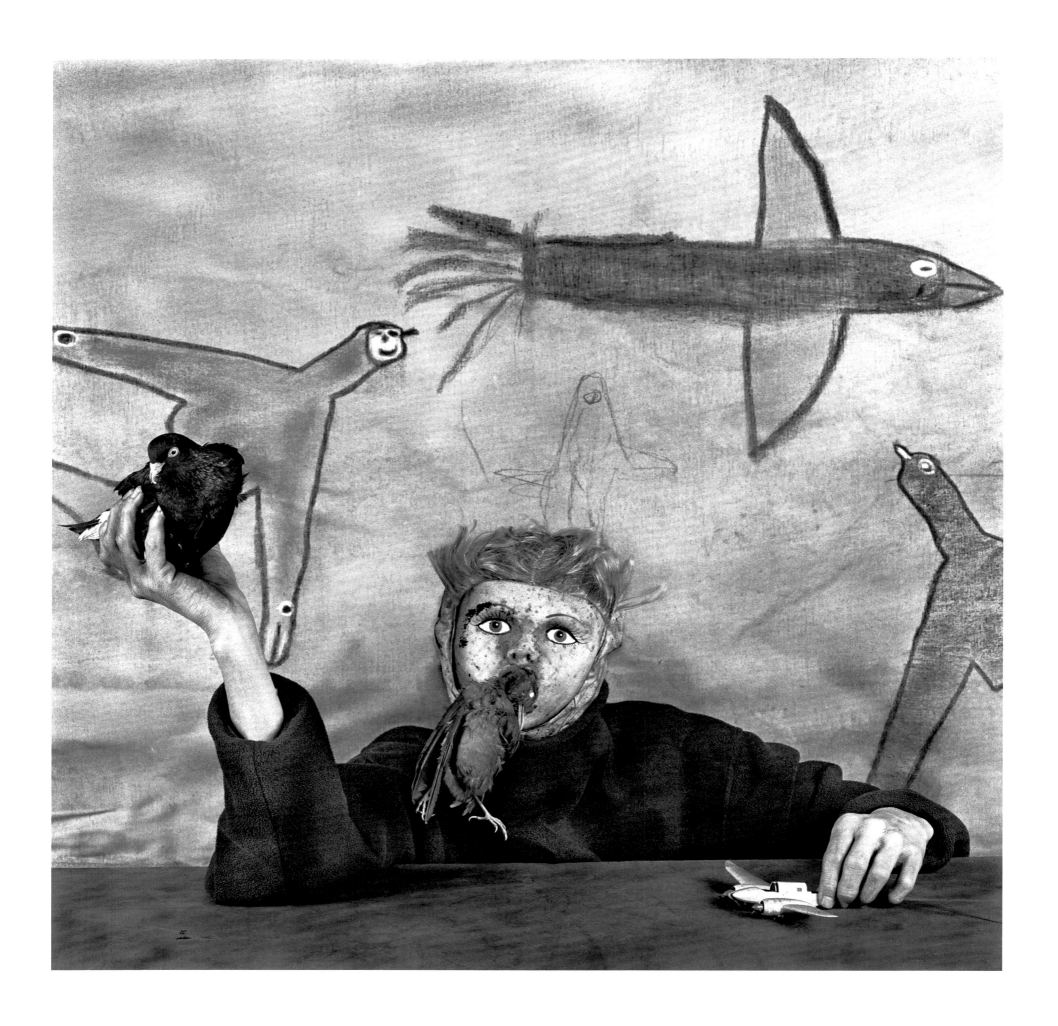

'*Asylum of the Birds* is a visionary, alogical, and amoral universe where good and evil exist side by side without excluding each other. Beauty does not correspond to the former, nor ugliness necessarily to the latter. It is a place where even beauty and ugliness are still – or even now – blurred together.'

Didi Bozzini, introduction to *Asylum of the Birds*

Take Off, 2012

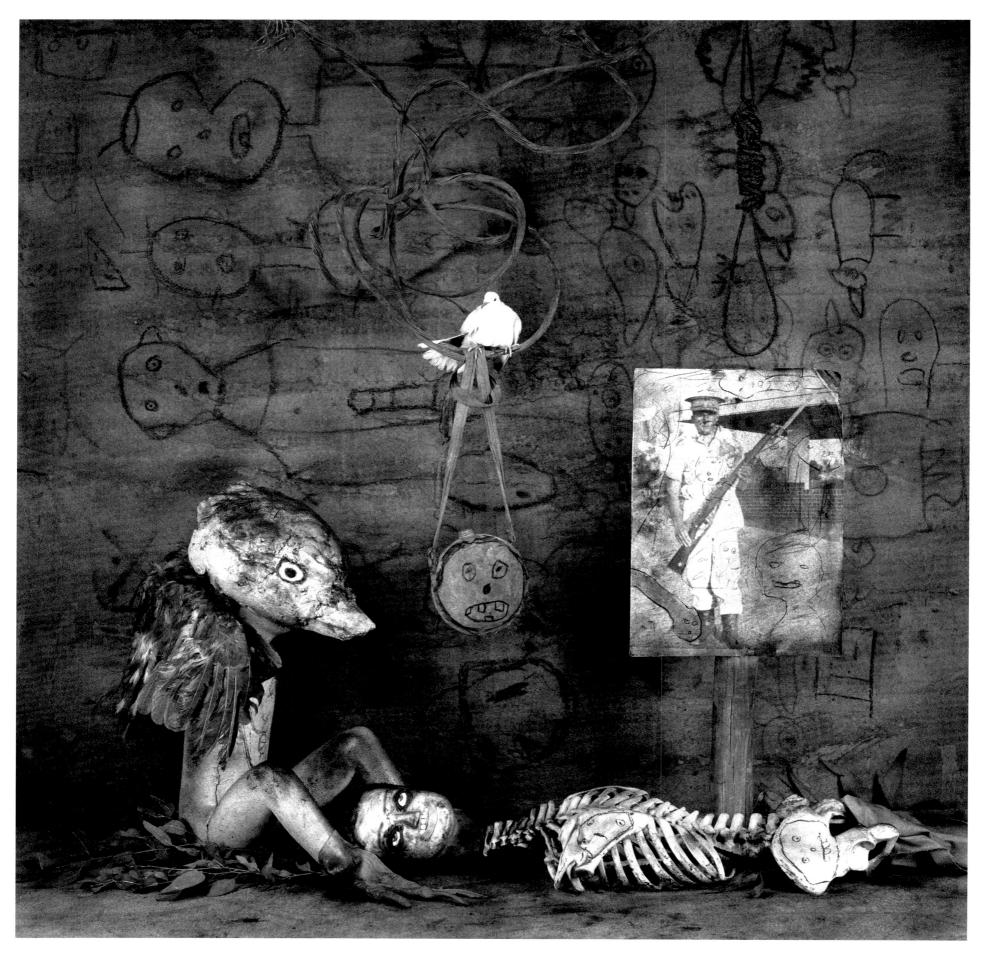

Mourning, 2012

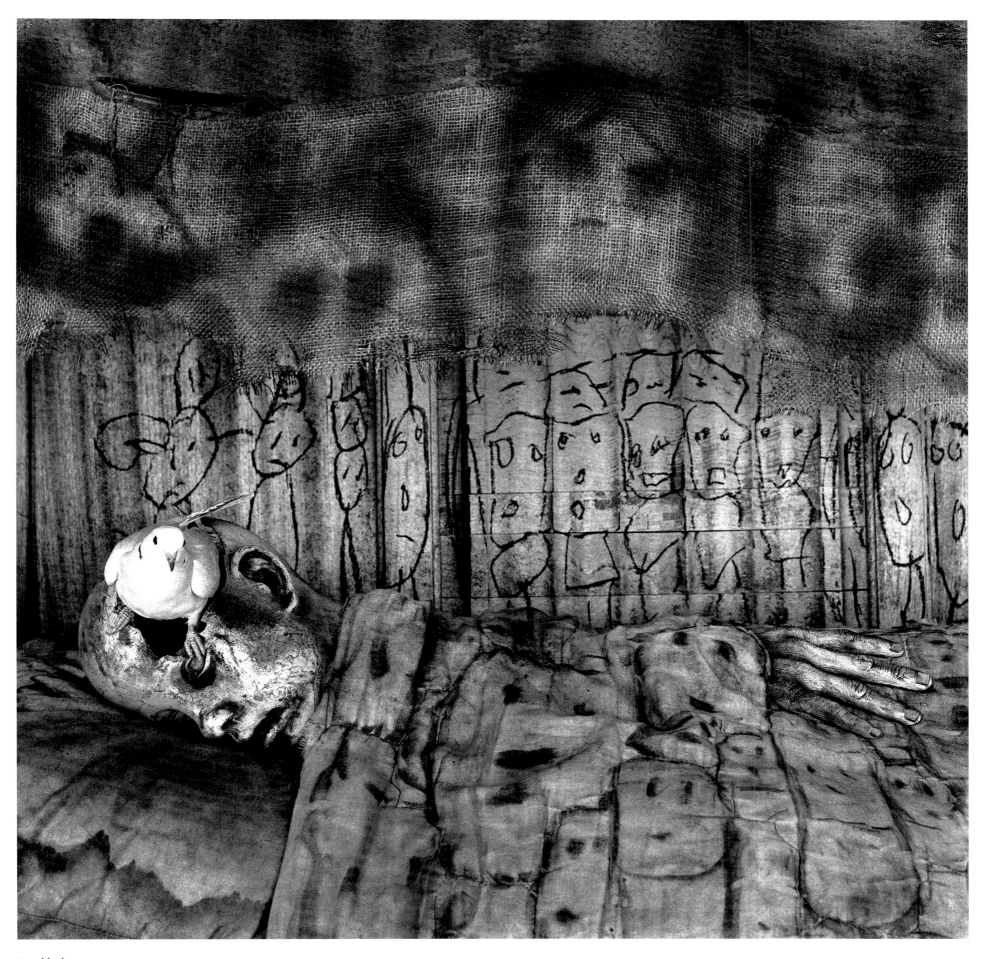

Deathbed, 2010

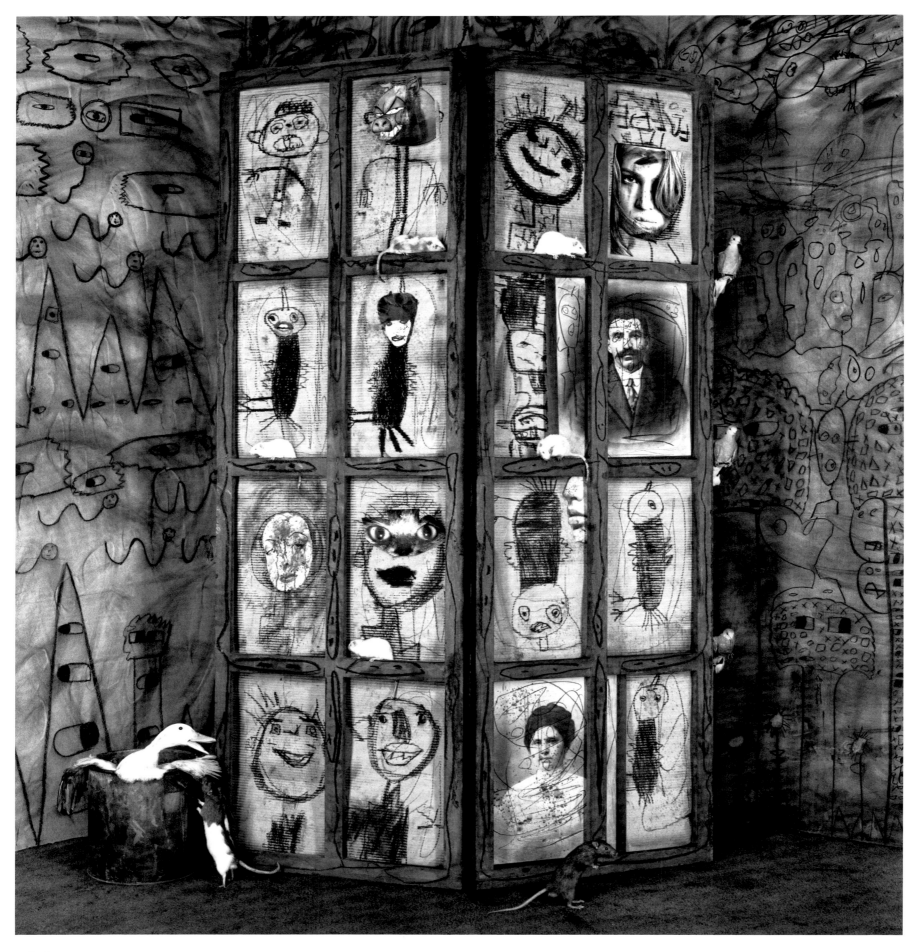

Onlookers, 2010

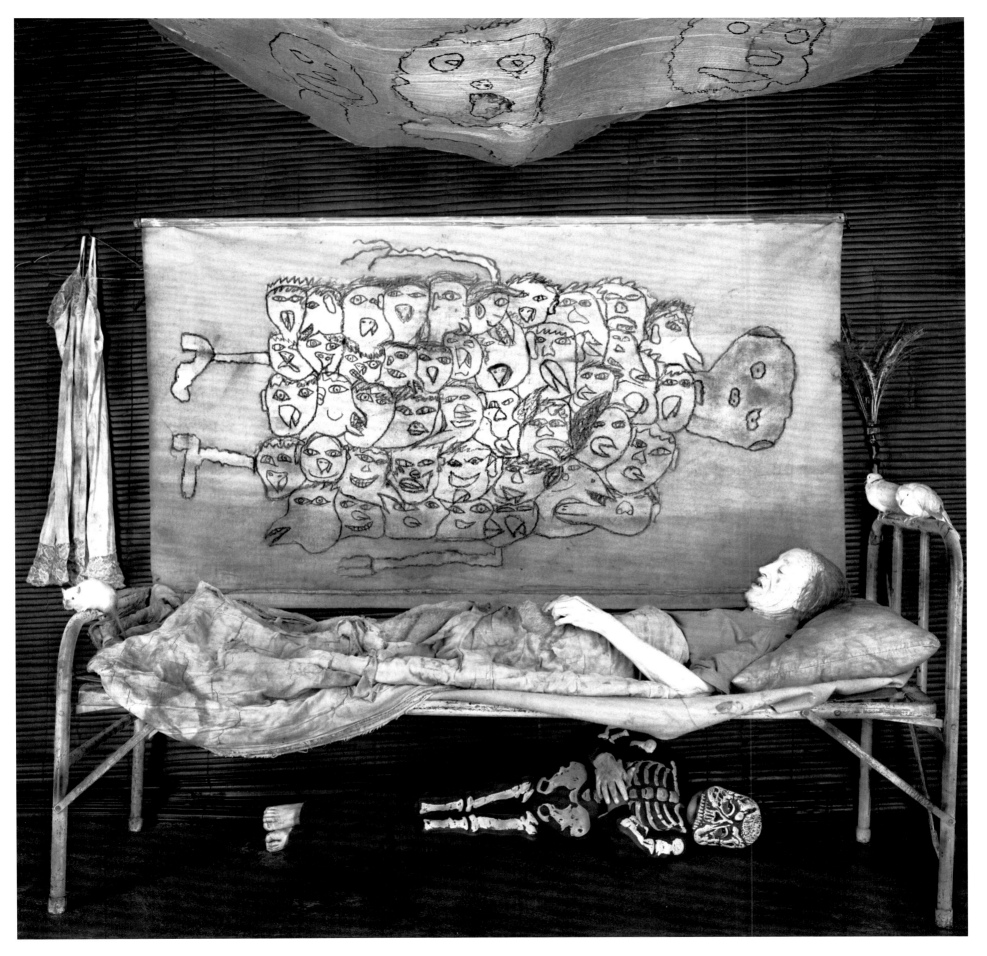

Memento Mori, 2012

chapter 4 **the space of the mind**

leica works

theatre of apparitions

ah rats

The compositions are very formal. They
are simple; they are clear. But inside there
is a theatre, a complexity that reflects the
human condition in some way. This is about
the human condition in a place. It is a place
in my mind, reflecting the human condition
in Roger Ballen's condition. Ultimately, it is
all about bypassing defence mechanisms and
confronting the self.

In the last thirty or forty years, I have seen my work gradually move away from the idea of the 'world as a stage'. As time has gone on, the places I photograph have become smaller and smaller, to the extent that, metaphorically speaking, my pictures are now about a single point on the wall. I keep going back to that same point, to a nail in the wall, and each time I get there, I try to drive the nail further into the wall. Hypothetically, the process of taking a photograph can begin at any place on the planet, where anything is possible; for me, it is about returning to the same place, to find different and deeper aspects of reality.

The physical rooms I work in can be seen as embodiments of unconscious psychic spaces within the human mind. As I have been working in similar kinds of spaces, rather that wandering from place to place, I am more in control of events. I would say that, over the years, my pictures have become much more psychologically orientated, much more about my own psyche and less about the psyche of others. By going back to smaller and smaller places, smaller and smaller rooms, I have been forced to focus on expressing my deep sense of self.

Since the mid-1990s, my photographic practice has evolved from using the elementary sets of people's homes in *Outland*, to sporadic drawings in *Shadow Chamber*, to a more elaborate visual dynamic in *Boarding House* and *Asylum of the Birds*. Once the so-called set has been created – sometimes wholly by myself, sometimes by so-called outsider artists – the challenge of creating lies in producing a moment of truth, a defining theatrical moment. It is my opinion that photography has the greatest impact when the viewer believes in the veracity of the moment, which in many ways is the essence of this medium. Consequently, it is a crucial aspect of 'Ballenesque theatre', as captured through my camera, to ensure that the images presented are seen as authentic and are able to transform the viewer's consciousness.

But allow me to explain how I have arrived at the term 'Ballenesque' as a describer of the art I create.

The period since the publication of *Asylum of the Birds* in 2014 has been characterized by the transformation of my work from pure photography to the integration of other media, namely drawing and painting. The term 'mixed media' might provide a clue to the approach I have taken since drawing became an important part of my work at the end of the 1990s, but it hardly describes in real terms what the work consists of.

By 2014 it was clear that, after many years of creating photographic images, I had developed a need to transcend what people referred to as pure photography. I became increasingly involved in video, installations, collage and painting. My goal in working in these other media was, and still is, to produce parallel art forms that expand and enhance one another to generate a wider, more encompassing aesthetic, namely the

Ballenesque. At first I felt inhibited about using such a self-defining word, but soon I felt confident enough to use the word regularly.

During the 1990s I would often state that my photographs had a similar, theatrical aesthetic to the works of Samuel Beckett: reduced, minimal, absurd. This interest in the aesthetics of the theatre continued to evolve in small but elaborate steps as drawings found their way into the sets I was starting to create. It became clear to me that the essence of my imagery had more to do with the means by which I was organizing a particular reality, one that was directly linked to my identity. Within these stage sets of mine, animals, people and props interacted to create a Ballenesque vision.

I think my work has developed in many ways. Up until the *Outland* project, which I began in the mid-1990s, I was present as a photographer, documenting the subject in a traditional way. But around that time a sense of theatre evolved, and it was hard to determine whether I or they, the subject, was the director, or whether it was just a spontaneous collaboration between me and other people. When faced with my camera, a person might do something that comes naturally to them, or they might want to please me. The best photographs usually occur when the subject forgets about the camera. Many of the people I have photographed over the years had probably never been photographed before; they were living on the edge of society without an understanding of what a camera does or how it transforms people, and therefore didn't feel self-conscious in front of one. That is often when the most interesting things happen.

But it's important to understand that my pictures are usually about much more than what the subject is doing. The subject is doing things in relationship to other things, and it's my job to find – as I mentioned earlier – that critical point, whether it's a sudden movement of the head, the blink of an eye, the scratching of a shoulder, or the picking up of something on the floor. An eye blink is a movement, and sometimes a critical one; perhaps it's the *way* a person blinks their eye that creates that crucial moment. Thus, it's not just a simple collaboration between me and the subject. I'm not looking at ten, fifteen, twenty different things around me. Mr Decider – the part of my mind that is processing all the information in my immediate environment – might be aware of literally thousands of different things, most of which are not part of the conscious mind. My pictures are made up of innumerable little decisions that get me to the point of pressing the shutter. To get there, you have to add things and take things away. It's almost infinite – the process, the choices.

This, then, is the hard part about my job as a photographer. What makes photography so difficult? There are so many things to shoot, that's what makes it so difficult. How do you break infinity into a few

shapes, forms, lines and drawings that work as a whole, that stay with the viewer for his or her lifetime?

From 2003 onwards, I felt that there was no need to place real people in the theatre I was creating. I wanted to eliminate any and all items that could be seen to relate to culture, society, economics and identifiable locales, and to create purely psychological images. At the same time, portraiture disappeared from my photography, as it was clear to me that I could not make the transition to another aesthetic as long as viewers were focusing on the state of the human subjects in the image to the exclusion of all other aspects.

I have tried to discover whether the drawn line can indicate the presence of life, and say something about the quality of life being lived in a certain space. I now believe it can, readily. Viewers will tell the story to themselves without real characters present, and the story will also include the story of the viewer's own life. Surely this is the gift the dramatist offers: a situation that many people can relate to, in a place where many occurrences are possible. It could be a room in the *Asylum of the Birds* house in South Africa, or a refugee centre in Europe.

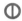

In 2016 I completed *The Theatre of Apparitions*, a book that had taken me eight years to finalize. The set for these images was the universe itself, where ghost-like figures could roam in a black, empty space, acting out psychodramas. Of the many questions that continually probe and obsess my mind, the two most persistent are, what happens after I die, and how did the universe begin from nothing? If I try to visualize my questions, I am left with an empty space that I cannot fill except with apparitions. As I note in the book, I believe that all forms of life have a unique spirit.

My first inspiration for the images in the book came from an abandoned woman's prison that we were using for the filming of *Memento Mori* in 2004. In one of the cells in which the prisoners had been kept, with only bare concrete walls and a dim light to comfort them, someone had painted over a window and used a sharp object to scratch out figures in the paint (see opposite). Shortly after this discovery, I began to create images similar to the ones I had seen in the prison. These initial images were characterized by objects in front of the window frame and drawings on white opaque glass. Unlike the later images, the texture of the background was flat, with black lines drawn on the surface.

Early in 2007, my assistant Marguerite Rossouw and I began to experiment with a range of paints, epoxies, emulsions, brushes, etc. in an effort to achieve the other-worldliness we strived for. To create such an effect, we applied the various materials to the glass in different orders, a process that continued to evolve until we felt that the project had reached its natural conclusion. As a result of our goal to produce images

Prison Windows, 2004

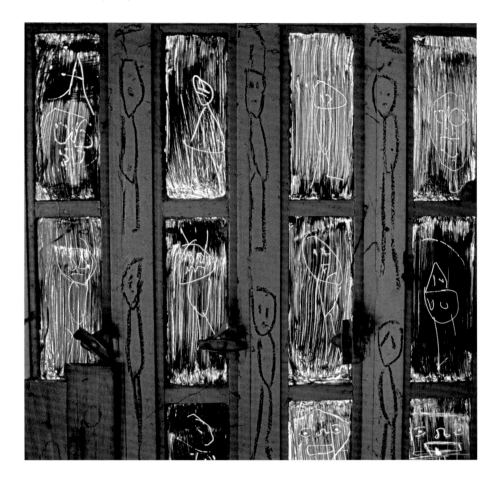

that could be photographed straight away, we were not concerned about preserving the works, which allowed us to reuse the same glass windows over and over again. I had a very short period of time to photograph the finished image before it would disintegrate. Like most photographs, these images preserve the transient.

The images were rarely planned. Instead, they were the result of a spontaneous process in which the materials we used sometimes created magical results. I often liken it to the moment in a darkroom when an image mysteriously emerges in the liquid developer.

As all of these photographs were taken without a flash, it was crucial that there was sufficient light from behind the camera. If the light in the room was not good enough, the images would lose their luminosity. In creating these photographs, I had to capture in one five-hundredth of a second imagery with a lasting value. Every piece of information is brought together in that single moment.

Initially, I took the photographs with my 6 x 6 cm Rolleiflex film camera, which I have used since 1981. However, as the windows were rectangular and not square, it became clear to me that I needed to use another format, namely a 4.5 x 6 cm Mamiya film camera. As I wanted to produce sharp, non-grainy images, I used TMax 100 film.

Although this work might be seen solely as drawings, it is crucial to realize that without my decades of experience in black-and-white art photography, these images would not have been possible. My understanding of the essential nature of integrating form and content through a camera was the pivotal factor in creating these photographs.

The images that make up *The Theatre of Apparitions* are a combination of our inner and outer worlds, a place of the archetypal mind. This place, and the images that arise out of it, are old. In a kind of amniotic darkness of the womb, the depictions recreate the perceptual realm of a fragmented world of part-objects, fears of annihilation, and chaotic perceptions merging reality and fantasy, self and other. They are flickering archetypes from the collective unconscious of humankind itself. In these silhouettes, there are evocations of the weathered rock of caves, depicting a life long gone in our Palaeolithic prehistory. Some of the recurring relationships in the book – those of human and canine, bird and beast – invoke familiar primordial bonds. They, and others, are a kind of mythological 'memory fossil', and they call on ancient shamanistic visions, sacred symbols inherited and embedded through the process of our own evolution.

The images in this project are likely to be embedded in the subconscious mind. They are all, in one way or another, pictographs made into photographs – brought out from the unbearable, the unacceptable, even the unthinkable. At times, they may escape and visit us as the vestiges of introspection. We may ignore them, watch with intrigue, or dispel them as nightmares entering as a curse from afar or signs of psychosis. But the apparitions are answers to a calling of absence, a comforting gift from deep within ourselves or from a more spiritual realm somewhere else. They are a kind of hallucination making up for that which is lost; a contact with that which one desires but does not have in physical form. The visions presented are glimpses of parts otherwise invisible to the eye, the stuff of dreams made perceptible through the power of the photographic lens. Embodied as living artworks, they are reminiscent of cave paintings, and, like the unconscious itself, timeless.

I called the book *The Theatre of Apparitions* because I wished to evoke the theatrical mechanics of this introspective experience: the way in which the forms of mental life – the pictures of dreams, imagination, memory or meditation – project themselves on to the screen of our mind's eye; figments that play themselves out on the stage of conscious experience. Often, especially when we allow our mind to bubble up and dance in its free-flowing stream, we find ourselves 'watching' these performances. It is as if our psyche is no longer our own, and at these times we become spectators, audience members sitting in on the wondrous entertainment provided by the diverse

Untitled installation, 2013
Mona, Hobart, Australia

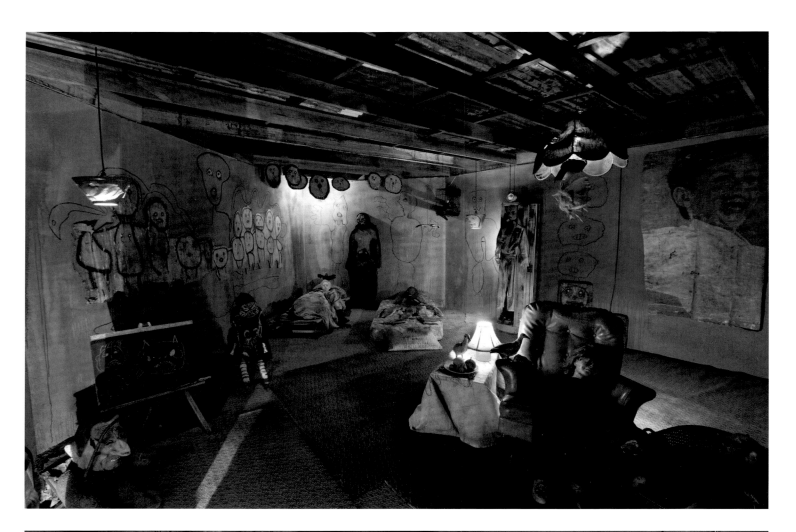

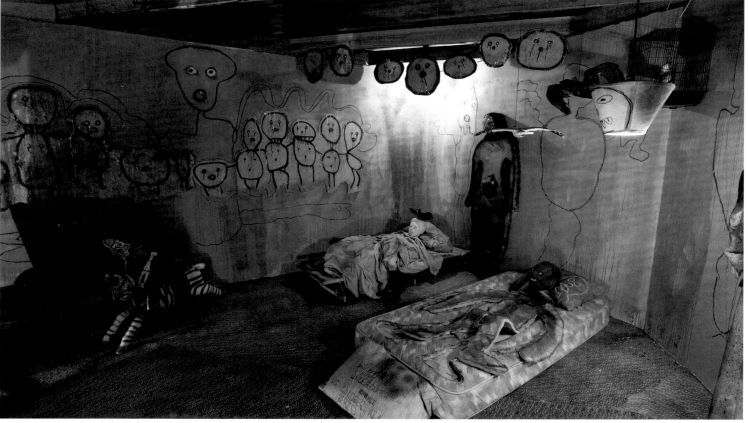

expressions of our internal world. In this set of stills, I have excavated scenes acted out by characters that live in the depths or peripheries of consciousness, where they have been repressed, extruded or exiled. They are the phenomenological visions that are mostly ignored, dispelled as nightmares, disowned as humiliating animalistic impulses, or pushed away as signs of psychological breakdown.

The works in *The Theatre of Apparitions* describe a journey deep into the psyche, like the journey of the Aborigines who penetrated the densest part of the Australian swampland, not to find dreams themselves, but to find the origins of dreams. Indeed, as a geologist by training, I could also be described as an excavator of the mental. I have striking memories of standing in a hoist at a mine in South Africa, waiting to be lowered into the mineshaft. I can remember descending rapidly into the earth's core, watching the rock layers go by, millions of years apart in time. Then the hoist slowing down as the bottom of the shaft was reached; the air was hot and moist and smelled of ammonia from the explosives. At this point we had intersected the ore, the treasure. In many cases the rocks had been deposited before the emergence of the first life forms.

The experience of going deep inside the earth's belly is one that I often think about as I try to penetrate my own psyche in order to produce my images. With each new project, I have to develop a mindset that will propel me to the next level down as I continue my journey towards a place that symbolizes the beginning of life, the place where consciousness was at the beginning of time. Still, it is one thing to get to this place, another to materialize this experience in the form of a timeless photograph. In other words, one is forced to question how one transforms the experience of finding another place in one's psyche into an artwork.

When I begin a new project, I don't have a beginning and an end. I never have a script. People always ask me, 'Are the pictures staged?' This notion – staged photography – is from contemporary art. With something staged or planned, it is possible to repeat it again and again precisely. But for me, a photograph has to feel as though it could never occur again. It has to express an authentic, unrepeatable moment. Usually, the more that people believe in the authenticity of this moment, the more impact, all things being equal, the picture has.

In its state of completion, my work makes people feel uneasy, because it affects their concept of normality, of order. As a defence mechanism, they will automatically ask about what the subjects of the photographs think, what my dreams are like, or refer to the darkness of the imagery. Most often, the people who ask these questions are the ones most deeply affected by my work. The pictures somehow touch on psychological issues that they don't know how to live with. They are issues that, in line with Antonin Artaud's concept of authentic theatre, challenge the mind

itself. Like his startling dramatic creations, the work breaks people's repression. It has the capacity to help them, although sometimes it makes them repress even more, makes them more anxious. In other words, it is the goal of my photography to assist not only myself but also others in making contact with the dominant forces behind their behaviour, which lie deeply implanted in the human subconscious.

The theatrical nature of my work, together with my interest in outsider art and the theatre of the absurd, culminated in the appropriately named exhibition *Roger Ballen's Theatre of the Mind* (2015). The exhibition took place at Sydney College of the Arts, a former mental hospital built in the 1880s. In the basement were dark, dungeon-like cells in which many of the patients had been kept. Although I had come to Sydney to open my show and create an installation in these cells, I was soon engaged in making a video of the same title with artists who had spent time in similar institutions.

Since I am not an academic, but a mere artist, I will allow those who have ably summarized my oeuvre to have their say. Writing in the catalogue for *Roger Ballen's Theatre of the Mind*, Colin Rhodes, an academic with a deep knowledge and interest in art brut and a particular understanding of the theatre of the absurd, summed up my work thus:

> *The embodiment and manifestation of Ballen's internal psychological excavation leads me to consider his work as a 'theatre of the mind', articulated in five parts: Theatre of the Absurd, Theatre of the Real and Unreal, Theatre of the Hidden, The Forbidden Theatre, and Theatre of Darkness. All are suggestive, multi-layered metaphors, joined together by the operations of the psyche; by the operations of contemplation and also of desire.*

Didi Bozzini, in his introduction to *Roger Ballen's Theatre of the Absurd* (2014), wrote:

> *The photographic theatre of Roger Ballen is a theatre of the absurd. What we see on stage reveals just how inadequate any rational, discursive tool is to describing the true human condition. If it is senseless to ask 'why', these photographs show 'what'. What is done, what is thought, what is dreamed up, to get the sense that one exists.*

My images, suggest such commentators, present an infinite number of mental events, whether they be memories, reflections, dreams or observations. Out of this complex mixture of thoughts and emotions comes a form of theatre – a theatre of the absurd – in which normal conventions and dramatic structure are ignored or modified in order to present life as irrational or meaningless.

Looking both inward and outward at the work itself, I now realize that so much of the Ballenesque theatre has been constructed in what might be thought of as domestic interiors. There is something suggestive of life lived in its fullness, with all of its complexity, in the weighty presence of the unmade bed, the frayed couch, the broken window, the rickety chair, the skewed picture, the wounded plastic doll. All these should signify a life lived in normalcy, yet they intrinsically reveal disturbing aspects of what it is to be human. In my images, confusion is a crucial metaphor of the human condition.

In essence, these small locations within bigger ones should give us a sense of security; they should at least provide us with a feeling that the people in them are being sheltered from the outside world. But with one move, the entire fabrication of domestic order is turned upside down. Introduce a pet dog into an infant's bedroom with a cradle, and people may smile sweetly; introduce a rat into the same interior, and hazard lights will start to flash in people's minds. So the drama is constructed around possibility. What might happen if such a world were to exist? To me, the home is a place of potential danger. Where people seek refuge from the outside, they often make the most perilous journey inwards.

In the spring of 2014, during my show at Fotografiska in Stockholm, an idea was initiated for a project centred on the house. Didi Bozzini suggested that we work on a book and exhibition together in which the house would serve as a metaphor for the mind. On more than one occasion, critics of my photography have drawn on Gaston Bachelard's notion of images of interiors functioning as representations of interior states. In *The Poetics of Space* (1958), Bachelard writes: 'On whatever theoretical horizon we examine it, the house image would appear to have become a topography of our intimate being.'

For *The House Project* – published in book form in 2015, and exhibited in Brescia, Italy, the following year – Bozzini sequenced a selection of images from different periods of my work to mirror the architecture of a house: the cellar (a disorderly heart), the ground floor (closely resembling the world), the first floor (divided, resembling that of a brain) and the attic (housing daydreams). Taking the house-as-mind metaphor as our starting point, Bozzini and I guided the viewer 'along a path of association based on analogies between images, from darkness to light, from cellar to attic' (Bozzini, *The House Project*, 2015).

From 2008 onwards, I had become increasingly obsessed with the idea of creating and exhibiting installations in three-dimensional spaces, rather than in two-dimensional images. What if the viewer became the subject of the journey, no longer a mere onlooker but a sojourner, a participant in the drama itself? The distance from two-dimensional representation to three dimensions is relatively short.

Arriving in Latvia in 2012, I met a photographer by the name of Ville Lenkkeri. Like me, he had been invited to the country to teach a series of photography classes, and we became friends. He told me he was interested in starting a project in a town he used to live in, with photographers coming from different parts of the world to take photos of it. My first installation – created in 2011 at Museum Het Domein in the Dutch town of Sittard (see opposite) – had been well received, so it was on my mind when I met Ville at Paris Photo in 2013 to discuss the potential for a project to take place in 2015 at Serlachius Museot in Gösta, Finland, as part of a series called *Touching from a Distance*.

I was supposed to create images in and around Mänttä, a small town near the Arctic Circle, but I impressed on Ville that I was no longer an outdoor photographer, and so our journey began. I suggested to him that we find a factory, warehouse or interior space of some kind that I could work in, making installation-type effects and then taking photographs of them, as I do in my practice. He made some suggestions, but no permission was granted. Then we began to look at houses in which we could work, but at some stage we decided to move an entire house and install it as an exhibit inside the museum (see pages 266–7). Once the house had been relocated to the museum, I had to reassemble the various objects we'd been working with. I added further props and drawings, and installed silicone faces and bodies, replacing the less effective papier mâché models I'd been using. But the real breakthrough was our use of sound, including voices for the various mannequins. It added another dimension to the project.

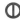

My work with Ville is one of a number of collaborations that I have undertaken with other artists. In 2013 *Vice* magazine approached the New York-based photographer Asger Carlsen and me about working together on their annual photographic issue. I had a look at Asger's work and found it to be very different from other photography I had encountered. His imagery reflected an aesthetic that revealed an alternative view of humanity, which many people might find psychologically threatening. Together, I thought that we might create imagery that would jolt viewers into reconsidering how the idealized body is used in photography.

The process began with Asger sending one or more of his images to me and Marguerite, my assistant. Initially, we would create a collage the old-fashioned way, by cutting out images from my existing work and manually gluing them on to Asger's photographs. I would then physically draw on the works with charcoal before having them scanned. After finishing the project for *Vice*, however, I started to add drawings to Asger's images using Photoshop. The resulting series, *No Joke*, which I worked on with both Marguerite and Asger between 2013 and 2016, represents

Shadowland, 2011
Museum Het Domein,
Sittard, the Netherlands

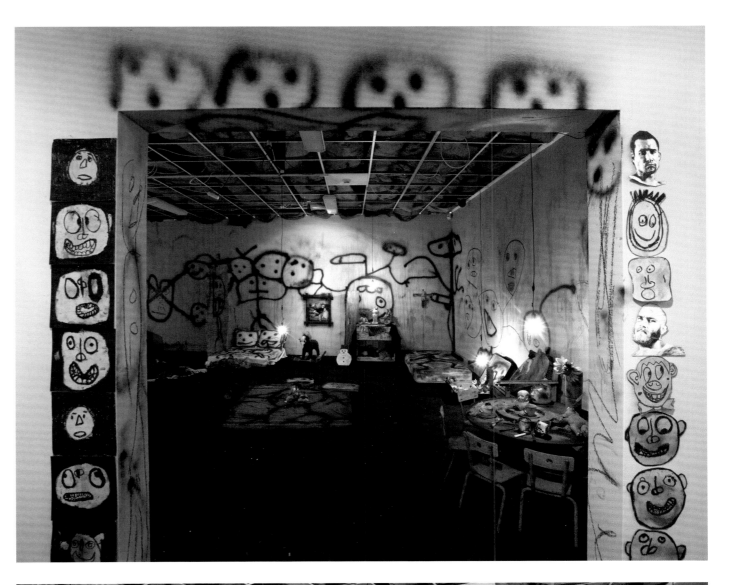

Resurrected, 2015
Serlachius Museot,
Mänttä, Finland

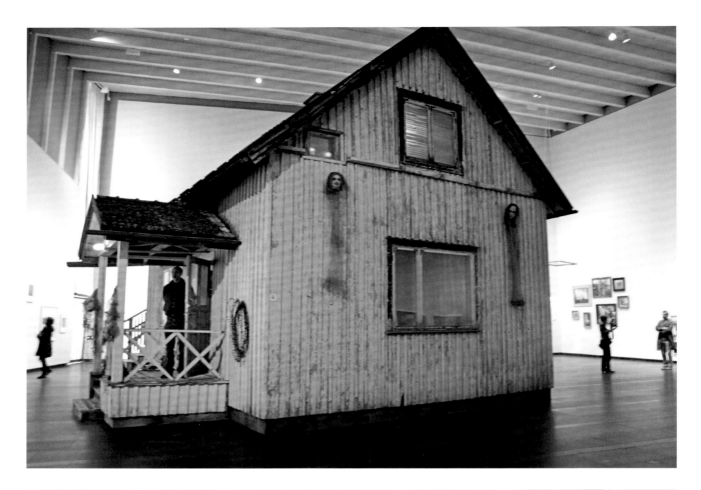

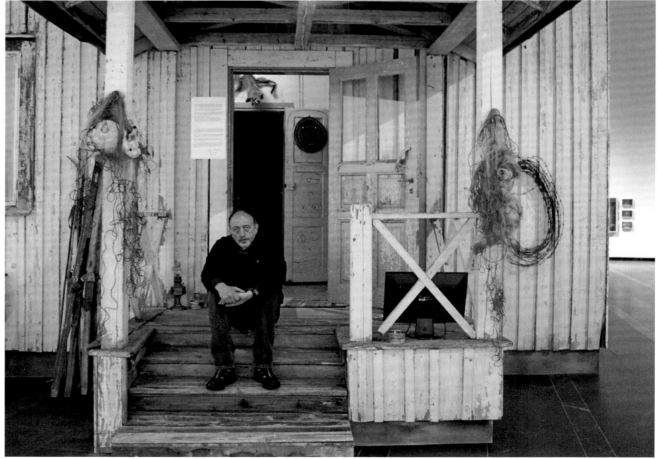

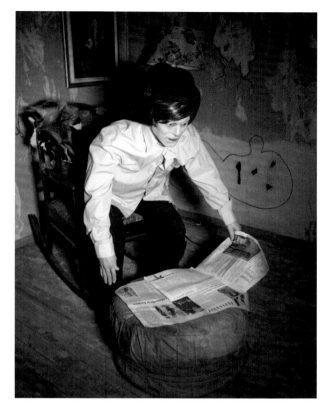
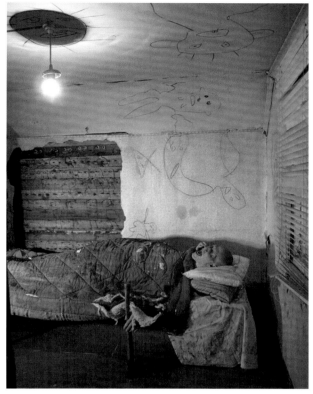
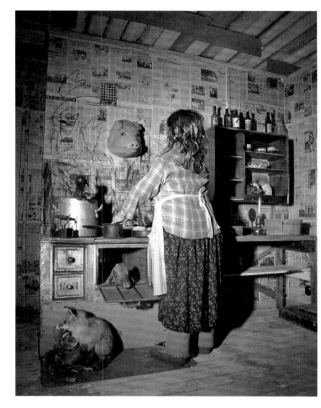
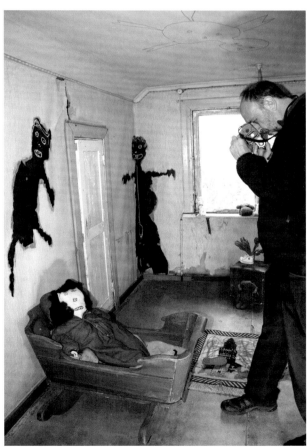
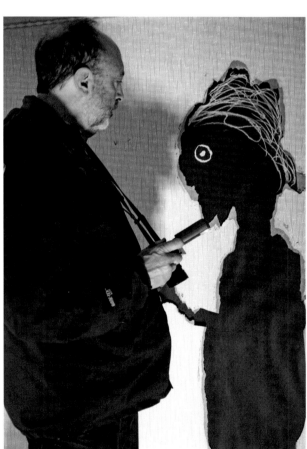

Resurrected, 2015

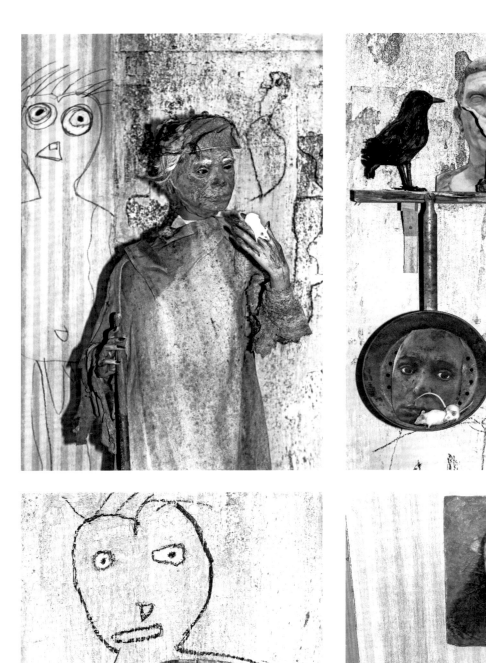
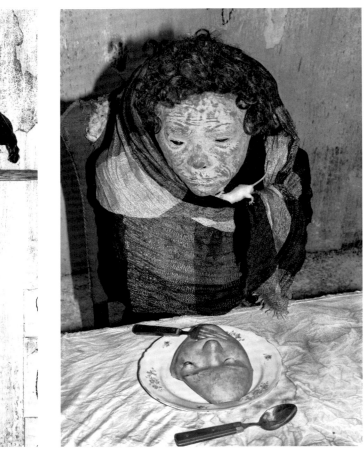
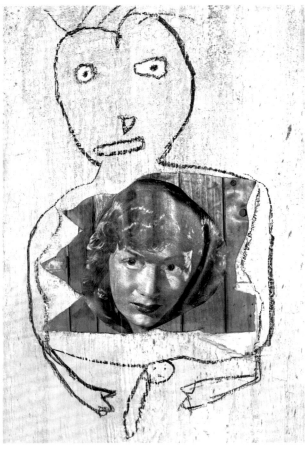
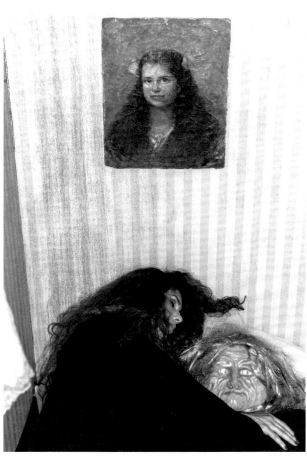
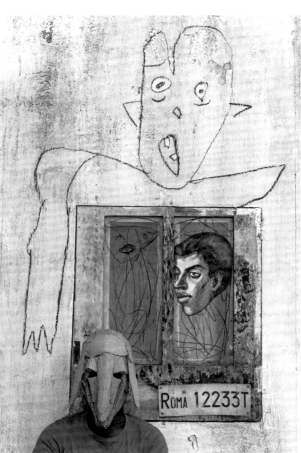

The House of Ballen, 2016
Macro, Rome, Italy

a key moment in my career, as it was the first time that my images had depended directly on the technology of Photoshop.

No Joke, and a subsequent project with fine artist Hans Lemmen (see below), involved the coming together of dichotomous aspects of artistic practice: the digital and the analogue, and, in my project with Lemmen, traditional mark-making and the creation of drawings as just one aspect of a larger photographic process. In the collaboration with Asger in particular, Photoshop allowed me to draw and manipulate images in a way that would not have otherwise been possible. While firmly rooted in the use of montage and cut-outs by such artists as Hans Bellmer, Brassaï and others in the 1920s and 1930s – my favourite period in the history of art – the work was made possible by modern technologies.

In the publication *No Joke* (2016), Carlsen described our working method to interviewer Aaron Schuman:

The first 'chapter' of images that I made were shot with a model in my office; I created ten images of a girl with abnormal limbs, which were inspired by Rodin's unfinished sculptures and were meant to look like a form that had been hammered out of a block of stone or marble.

The second 'chapter' was made after I asked Roger to have Marguerite photograph him in his studio, and to photograph some of his props as well. This series also included pictures of me in my studio, and images of masks and abstracted forms, which were all assembled from different materials that I found in the stores and trash around my neighborhood – Chinatown – and in archival images that were lying around on my hard-drive. The idea was to create the illusion that we worked together in a studio, and were testing different objects to be photographed with. In a sense, this work can almost feel like Renaissance portraiture.

The third 'chapter' was based on older images that I hadn't used or completed for reasons I don't remember; left-over images that were either reworked or remade into an updated interpretation. For instance, there are images from my projects Wrong *and* Hester *– projects that were inspired by surrealist and abstract paintings – that have been reused.*

It was around the time that Asger and I started working together that I met Hans Lemmen, at my exhibition in Sittard. That exhibition was important for two reasons: not only was it the first time in my career that I had created an installation, but also it was where I first met Hans. During the opening night of the exhibition, Hans volunteered to drive me around the Belgian countryside. One of the first places we visited was the studio/factory of Dirk Claessen, a skilled artisan producing human and animal replicas out of silicon-based materials. I was flabbergasted by his technique and its results, and begged him to sell me some of his off-grade body parts, which, after being sent to South Africa, were immediately used as props in my photographs. This was the first time I had used non-human limbs and heads in my photographs, and set a precedent for many of my later works.

As well as introducing me to Dirk, Hans took me to various places where he had found Neanderthal arrow and axe flints. I immediately identified with his quest, as I had been involved in a similar process as a geologist, trying to find treasures, fragments, relics of the earth's past. I soon understood that Hans's aesthetic, like mine, was rooted in nature, soil, primitive man, and the animal.

After Hans and I had got to know each other better, we agreed that it would be interesting to work together. We spoke to a number of curators, and decided in 2015 to create a show based on individual images. After much discussion, however, it became clear that this approach would not be a true collaboration. In 2016 we decided that each should utilize the other's imagery to create a genuine and novel aesthetic. The resulting works, collectively titled *Unleashed*, were exhibited at Paris's Musée de la Chasse de la Nature in the spring of 2017 (see pages 270–73).

To create the works, I sent Hans boxes of my images, allowing him to physically cut out my drawings, textures and shapes; in turn, he sent me large quantities of his own drawings and cut-outs. Within months of Marguerite and I receiving these items, we began to create works that resonated. We placed his cut-outs on backgrounds made up of my photographs, producing a transformed aesthetic that entered a new creative zone. Once we were satisfied with the integration of form and content, we photographed the image and then printed it. Importantly, these would be the first 'colour' photographs that I would exhibit.

The artworks we created – for that is what they are, something more than just photography or drawing – immediately haunted me. Looking at the images now makes me think of what Colin Rhodes wrote of my work in *Roger Ballen's Theatre of the Mind*: 'Each image is a complete thing in itself, and we, as viewers, have no idea where the real and unreal begin and end. Every image is non-sequential; it is its own world. The key signifier here is the co-extensiveness of the body and its parts in the created worlds of Ballen's photographs.' He goes on to say that the images cause us to compare and confront our own selves, and that we are 'in a constant relationship of becoming in the worlds we inhabit'.

It is clear to me that most people are out of touch with their own interior world, their own personality, their own identity. If my pictures scare them, it's because they are not able to integrate the various aspects of themselves; rather, they repress them. The biggest fear that everyone faces is their own obliteration, something that Western society doesn't deal with very well. Instead, it supplants it with mass consumerism.

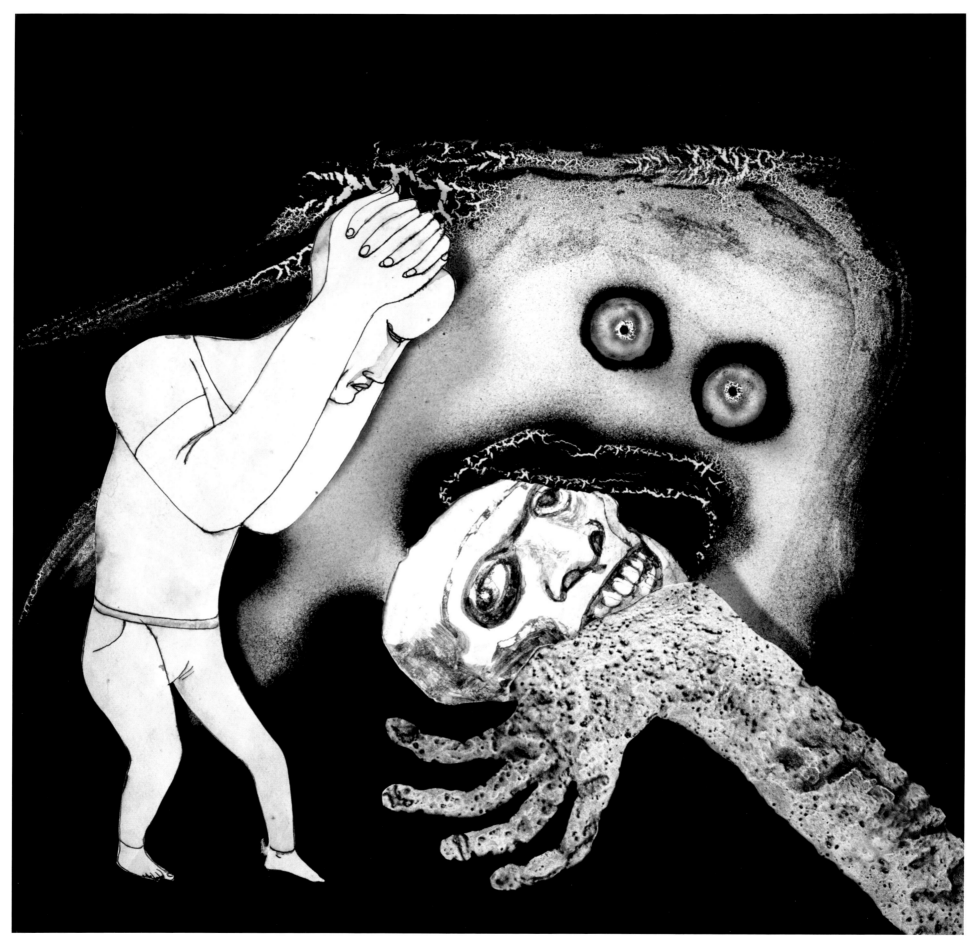

Oh No, 2016
Collaboration with Hans Lemmen

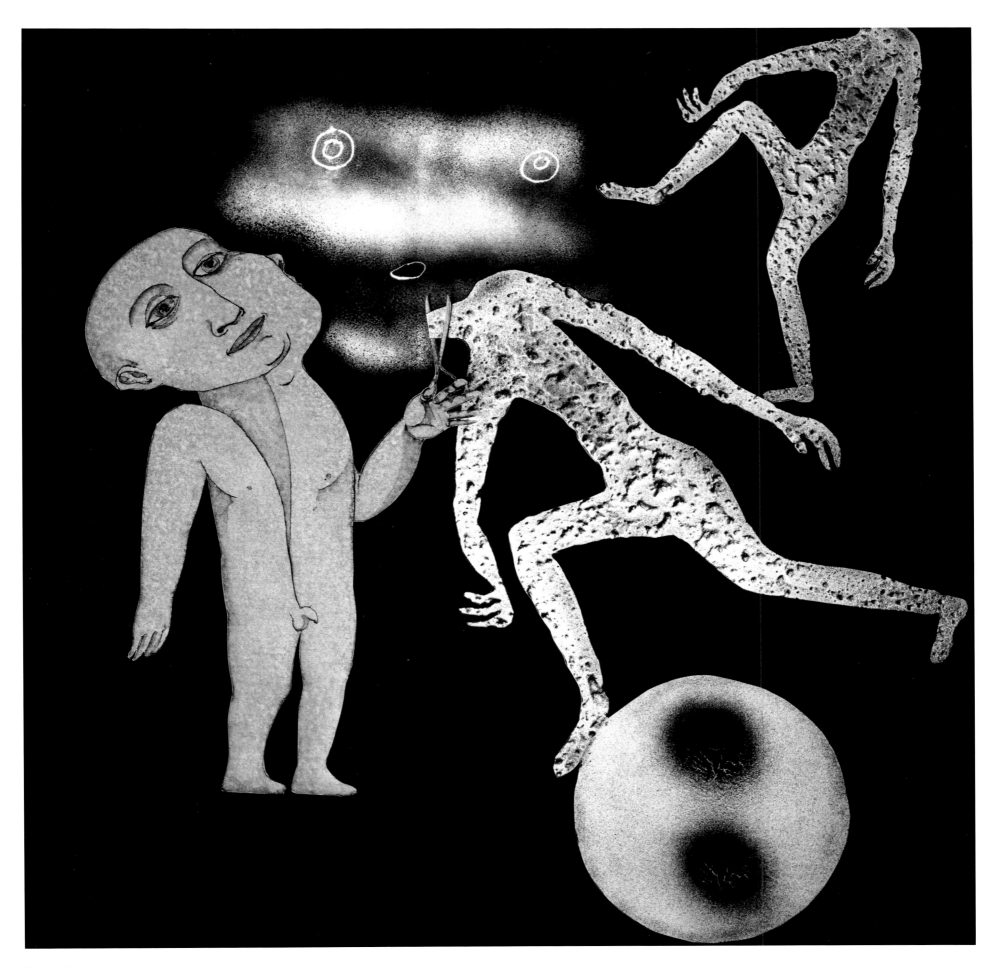

Cut, 2016
Collaboration with Hans Lemmen

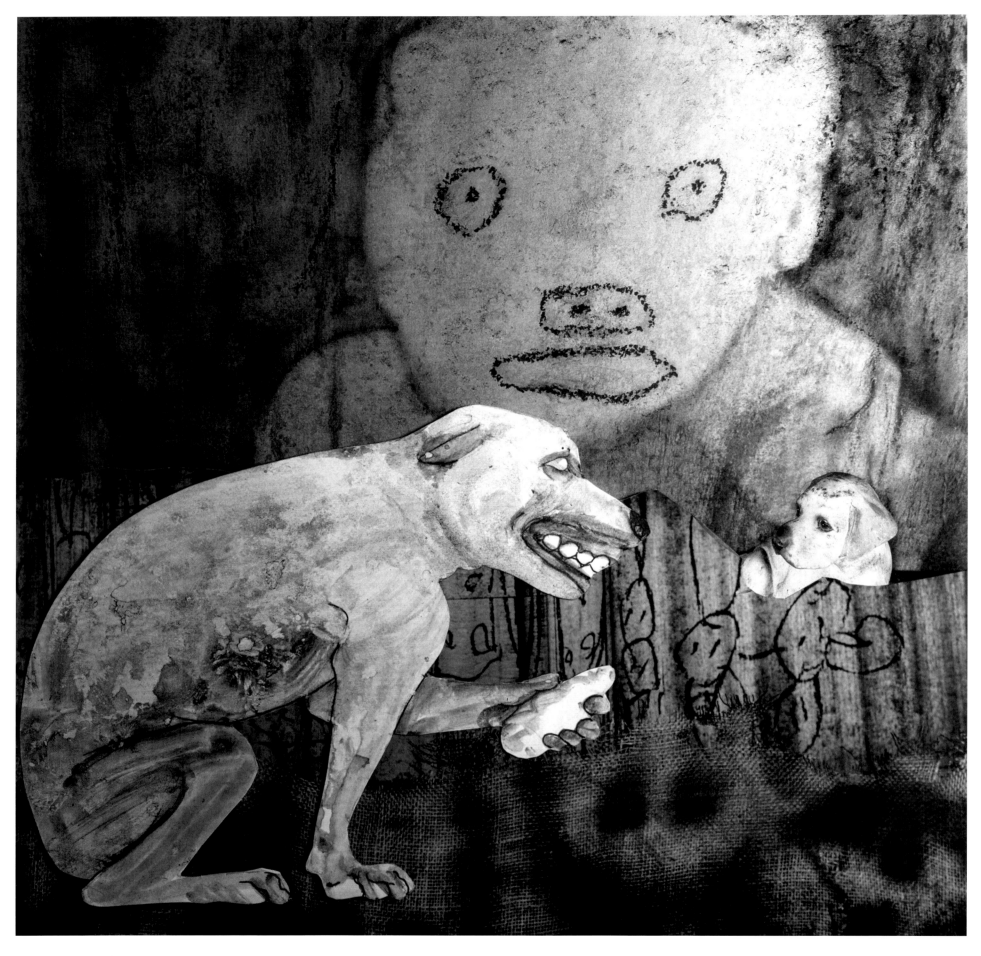

Dog meets Dog, 2016
Collaboration with Hans Lemmen

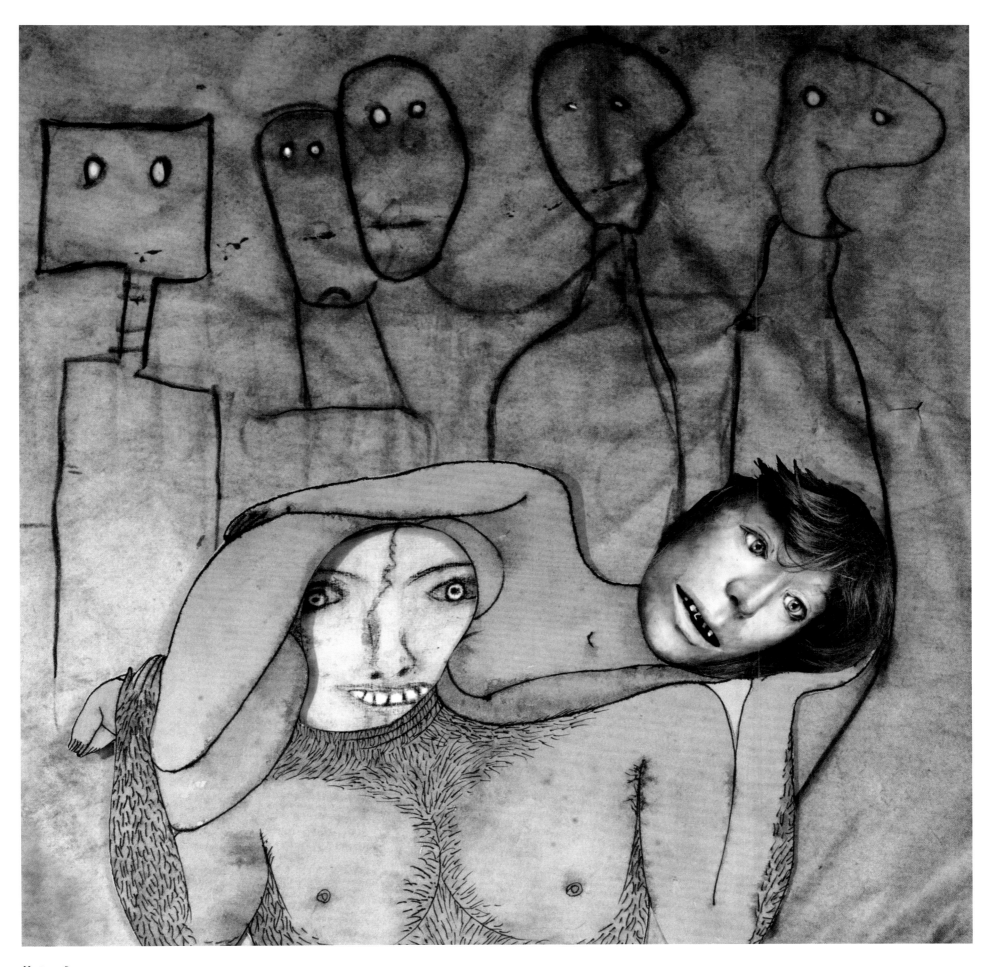

Hug, 2016
Collaboration with Hans Lemmen

273

Although what my collaborations with Asger and Lemmen have produced is only a small part of what the art market has to offer, I hope that it has the ability to expand people's consciousness.

I am often asked, 'What do your subjects think about your photographs?' In reply, I say that I am not sure what anybody thinks. Mostly, my subjects find my images humorous, and are proud of the fact that they are in them. I am usually given to explaining that since 2003 there have been more animals than people in my images, and that drawings of figures have taken over from live subjects. As far as the drawings are concerned, some of them weren't even mine, initially; rather, they began life as someone else's.

Then there are the animals. Creatures of one kind or another have pervaded my photographs ever since I started seeing the world through a lens. I have worked on two major animal series, one on birds, the other on rats. In a simplistic sense, these creatures have symbolized good and evil, darkness and light, throughout human history. Birds link the heavens to the earth, the destroyed human environment along with human aspiration; rats are unfairly associated with dirt, disease and darkness. That these two animals represent two opposing archetypes has assisted me, to quote a popular old song, in the contemplation of 'me and my shadow'.

Each animal on the planet has its own archetypal value, and those values are brought into being when humans interact with them. Over a period of three years, starting in 2013, my images were exclusively of rats. I had dealt with the sky and the birds; now I needed to deal with the rat. Although the rat is a challenging animal, it is just another part of nature. Intrinsically, there is nothing wrong with the rat; it is just an innocent creature. At the same time, a rat is a subject as much as a person is a subject. Yet the rat is a symbol of evil, a symbol of oppression, and a symbol of the darkness.

An animal is truth, a reflection of purity. I'm intrigued by animal psychology. Put metaphorically, the animal is the id. If you want to try to understand the deeper parts of human behaviour, sometimes a good place to start is with the animal. Each species of animal brings with it its own mythology, and when you bring that mythology into a photograph, it offers unlimited possibilities for creating deeper meanings relevant to the human condition.

A central theme of my most recent work has been the question of appearance versus reality, fact versus fiction, or documentary fiction. It is clear to me that we, as a species, implicitly trust a photograph to depict the 'truth', more so than a painting or a sculpture. We feel that photographs have the ability to document, that they are 'transparent', that we can 'see through them'. By contrast, painting and sculpture are regarded as essentially reconstructive – paint 'veneers' the canvas, creating a surface with its own reality. A painter can invent the existence of things in the reality of the painting, things that may not necessarily exist in the real world. Or, even more dramatically, he can construct an entirely abstract reality, one that does not correspond to any living creature or thing, but rather reflects on itself. Here, nothing in the painting refers to anything: it is line or form, and not a representation of something else. It is because the photographic process is mechanical, capturing through non-human means the features of the environment as they exist, that we feel it to be trustworthy and transparent. In fact, some think of it as a kind of mechanical 'third eye'.

One of the questions I am asked most often is, are my photographs real or are they staged. I respond by saying that very few of my photographs can ever be repeated in time. As I hold my camera in my hands, as I breathe in and out, the image is constantly changing, and even the smallest movement on the part of my subject can influence the meaning of the image.

It is for this reason that I tend to regard my photographs as a kind of psychological projection, rather than a veridical documentation of reality. My express intention, particularly as my work has evolved, has been not to create pictorial realms that mirror the world as we see it, but to create images that externalize scenes of the mind itself. In these various worlds, things do not operate according to the laws of physical reality, because they are not depictions of physical reality. In fact, what the viewer is observing are two different phenomena: Roger Ballen reality, and camera reality.

My hope is to challenge the viewer's very assumptions about their knowledge of reality. In other words, what we perceive as real may be unreal, and what we perceive as unreal might be real. Alternatively, neither may be the case. 'Reality' is a word that all of us use all the time; yet the essence of this term is shrouded in enigma and mystery. To assume otherwise is ultimately a case of self-deception.

Surrender, 2013
Collaboration with Asger Carlsen

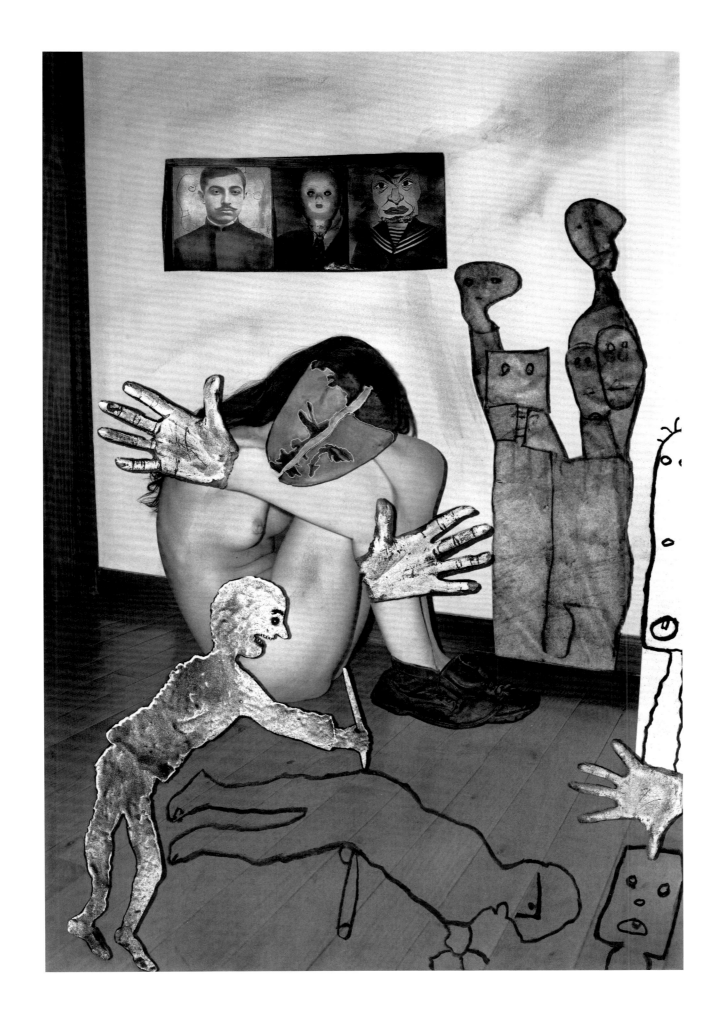

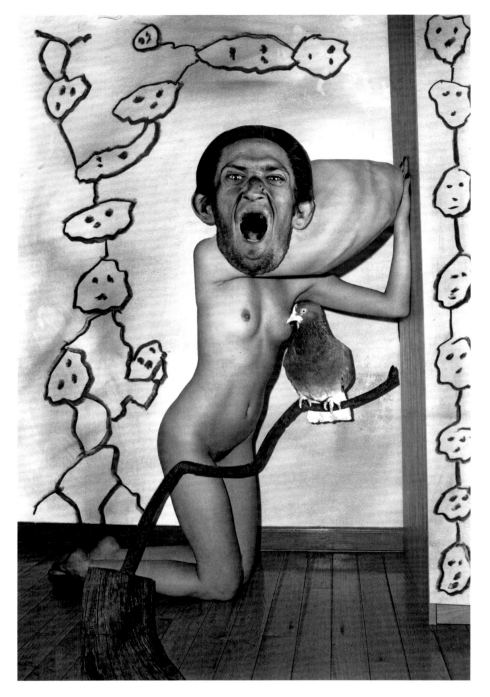

Kneeling, 2013
Collaboration with Asger Carlsen

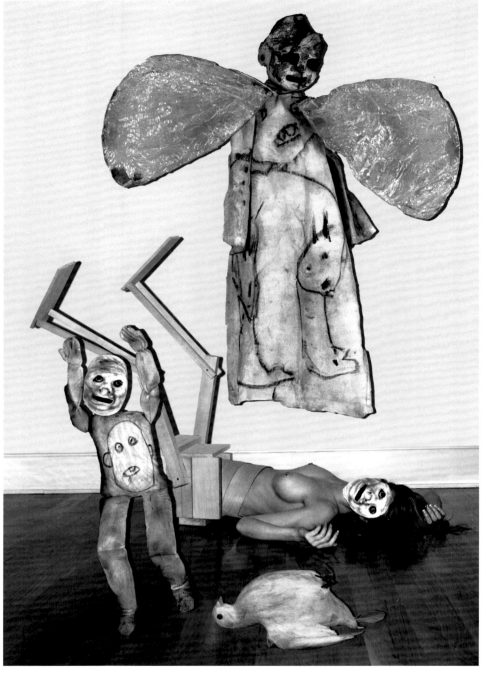

Fly-by, 2015
Collaboration with Asger Carlsen

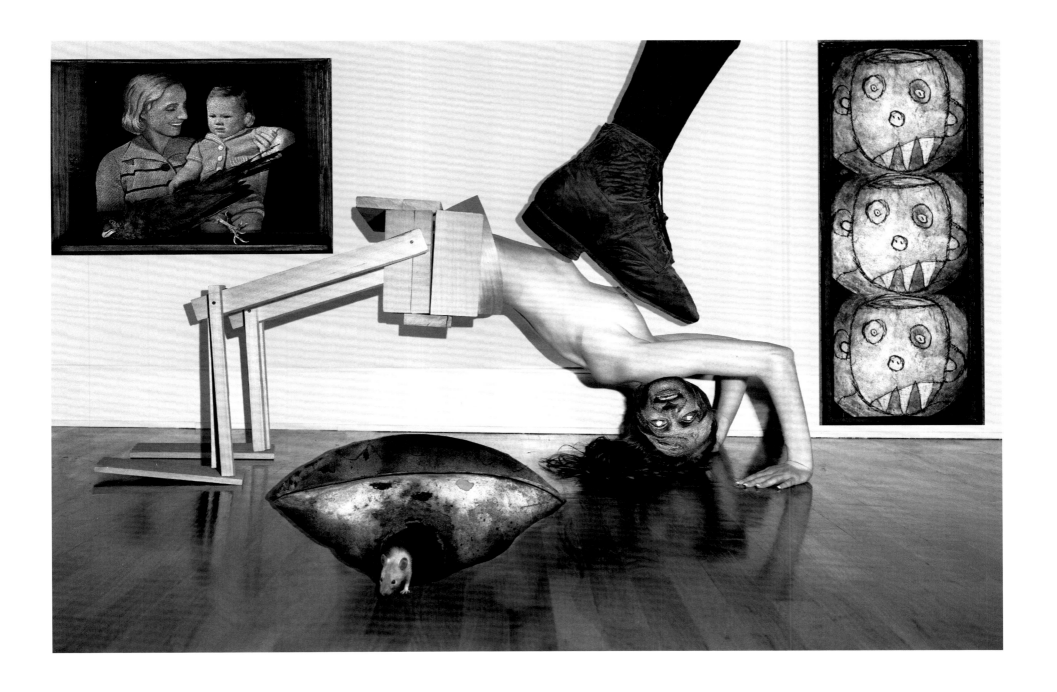

Trampled, 2015
Collaboration with Asger Carlsen

leica works, 2014–16

When I first obtained a Leica M Monochrom in 2014, I was sceptical, as I had been using a square-format Rolleiflex almost exclusively since 1982. To my great surprise, I began to create lasting photographs with the Leica, proving to me, once again, that the camera is a tool of the mind.

Couple, 2014

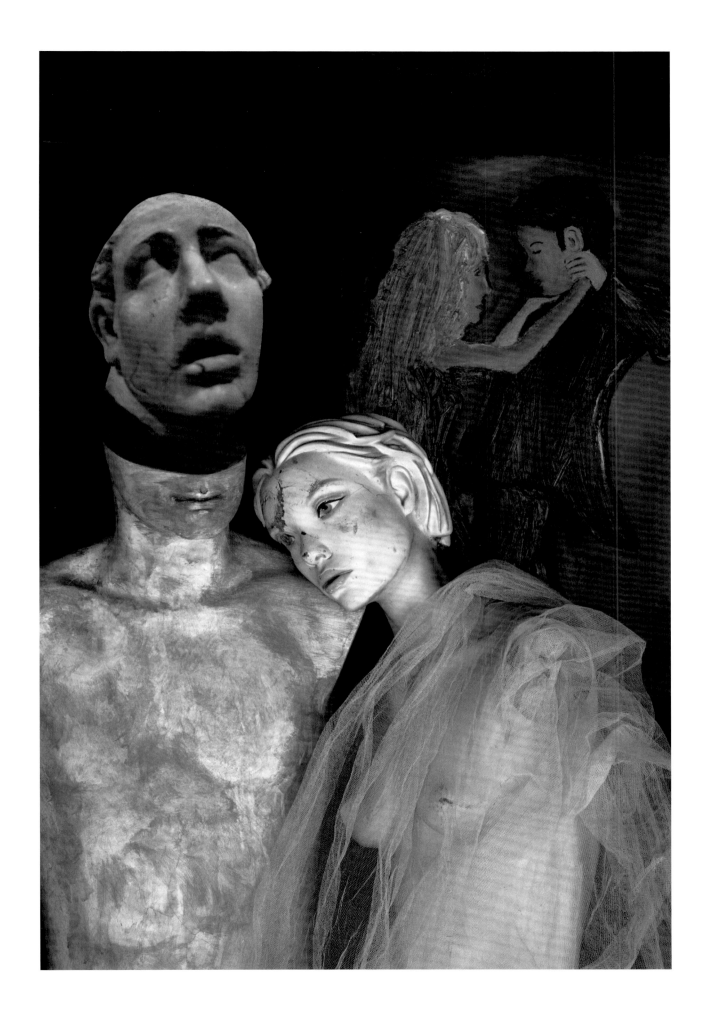

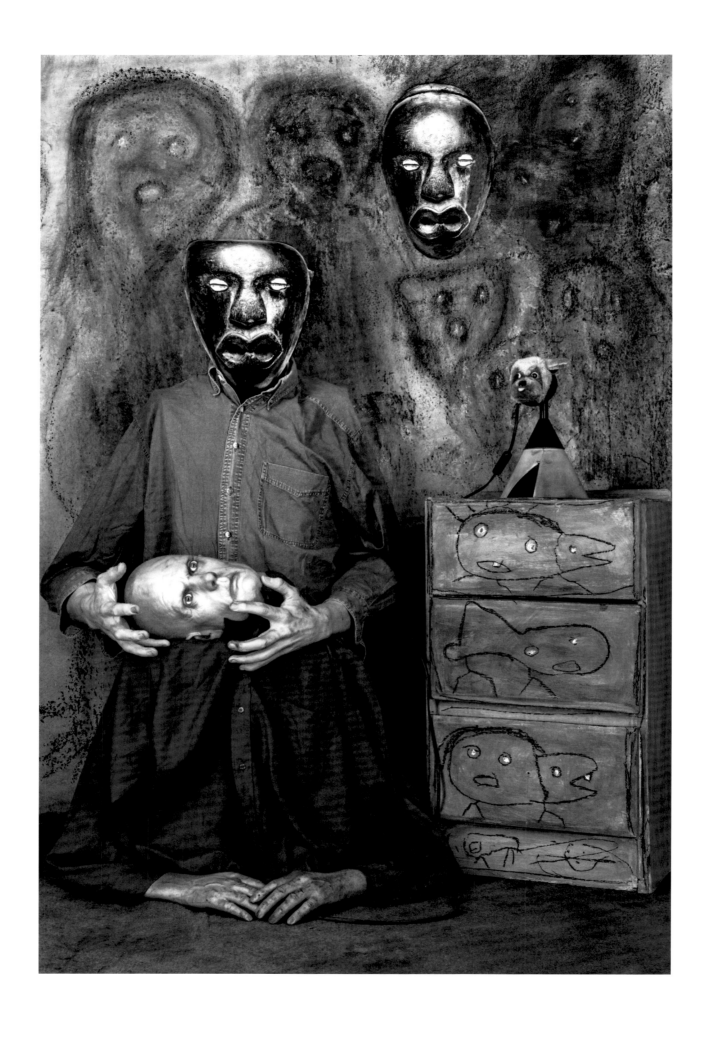

Deceased, 2015

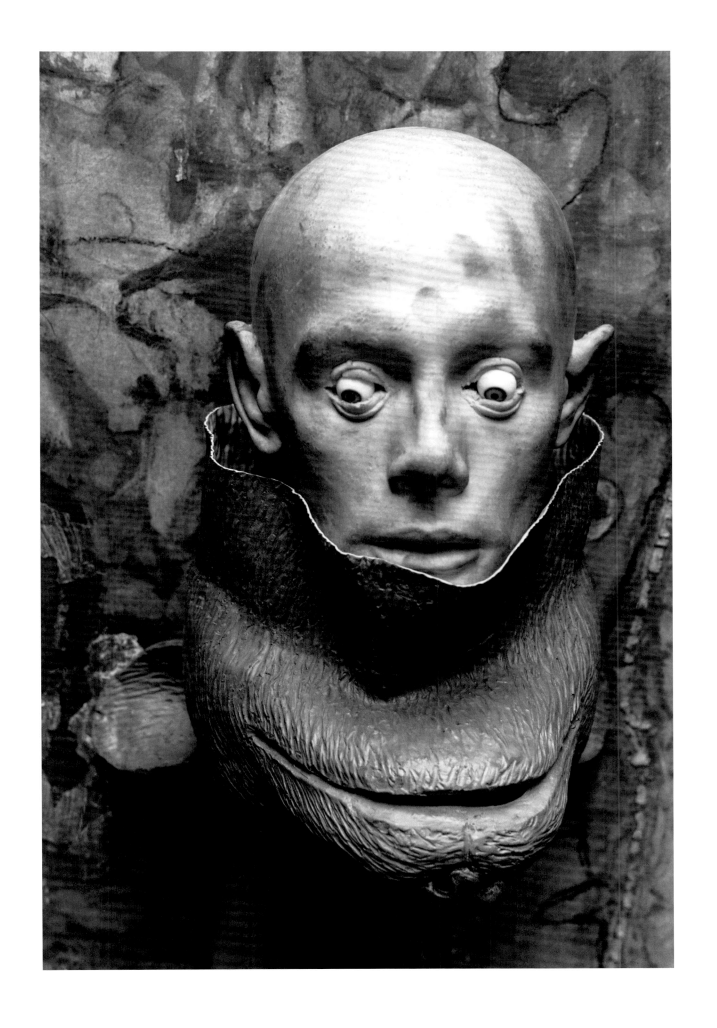

Primordial, 2016

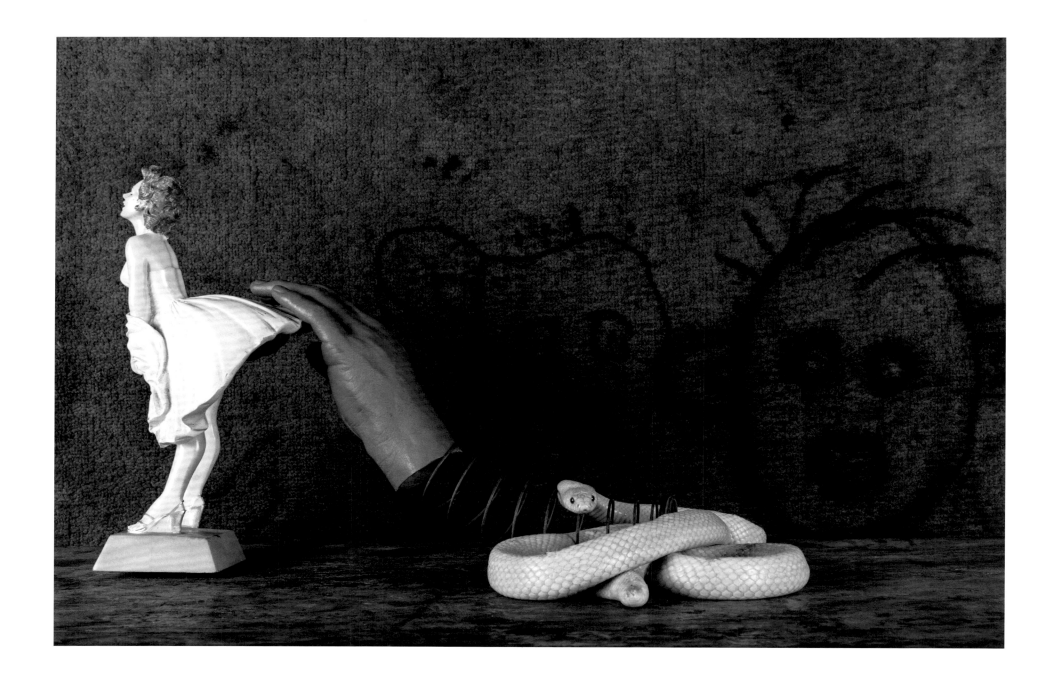

Sneak, 2016

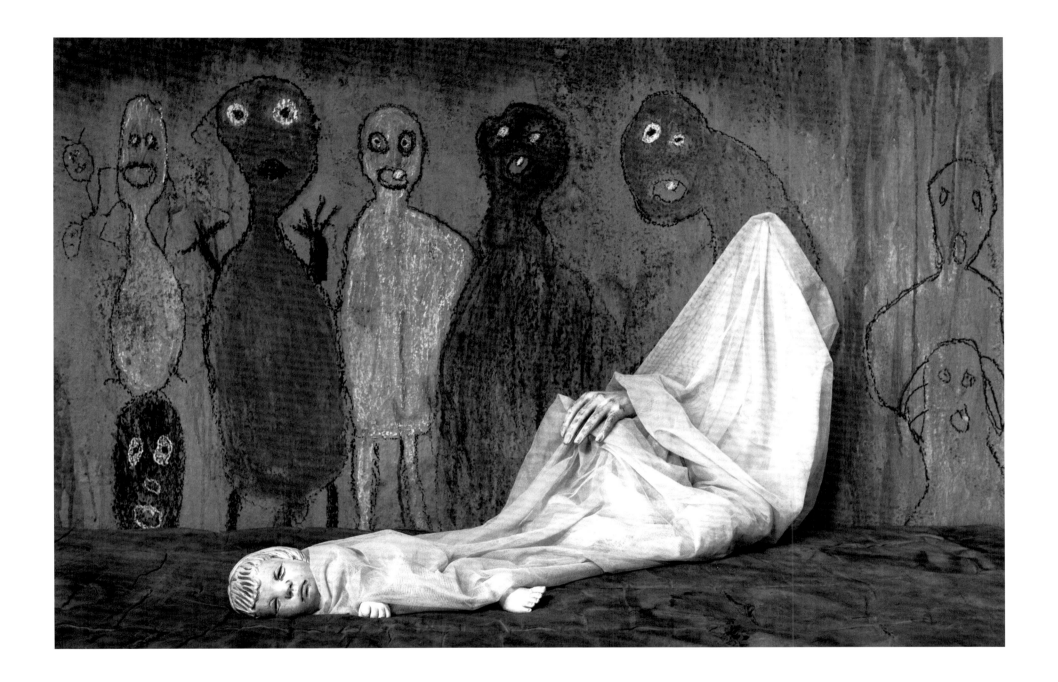

Outreach, 2016

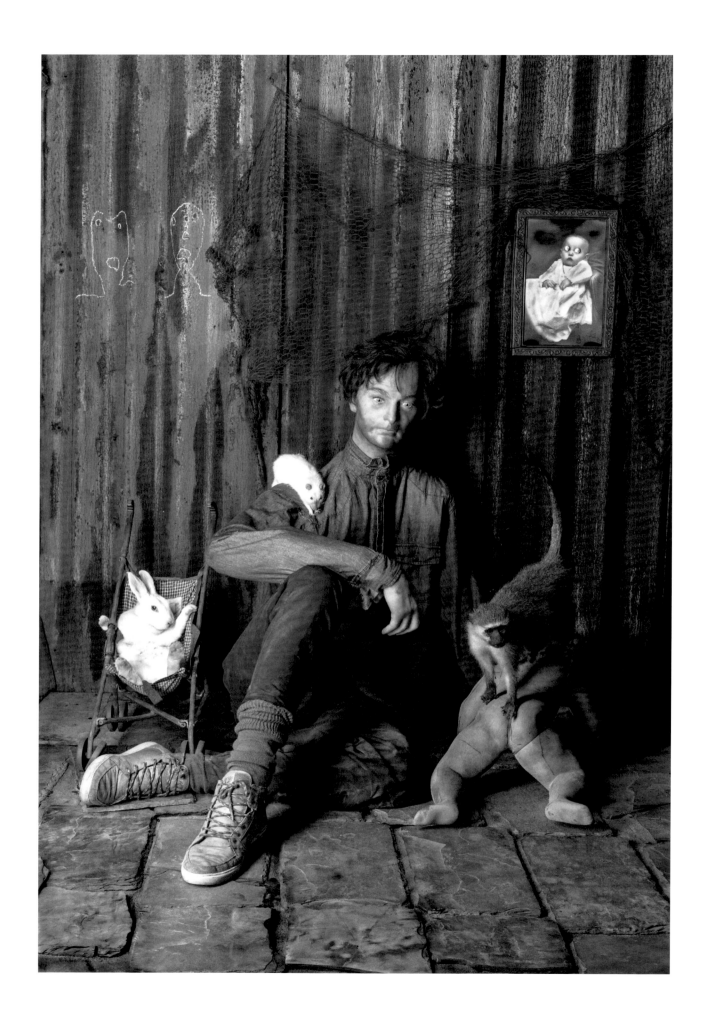

Family Man, 2016

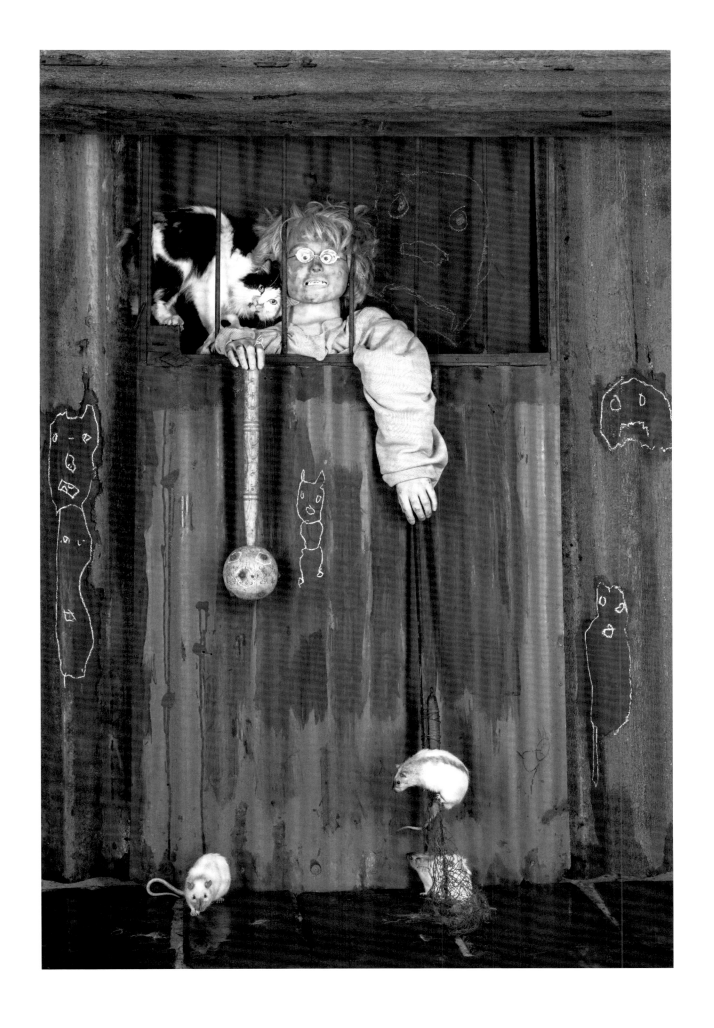

Exterminator, 2016

the theatre of apparitions, 2016

'These are spirit drawings. In a way. They are the permanent record of a bubbling-up of deeper, more primal psychological realms made manifest on a surface through the interaction between a particular individual and fluid, physical materials. Or rather, they are photographs of visual reports from some psychic elsewhere.'

Colin Rhodes, introduction to *The Theatre of Apparitions*

Waif, 2012

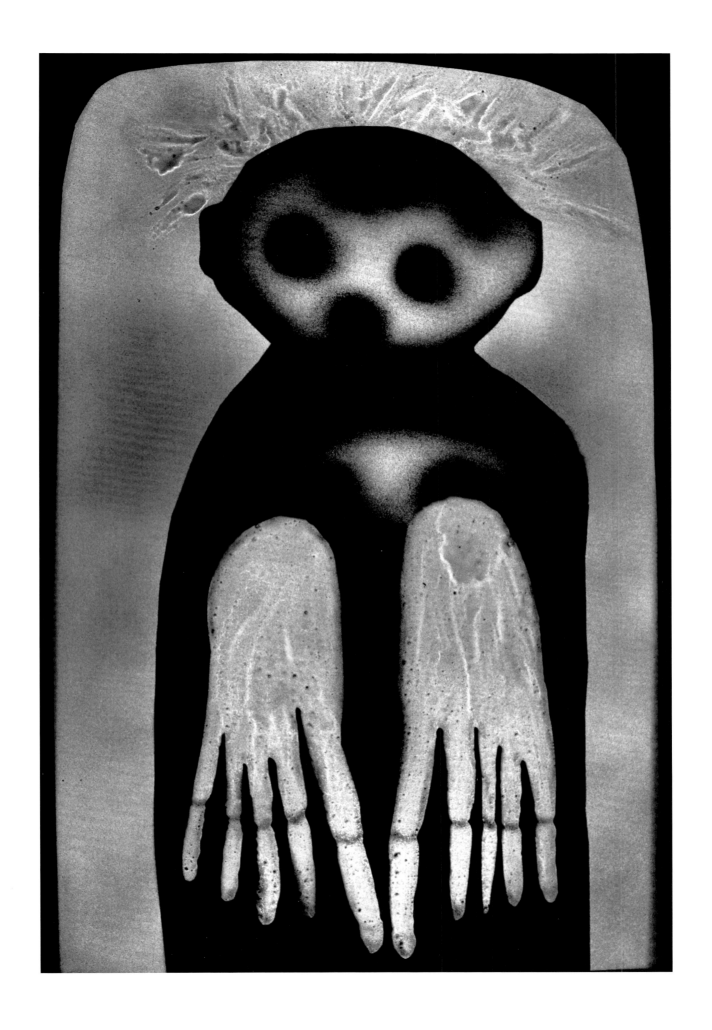

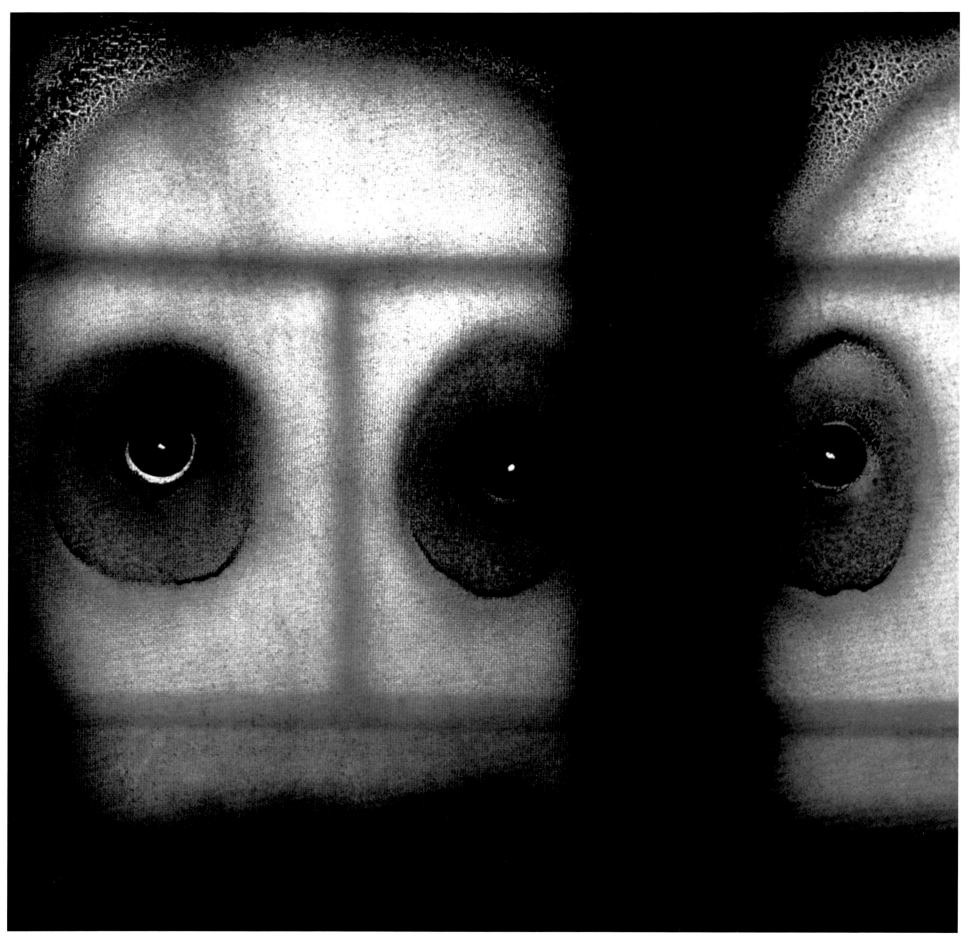

Stare, 2008

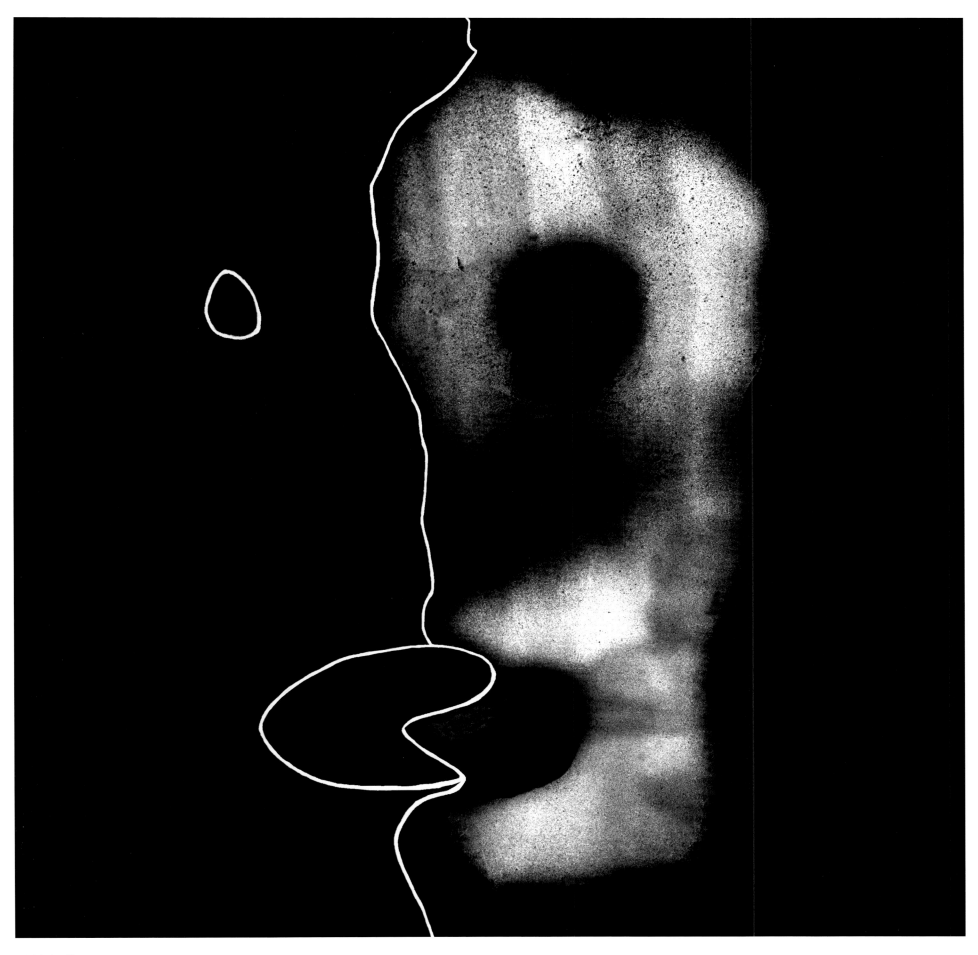

Divided Self, 2007

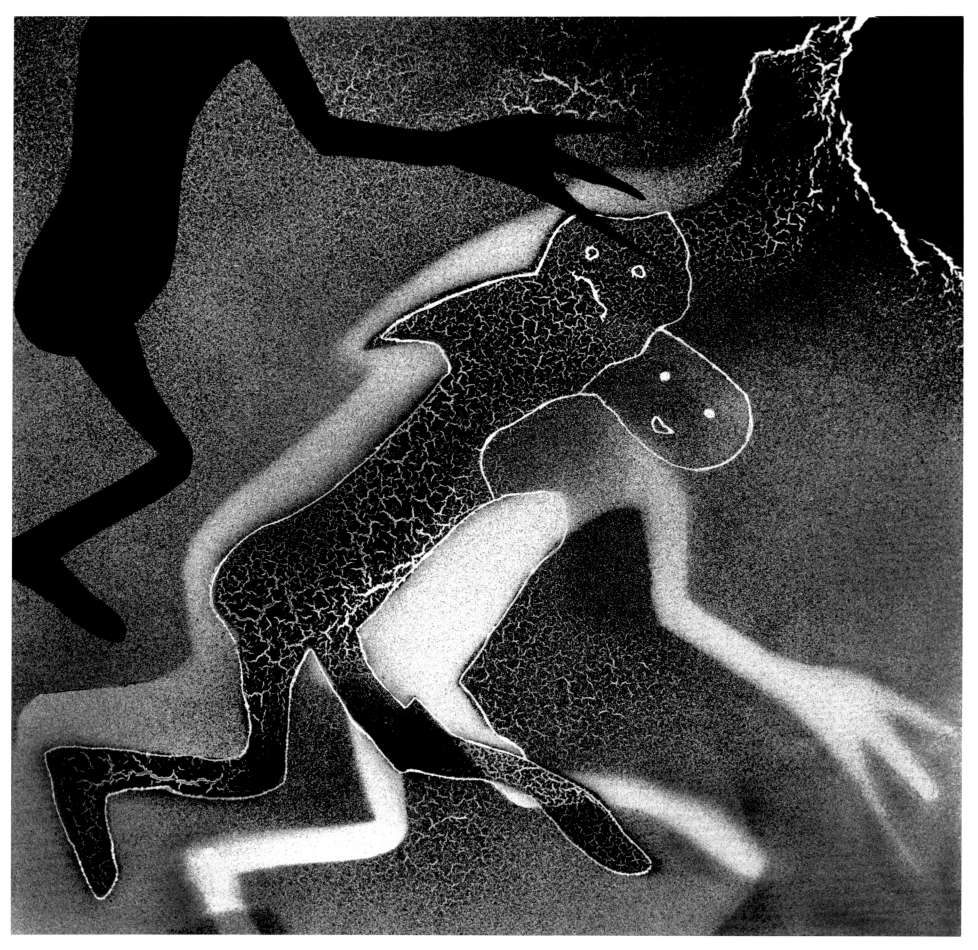

Desperados, 2009

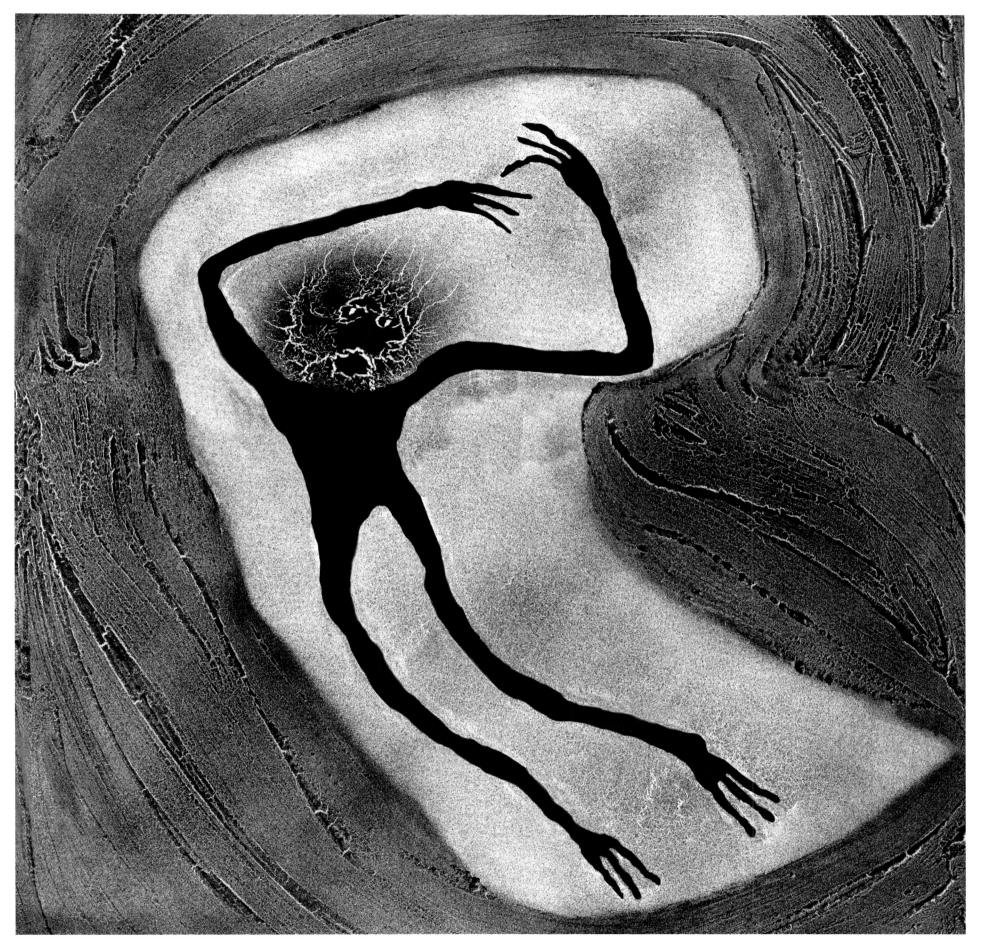

Embryonic, 2009

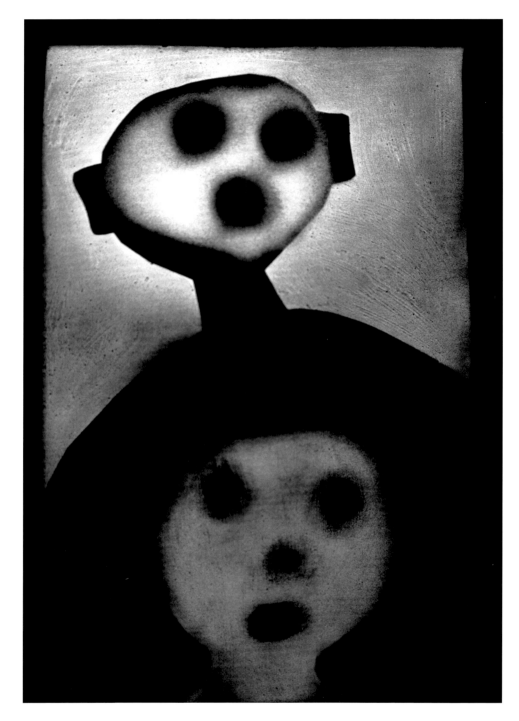

The Back of the Mind, 2012

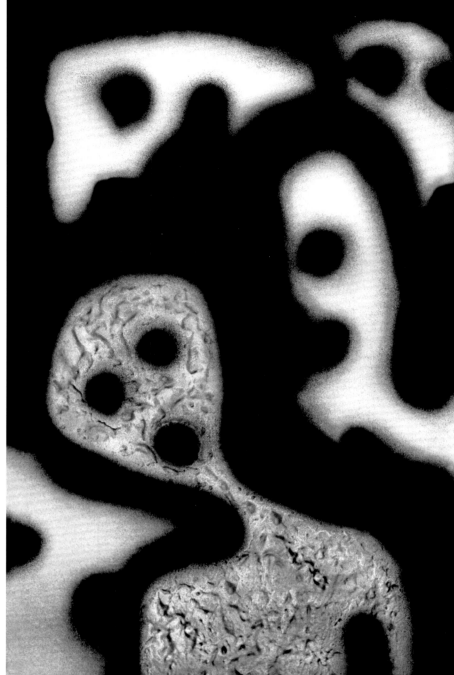

Haunted, 2013

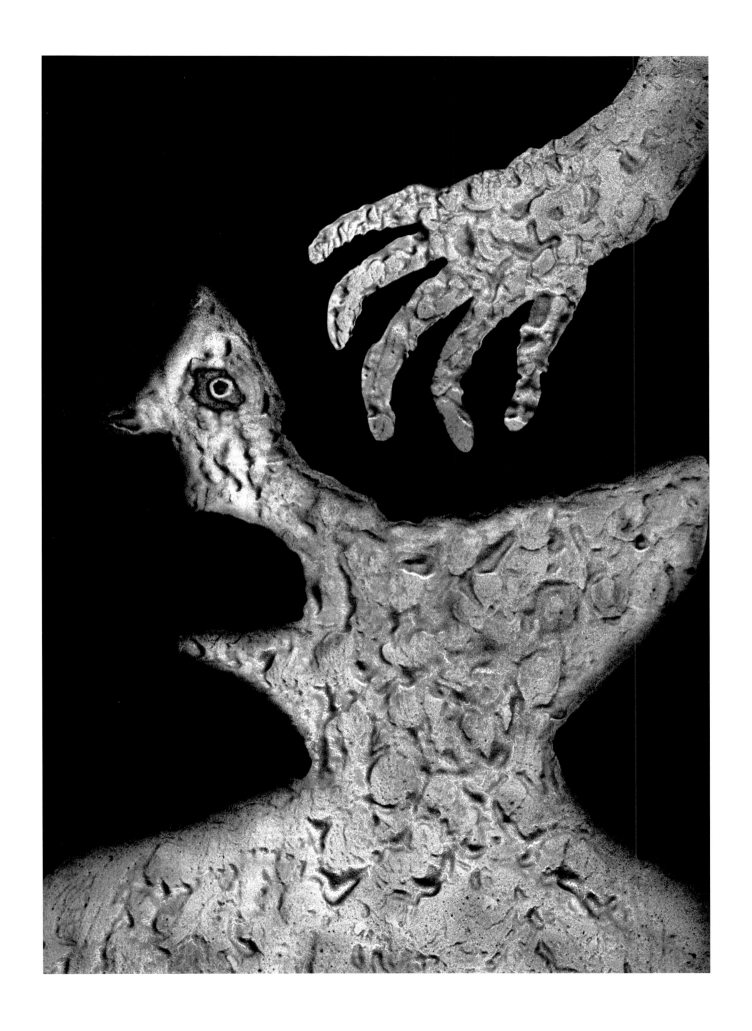

Black Hole, 2010

It has become apparent to me that all forms of life have a unique spirit. If we become a spirit after our short stint on earth, then it is not inconceivable that everything that has ever lived will become an apparition. The universe is a very big place, so there should be room for all.

Muse, 2009

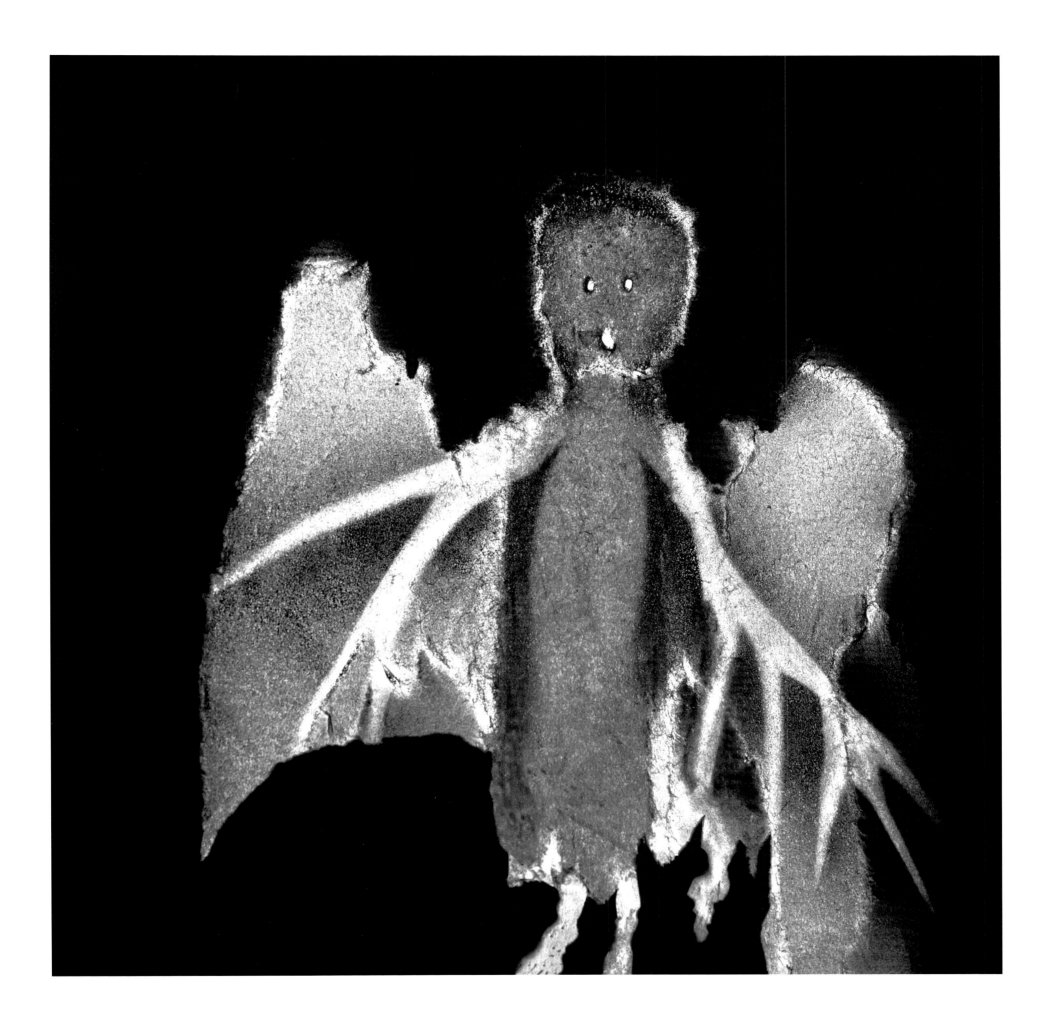

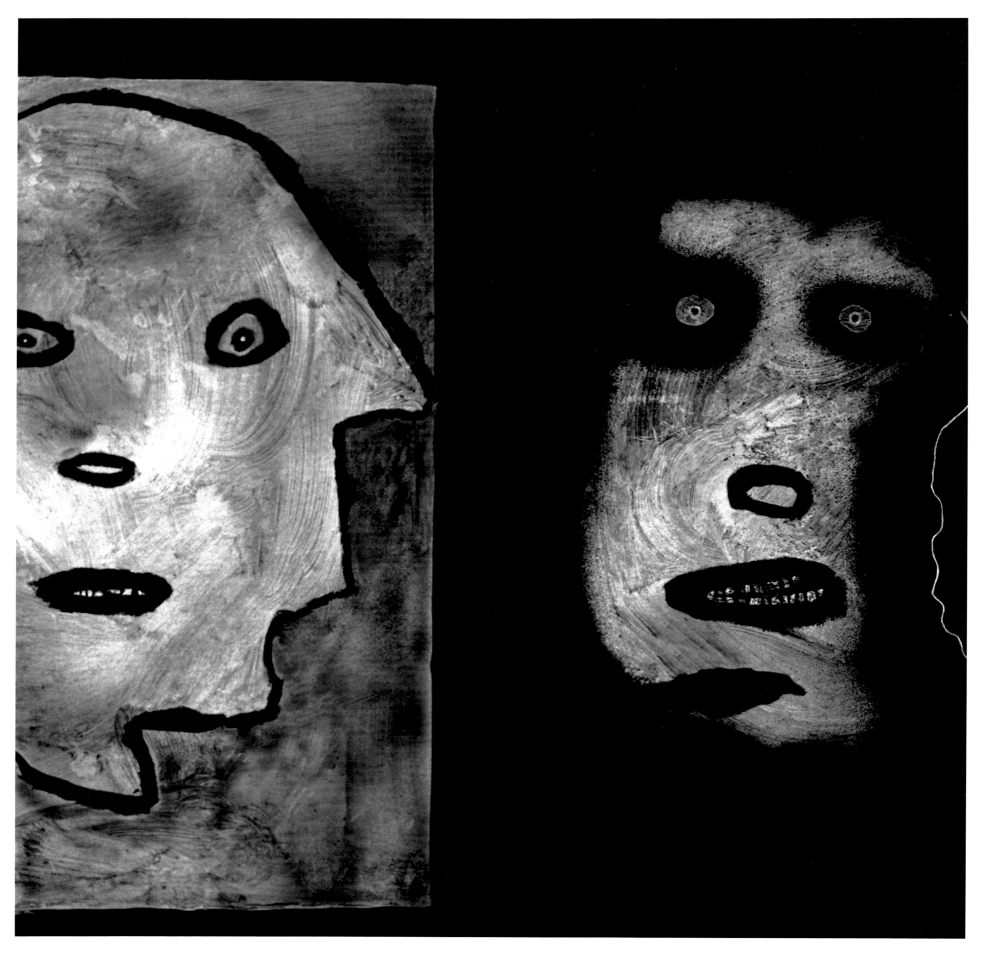

Then and Now, 2007

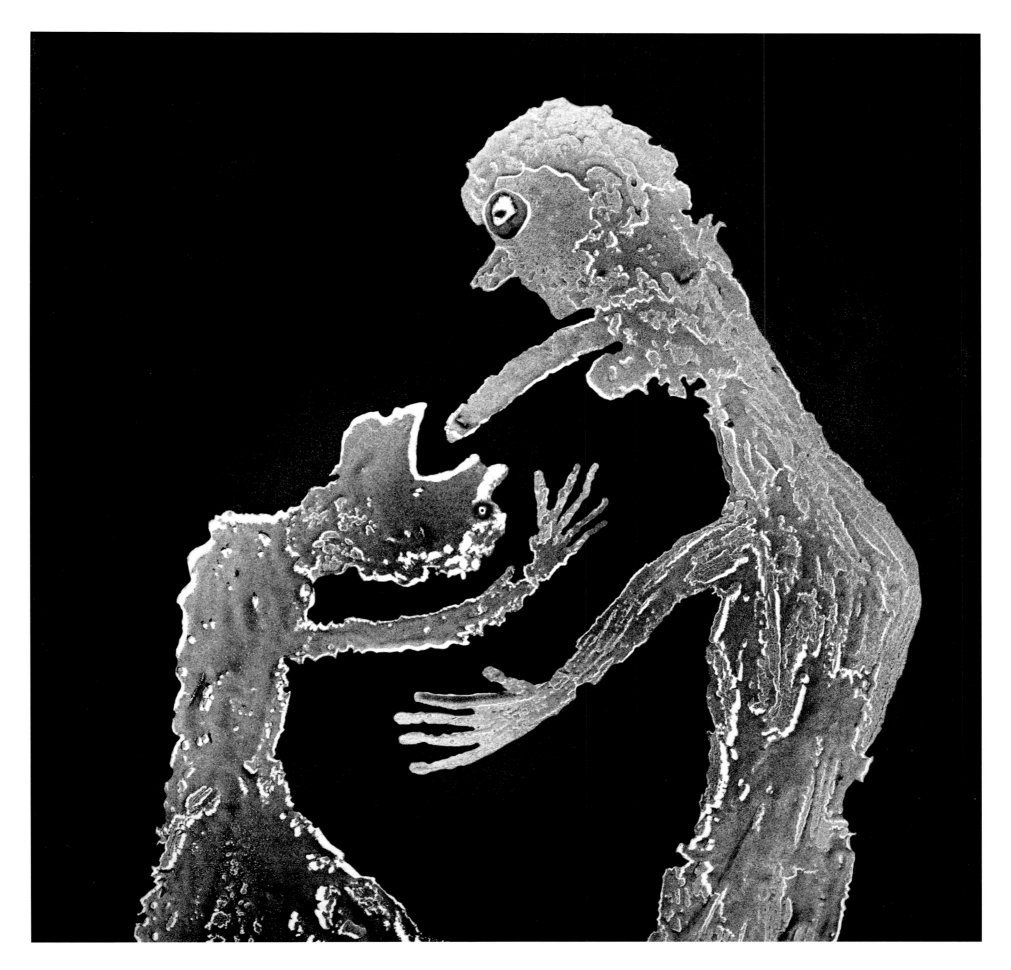

French Kiss, 2010

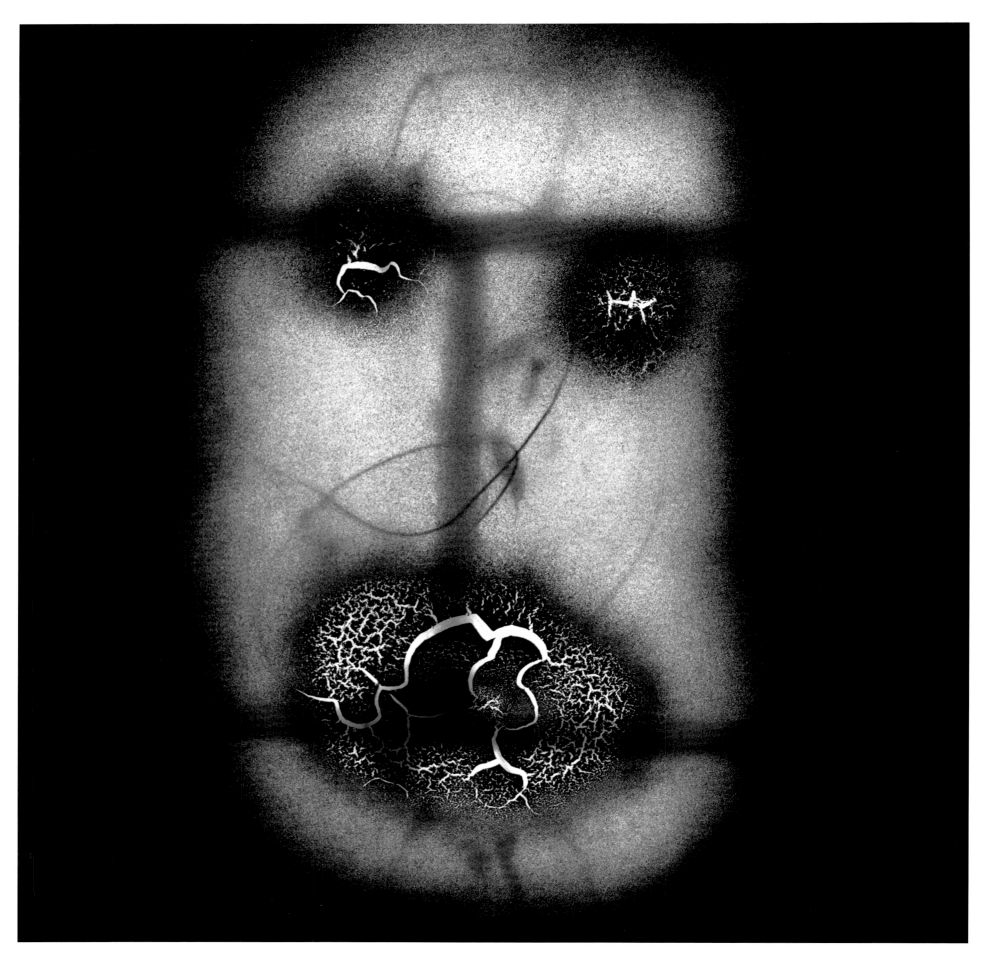

Breakthrough, 2008

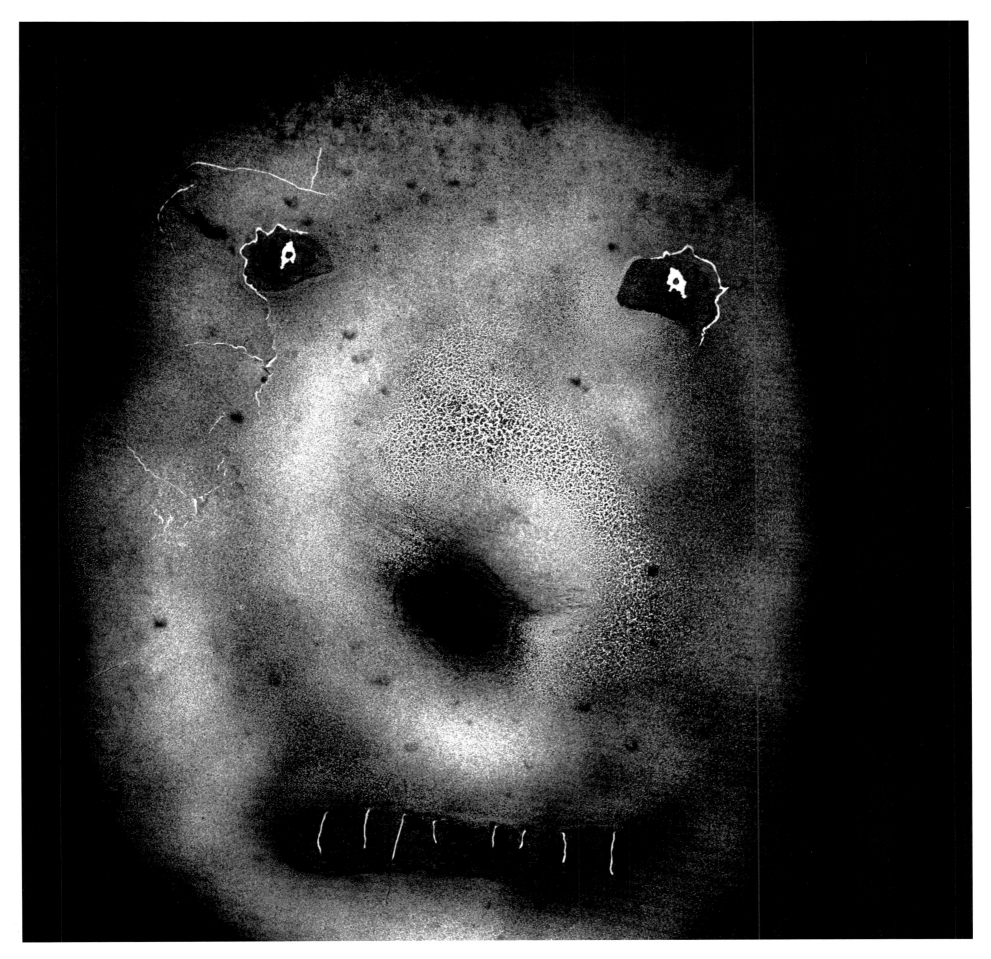

Spiky, 2007

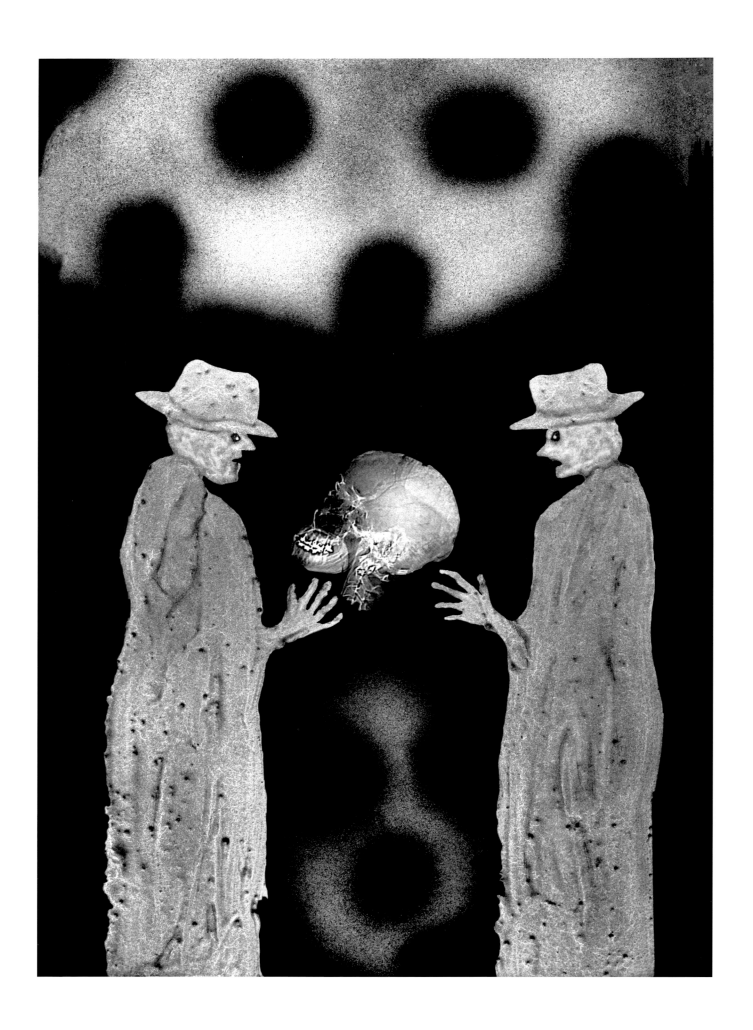

'How do you get to the mind?

Who is the mind?

Does the mind trick you?

Is the mind somebody else?

What would you be without the mind?

Would you actually exist?

There is no way out of the mind.'

From the video *Roger Ballen's Theatre of the Mind*, 2016

Guardians, 2011

ah rats, 2013–

The rat is just another part of nature; there is nothing wrong with the rat. Yet the rat is a symbol of evil in Western culture. It represents a breakdown of order, and is a metaphor for darkness. But the rat is actually innocent; it could be seen as one of the many children of God.

Open Up, 2013

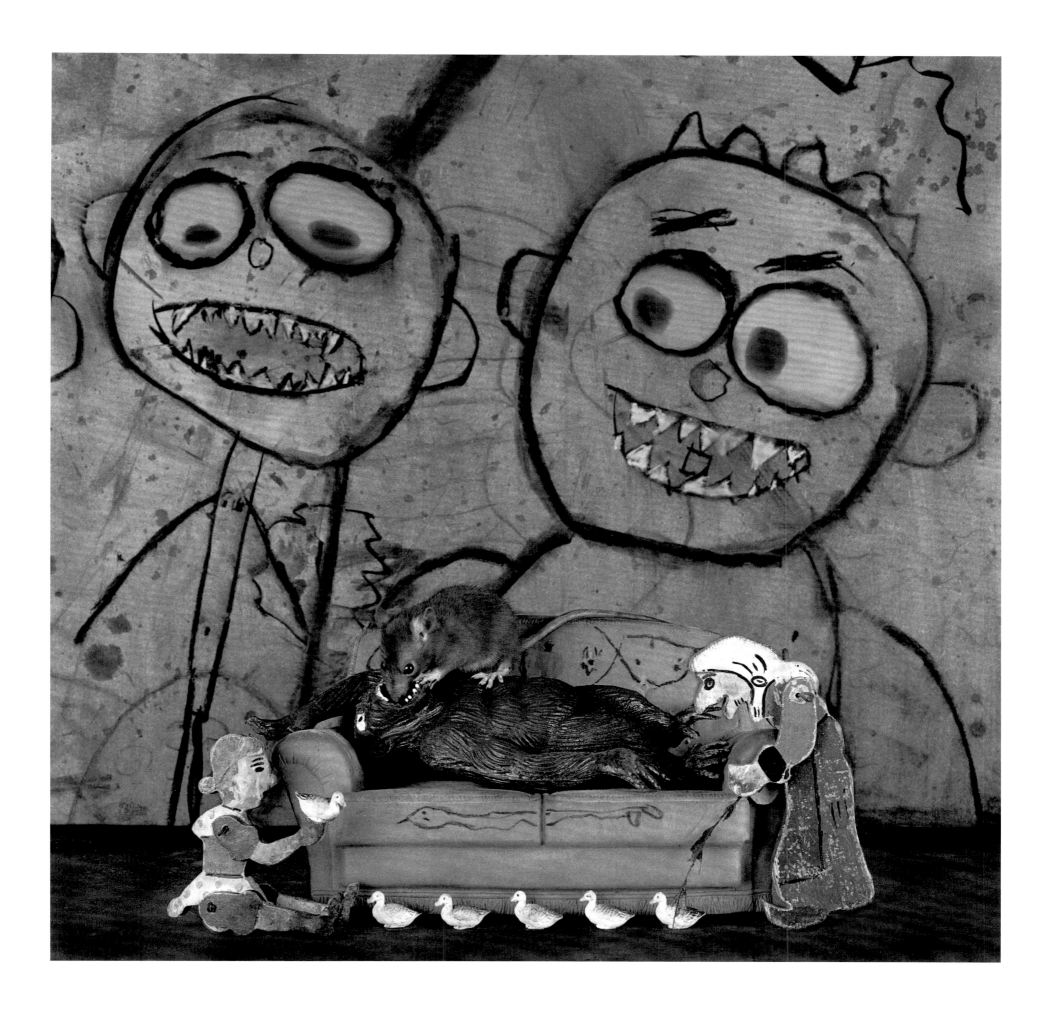

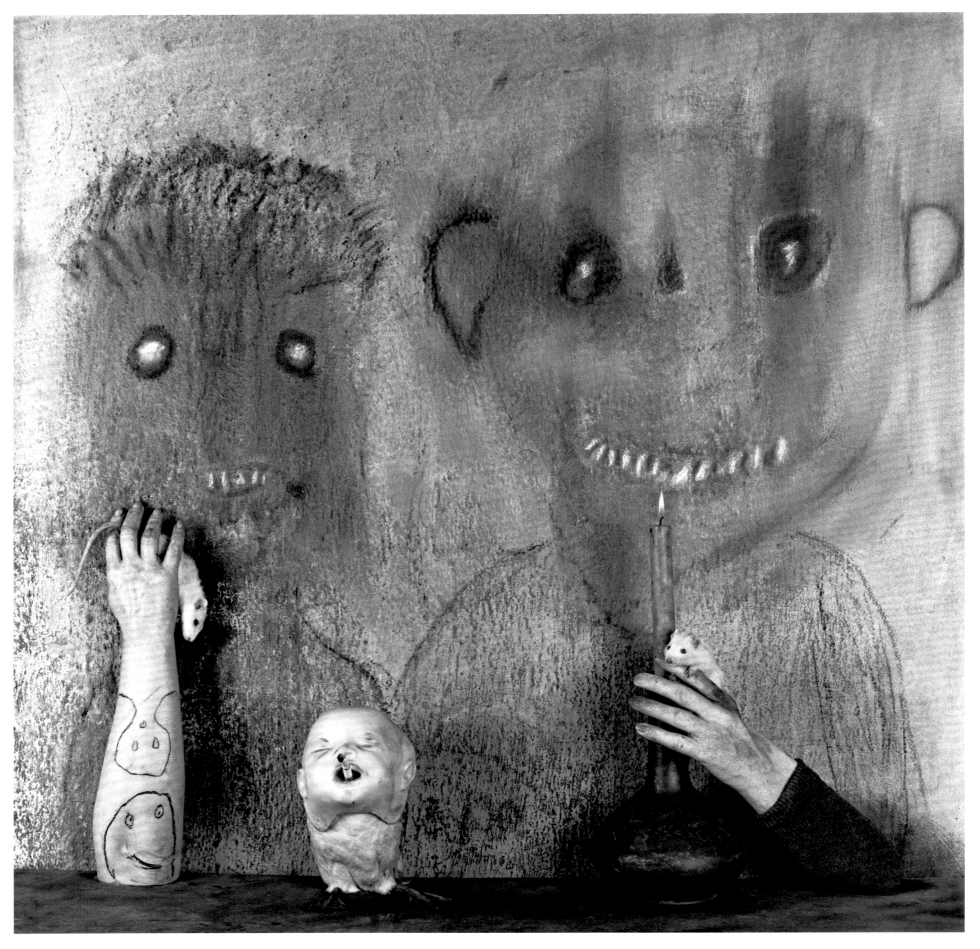

Candlelight, 2014

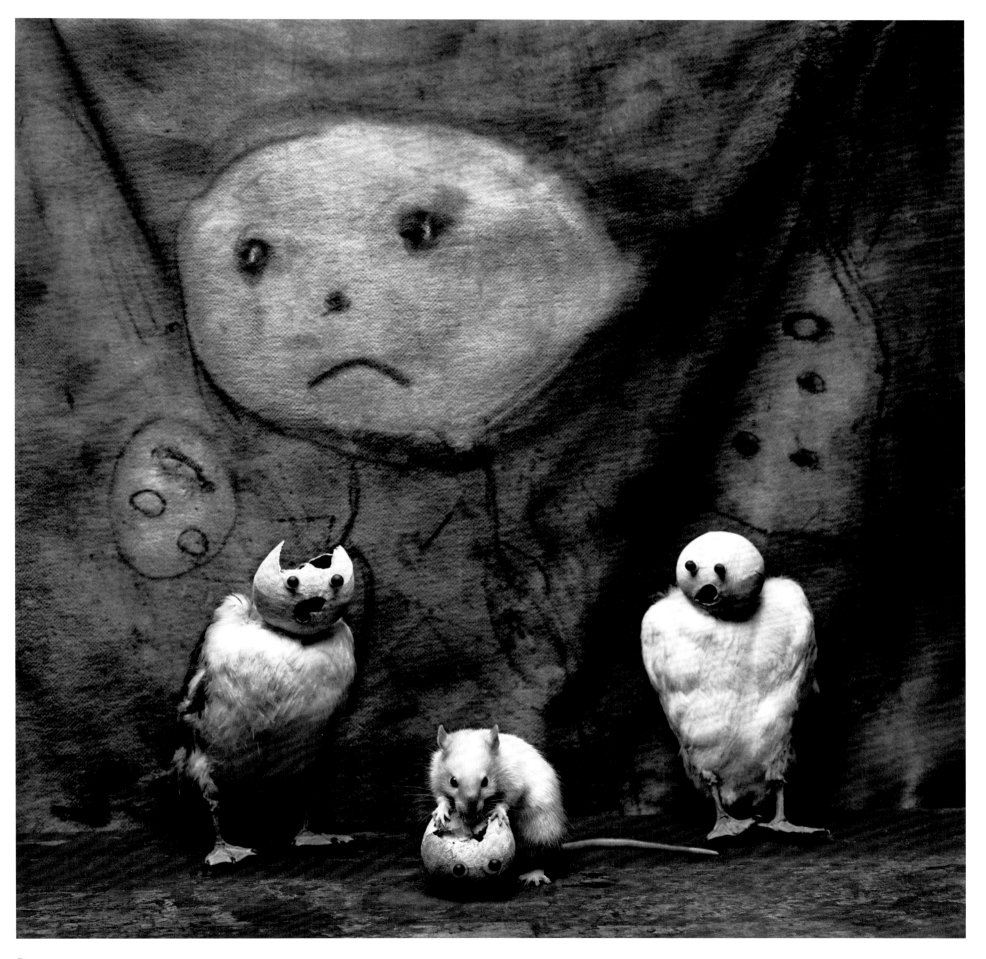

Devour, 2013

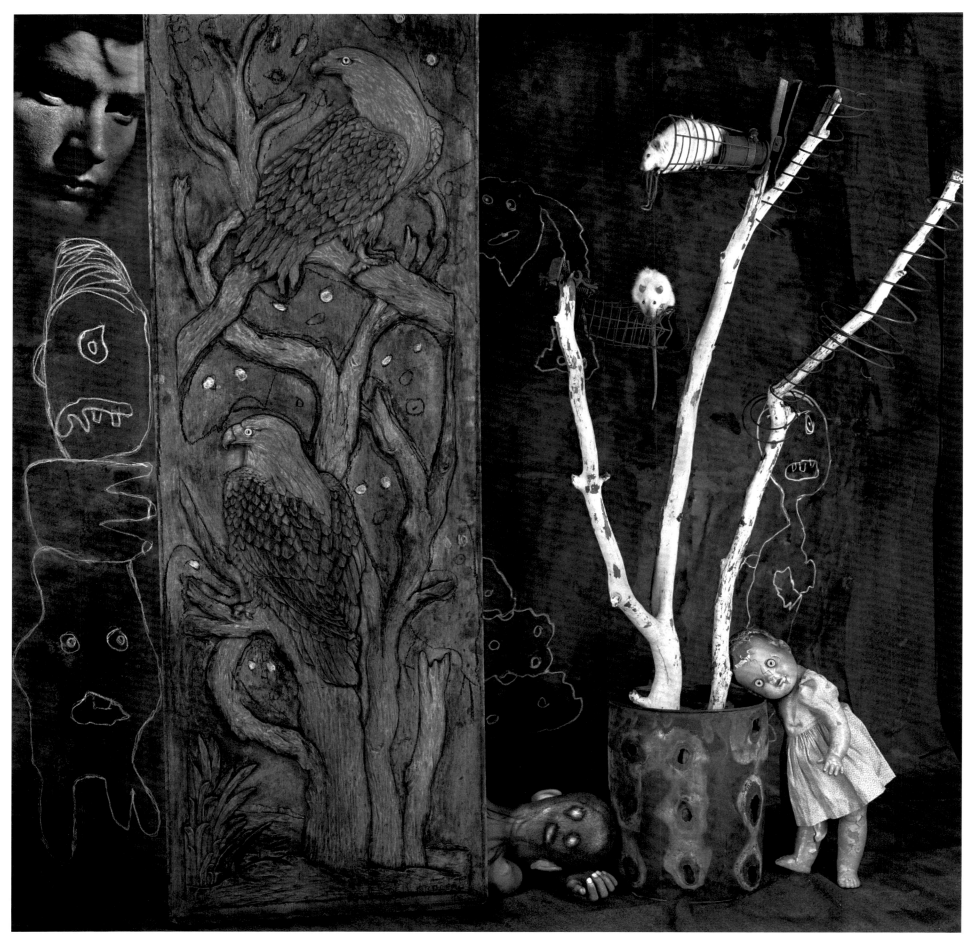

Front to Back, 2014

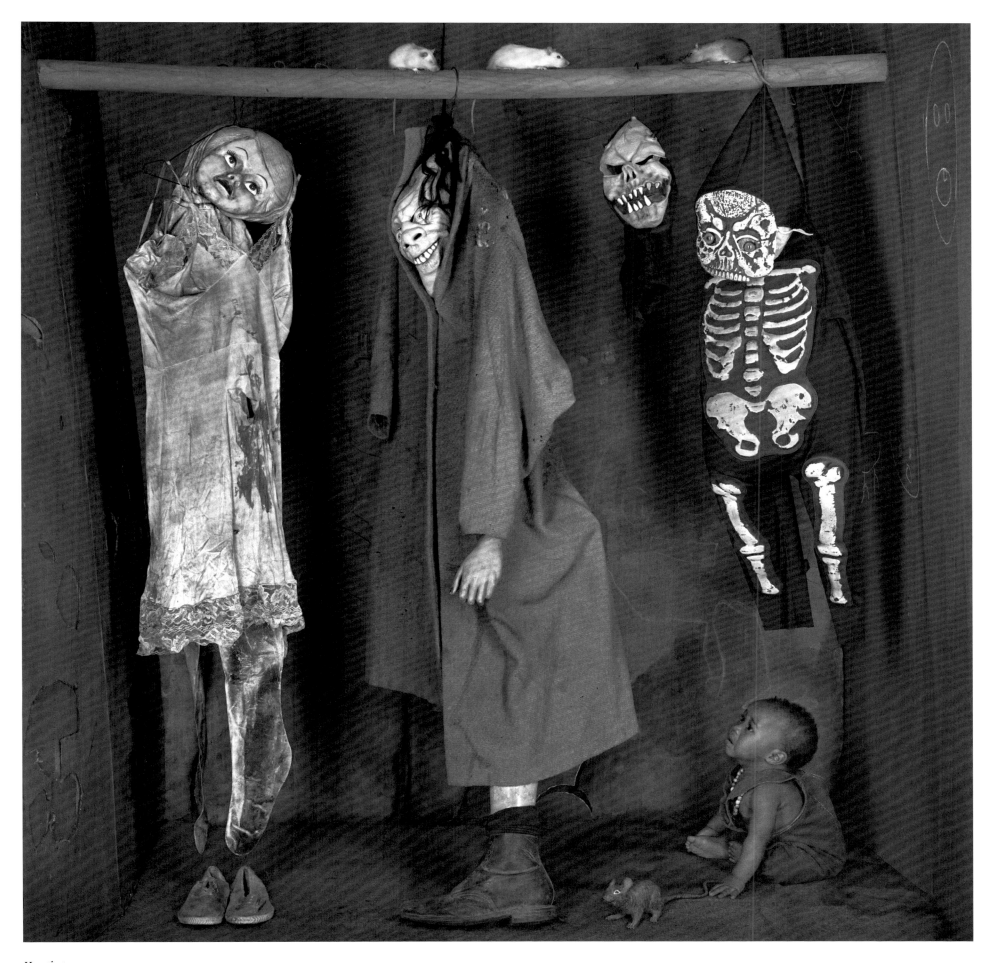

Hanging, 2013

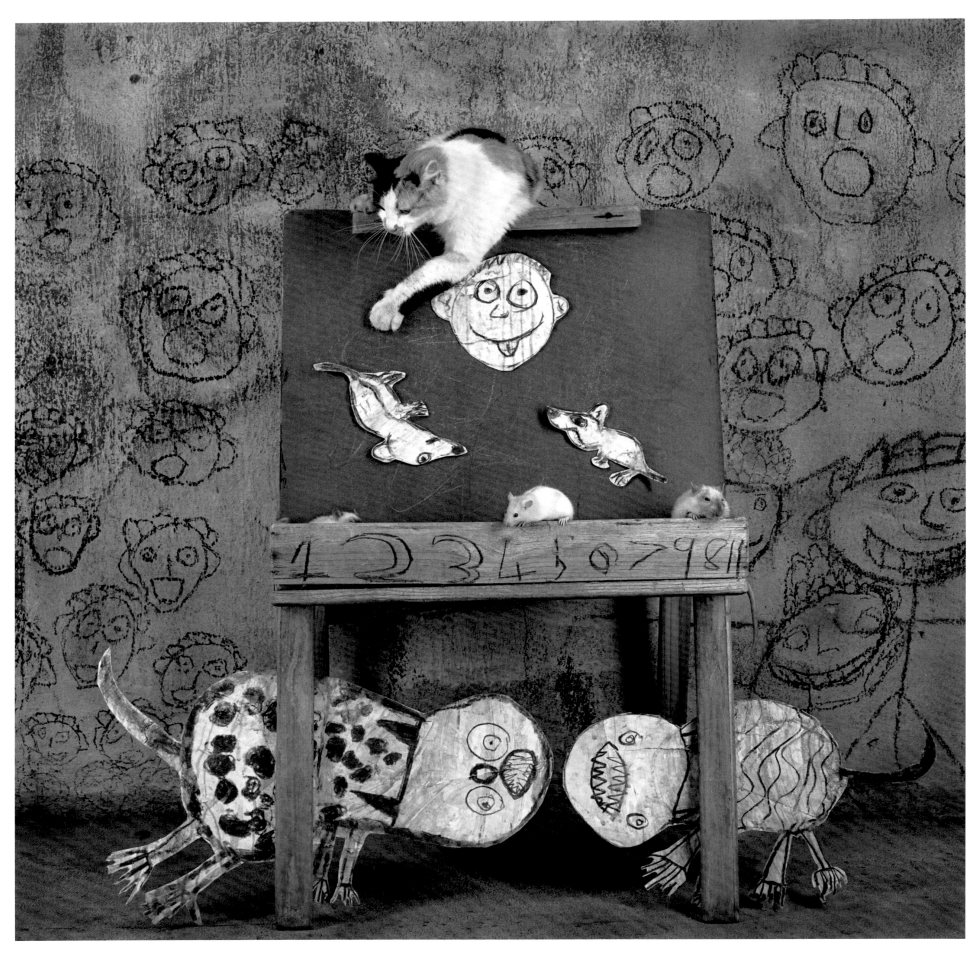

Pawing, 2013

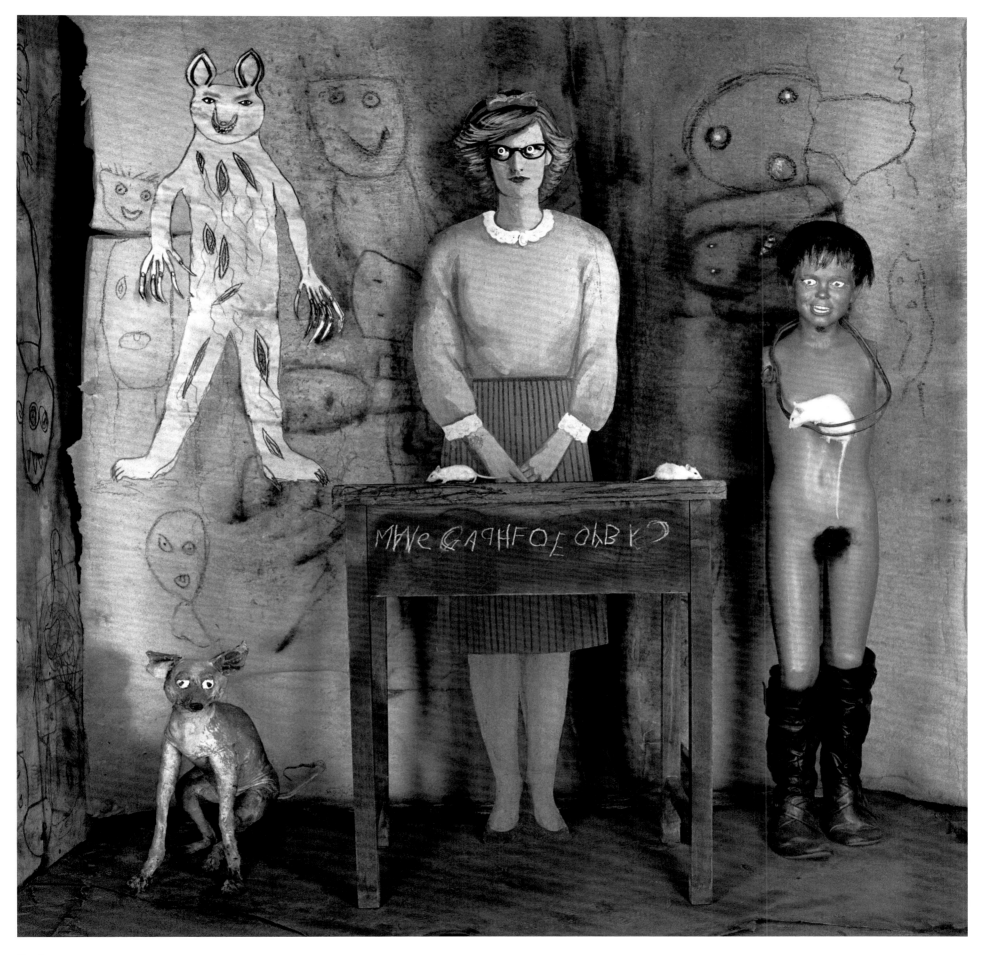

Teacher, 2014

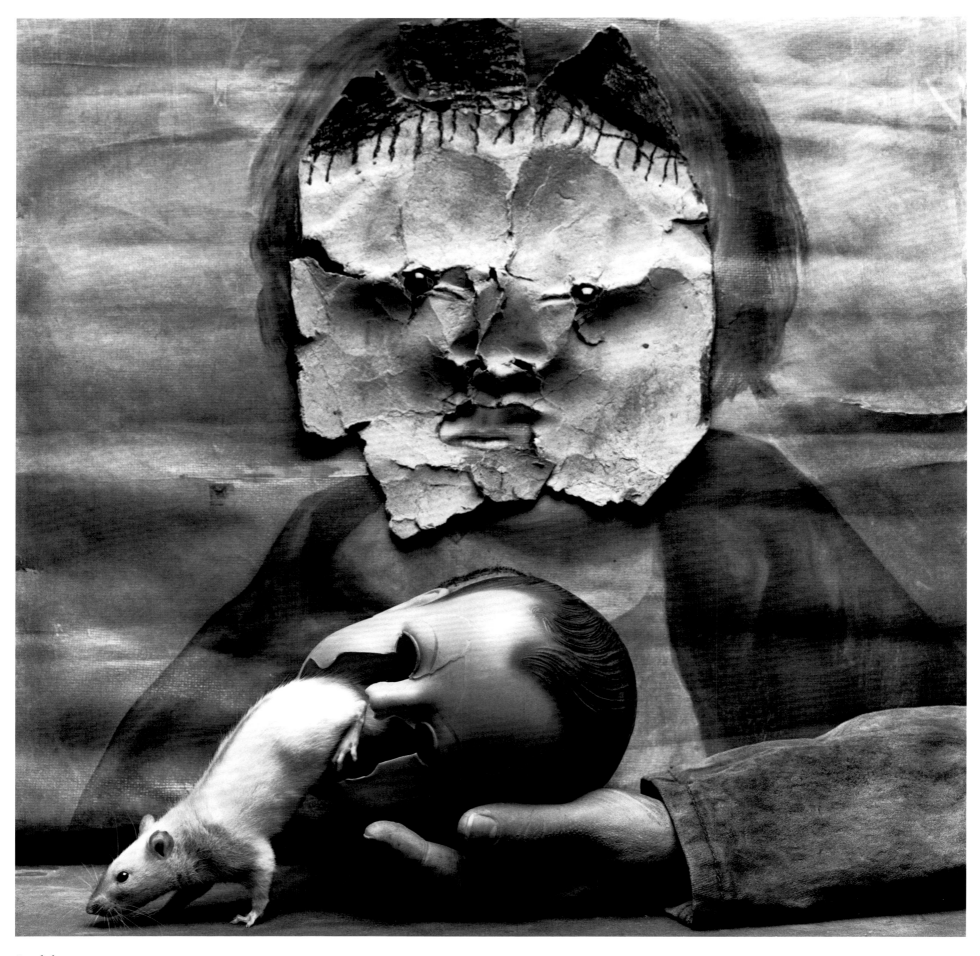

Startled, 2014

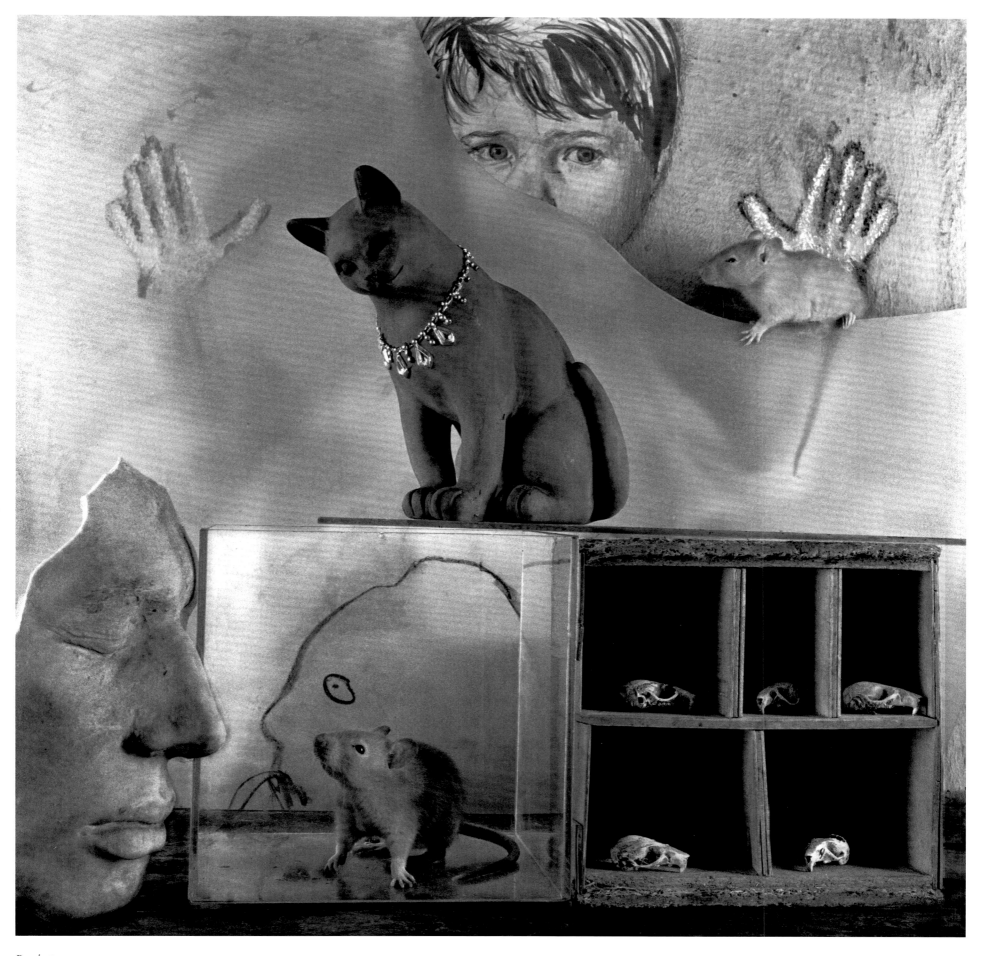

Peering, 2014

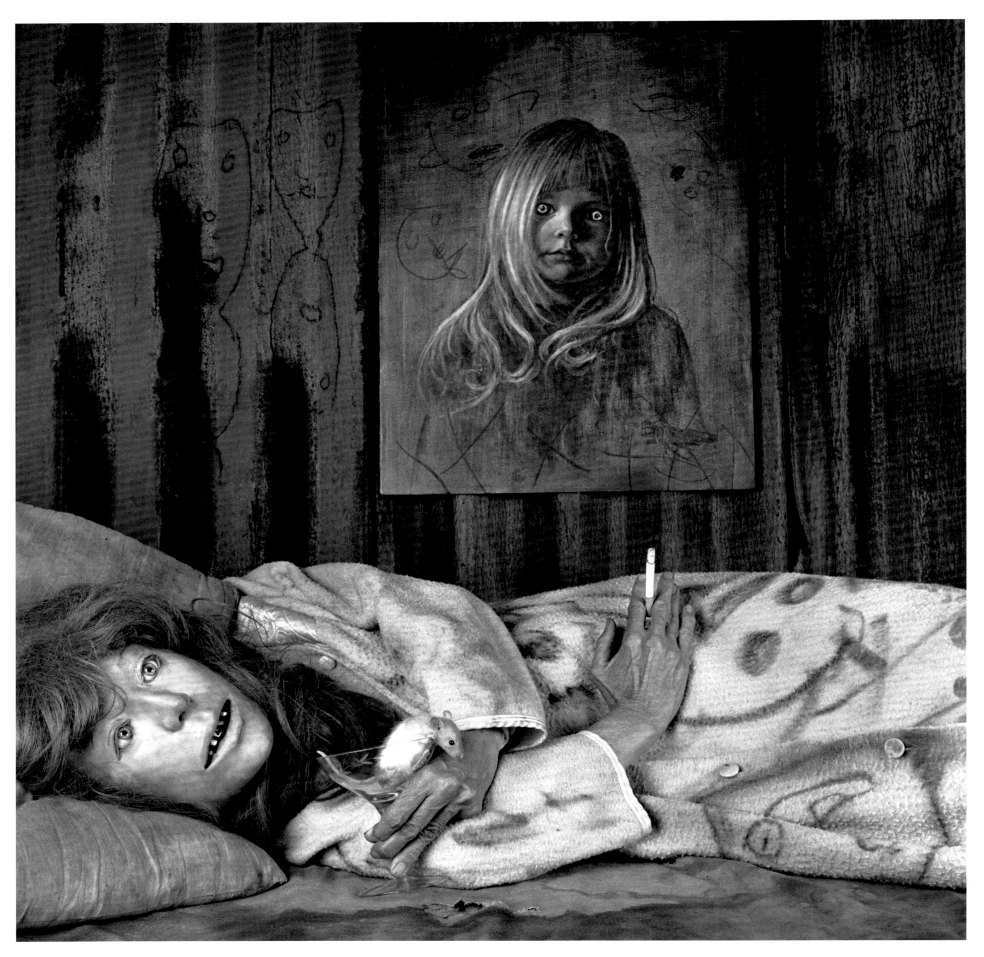

Addict, 2014

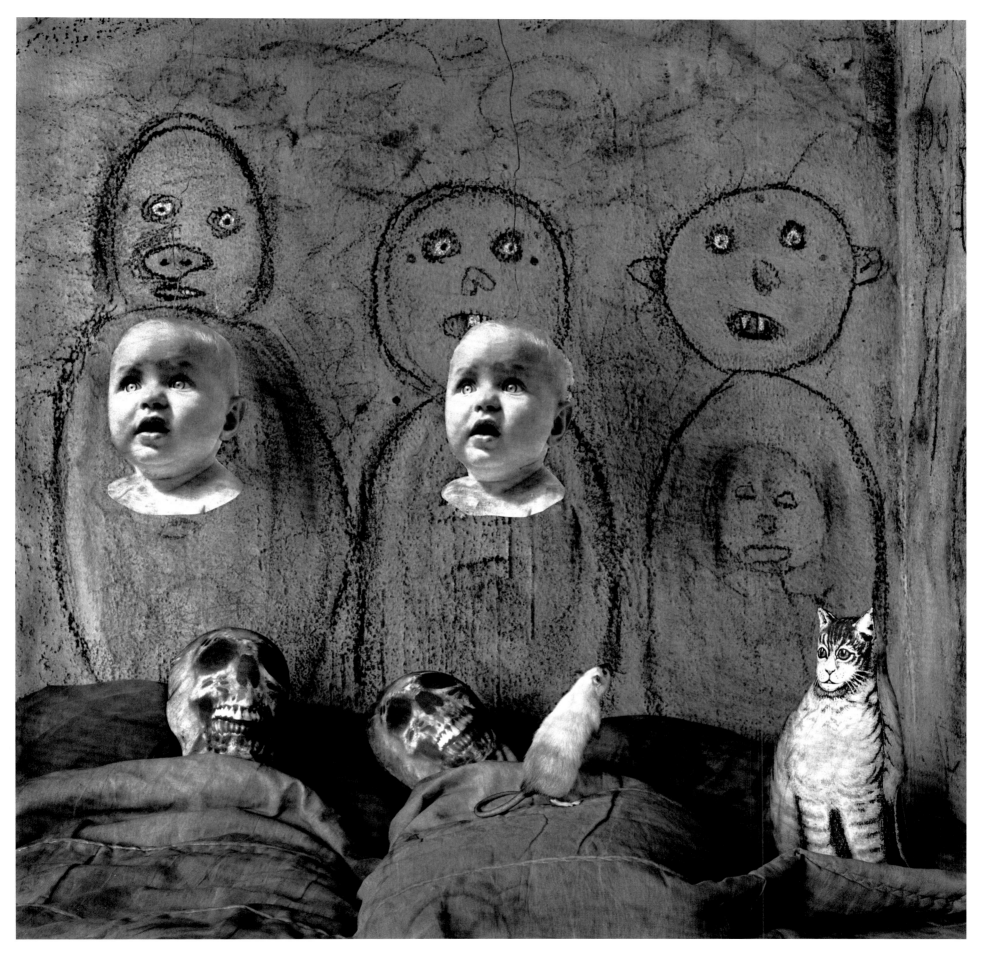

Beginning and Ending, 2013

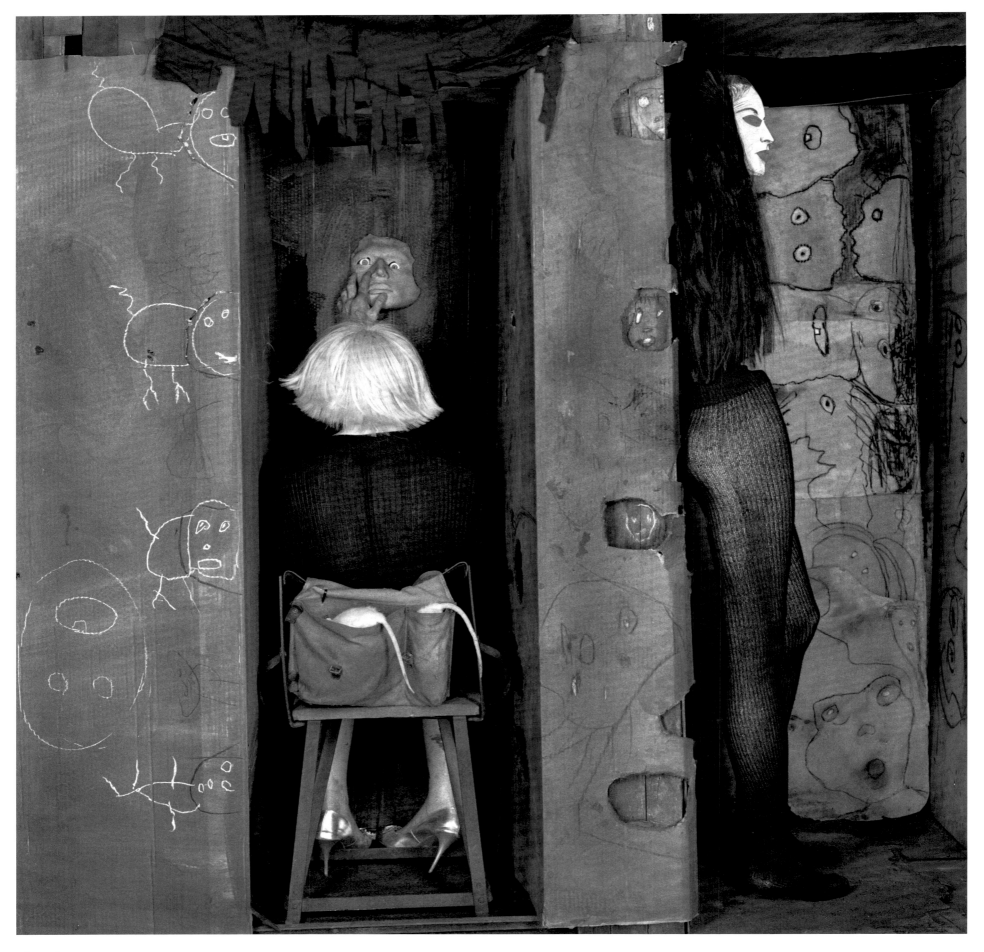

Closeted, 2015

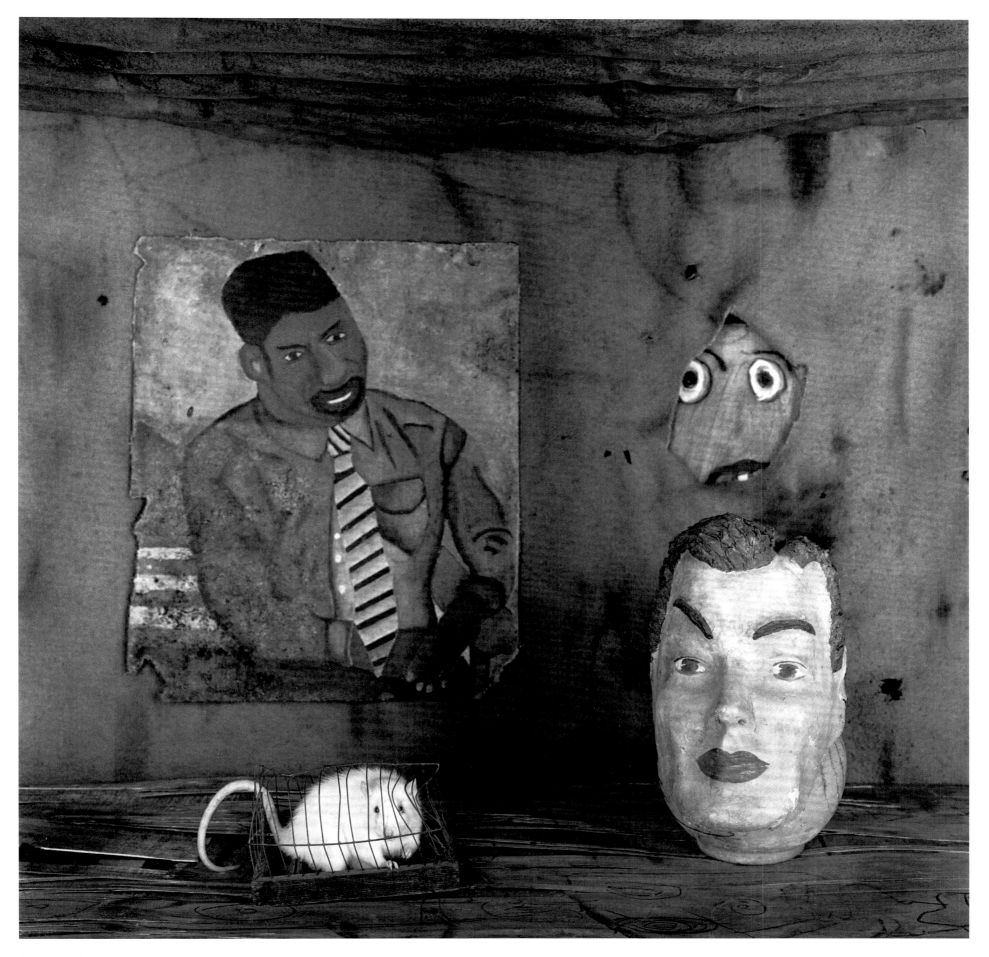

Caught, 2016

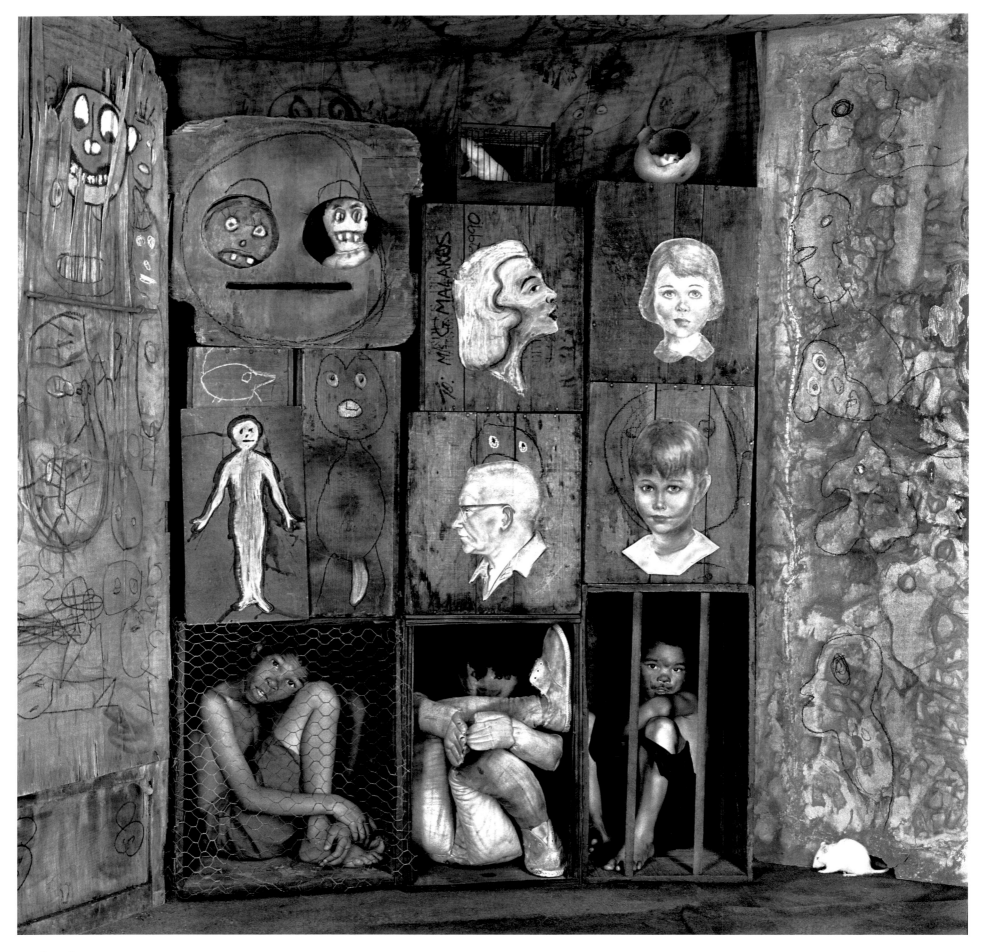

Imprisoned, 2014

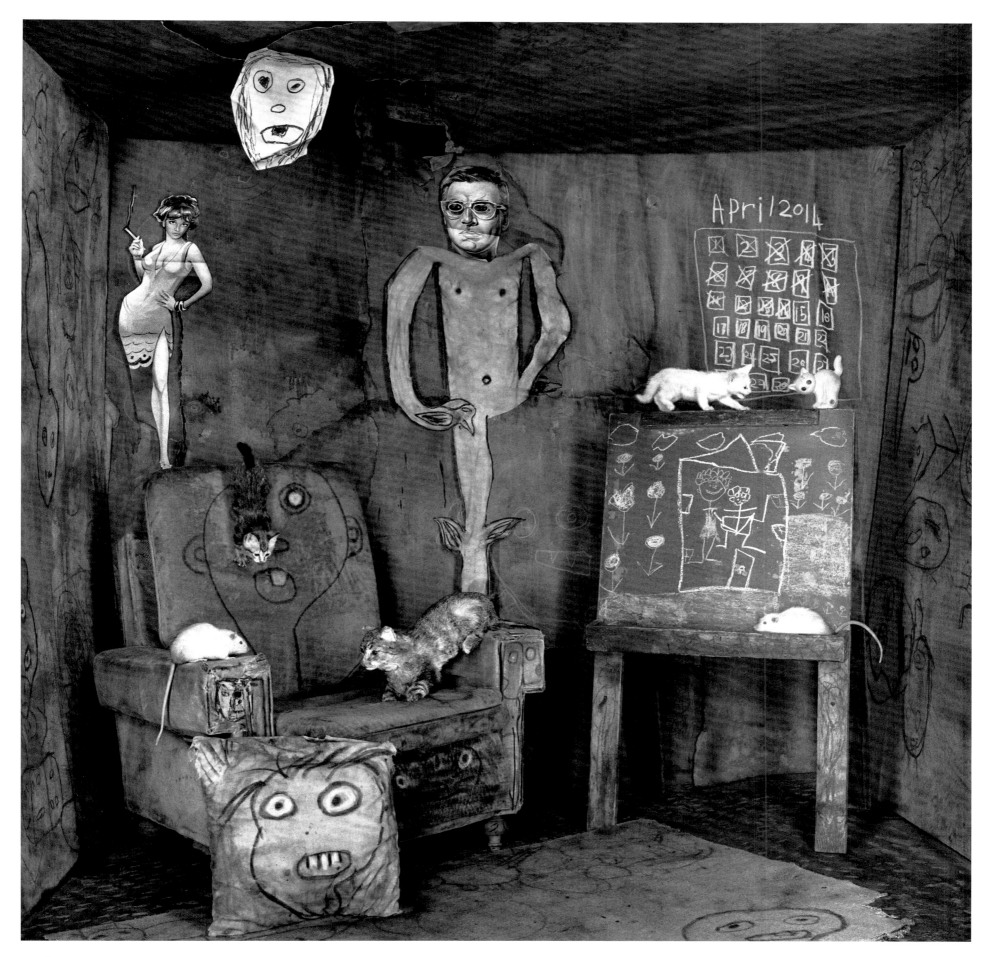

Family Room, 2014

I often question whether the face I see in
the mirror is mine, and where my thoughts
actually come from. 'Reality' is a word that
has no meaning to me; it is unfathomable.
I would rather express the enigma behind this
word than ponder its fundamental nature.

Jump, 2012

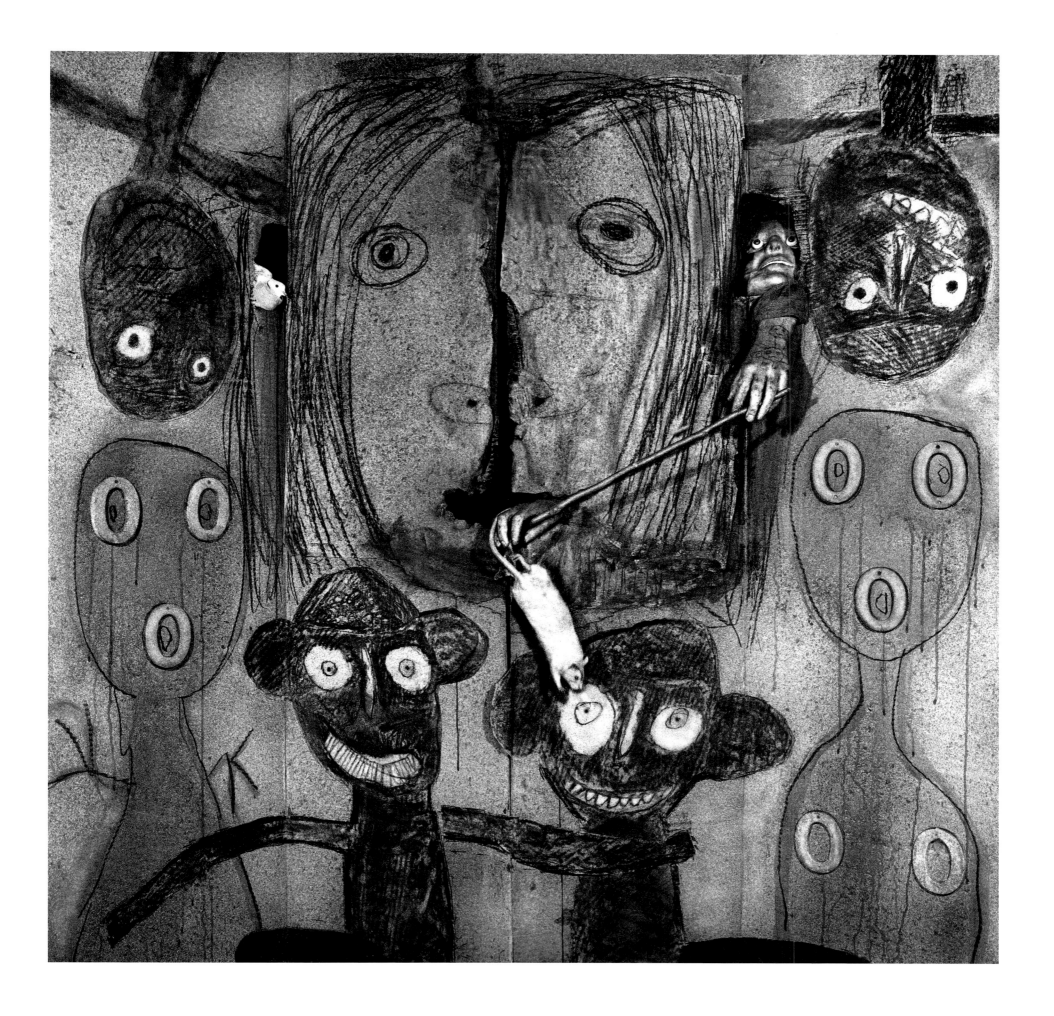

afterword

My purpose in taking photographs over the past forty years has ultimately been about defining myself. It has been fundamentally a psychological and existential journey.

If an artist is one who spends his life trying to define his being, I suppose I would have to call myself an artist.

The photography I have produced over the last few decades seems to increase in its complexity as time goes on. Although the medium is static, I am often struck by the fact that my images contain opposing meanings. They may have an aspect of darkness to them, but they may also be funny. What does it mean, then, if something is humorous but also disconsolate? There's not even a word in the dictionary for that quality or relationship; what one *can* say is that it's complex and multidimensional.

If you look at humanity, we all consist of contrasting emotions and states of minds. We find things funny but also disturbing; we can be reflective but also spontaneous. This is the way consciousness works.

I do not see myself as a political photographer; rather, I see myself as a psychological one. It is my opinion that in order to have lasting political transformations, there must be corresponding psychological ones. If my photographs are able to alter the inner psyches of those who view them, then there is a possibility that I might have altered their political consciousness. If there is a politics, it goes back to R. D. Laing – the politics of the self. It is all about getting one part of the mind to speak to the other parts; to discover the other parts of the mind.

I think what is probably most defined in southern Africa, where I have made my home, is the dichotomy between the First and the Third Worlds. I'm originally from the First World, and live like a First World person. But in just five steps, I'm in the Third World. I like to bring that concept to mind because the unconscious, the id, is like the Third World; the First World is like the ego. For me, living in South Africa is like my relationship between my ego and my id. I'm constantly going back and forth between them, and so the environment is similar to my state of mind.

The goal of my images has been to help viewers make peace with their inner selves. In other words, I am hopeful that my photographs can break through layers of mental repression and allow different sides of people's minds to communicate with each other. It is my strong belief that unless a substantial proportion of humanity is able to unshackle mental repression, the condition of the species will not substantially improve.

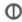

I am not overly involved in what is commonly referred to as contemporary art. Great art has to relate to the universal, the archetypal, not to the sensational, fashion, or what sells. It is quite common in the art world to assume that price is the crucial factor in deciding artistic value.

The art business must be one of the most difficult businesses in the world to understand. I have therefore tried to perfect my practice, rather than becoming a denizen of the art world; I have tried to define a practice that is wholly mine. It's a matter of the way I organize reality. My images are essentially transformed photographic realities, created by the interaction between my mind and the location I'm working in.

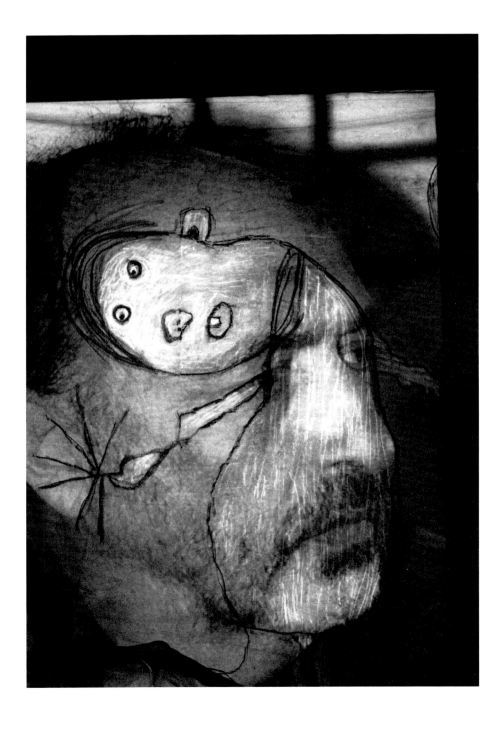

Marguerite Rossouw,
Untitled, 2015

If I go to a gallery, I enjoy walking around; but I stop when something grabs my attention. It's like a hand coming out of a painting, grabbing me by the neck. That's what I want to happen to me when I look at art: I want to be jolted. I want my pictures to jolt people too, because if they get that little jolt, I know my work has found its way inside; no matter how hard they resist, I know it's there. Maybe that's the first step in coming to terms with one's own identity. It's an infinite process, the process of a lifetime, but I'm convinced that art can help people get to know themselves better.

I always say that a photograph began before I started making it, deep down in some part of my mind. It formed before my consciousness about it was formed. Since I am part of all sorts of other consciousnesses that have existed throughout time, it's difficult to say exactly when a photograph began. On a practical level, it usually begins with an object or a person sitting there, and with me connecting one thing to another. I'm basically an organizer: I organize visual chaos into visual coherency.

I never plan my photographs, yet relying on one's dreams and imagination alone will not guarantee a successful image. My photographs come about as a result of thousands of tiny decisions, just like the innumerable brushstrokes in a painting. There are an infinite number of options. That is what makes photography so difficult: there is no limit to the possibilities.

I am inspired by blank white walls. They symbolize the challenge that I face on a regular basis: to find a way of transforming vast nothingness, to give birth to imagery that has a life beyond my own. My creative processes evolve from silence: they are filtered through consciousness and hopefully end with the inexplicable.

Archetypal symbols from the deepest level of the subconscious pervade my photographs. This place cannot be tamed; it has its own rules, and functions according to its own laws. As a geologist by training, I have descended many mine shafts, heading to the centre of the earth. As I headed downwards in the elevator, I passed through different layers of the earth's history. Arriving at the bottom of the shaft, I would reflect on my creative process. When taking photographs, I often travel through the layers of my mind to locate this spot, this black core – a place where dreams and many of my images are born.

It is one thing to find yourself in this deep subconscious, but quite another to bring the buried fragments out so they can manifest themselves. That is the crucial step: bringing the pieces to the surface and linking them with the exterior world that one is trying to transform through the camera. I do not work out of a sense of inspiration, but rather out of a deep existential need to define my own identity. I am also not concerned about what is real and what is not; the term defies definition. Nevertheless, my images are meant to straddle the strange,

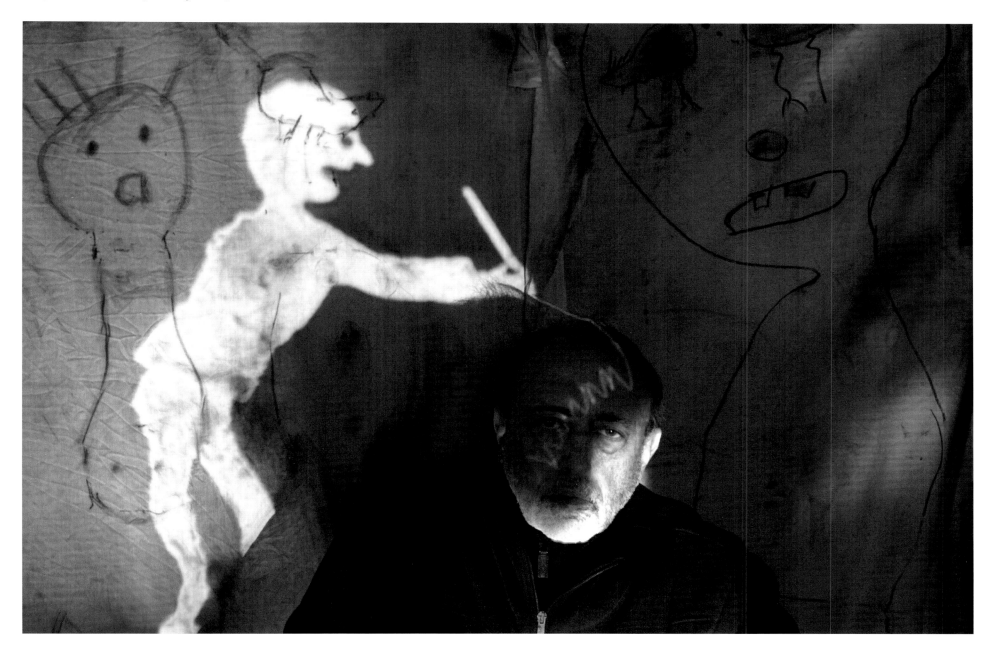

vague line where illusion becomes delusion, fact becomes fiction, and the conscious merges with the unconscious. My photographs are intended to break down the boundaries of logic and language and, in so doing, shatter the enclosing walls of habit and fear.

I see myself as a formalist. As in nature, there is a harmony between the various aspects of my images; if one part works against the other, you end up with a cancer. So, form is crucial to what I do, and I believe that form is the basis of content. If you don't bring the forms together, you don't get the content. Of course, a picture doesn't stand by its form alone; you can have forms that relate, but without meaning. Ultimately, a picture is judged by its meaning, but is dependent on its form. And that, I think, is what many people lose sight of.

The camera has its own mind, its own stomach and digestive system. However, as I have always said, it does not have any ears. People can tell stories for the next million years, but it won't help me one jot with my photographs, because a photograph has nothing to do with words. I'm still stuck with visual relationships; indeed, my job is to organize visual relationships.

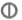

I take pictures four or five days a week. Taking pictures is like keeping a diary for me, a way of expressing who I am over time. It helps solidify my life experiences, defining moments of time. To me, pictures are like shooting stars crossing the night sky – an epiphany, an explosive reality.

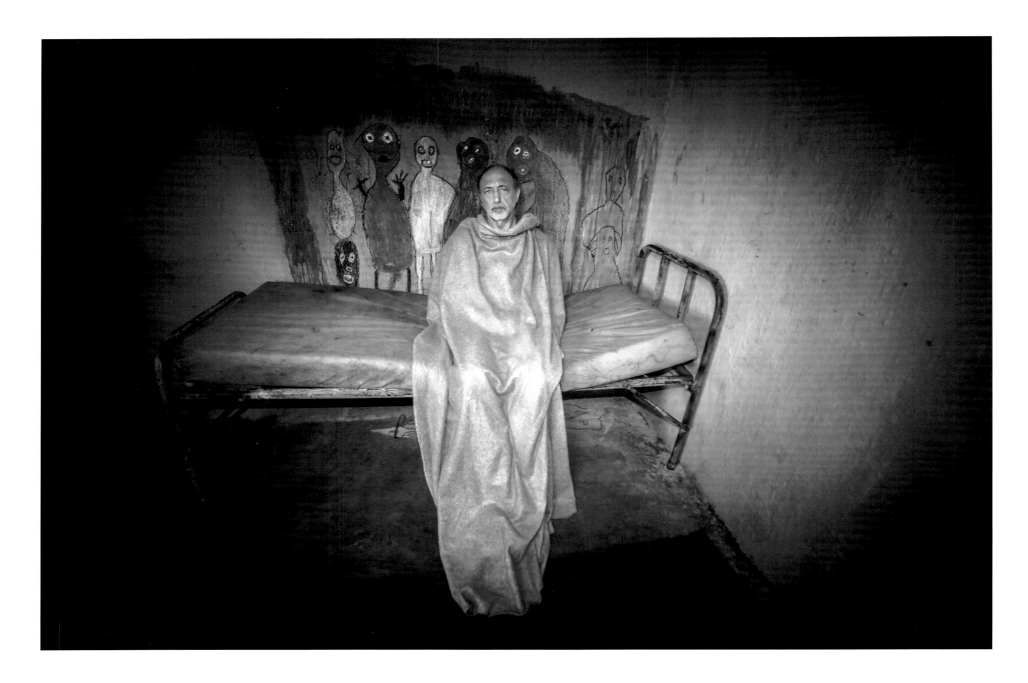

Marguerite Rossouw,
Roger and Friends, 2015

I do not think that we humans are able to appreciate cosmic time or timelessness in any shape or form. We cannot even think in these terms.

I have been taking photographs in many of the same locations for a number of decades. Nevertheless, many of the places that I keep returning to are full of possibilities for further image-making; it might be the walls, the animals, the objects, the people, or a combination of all of these. There are some people I keep in touch with, and others who come and go. Some of those whom I have known for long periods of time have never been successfully photographed, while others whom I barely know have ended up in some of my most memorable images.

As I have said, my photographs are never planned. Rather, it is my goal to arrive at a location with a quiet, silent mind. Then the photographs come about through the interaction between my conscious and unconscious mind, between me and the subject. Like working one's way through a maze of traffic to a nebulous destination without a map, one can only hope that the results will be worth the effort.

The best pictures arise when, like a good actor, the subject forgets about the stage and fully embodies their character. Most of the people I have worked with in South Africa probably have no real conception of what I am trying to achieve or how the camera might transform them. Thus, the issue of them fearing it does not arise. However, my belief is that, if I were to encounter a subject with a more sophisticated mask, I would still be able to capture that state of being I am known for.

Most of my projects have taken approximately five years to complete. *Outland* took five, *Shadow Chamber* four, *Boarding House* four and a half, and *Asylum of the Birds* six. With each new series, my hope is to give birth

to a reality that is complete, dense and enigmatic. For me, such a goal is achievable only after years of hard work and taking photographs on a regular basis. As I often say to my students, without any doubt the most effective way of improving one's work is to go out and take photographs. The hardest part of this profession is to create great images; everything else is relatively easy.

The locations I work in are often violent, socially chaotic places. There are people running from the law, as well as escapees from prisons and mental institutions. One cannot expect to enter such environments as a photographer and receive a warm welcome. I often bring up the analogy of the circus trainer in the tiger's cage: mutual respect is a necessity for survival.

Is violence or a love of peace endemic to society? In the part of the world in which I live, the answer is clear. But because the people there are able to identify with me in some way, I have been allowed to remain. They see me partly as a friend, partly as a lawyer, partly as someone who'll take them to the doctor's, partly as a social worker, partly as a father or mother figure. That's how I have survived.

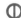

Today, people want everything packaged. Someone can package an artwork in a way that will make a potential buyer feel comfortable. That's the work that usually sells well in today's world. It's got to be packaged. Think of the meat one finds in supermarkets: if consumers had to kill those same animals themselves, it would be a whole different story. The economic forces out there are so sophisticated that they have twisted everybody's mind. But I'm fortunate; maybe it's the way I grew up. I'm fortunate to have grown up in the counterculture, in a pre-computer age. Unfortunately, people today cannot separate the slogans from the reality.

Many of my projects, such as *Outland*, *Shadow Chamber*, *Boarding House* and *Asylum of the Birds*, began with an abstract word. Then, over the course of each project, I attempted to define that word visually on my own terms, through my photographs. However, when it comes to taking a photograph, I stay away from words completely; indeed, my best works are difficult to assign words to. If you look at it logically, the pictures are first and foremost visual in nature, and the greater the visual aspects of a photograph, perhaps the greater the image. Secondly, many of my pictures have contradictory meanings, so it's almost impossible to describe them using words. I don't even think of words. I just deal with my own emotional level, which is wordless.

When I refer to a narrative, I mean that the picture has a complete logic to it; it implicitly makes sense. It doesn't mean that there can't be ambiguity, but logic runs throughout every part of what's there. It makes

Marguerite Rossouw, *Roger Ballen*, 2012

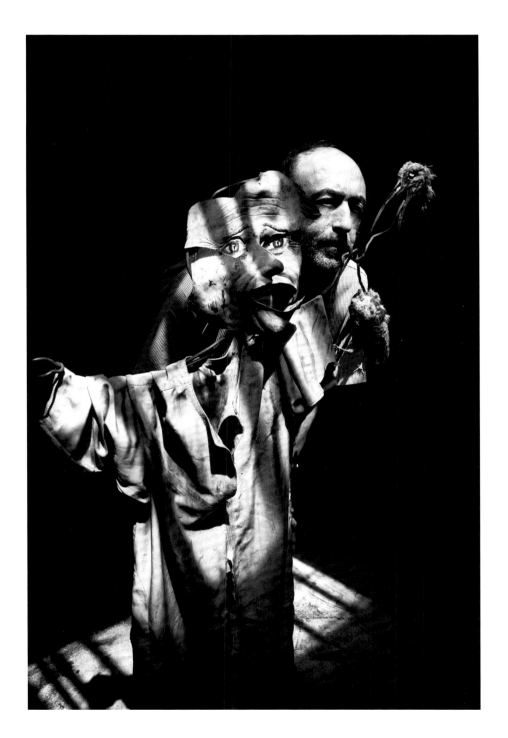

Marguerite Rossouw,
Roger and the Inner Voices, 2015

sense to the mind. Thus, I believe that most good photographs have to have a narrative, a beginning and an end, a sense of completion. And it must be visual.

One of the most difficult aspects of my work to verbalize – to deconstruct – is the meaning of the drawings that have moved from being backdrops to being central to the compositions. In short, I do not have a lucid explanation for this part of my work. Many of the elements in my photographs are beyond my conscious mind; it might be years before I come to a conclusion about them. These are the images I am most inspired by, the ones I do not understand.

The scale of my work has grown gradually larger over the years, but I'm certainly the last one to believe that bigger is better. We've seen a trend over the last ten to fifteen years, especially in colour photography, towards larger images, and it tricks the mind. We've been trained to think that if something is bigger, it must be better. I've done larger pictures for one main reason: to be able to show detail and density. On the other hand, I've noticed at some of my retrospectives that the smaller pictures, the 8 x 10s, have had a greater impact than some of the bigger ones. This might be because, compared to the experience of viewing large photographs from a distance, people feel more intimacy with an image, and are more affected by it, when they have to stand much closer in.

In the places I work in, there is always a lot of activity; there is movement all the time. Objects and drawings are being put up and taken down; people are coming in and out; birds are flying around; animals are crawling along the floor. It's then my responsibility, and no one else's, to recognize the exact moment when the picture should be taken. It is my job to perceive the flux as it moves from one place to the next.

At a certain moment in time, unity, life, intensity and poetry come about, and it's my job to know that point. To find it, I have to rely on various parts of my mind. We commonly divide the mind into the conscious and the subconscious, but that's the easy way of talking about it. In reality, there is an internal force – a being that is outside the control of consciousness, working on so many different levels – that makes the final decision. There is a moment when this decision-maker, to give it a name, changes from a red light to a yellow light. Then I walk to my camera, pick it up, and start to get it ready. But I don't press the shutter until I get a green light and hear 'Go, go!' But what tells this decision-maker to say 'go'? I'm not sure I have an answer to that question.

I never leave a location and say that I 'got the picture'. That's the one thing I like about black-and-white film photography: you cannot ever be sure that you've taken a successful photograph until you view the developed film. It's like shooting an arrow at an archery target. Sometimes I feel as though I've got close to the centre, but I never say that I've hit the bull's eye. I tend to shoot 'around' the picture as best I can – around

movement or whatever else is happening – until I've had enough. It's like food: you eat, and then after a while you're not hungry anymore.

It's the same with the work. Let's say a rat or a mouse runs, stops, and then runs into a hole. That's the end of the picture. Sometimes somebody's fallen asleep on the floor, which was what made the picture, and the shot has been taken – then there's nothing more I can do there. It's finished.

All sorts of things happen during a shoot. Someone's sleeping, then a dog comes over and licks that person, the person gets up, and then a cat jumps on top of the dog. In digital photography, you sometimes have more than a thousand shots per memory card. But when I use film, the process is precious; I've got to stop and change the roll every so often. I have to make the best of my shots.

As I enter my late sixties, the passage of time becomes foremost. I cannot help feeling that, because there are so many parts to the puzzle, life will never be understandable in any way whatsoever.

Confusion is a crucial metaphor for the human condition. We try to find purpose in confusion, but fundamentally it's just confusion. Nevertheless, bodies of work arise, whether random or planned. I have been working for fifty years now, so it is known to me that the work has a life of its own. And that, I believe, is one of the most important aspects of art: that the work has a life beyond the artist. There are not many artists who can achieve this, because over time the work has to remain relevant to those who view it, even though they weren't part of the era in which it was created. It's important to me that the work has a relevance beyond my lifetime, but I cannot control this.

Moving on, I see death as something that transforms my imagination. I have tried to express what the enigmatic qualities are, the qualities I can relate to, when I think about death in my photographs. My photographs need to be enigmatic. When you ponder the nature of death, you begin to understand what enigma is. The goal is to create pictures that have the same quality. If you produce pictures that have enigma, then perhaps they are making a profound statement.

I have often asked myself, what is the statement I am trying to make? Through photography, I have arrived at a place where the only answer to my lifelong questioning is no answer. As I have said on many other occasions, the most profound word in the English language is 'nothing'. I have come from nothing, know nothing, and will become nothing. My photographs are likely to outlive me.

You cannot beat life …

selected bibliography

books

No Joke. Asger Carlsen, Roger Ballen. Morel, UK, 2016

Roger Ballen: Appearances, Disappearances, Reappearances. Nazraeli Press, US, 2016

Roger Ballen's Theatre of the Mind. Text by Colin Rhodes. STOARC, Australia, 2016

The Theatre of Apparitions. Roger Ballen in collaboration with Marguerite Rossouw. Introduction by Colin Rhodes. Thames & Hudson, UK, 2016

Unleashed. Roger Ballen, Hans Lemmen. Introduction by Claude d'Anthenaise and Stijn Huijts. Essay by Jan-Phillipp Freuhsorge. Kerber, Berlin, 2016

Elemental. Roger Ballen and Adam Ganz. Hotshoe, UK, 2015

The House Project. Text by Didi Bozzini. Oodee Books, UK, 2015

Outland. Second edition. Introduction by Peter Weiermair, essay by Elizabeth Sussman. Phaidon, UK, 2015

Resurrected. Roger Ballen. Kerber Art/Serlachius Museot, Finland, 2015

Asylum of the Birds. Thames & Hudson, UK, 2014

The Audience. Nazraeli Press, US, 2014

Roger Ballen's Theatre of the Absurd. Pug, Oslo, Norway, 2014

Lines, Marks, and Drawings: Through the Lens of Roger Ballen. Smithsonian National Museum of African Art, Washington, DC; DelMonico Books; Prestel, US, 2013

Roger Ballen/Die Antwoord: I Fink u Freeky. Prestel, UK/US, 2013

Roger Ballen. Introduction by Dominique Eddé. Photo Poche, France, 2012

Animal Abstraction. Introduction by Wim Pijbes. Reflex, the Netherlands, 2011

Roger Ballen: Photographs 1969–2009. Introduction by Ulrich Pohlman. Kerber Verlag, Germany, 2010

Boarding House. Introduction by David Travis. Phaidon, UK, 2009

Shadow Chamber. Introduction by Robert A. Sobieszek. Phaidon, UK, 2005

Outland. Introduction by Peter Weiermair. Phaidon, UK, 2001

Cette Afrique là. Introduction by Lionel Murcott. Photo Pouche series, Editions Nathan, France, 1997

Platteland: Images of a Rural South Africa. Introduction by Roger Ballen. William Waterman Publications 1994; Quartet Books, UK, 1994; St Martins Press, US, 1996

Dorps: Small Towns of South Africa. Introduction by Roger Ballen. Clifton Publications, South Africa, 1986

Boyhood. Introduction by Roger Ballen. Chelsea House, UK/US, 1979

exhibition catalogues

Roger Ballen: Retrospective. Istanbul Modern, Istanbul, Turkey, 28 December 2016 – 4 June 2017

Roger Ballen: The Theatre of the Absurd. CAFA Art Museum, Beijing, China, 2–23 September 2016

In Retrospect: Roger Ballen. Southeast Museum of Photography, Daytona State College, US, 2016

Roger Ballen: Nothing Is More Real than Nothing. Photoink, Sunaparanta, Goa Centre for the Arts, India, 2016

Roger Ballen's Shadowland, 1982–2014. Czech Centre for Photography, Kafka House, 3 February – 17 March 2015

Roger Ballen: Retrospektiv = Retrospective. Nikolaj Kunsthal, 27 August – 3 November 2013

Roger Ballen: Playpen, North-West University, Potchefstroom, South Africa, 2012

Shadowland Photographs, Manchester Art Gallery, UK, 2012

Roger Ballen. Seravezza Fotografia 2011, Palazzo Mediceo, Seravezza, Italy, January–April 2011

Roger Ballen. Museu de Arte Contemporânea de Niterói, Rio de Janeiro, Brazil, 19 March – 15 May 2011

Iziko South African National Gallery, 2010–11

(Re)construcoes: arte contemporanea da Africa do Sul. Museu de Arte Contemporânea de Niterói, Rio de Janeiro, Brazil, March–May 2010

Roger Ballen Storie. Museo Riva del Garda, Italy, June–August 2010

Roger Ballen Fotografien, 1969–2010. Introduction by Ulrich Pohlmann, Münchner Stadtmuseum, Munich, Germany, 2010

Galerija Fotografija, Ljubljana, Slovenia, 2009

Brutal, Tender, Human, Animal: Roger Ballen Photography. Art Gallery of Western Australia, Perth, 25 April – 4 May 2008

The Sorrow of Death. BWA Katowice, Poland, November 2008

Roger Ballen: Dietro l'ombra. Su Palatu, Spazio Culturale per la Fotografia, Vilanove Monteleone, Italy, 2008

Roger Ballen: l'humanité pour prétexte. Toulouse, France, January–March 2004

Galleria Carla Sozzani, Milano, Italy, January 2003

Fact & Fiction. Galerie Kamel Mennour, Paris, France, March 2003

films

Roger Ballen's Theatre of Apparitions. Directed by Emma Calder and Ged Haney, 2016

Roger Ballen's Theatre of the Mind. Collaboration with Sydney College of the Arts students and alumni, 2016

Roger Ballen's Outland. Directed by Ben Crossman and Roger Ballen, 2015

Asylum of the Birds. Directed by Roger Ballen and Saskia Vredeveld. The Netherlands Film Fund, 2012

I Fink u Freeky. Music video. Directed by Roger Ballen and Ninja, 2012

Memento Mori. Directed by Saskia Vredeveld. The Netherlands Film Fund, 2005

Ill Wind. Directed by Roger Ballen and Larry LePaule, Berkeley, California, 1972

public collections

Art Gallery of Western Australia, Perth, Australia
Berkeley Art Museum, California
Bibliothèque Nationale, Paris
Birmingham Museum and Art Gallery, Alabama, US
Brooklyn Museum, New York, US
Central Academy of Fine Arts Museum, China
Centre Georges Pompidou, Paris, France
Centro Fotográfico Manuel Álvarez Bravo, Mexico
Durban Art Gallery, Durban, South Africa
Fotomuseum, Munich, Germany
George Eastman House, Rochester, New York, US
Haifa Museum of Art, Israel
Hasselblad, Gothenburg, Sweden
High Museum of Art, Atlanta, US
The Jewish Museum, New York City, US
Johannesburg Art Museum, South Africa
Los Angeles County Museum of Art, US
Louisiana Museum, Denmark
Maison Européene de la Photographie, Paris, France
Manchester Art Gallery, Manchester, UK
MONA, Hobart, Tasmania
Musée de la Photographie á Charleroi, Belguim
Musée de l'Elysée, Lausanne, Switzerland
Museet for Fotokunst, Denmark
Museo Nazionale Della Fotographia, Brescia, Italy
Museu de Arte Moderna do Rio de Janeiro, Brazil
Museum Folkwang, Essen, Germany
Museum of Contemporary Art, Italy
Museum of Contemporary Art, San Diego, US
Museum of Fine Arts, Houston, US
Museum of Modern Art, New York, US
National Gallery, Cape Town, South Africa
National Museum of Film and Photography, Bradford, UK
Palm Springs Art Museum, California
Pori Art Museum, Pori, Finland
Pushkin Museum, Moscow, Russia
Oliewenhuis, Bloemfontein, South Africa
Rijksmuseum, Amsterdam, the Netherlands
Serlachius Museum, Mänttä, Finland
Spencer Art Museum, Kansas, US
State Museum of Russia, Moscow, Russia
Stedelijk Museum, Amsterdam, the Netherlands
Tate Britain, London, UK
Tel Aviv Museum, Israel
Victoria and Albert Museum, London, UK
Virginia Museum of Fine Arts, Virginia, US
Wadsworth Atheneum Museum of Art, Hartford, US

selected exhibitions

2017

Arles Photo Festival, Arles, France
Daum Museum of Contemporary Art, Sedalia, United States
John and Mable Ringling Museum of Art, Sarasota, Florida, United States
Stadtmuseum + Kunstsammlung Jena, Germany
Tauranga Art Gallery, Tauranga, New Zealand

2016

Central Academy of Fine Art Museum, Beijing
Centro Fotográfico Manuel Álvarez Bravo, Mexico
City Gallery Palffy Palace, Bratislava
Etherton Gallery, Tucson, United States
Foto Museo de Cuatro Caminos, Mexico City
Southeast Musuem of Photography, Daytona, United States
Sunaparanta, Goa Centre for the Arts, India
Sydney College of the Arts, University of Sydney, Australia
Von der Heydt-Kunsthalle, Wuppertal-Barmen, Germany

2015

Chazen Museum of Art, Wisconsin, United States
Kafka House, Prague, Czech Republic
Montserrat, Barcelona, Spain
Museu de Arte Contemporânea, Universidade de São Paulo, Brazil
Museum of Image, Braga, Portugal
Pori Art Museum, Pori, Finland
Serlachius Museum, Mänttä, Finland

2014

Atlas Sztuki, Lodz, Poland
Fotografiska, Stockholm, Sweden
Galerie Karsten Greve, Paris Photo, France
Kunst- und Kulturzentrum Monschau, Aachen, Germany
Moscow Media Centre, Moscow, Russia
Musée Nicéphore Niépce, Chalon-sur-Saône, France
Museo d'Arte Contemporanea di Roma, Rome, Italy
Museu Oscar Niemeyer, Brazil
Museum Dr. Guislain, Gent, Belgium
Museum Villa Stuck, Munich, Germany
Oliewenhuis Art Museum, Bloemfontein, South Africa

2013

Museum of Old and New, Hobart, Australia
Nikolaj Copenhagen Contemporary Art Centre, Denmark
Palm Springs Art Museum, California, United States
Samara State Art Museum, Samara
Smithsonian National Museum of African Art, Washington, DC, United States
Westlicht, Schauplatz fur Fotografie, Vienna, Austria

2012

Manchester Art Museum, United Kingdom
Marta Herford Museum, Herford, Germany
Metenkov House, Museum of Photography, Ekaterinburg, Russia
Musée de l'Elysée, Lausanne, Switzerland
Museu de Arte Moderna, Rio de Janiero, Brazil
Northwest University Museum, Potchestroom, South Africa
Novosibirsk State Art Museum, Novosibirsk, Russia
Perm State Art Gallery, Perm, Russia
ROBA Gallery, Omsk, Russia
ROSPHOTO Museum Exhibition Centre, St Petersburg, Russia
Tel Aviv Museum of Art, Israel

2011

Fondazione Terre Medicee, Seravezza, Italy
Museum Het Domein, Sittard, the Netherlands
Omsk Museum, Russia
Sammlung Prinzhorn, Heidelberg, Germany

2010

Bozar, Brussels
Centro de Arte la Regenta, Las Palmas, Spain
Comune di Arco/Galleria Civica, Italy
George Eastman House, Rochester, USA
Iziko South African National Gallery, Cape Town, South Africa
Sammlungsleiter Fotomuseum, Munich, Germany
Stenersen Museum, Oslo
Sydney Biennale, Australia
University of the Orange Free State, South Africa

2009

City Museum of Ljubljana, Slovenia
Gagosian Gallery, New York, United States
National Library of Australia, Canberra
Ontario College of Art and Design, Toronto, Canada
Triennale, Milan, Italy
University of Johannesburg, South Africa
University of Pretoria, South Africa

2008

BWA Gallery, Katowice, Poland
Su Palatu, Sardinia

2007

Art Gallery of Western Australia, Perth
Deichtorhallen, Hamburg, Germany
Johannesburg Art Gallery, South Africa

2006

Atlanta College of Arts, Georgia, United States
Berlin Biennial, Berlin, Germany
Bibliothèque Nationale, Paris
Museum voor Fotografie, Antwerp, Belgium
Oliewenhuis Art Museum, Bloemfontein, South Africa
Sasol Art Museum, Stellenbosch, South Africa

2005

Durban Art Gallery, South Africa
Frans Hals Museum, Amsterdam, the Netherlands

2004

Berkeley Art Museum, University of California, United States
Le Château d'Eau, Toulouse, France
State Museum of Russia, St Petersburg

2002

Gagosian Gallery, New York, United States
Galleria d'Arte Moderna Bologna, Italy
Musée Nicéphore Niépce, Chalon-sur-Saône, France
Museet for Fotckunst, Odense, Denmark
Museo Nazionalle Italy, Brescia
Museum for Contemporary Art, San Diego, California, United States
Russian Museum, Museum Ludwig, St Petersberg, Russia

2001

Hasselbald Centre, Gothenburg, Sweden
Krefelder Kunstmuseen, Krefeld, Germany
Rupertinum, Salzburg, Austria
Wurttembergischer Kunstverein, Stuttgart, Germany

2000

Museum of Fhotography, Athens, Greece
Royal Theatre of Namur, Belgium

1999

Fait & Cause, Paris
Melkweg, Amsterdam, the Netherlands

1998

Kunstal Museum, Rotterdam, the Netherlands
Kunsthaus, Zurich, Switzerland

1995

Arles Photographic Festival, Arles, France
Royal Festival Hall/Hayward Gallery, London, United Kingdom

on working with roger

I walked into Roger's office ten years ago. Not in my wildest dreams could I have imagined the journey waiting for me. What started out as a simple translation job evolved into a full-time, all-consuming new life for me. I remember him showing me his photographs during that first interview, carefully watching my reaction. When I made the comment that I like the dark side, that is what got me the job.

The term that accurately describes the man is 'maverick'. He is the maverick of the photo world. Individualist, nonconformist, free spirit, unorthodox, unconventional, original, bohemian, eccentric, outsider. He has basically created his own Roger Ballen world. He has never felt the need to copy anybody else.

I asked him recently what attracted him to the people he photographs. His answer was: they have no pretensions. They have given up trying to control their lives and are like the characters of a Beckett play.

Working for Roger has meant working with dedication and uncompromising quality. He has enormous willpower, unwavering discipline, a true obsession with his photography and an undaunted spirit and drive. He crosses all boundaries without fear, he explores all options, he never stops asking questions and he has the patience of a saint.

Roger has the ability to interact with anyone, no matter who they are. He can talk to anybody on their level and never judges. The people he works with all have enormous respect and love for him, and he is never too busy to answer their phone calls or text messages. They all have his phone number.

Since starting with him ten years ago, his work has developed into another direction completely. I think the artist in Roger has finally come full circle. For him, it is all about creating the perfect image. We never plan the photos, but an interesting object is often the start of a great image, as he slowly builds it up to become what he calls 'perfect imperfection'. There is no compromise in his work, and he will never sign off on anything until he is completely happy with it. It means redoing and reworking and always striving for perfection. He is obsessed with creating new photographs. We do shoots every afternoon, come rain or shine. It is not a glamorous job; after a shoot I always look as though I have just stepped out of one of the photographs.

Roger has always been generous in sharing his knowledge, and he has included me and allowed me to contribute to his art. He is always open to suggestions.

This is my experience of working with Roger.

Marguerite Rossouw

acknowledgments

I would like to express my sincere gratitude to the following individuals:

Andrew Sanigar, whose enthusiasm for and dedication to this project were crucial to its realization. His professional contribution to the various aspects of this publication was essential.

Sarah Praill, whose superb design and artistic input was paramount. Her aesthetic sensibility pervades every aspect of this book, as well as all the others I have worked on with her.

Ginny Liggitt, for her astute technical input, ensuring that the images in this book are of the highest quality.

Mark Ralph, for his valuable and elucidating comments regarding all aspects of the text.

Marguerite Rossouw, whose commitment to my art over the past decade has been unsurpassed. Her dedication, artistic sensibility and photographic skill have been paramount in the creation of many of the images in this book, as well as the publication itself.

Sarie Pretorius, who played an important role in communication and organization.

Gerald Rossouw, for his depth of technical skill, which has been crucial to ensuring the print quality of this book.

Robert Young, for bringing to bear on the introductory essay his profound understanding of the written word.

Jenny and Dennis Da Silva, for their friendship and important contributions to my work over the past three decades.

Lynda, Paul, Amanda and Sooty Ballen, for their love and support.

And finally, the many friends, acquaintances, passers-by, animals and invisible spirits who have contributed to these photographs in one way or another. Our beings are mysteriously interwoven into each one of these images.

picture credits

14 tl, tr, bl: photographer unknown; 15 r: Kate Ballen; 20–21: Gerald Rossouw; 85: Kate Ballen; 152: Dennis Da Silva; 153: Director: Ben Crossman; 163: Director: Ben Crossman; 262 Marguerite Rossouw; 265: Marguerite Rossouw; 266–7: Marguerite Rossouw; 326–30: Marguerite Rossouw

index

Figures in *italics* refer to illustrations, those in **bold** to the main illustrated entry for a particular series. All works are by Roger Ballen, unless stated otherwise.